FROM PERIPHERY TO CENTER

Art Museum Education In The 21st Century

Pat Villeneuve, Editor

ACKNOWLEDGMENTS

This book would not have been possible without the support of the National Art Education Association, the NAEA Museum Education Division, and the leadership of NAEA Past-President Mary Ann Stankiewicz. I would like to thank those who reviewed proposals for the book: Gail Davitt, Catherine Fukushima, Suzan Harris, Ann Marie Hayes, Dana Carlisle Kletchka, Elizabeth Reese, Beth Schneider, Dawn Salerno, Virginia Shearer, Laura Thompson, and Betty Lou Williams. I would also like to acknowledge the capable editorial assistants provided by Florida State University: Amy Gorman, Ann Rowson Love, Hilary Pendleton, and Jonelle Prill, and the fine work done by Lynn Ezell and Clare Grosgebauer in the NAEA Publications Department. In particular, I appreciate the efforts of those who submitted proposals for the book and participated in the *Many Voices Project*. Although I could not publish everything, I read them all. And, most of all, thank you to Tom.

DEDICATION

This book is dedicated to all art museum educators and their inspirational commitment
to making art museums welcoming places where people of all ages and from every
walk of life can find meaning in and learn about works of art.

TABLE OF CONTENTS

INTRODUCTION

The title of this book represents our collective vision of art museum education as a critical, highly regarded function at the heart of the museum. Although museum education has developed as a field in the last 20 years, the vision is not yet a reality in many art museums. I have studied the sociology of professions, and I am convinced we can advance our position in the museum by demonstrating an informed, deliberate, reflective practice. As art museum educators, we need to be knowledgeable about art *and* education, we need to have an educational philosophy that gives coherence to the decisions we make, and we need to articulate that philosophy regularly. That will allow us to practice more effectively and create successful programs that will earn the respect of the museum administration and community.

This book is intended for practitioners and students in university classes on art museum education. It contains theory, which is an essential base for informed practice, as well as information on museum programs and models for practice. The book is necessarily incomplete, and I do not consider that it contains all "the answers." Rather it is full of ideas and possibilities to consider, to adapt to individual museum situations, or to disregard, as appropriate.

When I agreed to serve as editor for this book, I wanted to incorporate as many ideas and perspectives from the field as possible. In addition to encouraging first-time authors, I devised the *Many Voices Project*. We placed unedited manuscripts on a dedicated website and invited art museum educators and others to read and offer their comments. Responses included examples from practice, alternate views, and ideas to ponder. By incorporating these comments in the chapters I have tried to simulate—and stimulate—dialogue.

Another dialogue is featured in the Preface. Inspired by Melinda Mayer's conception of gallery dialogue as "scintillating conversation,"[1] I asked key leaders from the National Art Education Association's Museum Education Division to record a conversation that would reveal to readers the current state of art museum education practice.

Many factors constrain the editing process, and I do not expect that readers will agree with all the decisions I made regarding this book. Nonetheless, there is a great deal of content here, and I hope that it will provoke reflection and dialogue[2] and lead toward improved practice in art museum education.

Pat Villeneuve
Editor

[1] See Part 4.

[2] For online resources and continued discussion, go to www.artmuseumeducation.org

PREFACE

On April 26, 2006, five seasoned museum educators, all current or past directors of the National Art Education Association (NAEA) Museum Education Division, met in Boston for a roundtable discussion of art museum education. Participants included Peggy Burchenal, Curator of Education and Public Programs at the Isabella Stewart Gardner Museum in Boston; Gail Davitt, The Dallas Museum of Art League Director of Education at the Dallas Museum of Art; Marla Shoemaker, Senior Curator of Education at the Philadelphia Museum of Art; Kim Kanatani, Gail Engelberg Director of Education at the Solomon R. Guggenheim Museum; and Beth B. Schneider, W. T. and Louise J. Moran Education Director at The Museum of Fine Arts, Houston.[3] The conversation, presented below, touched on some of the major issues in the field—past, present, and future.

Museum Educators

Beth: Let's start with a discussion of museum educators.

Peggy: One of the great strengths of museum educators as a group is that we all have slightly different backgrounds. When I went into the field, the art history degree was almost a requirement for museum work, while educational theory and teaching experience was something to acquire on the job. I quickly discovered that there were many other kinds of expertise that came into play: grant writing, public relations and marketing, working with trustee committees and community advisory groups, and so on. Museum educators have creative, flexible minds and are always open to learning new things.

Gail: Do you think that people coming into the profession now come from a broader range of academic backgrounds? My training in art history is part of a broad humanities background that includes literature and studio. I've always thought that an interdisciplinary perspective has served me well in this field. Because of the various things that we're called upon to do, I believe we also may be looking for experience in performance or for someone who may have a Master of Fine Arts degree in writing. They bring certain skills that have become a valuable aspect of interdisciplinary programming.

Kim: It has to do with the blurring of lines between the various disciplines within the art museum. When you talk about somebody with an MFA in writing, I immediately think of positions now that exist where there is more of an editorial, interpretive writer who serves as a liaison between Publications, Education, and Curatorial.

[3] Special thanks to Kem Schultz at the MFA Houston for transcribing the recording of this roundtable.

Beth: As the head of a large education department, I am looking for staff with a wide range of skills and backgrounds so that collectively we have expertise in art history, art education, studio art, and so forth. We could also benefit from expertise in aspects of anthropology, history, and religion. But for all museum educators, communication through writing is incredibly important, and in my experience, is the biggest deficit in many young museum educators. Excellent writing skills are essential for writing about art, preparing grant proposals, and general communication.

Marla: That's something that should be in museum education programs. I don't think people have any idea about the importance of writing in an art museum.

Peggy: Museum education has always prided itself on using an apprenticeship model of learning, which is partly why museum education departments provide so many internships. And while I think some academics may have thought, "Oh, how old-fashioned," I think learning by doing has a lot of validity. The trick is to make sure to leave time for reflecting on what's been learned—and that's often hard to do. Identifying and understanding the theory behind your practice is a key element to growing individually as a professional and collectively as a field.

Gail: I would also emphasize a deliberate commitment to continual learning—learning from what you're doing, examining it, improving it, all as part of the process of developing a richer understanding and a theoretical basis of what it is that you do.

Kim: I think the training of museum educators is an absolutely critical and challenging piece. Politics and strategizing—that's what I'm constantly preoccupied with these days—figuring out a strategy for overcoming a hurdle within the museum, building alliances, and navigating through the institutional culture. But other than through experience, where can you learn how to be political, a strategic thinker, a diplomat, a persuasive orator, and a promoter for your initiatives? I still see many in the field getting disillusioned and frustrated about issues related to power, lack of internal and external recognition, and so on. Burnout is an ongoing concern.

Marla: Could we talk about diversity of staff? In terms of the future of museums, this is a place we need to go. We need those voices; we need people on the staff. We have a Korean heritage advisory group that is celebrating its 10th anniversary. It began because, among other things, we had a Korean person on the staff in a curatorial role who wanted to start it. She was a junior person, and she was actually only there for two years, but once it got started, it continued. We've hired Korean people because of it; we've tripled our collection of Korean art because of it. It really does make a difference who's on the staff. Would we have started it without that person? I'm not sure we would have made the effort in this particular direction—or had the contacts.

Beth: Our summer internship program for undergraduates has been instrumental in identifying and hiring a more diverse staff. And this program is especially important in a city like Houston that does not have graduate programs in art-museum-related areas. Recruiting and hiring museum educators is an ongoing challenge here. I do think one of the major issues in building a diverse staff is the level of pay in art museums. If museums are really committed to diversity, then they have to raise salaries for entry- and mid-level professionals as a way to encourage people to build careers.

Peggy: I guess I'm a little cynical, but museums have always found it easy to find plenty of people to fill their positions, until they are looking for a community outreach person or someone to lead a diversity initiative. Then it's a different kettle of fish, and museums usually end up paying more in order to attract qualified candidates, often, of necessity, from outside the museum field.

Kim: My feeling, though, is that, of any department, it's usually the museum education departments that are most ethnically diverse, both internally and externally, with the audiences we serve. I like to think that we have been proactive in setting positive examples and reminders to the institution that we need to continue to seek it at all levels.

Reflective Practice

Beth: I'm interested in the idea of a more reflective practice in museum education now and how our practice changed over the past two decades. I think a lot of change has come from outside museums through initiatives like the Getty's development of Discipline-Based Art Education (DBAE). Government funders—the National Endowment for the Arts, the National Endowment for the Humanities, the Institute of Museum and Library Science, and state and local arts councils—now require evaluation studies, outcome-based studies, as part of their funding. Foundations like the Wallace Foundation and the Pew Trust issue requests for proposals that involve research into audiences, and that has reshaped the field. Our museums may not have adopted this more reflective and analytical approach to education, but these outside forces have made it an integral part of the culture at many museums.

Marla: And people are publishing those evaluation reports. More and more museum educators are putting studies on their website—like the Minneapolis Institute did with their study of technology or the Denver Museum study of family programs. And the whole area of visitor studies—the Visitor Studies Association—is connected to the field of museum education. People who do visitor studies have figured out more interesting questions to ask and have come up with different ways of getting at sort of what the public wants … what creates a spark between people and objects. We're also willing to experiment and try different formats, work as part of that team to suggest alternate arrangements, alternate plans, and different ways of opening up to different kinds of experiences for people.

Peggy: I do think that the whole idea of experimentation is a really important concept. It's harder to experiment when money is tighter, but it's absolutely essential. Experimenting takes many forms; it might mean looking carefully at your current programming to identify audience needs that aren't being met. You articulate what that need is—I want to connect with this audience in a more meaningful way—and then you think about the kinds of ways that you can go about it, and then that's your question, whether or not you've succeeded. Sometimes you succeed, and sometimes you don't, but it's important to keep taking risks.

Gail: I agree that it is necessary to be analytical and focused as we do that so that it's not just scattershot. We need to be asking: Is it working? How do we know it's working? And then why is it working? Part of experimenting does involve taking risks and having permission to fail. If you're not doing some of that, you probably aren't really pushing your profession forward.

Beth: That experimentation keeps people in the field and attracts creative young educators. The student programs manager at the Museum of Fine Arts, Houston, has great insight into teen audiences based on what he has learned from different program structures and from really listening to his audiences. His knowledge is beginning to shape our rethinking of our high school tour program. Our programs are opportunities for research and development if we ask the right questions and try to draw larger lessons out of our practice.

Gail: I suspect that most of the people who are engaged in programs that end up having an impact more broadly within the institution are often the people who deeply care about their jobs. They are just driven to do it really well. We have a manager of teaching programs who is unbelievably committed to teaching well, and when she comes back from a conference and talks to the rest of the people in the division about how her thinking about teaching has been transformed, it's just fantastic to watch. Due to her individual commitment, others are willing to apply her ideas to what they do. It moves us all forward.

Art Museum Education and the Culture of Museums

Beth: We talk about art museum education as if it's monolithic. But there are so many different kinds of art museums: collecting and non-collecting; museums that focus on a particular culture, time period, artist, artistic medium; large and small art museums; urban, suburban, and rural. The underlying culture of a museum is so crucial in shaping the work of museum educators.

Gail: I think that's absolutely true. The Dallas Museum of Art is in an unbelievable place right now in terms of the history of the institution. The particular director and deputy director, the involvement of our board, the whole impact of the recent gifts of contemporary art, a new emphasis on families and partnerships, our visitor research project, even being open until midnight once a month with rich programming—all of this coming together now has resulted in the museum being connected with the community in a wholly new way. It's like we've figured out who we are and what it is that distinguishes us—how we define ourselves— in a very conscious way. All of this impacts what we do as an education division and how we interact with the rest of the museum staff.

Kim: It's so critical to know as much as you can about the institutional culture before you take the job to make sure it's the right match for your sensibilities and aspirations.

Beth: In the early '90s, I was charged with writing a history of education at the Museum of Fine Arts, Houston. The MFA Houston was founded by a group of women who wanted to teach art appreciation in the public schools, so education was there at the very beginning. We all have to study the history of our own institutions because in that history are ideas, events, and beliefs that can support the work we do today. So much of our current practice is rooted in our history, and we can find things in the history of our museums that support what we want to do now.

Peggy: That's so true. Coming to the Gardner, which is a relatively new education department—really only 10 years old—I realized that we had the chance to write that history while it's still fresh in everybody's mind. Being able to talk persuasively about how programs have evolved over time can free you from the "we've always done it this way" argument.

Kim: Or in the Guggenheim's case, where it wasn't so fresh in everyone's mind. We've recently uncovered a gold mine of archival information about the museum's Founding Director, Hilla Rebay, that clearly demonstrates an almost missionary zeal for making art accessible to the public. Because she was better known as a curator, director, and artist, few looked at what she did through an education lens. In fact, she evidenced a keen sense of progressive interpretive strategies, an empathy for audience with her exhibition presentations, and involvement of artists in the educational process, among others. It's powerful to cite it all as a founding principle of your institution.

Marla: Fiske Kimball was the director of the Philadelphia Museum of Art when the current building was built, and he founded the education department in 1929 with three staff people: a lecturer, who gave something like 600 lectures in the first years, a school liaison, and a psychologist. The psychologist's job was to find out what people thought about art and what they wanted to learn. Even back in 1929, Kimball wanted to know what the audience thought, how people interacted with art, and how we could make that happen.

Audiences

Gail: We know that the field of museum education has grown and involves more than the number of school buses that are lined up outside. Certainly schools are central to our mission, but we now are more apt to balance that with a commitment to other audiences, as well. I wonder if others are as aware of this change as we are. Have perspectives regarding what we do changed within our museums? Within our cities and our schools? Have we impacted the understanding that funding institutions have of education in art museums? When we're seen as being relevant to schools and to other museum issues, that affects the professionalism and the perception of museum education as a career. Interestingly, we have been able to apply what we have learned from those very focused school audience programs and materials to what we do to engage other types of visitors.

Peggy: It goes back to this idea of museum educators being experts in how visitors learn. Once others in the museum realized the importance of that skill, they were eager to use it in new ways, beyond the school audience.

Kim: The focus on audience has really shifted how the disciplines within the art museum need to work with each other. It's just added a whole other element, a really critical element that was overlooked 10 or 15 years ago.

Marla: I think museums have a certain civic obligation to figure out ways to make things better for all audiences. I find myself wanting to work with audiences who do not have advanced-level education, do not speak English well, and are not on the membership tracks. Defining that with my institution as our civic responsibility—that we have this fabulous resource, and we need to figure out ways everyone uses it, even though those people aren't going to join as members—is critical.

Gail: A new project that we are involved in, I think, may help us with that very audience. The project, which is immense, is focused on arts experiences for students, but expands to include those students' families. What makes the project new may be its scale. It involves the whole school district in Dallas. The focus is on both improving arts education within the district and on integrating arts and cultural experiences into a very specific, sequential art education and classroom curriculum and then extending it further to after-school programs and to families. It's through the family component that we may get to groups like you were talking about— folks who would never come, who would never think that our museum was a place for them.

Beth: At the MFA Houston we are trying to concentrate programs for teachers, students, parents, and families in small groups of schools serving low-income children. We want these teachers and families to encounter the museum, its art, its teaching resources, its programs in a variety of ways, over and over again every year to make the point that we are committed to being part of the life of local neighborhoods. And in Houston, we go to the schools, the parks, the libraries—they become almost like branches of the museum where we meet people at places that are familiar and comfortable to them. And we have learned that we have to provide transportation to the museum because the physical and psychological distances between inner-city neighborhoods and museums can be great. These families are involved in the museum, but coming on their own is still a big leap.

Marla: I'm saying that maybe we say that's okay. We have the civic obligation to do all the things you've done, and there is no expectation. There needs to be a place for that kind of a program, even if at the end, they're probably not going to come on their own. Nonetheless, they will have had a wonderful experience. There has to be room for those audiences.

Peggy: We have to understand that there are many different kinds of museum-goers and allow for different kinds of museum experiences. Museums have got to face up to the class issues pretty soon. Museums don't exactly draw their broad audience from all classes of society—at least not yet.

Gail: We have that one Friday a month where we are open until midnight and are full of programming options, but it's not just the performance areas that are filled with visitors. The galleries are full of people looking and talking about what they see. What is truly astounding to me is the diversity of the audience in terms of their backgrounds and education and age, and I can't quite figure out why that is. Those Friday nights are not free. Is it simply a matter of timing? Or is it marketing? Or is it the range of programming that is offered, making the museum a comfortable place for many different types of visitors? People sense that there is something here for them then.

Art Museum Education and the National Art Education Association

Gail: I think a lot has to be said for the NAEA being comfortable with the museum division broadening its sense of itself beyond working with teachers. I think it's to everybody's credit that the leadership in NAEA did not have a problem with that.

Beth: When I started going to NAEA conferences in the late 1980s, I really valued the opportunity to talk with audiences of K-12 art teachers, people from universities. In some of the conferences, we talked to other museum educators, but at NAEA you could also talk about what is happening in the art classroom.

Gail: I think one of the things that a lot of museum educators have learned in terms of their partnerships with schools is how critical it is to be aware of the culture of the classroom. With NAEA, there's a real opportunity to become much more aware.

Peggy: I couldn't agree more, because I think one thing that we are still struggling to help K-12 and art teachers understand is what kinds of learning are best suited to the context of a museum and what kinds of learning are best in the classroom. That's a really big issue for art, classroom, and museum educators: to understand those special qualities of the museum and school environments and take best advantage of where you are.

Kim: I would like to hope that one of the critical contributions that museum educators have made to NAEA is sharing our expertise in teaching with objects and sharing various approaches that classroom teachers can consider including even in a more studio-based practice.

Marla: Or even in looking at art. You have to get training in looking at art and be taught how to engage kids in looking at art. And teachers often don't really know how to engage in a visual dialogue of the object. It seems to be something that's really left out of our education.

Beth: Looking ahead, it would be really valuable if the NAEA Museum Education Division could develop a long-range plan to guide the work of future division directors and to set priorities. Teaching from works of art is something we can contribute to all the educators in NAEA. The Museum Education Division did a Super Session on teaching from art at the Chicago conference, but this was only a beginning. Museum educators need to present sessions for NAEA about teaching from objects at every conference. And we need to write about teaching from art. This volume contains some important essays on that subject. If we make teaching from art a centerpiece of our work within NAEA, we as a field are making a major contribution to art education.

Kim: I was also thinking about the forums and the platforms we have now—both nationally and internationally—that we didn't have 15 to 20 years ago to really vigorously share and exchange ideas. I think all of these options have enabled our field to become much more sophisticated, progressive, and substantive with our exchanges. I appreciate NAEA's willingness and support in letting us experiment with different formats, such as our increasingly popular pre-conference. Curatorial has catalogues to document their practice; we have conferences, and they are our primary vehicles for documenting what we do and sharing our practices with each other.

A More Certain Profession

Beth: Let me raise one more question. The Eisner-Dobbs study in the mid-1980s called museum education an "uncertain profession." What do you think about museum education as a profession now? Are we a more certain profession?

Marla: I think what has happened since is tremendous growth in museum education departments and their responsibilities. So I think it's a very vital, multifaceted field. We are looking for people who have a passion for art and a passion for people and a high level of creativity, strong work ethic, and want to figure out how to make connections.

Kim: I really think that the richness and diversity of our professional backgrounds or training makes our profession quite special. Whether as artists, art historians, or art educators, I think that such a mix fosters a wonderful multifaceted synergy that really empowers and fuels our profession.

Gail: Have we been ahead of our time as a learning profession or a learning community, able to deal with change, able to bring in varied perspectives? It may turn out that whether uncertain or certain, what characterizes and makes this such a vital profession is that the people within in it are so passionate about what they do and are so committed to excellence.

Peggy: Museum educators tend to be constantly flexible and willing to learn. I think those skills become highly developed because we spend so much of our time working with different kinds of people—inside and outside the museum. Museum educators have always worked to engage other museum departments, local communities, or the academic world in group problem-solving: "Here is something I don't know; how do I find it out? Who is the best person to help with this project?" Museum educators were early adopters of the team approach.

Kim: There has been a sea-change in terms of the accomplishments, but to think that we've made it is a mistake. We still have our work cut out for us. In many cases, it's still the misunderstood profession. So while we're not uncertain, we have to keep on writing, documenting, publishing, and educating about what we're doing. Projects like this anthology are absolutely critical for moving the profession forward.

PART 1

Our History, Research, And Theoretical Foundations

Six Themes in the History of Art Museum Education

Melanie L. Buffington
Virginia Commonwealth University

There is little scholarly agreement about the origins of museum education. Though many authors trace its origins to efforts at several European museums, others think museum education originated in the United States (Caillet, 1994; Curran, 1995; Hooper-Greenhill, 1992; Lehmann, 1995; Newsom & Silver, 1978; Roberts, 1997; Zeller, 1989). Until 30 years ago, education received less attention and funding than many other museum functions. However, education has become increasingly important within the scope of museum programming (Ebitz, 2005). This chapter explores six important themes[1] in museum education:[2] experimenting and responding to society; educating to improve society; delivering appropriate content; meeting school curricula and collaborating with teachers; improving practice with theory and research; and developing and implementing emerging technologies.

Experimenting and Responding to Society

As art museums emerged as public institutions, they experimented with various educational programs, although no employees held the title "museum educator." Hooper-Greenhill (1992) cited the Louvre, opened in 1793, as the first free public art museum and therefore a part of the French educational system. The Louvre published inexpensive catalogues that were translated into many languages. Throughout the second half of the 19th century, European museums experimented with didactic labels, public lectures, school programs, and educational exhibitions (Hein, 1998).

In the United States, early public art museums included the Pennsylvania Academy of the Fine Arts, founded in 1805 from the personal collection of Charles Willson Peale (Coleman, 1939; Stone, 2001). In Boston, the library and art gallery named the Boston Athenaeum held public displays of art. After the Boston Athenaeum received a sizeable gift of art that was too large for its facilities, the Museum of Fine Arts, Boston, was founded in 1870 with a bill passed by the Massachusetts General Court. Some of the collection from the Boston Athenaeum became part of the Museum of Fine Arts, Boston, and, for its first several

years, the museum shared the facilities of the Boston Athenaeum (Coleman, 1939; Harris, 1962; Stone, 2001; Zeller, 1989). Roberts (1997) argued that museum education was a uniquely American concept and that in contrast to their European counterparts, U.S. museums granted significant access to the public. She cited the use of the word "education" in the charters of many early U.S. museums as evidence of their commitment to the public.

An early development in formalized museum education was the emergence of museum schools, affiliations between art museums and professional art schools. These associations developed in three ways in 19th-century North America: schools formed to complement a museum collection (Buffalo Fine Arts Academy), museums formed after schools were founded to provide a teaching collection (Art Institute of Chicago), or schools and museums founded concurrently to function in tandem (Pennsylvania Academy of the Fine Arts). The purpose of these schools was to train artists and artisans using the collection of a museum. Museum schools flourished throughout the 19th century. However, as colleges and universities established art departments, art museums refocused their educational efforts on the public, and only a few of these museum schools remain (Lehmann, 1995).

Educating to Improve Society

As museums became prominent institutions within communities, they moved beyond their early educational "experiments" and developed more formal educational programs that acknowledged contemporary social trends. Coleman (1939) attributed the late-19th- and early-20th-century increase in adult education offerings at U.S. museums to the newly articulated belief that humans learn throughout life. As the amount of leisure time for workers increased, museums offered the growing middle class ways to spend their time, including educational lecture series, special classes, and gallery talks. Additionally, in 1877, the Museum of Fine Arts, Boston, opened on Sundays, free of charge, allowing working-class people access to the museum on their day off. Some museums also provided tours in other languages to reach the numerous recent immigrants (Museum of Fine Arts, Boston, 1878; Newsom & Silver, 1978). John Dana, founder of the Newark Museum in 1909, created educational programs in response to public interest. Whereas other museums referred to certain sections of their audience as "problem elements like the foreign born" (Coleman, 1939, p. 317), the Newark Museum reached out to various immigrant, minority, and working-class individuals. The museum held exhibitions related to the Newark community, including German Applied Arts, Primitive African Art, Newark of the Future, and Inexpensive Articles of Good Design (Alexander, 1979).

Zeller (1989) explained that U.S. art museums emulated the educational model at London's South Kensington Museum (now the Victoria and Albert) that was intended to create positive social change by teaching good taste. The South Kensington collected and displayed objects that were both beautiful and utilitarian in the hopes of educating English citizens about art and refining the design of everyday objects. In 1914, the Toledo (Ohio) Museum of Art held an exhibit of two furnished rooms, one in "good" taste and the other intentionally designed to show common problems in home décor. Labels pointed out the differences to educate the public about "proper" home décor.

Although linked to the progressive education movement and the writings of Dewey (1916), the movement to use museums to improve society did not involve the public in determining the programs that would help them. The power to make decisions resided with the curators and educators, not the visitors. The goal of these museum exhibitions was for the public to learn the "right" way. The "excellent" examples museums displayed promoted an ideal taste (Hein, 1998; Zeller, 1989). As museums experimented with different programmatic offerings, they experienced both successes and failures in their early educational efforts.

Delivering Appropriate Content

Believing that the goal of education was to improve society, early-20th-century museum educators developed programs that focused on delivering correct information about museum objects and philosophies. Both the use of the word "docent" and the concept of facilitators leading public tours emerged in 1907 at the Museum of Fine Arts, Boston (McCoy, 1989). Educators trained docents to present historically accurate, factual information about museum objects, placing little emphasis on personal connections, contextual information, and meaning making (Alexander, 1979; Coleman, 1939; McCoy, 1989).

In the early 1900s, U.S. art museums developed educational programs for children, including the formation of museum clubs and special classes (Alexander, 1979; Coleman, 1939; Roberts, 1997). Students participated in highly structured lessons about museum objects and learned artistic skills (Coleman, 1939). Museum personnel also developed programs for school groups, including lectures and museum stories presented to large groups of students. Museums created informational presentations featuring important works in their collections or offered historical overviews of their objects. Relating to the school curriculum was not a priority (Alexander, 1979). Many districts participated in programs that allowed all students in one grade to visit the museum, pressing museums to provide tours or other educational opportunities for thousands of students (Alexander, 1979; Coleman, 1939).

Ellie Caston

Mayborn Museum Complex, Baylor University

Beth B. Schneider

Museum of Fine Arts, Houston

Some Historical Notes on the NAEA Museum Education Division

In the discussion in the Preface of this book, Kim Kanatani noted that, for museum educators, conferences "are our primary vehicles for documenting what we do and sharing our practices with each other." The history of art museum education within the NAEA is tied to the Association's annual conference.

At the 1976 NAEA convention in St. Louis, a group of museum and university art educators began conversations about including art museum education within NAEA's purview. Over the next several years the number of museum education sessions grew from a handful in 1977 to 10 in 1978, 29 in 1979, and 33 in 1980. Thanks to the work of art museum and university art educators and to the growing presence of museum education sessions at NAEA conferences, the Association created a Museum Education Affiliate between the 1978 and 1979 conferences. Two years later, in 1981, the affiliate became a division within NAEA, joining Elementary, Secondary, Higher Education, and Supervision and Instruction (now called "Supervision and Administration").

Many people were instrumental in the growth and development of the Museum Education Division of NAEA. Teresa Grana, then working at the National Museum of American Art, Smithsonian Institution, probably had the most influence in creating the Museum Education Affiliate group and served as its chair from 1979 to 1981. When the Museum Education Division was created in 1981, its director was given a place on the NAEA's National Board of Directors. Those serving as early directors of the new division were Ellie Caston at Carnegie Museums, Chuck Bleick at Virginia Commonwealth University, and Susan Mayer at the University of Texas.

Establishing the Museum Education Affiliate and Division required the active, enthusiastic support of three NAEA presidents. Elliot Eisner, NAEA president from 1977 to 1979, provided crucial backing in creating the affiliate; O. Kent Anderson, NAEA president 1979to 1981, continued to support the affiliate; and Edmund B. Feldman, NAEA president from 1981to 1983, was essential in forming the Museum Education Division.

The January 1980 issue of *Art Education*, with Susan Mayer as guest editor, focused on museum education, a first for NAEA. In 1989, Susan Mayer and Nancy Berry, then director of public programs at the Dallas Museum of Art, solicited essays for and edited *Museum Education: History, Theory, and Practice*, a foundational work on art museum education published by NAEA. This volume, and the efforts of Sue and Nancy, established the NAEA Museum Education Division as the active professional organization that it is today.

Hein (1998) noted that the educational missions of museums differed from the educational missions of schools. Liu (2000) found that most museum resources for school programs were developed by art museum educators without the participation of teachers. In this situation, museum educators held most of the power in designing school programs.

Meeting School Curricula and Collaborating With Teachers

As the field grew, museum educators began working closely with teachers to provide students with meaningful experiences. Today, some museum education programs related to schools involve little teacher input, and other programs require almost constant cooperation among all the educators. In the early 20th century, museum educators increased the number of lending programs, allowing teachers to use objects to complement lessons (Coleman, 1939). Dana (1927) advocated the formation of school museums to house objects for teachers and emphasized ways museums could assist teachers, thus changing the traditional roles. Newsom (1975) noted that museums provided content, objects, and experiences, and teachers chose which ones to use. In the United States, it is now increasingly common for museum educators to develop educational programs that meet state or national curriculum guidelines and to implement teacher institutes and formalized partnerships with schools (Art Institute of Chicago, 2000; Chicago Board of Education, 2002; Detroit Institute of Arts, n.d.; Institute of Museum and Library Services, 2005; Saint Louis Art Museum, 1999).

Teacher Institutes

Walsh-Piper and Berk (1994) described the National Gallery of Art's weeklong summer teacher institute that builds relationships between school curriculum and museum experiences. They noted that the development of such programs was a manifestation of the emerging idea that collaborating with teachers was an important component of a successful school outreach program. The Houston Independent School District offers an interdisciplinary summer institute that provides technology training based on resources available at multiple museums (Garner & Smith, 1999). Through these programs and others, museums help teachers learn ways to integrate museum experiences into their classroom teaching.

Partnerships

Formalized partnerships between museums and schools are increasingly prevalent. Studies conducted by the Institute of Museum and Library Services (IMLS) in 1996 and 2005 found that most museums dedicated more resources than ever before to meet teachers' needs (Hirzy, 1996; Institute of Museum and Library Services, 2005; Manzo, 1999) examined museum partnerships and explained the difference between cooperation, requiring little communication and interaction, and collaboration, requiring almost constant interaction. He contended that collaborative efforts are more likely to create cohesive educational experiences. Hannon and Randolph (1999) described six ways museums and schools create partnerships, including professional development, outreach, pilot programs, field trips, residencies, and museum schools. Ranging from little interaction between teachers and museum educators to frequent prolonged contact, these partnerships focus on improving education. Museum schools involve significant integration of museum and school learning, resulting in an almost seamless relationship. Although contemporary museum schools share the same name as their 19th-century predecessors, they use different educational theories. Teachers and museum educators meet regularly to develop lessons based on museum practice and state curricula. Although the practice at every museum school is unique, the shared principles include close collaboration of museum and school personnel, learning from objects, and a commitment to school reform (Takahisa, 1998).

Earlier, Stone (1992) surveyed art museum educators and found that only a small number recruited teachers to develop, implement, or evaluate educational programs. Talboys (2000) advocated that museum educators browse through the school curriculum when developing museum programs and offered short generalizations of school curriculum as related to museum practice. He stated that school curriculum should not dictate museum practice and that an overview of curriculum is sufficient for understanding teachers' goals. Liu (2000) studied art museum educators' attitudes about school collaboration and found that museum educators often approached their relationships with elementary school teachers as one-sided—the museum educator passed information or resources to the teachers rather than engaging in collaborative work. Museum schools represent complete integration of museum and school learning; other programs use various levels of integration between museums and schools (Bailey, 1998; Berry, 1998; Hirzy, 1996; Institute of Museum and Library Services, 2005; Irwin & Kindler, 1999; Lehman & Igoe, 1981; Liu, 1999; McIntyre, 1999; Newsom & Silver, 1978).

Improving Practice With Theory and Research

Although education was part of many museums since their early days, little theoretical, evaluative, or research-oriented literature emerged before the 1970s. Newsom (1975) noted the lack of scholarly writing about art museum education programs and explained why studying this field is crucial: "There is virtually no body of evaluative literature in this field. … Museum educators are thus forced to do their work on a hit-and-miss basis, inventing programs on their own without professional knowledge or experience to guide them, and often repeating, unwittingly, programs and mistakes of the past" (p. 54).

In a study of art museum education programs a decade later, Eisner and Dobbs (1986) found that little had changed, noting that there was still insufficient theory guiding museum education practice. In 1992, the American Association of Museums published *Excellence and Equity: Education and the Public Dimension of Museums*, emphasizing the central role of education to a museum's functions (Hirzy, 1992). Since then,

museum educators have articulated museum-specific ways for engaging learners, including dialogic looking, object-centered learning, and the curriculum called Visual Thinking Strategies, among others (Rice & Yenawine, 2002; Wilson McKay & Monteverde, 2003). Recent museum education articles and books reflect the growing role of educational theory in the field and indicate the importance of two theories, constructivism (the idea that learners construct knowledge for themselves) and hermeneutics (the theory and practice of interpretation) (Caston, 1989; Falk & Dierking, 1995; Hein, 1998; Hooper-Greenhill, 1994b, 2000a, 2000b; Lankford, 2002; Mayer, 2005; Oguibe, 2004; Stone, 2001).

Hein (1998) advocated the emergence of the constructivist museum, asserting that museums should assist visitors in creating connections between their prior knowledge and museum exhibitions. He explained that museum educators need to consider the diverse learning styles of their audiences, how collaborations can foster museum learning, and how the social environment of the museum influences visitor experiences. Mayer (2005) also explained the need for visitors to be active participants in their own learning.

Hooper-Greenhill (1994a) described the effects of educational psychology on museum practice and focused on the process of interpreting objects as related to Gadamer's (as cited in Hooper-Greenhill, 2000a) hermeneutic circles. She related making sense of objects to the hermeneutic cycle, developing understanding through the continuous movement between the parts and the whole. Additionally, she noted that interpretations of objects are always historically situated.

Meaning making in museums is a continual process involving past experiences, traditions, cultures, representations, human biases, current situations, the objects, and the social setting of the museum (Chung, 2003; Ogbu, 1995). The notion that meaning making is individual, ongoing, and subject to interpretation is fundamentally different from early ideas of museum education programs when educators communicated the correct interpretation of an object. Hooper-Greenhill (2000a) explained that traditional interpretation in a museum centered on museum personnel delivering objective facts, as determined by authorities, to passive visitors. Wilson McKay and Monteverde (2003) explained that dialogic looking validates the importance of viewers' responses to artworks, recognizes three different contexts of dialogues, and emphasizes that visitors should not trust only the voice of the museum authority. Chung (2003) wrote that Western art criticism traditions are not appropriate for understanding all objects and that they can restrict what interpretations can be made.

To continually improve their educational programs, museums often conduct research. Studies of museum visitors and their experiences first emerged in the 19th century. Recent efforts concentrate on understanding how visitors learn and the effects of museum experiences on students. Falk and Dierking (1992, 1995, 2000, 2002) conducted early research into learning on field trips and investigating the contexts that make up a museum visit. Whereas some researchers conducted

large-scale studies to document conditions in museum educational programs (Eisner & Dobbs, 1986; Hirzy, 1996; Newsom & Silver, 1978; Wetterlund & Sayre, 2003), others offered in-depth investigations of a particular group or experience in the museum setting (Brodie & Wiebe, 1999; Chung, 2003; Falk & Dierking, 1992; Floyd, 2002; Henderson & Watts, 2000).

George (1999) noted the importance of conducting research in museums: "Researching and understanding the process of learning are essential, but unless we apply that knowledge to everything we do—the exhibit plans, the labels, the teaching strategies, and all our communication—we will not be successful in expanding and diversifying our audience" (p. 41).

George (1999) explained that conducting research is not the end of a process, but the beginning. Falk and Dierking (2000) contended that museum exhibitions could be more effective if exhibit design reflected an understanding of how people learn, why people visit museums, and how the context of an exhibition affects what and how people learn. The growing interest in theorizing and researching museum practice brings about greater reflexivity in the field. Additionally, museum educators use theoretical and research knowledge to improve their relationships with the schools they serve. This knowledge can connect museum education to the larger field of education, yet allow it to retain the aspects that make it a unique discipline.

Developing Emerging Technologies

Within the last decade, museum educators increasingly developed programs that exist online or include interactive devices. However, research into successful online experiences is just developing (Soren & Lemelin, 2004). Art museum educators work with teams of technology developers to create online discussion forums, mobile devices, and educational websites (Albertsen & Sackrey, 2001; Schaller & Allison-Bunnell, 2005; Silveira et al., 2005). Wetterlund and Sayre (2003) found that 90% of art museums provided information about their educational programs online. In a 2005 survey of art museum websites, Varisco and Castes (2005) identified 11 types of educational resources that focus on the delivery of information. They noted the lack of tools that allow social interactions, collaborations, and audio or video interactions.

In a study of children who interacted with two programs based around art museum collections, GeeGuides found that students were deeply involved by programs that allowed them to be creative, assert a degree of control, or offered feedback. Additionally, they found that students' gallery interactions were more likely to occur when they used a handheld guide. As technological developments allow more types of interaction, the differences between real and virtual museum experiences are increasingly blurred.

Museums use other emerging technologies including user-generated content, blogs, and podcasts. The issue of user-created content on websites is central to the examples offered by Durbin (2004) from the Victoria and Albert Museum (V&A). She described how the V&A incorporates ideas from their visitors, submitted both online and in person, to their websites. During one exhibition, visitors left comments about defining moments in their lives; museum personnel collected more than 50,000 comment cards and posted some of them online. For an exhibition on fashion designer Ossie Clark, the museum solicited e-mail descriptions from the public about their experiences with the designer's clothes and posted some of these stories on their website for the exhibit. Durbin noted that these stories, though low in number, were of high quality and

brought an excitement to the website that traditional didactic museum text would not have. The inclusion of community voices on the website is an important change in educational practices that may work toward developing an online community.

In addition to user-generated content, blogs (or web logs) are an emerging technology that is relevant to art museum educational programs. Blogs are a type of web page in which the newest information appears first and older information is available through an archive. Blogs may be written in a journal style on a variety of topics including personal, political, corporate, news, and so on. The blog may be configured so that one person, many people who have permission, or anyone

Ellen Turner
GeeGuides, LLC

GeeGuides program assessments show that innovative use of technology effectively engages children and helps focus their attention on art. The assessments also show that a handheld guide designed for children can make the museum experience more meaningful by making the concepts more memorable. The technology accomplishes this by bringing an element of interactive play into the learning experience. The animated movies present the materials through a humorous and kid-friendly medium in contexts kids can relate to. The study concludes that children "love using the program" and that it helps them to retain multifaceted concepts.

In addition, the Web-based nature of the GeeGuides program makes it possible to embed customized research tools that can make the program invaluable for museum education. Teachers can obtain real-time assessments of each student's progress at any time. And lastly, because the program is an Internet application, it is a convenient and effective way to provide information as it can be easily kept current, and there is no installation or download required.

can post information or make a comment on a previous post. Since their emergence in the late 1990s, blogs have become increasingly mainstream (Glenn, 2003; Greenberg, 2005).

Walker Art Center was perhaps the first museum to have a functioning blog related to educational practices (http://blogs.walkerart.org/index.wac). Since its inception in March 2005, museum educators, curators, and other personnel have used the blog to talk about the exhibitions, educational goals, and other practices of the museum. Although this blog allows only Walker employees to create posts, it has become the most visited part of the Walker's website (R. Primm, personal communication, April 7, 2006).

Podcasts[3] are multimedia files that are compressed and posted on the Internet for playing on MP3[4] players and computers. Unlike traditional audio tours that are available only in the museum, podcasts can be accessed for free, through the Internet, and played at the museum, or anywhere else the user has access to a computer or a MP3 player. For instance, the Tate's website offers podcasts made by museum personnel, school children, and members of the public. These diverse podcasts offers visitors to the museum or the Web (http://www.tate.org.uk/learning/youngtate/artlookers/) various ways to learn about works of art in the collection. As such, museum podcasts have vast potential to change the way people learn about objects and the way museum education programs operate.

Conclusions

Over time, as museums changed from palaces for the scholarly elite to educational institutions for everyone, the role of education within the scope of museum activities also changed. Currently, many museums recognize that educating is as important a function as collecting and exhibiting. As museum education grew into its own field, educators worked from a variety of paradigms to meet the needs of their audiences. Although some early educational programs now seem elitist, there was value in these efforts. Now, many museum educators recognize the importance of educational theories and work within theoretical frameworks to guide their practice. Additionally, research about museum practice is now more common, related to educational practice, and directed by educational theories. When increasing their educational offerings and connections to schools, museums should create situations that foster the collaboration of teachers and trained museum educators to develop innovative programs for students and teachers. The convergence of these important issues in our field may lead to exciting new learning opportunities for museum personnel and the public.

REFERENCES

Albertsen, T., & Sackrey, P. (2001, March). *Art tales: A story of collaboration and integration.* Paper presented at the annual meeting of Museums and the Web 2001, Seattle, WA. Retrieved May 2, 2002, from http://www.archimuse.com/mw2001/papers/sackery/sackrey.html

Alexander, E. P. (1979). *Museums in motion: An introduction to the history and functions of museums.* Walnut Creek, CA: AltaMira Press.

Art Institute of Chicago (2000). *Chicago: The city in art.* A collaboration with the Chicago Public Schools. Retrieved September 10, 2007, from http://www.artic.edu/aic/education/mural_project/

Bailey, E. (1998). Two stories of collaboration and cross-fertilization: Museum-school partnerships in Massachusetts. *Journal of Museum Education, 23*(2), 16-18.

Berry, N. W. (1998). A focus on art museum/school collaborations. *Art Education, 51*(2), 8-14.

Brodie, L. & Wiebe, L. M. (1999).Yellow busloads from hell: A museum field trip in three voices. *McGill Journal of Education, 34*(2), 173-187.

Caillet, E. (1994). Schools and museums: Reflections from France. *Journal of Museum Education, 17*(2), 15-19.

Caston, E. B. (1989). A model for teaching in a museum setting. In N. Berry & S. Mayer (Eds.), *Museum education history, theory, and practice.* Reston, VA: National Art Education Association.

Chesebrough, D. E . (1998). *A survey of characteristics, factors, and conditions of museum partnerships.* Unpublished doctoral dissertation, Duquesne University, Pittsburgh, PA.

Chicago Board of Education (2002). *The art of survival: Student activity book.* Chicago: Chicago Board of Education and the Museums in the Park.

Chung, S. K. (2003). The challenge of presenting cultural artifacts in a museum setting. *Art Education, 56*(1), 13-18.

Coleman, L. V. (1939). *The museum in America: A critical study (Vol.1).* Washington, DC: American Association of Museums.

Curran E. (1995). Discovering the history of museum education. *Journal of Museum Education, 20*(2), 5-6.

Dana, J. C. (1927). *Should museums be useful?* Newark, NJ: The Museum.

Dewey, J. (1916). *Democracy and education: An introduction to the philosophy of education.* New York: Macmillan Company.

Detroit Institute of Arts. (n.d.). *Lesson plans.* Retrieved October 23, 2006, from http://www.dia.org/education/lesson_plans/index.asp

Durbin, G. (2004, April). *Learning from Amazon and eBay: User-generated material for museum web sites.* Paper presented at the annual meeting of Museums and the Web, Washington, DC. Retrieved May 18, 2004, from http://www.archimuse.com/mw2004/papers/durbin/durbin.html

Ebitz, D. (2005). Qualifications and the professional preparation and development of art museum educators. *Studies in Art Education, 46*(2), 150-169.

Eisner, E. W., & Dobbs, S. M. (1986). *The uncertain profession: Observations on the state of museum education in twenty American art museums.* Los Angeles, CA: The Getty Center for Education in the Arts.

Falk, J., & Dierking, L. (1992). *The museum experience.* Washington, DC: Whalesback Books.

Falk, J., & Dierking, L. (Eds.), (1995). *Public institutions for personal learning: Establishing a research agenda.* Washington, DC: American Association of Museums.

Falk, J., & Dierking, L. (2000). *Learning from museums: Visitor experiences and the making of meaning.* Walnut Creek, CA: AltaMira Press.

Falk, J., & Dierking, L. (2002). *Lessons without limit: How free-choice learning is transforming education.* Walnut Creek, CA: AltaMira Press.

Floyd, M. (2002). More than just a field trip…Making relevant curricular connections through museum experiences. *Art Education, 55*(5), 39-45.

Garner, D., & Smith, R. A. (1999). Advanced technology training: Multimedia institutes go to the museum district. *Learning & Leading with Technology, 27*(3), 36-41.

GeeGuides, LLC. (2004). Summary of formative evaluation of GeeGuides, LLC interactive education programs. Retrieved September 6, 2007, from http://www.geeguides.com/_assets/documents/ReportSchoolMuseumFindings.pdf

George, A. S. (1999). Critical issues for museums in our expanding role. In B. Pitman, (Ed.), *Presence of mind: Museums and the spirit of learning* (pp. 37-43). Washington, DC: American Association of Museums.

Glenn, D. (2003, June 6). Scholars who blog: The soapbox of a digital age draws a crowd of academics. *The Chronicle of Higher Education.* Retrieved March 30, 2005, from http://chronicle.com/free/v49/i39/39a01401.htm

Greenberg, D. (2005, May 15). A guest blogger's diary: Get me out of here. *The New York Times,* p. 4-5.

Hannon, K., & Randolph, A. (1999). Collaborations between museum educators and classroom teachers: Partnerships, curricula, and student understanding. (ERIC Document Reproduction Service No. ED 448 133).

Harris, N. (1962). The gilded age revisited: Boston and the museum movement. *American Quarterly, 14*(4), 545-566.

Hein, G. E. (1998). *Learning in the museum.* London: Routledge.

Henderson, A., & Watts, S. (2000). How they learn: The family in the museum. *Museum News, 79*(6), 41-45, 67.

Hirzy, E. C. (Ed.). (1992). *Excellence and equity: Education and the public dimension of museums.* Washington, DC: American Association of Museums.

Hirzy, E. C. (Ed.). (1996). *True needs, true partners: Museums and schools transforming education.* Washington, DC: Institute of Museum and Library Services.

Hooper-Greenhill, E. (1992). Museum education. In J. Thompson (Ed.), *Manual of curatorship* (pp. 670-689). London: Butterworths.

Hooper-Greenhill, E. (1994a). Museum education: Past, present and future. In R. Miles & L. Zavala (Eds.), *Towards the museum of the future: New European perspectives* (pp. 133-146). London: Routledge.

Hooper-Greenhill, E. (Ed.). (1994b). *The educational role of the museum.* London: Routledge.

Hooper-Greenhill, E. (2000a). Learning in art museums: Strategies of interpretation. In N. Horlock (Ed.), *Testing the water: Young people and galleries* (pp. 136-145). Liverpool, UK: Liverpool University and Tate Gallery Liverpool.

Hooper-Greenhill, E. (2000b). *Museums and the interpretation of visual culture.* London: Routledge.

Institute of Museum and Library Services (2005). *Charting the landscape, mapping new paths: Museums, libraries, and K-12 learning.* Washington, DC: Author.

Irwin, R. L., & Kindler, A. M. (Eds.). (1999). *Beyond the school: Community and institutional partnerships in art education.* Reston, VA: National Art Education Association.

Lankford, E. L. (2002). Aesthetic experience in constructivist museums. *Journal of Aesthetic Education, 36*(2), 140-153.

Lehman, S. N., & Igoe, K. (Eds.). (1981). *Museum school partnerships: Plans and programs.* Washington, DC: American Association of Museums.

Lehmann, J. (1995). Art museum schools: The rise and decline of a new institution in nineteenth-century America. *Proceedings of the American Antiquarian Society, 105,* 231-243.

Liu, W. C. (1999). Issues in art museum and school collaboration. *INSEA News, 6*(2), 6-7.

Liu, W. C. (2000). Art museum educators' attitude toward the role of the teacher in art museum-elementary school collaboration. *Visual Arts Research, 26*(1), 75-84.

Manzo, K. K. (1999). Museums say they're making more links to K-12. *Education Week, 18*(24), 3.

Mayer, M. M. (2005). Bridging the theory-practice divide in contemporary art museum education. *Art Education, 58*(2), 13-17.

McCoy, S. (1989). Docents in art museum education. In N. Berry & S. Mayer (Eds.), *Museum education history, theory, and practice* (pp. 135-153). Reston, VA: National Art Education Association.

McIntyre, D. (1999, Winter). Further down the collaborative road: Partnerships among schools, foundations and museums. *NAEA Advisory.*

Museum of Fine Arts, Boston. (1878). *Second annual report for the year ending Dec. 31, 1877.* Boston: Alfred Mudge and Son.

Newsom, B. Y. (1975). On understanding art museums. *Studies in Art Education, 16*(2), 46-57.

Newsom, B. Y., & Silver, A. Z. (Eds.). (1978). *The art museum as educator.* Berkeley: University of California Press.

Ogbu, J. K. (1995). The influence of culture on learning and behaviour. In J. Falk & L. Dierking (Eds.), *Public institutions for personal learning* (pp. 79-96). Washington, DC: American Association of Museums.

Oguibe, O. (2004). *The culture game.* Minneapolis, MN: University of Minnesota.

Rice, D., & Yenawine, P. (2002). A conversation on object-centered learning in art museums. *Curator, 45*(4), 289-301.

Roberts, L. C. (1997). *From knowledge to narrative: Educators and the changing museum.* Washington, DC: Smithsonian.

Saint Louis Art Museum (1999). *George Caleb Bingham curriculum kit.* Saint Louis, MO: Author.

Schaller, D. T., & Allison-Bunnell, S. (April, 2005). Learning styles and online interactives. Paper presented at the annual meeting of Museums and the Web, Vancouver, BC. Retrieved May 10, 2005, from http://www.archimuse.com/mw2005/papers/schaller/schaller.html

Silveira, M., Pinho, M., Gonella, A., Herrmann, M., Calvetti, P., Bertoletti, A. C., & Girardi, M. (2005). Using mobile devices to help teachers and students during a visit to a museum. Paper presented at the annual meeting of Museums and the Web, Vancouver, BC. Retrieved May 10, 2005, from http://www.archimuse.com/mw2005/papers/silveira/silveira.html

Soren, B. J., & Lemelin, N. (2004). "Cyberpals!/Les cybercopains!": A look at online museum visitor experiences. *Curator, 47*(1), 55-83.

Stone, D. (1992). A descriptive study of the art museum relative to the schools. *Visual Arts Research, 18*(2), 51-61.

Stone, D. (2001). *Using the art museum.* Worcester, MA: Davis.

Takahisa, S. (1998). A laboratory for museum learning. *Journal of Museum Education, 23*(2), 5-8.

Talboys, G. (2000). *Museum educator's handbook.* Hampshire, UK: Gower.

Varisco, R. A., & Castes, W. M. (2005). Survey of web-based educational resources in selected U.S. art museums. Unpublished manuscript.

Walsh-Piper, K., & Berk, E. (1994). Teacher programs at the National Gallery of Art. *Journal of Museum Education, 19*(3), 19-21.

Wilson McKay, S., & Monteverde, S. R. (2003). Dialogic looking: Beyond the mediated experience. *Art Education, 56*(1), 40-45.

Wetterlund, K., & Sayre, S. (2003). 2003 art museum education programs survey. Retrieved April 10, 2005, from http://www.museum.org/research/surveys/2003/mused/index.shtml

Zeller, T. (1989). The historical and philosophical foundations of art museum education in America. In N. Berry & S. Mayer (Eds.), *Museum education history, theory, and practice* (pp.10-89). Reston, VA: National Art Education Association.

FOOTNOTES

[1] The themes do not constitute a linear timeline, are not discrete, and largely represent practices in North American and European museums.

[2] As noted by Newsom (1975), many museum education programs are not documented. Thus, this chapter focuses on published literature on educational programs.

[3] For more information on museum podcasts, refer to the MuseumPods website at http://www.museumpods.com/index.html

[4] The word "podcast" is a reference to a specific MP3 player, the iPod made by Apple, Inc.

Transacting Theories for Art Museum Education

David Ebitz

The Pennsylvania State University

When I entered the field of art museum education in 1987, Eisner and Dobbs (1986) had just concluded that art museum education was as yet an "uncertain profession," citing as one reason its lack of "sufficient intellectual base and theoretical foundation" (p. 29). Their conclusion rang true to me at the time, coming as I did from 9 years as a university art historian. By contrast, my practice of art history was based on a rigorous structure of theory and method that originated in Germany in the 1920s and 1930s and gave me confidence that I knew what I was doing and why. As an educator looking for models to guide me in my new profession, I was happy to find and make use of the simple metaphor of the educator as bridge between the viewer and the object. That was a beginning.

In hindsight, I can see that I entered museum education at a moment of transition in U.S. museums, as educators were gaining more prominent roles in the broad, but incomplete, shift of attention from collections to the visitors they serve (Ebitz, 2005; Weil, 2002). This shift is reflected, for example, in two position statements published by the American Association of Museums (AAM), *Excellence and Equity: Education and the Public Dimension of Museums* (Hirzy, 1992) and *Mastering Civic Engagement: A Challenge to Museums* (American Association of Museums, 2002), and in *Excellence in Practice: Museum Education Principles and Standards* (EdCom Task Force, 2002), the revised standards for educators and education in museums published by AAM's Education Committee. This transition was prompted by external demographic, economic, and political pressures and by responses to these pressures from boards of trustees and museum staff and supporters (Hein, 2000). This transition found a rationale in, and was in some measure influenced by, a cluster of theories in disciplines concerning museums and their functions, theories sometimes prefaced by "new," as in the "new art history" and "new museology" (Vergo, 1989), and generally gathered under the umbrella of postmodern and critical theory. These theories have discoursed on the nature of museums and problematized our understanding of their functions within the uncertain contexts of a postmodern society (Starn, 2005). At the same time, somewhat more practical theories emerged that focused on the visitor and the nature of learning in museums and were incorporated into the practice of museum education. During the past decade, the theoretical discourse on museums has begun to influence and merge with the discussion of education and learning in museums (Mayer, 2005).

In this chapter I discuss the nature of theory and how we might go about evaluating competing theories, and I review some of the theories that have caught the attention of art museum educators in the past 20 years. I will then propose what I call "transacting theory" as a means to encourage reflection and critical understanding of our practice.

What is Theory?

Many of us first encountered theory in high school in the form of positivist scientific theories, usually to be memorized, whose purpose was to provide an objective, verifiable, and coherent explanation of natural phenomena. The certainty of high school scientific theories was first

undermined for me by reading Popper's (1959) proposition that a theory is only a hypothesis that has yet to be falsified by contradictory evidence. The scientific method was further challenged by Kuhn's (1962) notion of paradigm that argues that theory originates and is embedded within the shared assumptions of a particular scientific community. Encountering Feyerabend (1975), I was confused, but felt empowered in a postmodern state to consider that there might, indeed, be no reliable method or methodological rules to science at all. And the same has been said for the social sciences (Law, 2004).

The alternative to the scientific method as a means to understand a preexisting world has been to construct, give meaning to, and evaluate our own worlds, as Goodman (1978), among others, proposed in his ways of world making. Contrasting the methods of science with the humanities, Bruner (1986) characterized the humanist as dealing "with the world as it changes with the position and stance of the viewer" so that humanities seek "to understand the world as it reflects the requirements of living in it" (p. 50). This engages what Bruner calls the "narrative mode of thinking" that makes "good stories, gripping drama, believable (though not necessarily 'true') historical accounts," and that "deals in human or human-like intention and action and the vicissitudes and consequences that mark their course" (p. 13). Roberts (1997) proposed narrative as both the source and means to evaluate the world we make in museums: "to understand the sense in which either a scientific or a narrative version of the world might be true, one must finally engage in narrative about their respective criteria of truth" (p. 136). Her notion of knowledge as narrative is good to keep in mind as we try to make some sense out of theory and our practice.

Various kinds of so-called critical theory (Macey, 2000) in the social sciences and humanities have directed our attention to ethical implications and to our responsibility for the worlds we construct. Feminist theory, postcolonial theory, queer theory, and social ecology, for example, have all taken a critical view of society and of the social processes of communication and knowledge production that lead us to legitimate existing power structures as the "natural" order of things. Critical theory often originates in the critique of an ideology and provides a guide for human action. Unlike most scientific theories, it is self-conscious, self-critical, and ultimately emancipatory.

What, then, are we to make of theory? Theory may be a good story, situated somewhere between a simple model and a meta-theory (theory of theories), between a metaphor and a comprehensive world view. Theory is usually stated in words, but also in images or other symbol system. It may range from a simple explanation of our observations to a general principle organizing our understanding of shared experiences. Theory leads to insights or hypotheses to generate new knowledge, worlds, and ways of working in the world that are practical and good enough to get our job done. It is both a lens to look at the world and a tool to fashion it.

Although we have talked about theory in museum education (Mayer, 2005; Villeneuve, 2003), only with rare exceptions (Yellis, 2000) do we say what we mean by it. Theory as a concept has quite different and competing meanings depending on whether it is part of a theoretical discourse in an academic setting or is informing a practical discussion among educators in a museum. This dichotomy and tension between the academic thinker and the practitioner is found generally, for example, in education (Burbules, 2002) and the social sciences (Weinstein, 2000). My purpose here is to bridge the gap between the theoretical and the practical, while paying special attention to practical experience as the ground from which the most useful theories grow and where their value can be assessed in terms of their fruitful application. Thus I have ignored the question of whether any generalization described below may properly be called a theory, in favor of asking another, more pressing question: whether it is a good story and works to make sense of things. If it does, we will call it a theory.

Criteria for Evaluating Theories

Just as we do not have a simple definition of what theory is, we also lack generally agreed-upon criteria for evaluating a theory. But we may agree that we know a good theory when we see one and that its value depends on the purpose and context of its application. Keeping in mind a dynamic relation between theory and practice, I propose six possible criteria that begin and end with practice, but that also seek value

in a theory as theory for its own sake (Ebitz, 1988). In the process of applying these criteria, we may come to a judgment regarding both the theory and the criteria used to evaluate it. These criteria overlap and intermingle. Unlike philosophers who regard several of the criteria as being related to competing theories of truth and therefore mutually exclusive (David, 2002; Young, 1996/2001) I am taking a pragmatic approach and regard the criteria as mutually supportive considerations in evaluating theory.

First, does the theory correspond or align with experience and practice? This is the most important question asked of a positivist scientific hypothesis or theory, which remains provisionally true until falsified by contradictory evidence. In similar manner, we can ask whether the theories we use in museum education are supported by research and evaluation. And we are increasingly conducting studies to find out. But in a looser sense, it may be enough for us to reflect on whether a theory is grounded and originates in our experience and practices and in turn constructs our human reality (Alasuutari, 2004). Does it fit our notion of the world (Goodman, 1978)? Does it work? Does it identify the participants, whether people, places, or things, real and virtual, and the perceptions and discourses they embody? Does the theory characterize the process in our practices? Does it situate the process in a context of space and time?

Second, is the theory coherent? This is to evaluate a theory on its own terms. Is the theory comprehensive and well organized? Does it include all that is needed in the situation under consideration? Do the parts of the theory hang together? Are its various propositions or what these propositions imply consistent with one another?

Third, is the theory clear and compelling? Is it elegant and powerful? Can we figure it out, and are we convinced? If our understanding of a theory is clear enough, we need no more words to justify its value. Because we are not philosophers, we can simply say, "I don't know anything about theory, but I know what I like." Of course, as we know with art, we are predisposed to like what we already like—and to value a theory that embodies our values and existing view of the world (Kuhn, 1962). Thus it may be useful, though not comfortable, to ask whether the theory has the capacity to move us away from the familiar.

Fourth, is the theory adequate? Does it explain enough or at least provide sufficient context to understand what we want to figure out? Is the theory adequate to do the work we want to do with it?

Fifth, is the theory fruitful? Does it do productive work in the real world? Does it focus our attention in new ways? Does it disrupt accepted notions? Does it help us form new understandings that we can apply to our practices? Does it provide a context for and facilitate reflection on other theories we may espouse?

Sixth, is the theory ethical? Some compelling and successful theories have done us great harm, such as race science's rationalization for the Holocaust (Weinstein, 2000). Keeping in mind the ethical implications of museums as educational institutions (Roberts, 1997), we may ask whether a theory enables personally and socially responsible decisions and actions.

We are encouraged as museum educators to be reflective practitioners. We can be reflective theorists, as well, by considering these and other criteria for evaluating theories.

Theories of the Object, Disciplines, and Museum Literacy

Objects and such models for their classification and interpretation as connoisseurship (Ebitz, 1988) and iconographical analysis were my focus as an art historian. Moving to museum education, I felt right at home with the object-centered paradigm of my new colleagues. For Schlereth (1992), Williams (1992), and others in the mid-1980s, "a museum object must be central to the experience," and museum literacy was the ability to "have personally significant experiences with museum objects" (pp. 118-119). A variety of interpretive approaches to the object were adopted from material culture studies, art history, and art education, and others were home grown in the particular context of individual museums. One such model was Discipline-Based Art Education (DBAE) (Clark, Day, & Greer, 1987). Thinking that the viewer would best be served by acquiring the knowledge and skills of experts in the disciplines that

Figure 1. Number of Check Marks for Theories or Theorists That Have Informed Their Practice Made by Museum Educators Attending a Presentation on Theory at the NAEA 2005 Convention.

14 Gardner's Theory of Multiple Intelligences

12 Housen & Yenawine's Visual Thinking Strategies (VTS)

8 Discipline-Based Art Education

8 Dewey's Experience and Education

7 Piaget's Developmental Theory

6 Vygotsky's Sociocultural Theory of Learning

5 Project Zero's Teaching for Understanding

4 Greene's Releasing the Imagination

4 Constructivism

3 Feldman's Nonuniversal Theory of Cognitive Development

3 Csikszentmihalyi's Flow or Psychology of Optimal Experience

address art, the Getty Education Institute put its support behind DBAE. This model for education in art incorporated instruction in art history, criticism, and aesthetics as well as in art production. It became pervasive in schools in the United States during the late 1980s and 1990s (Wilson, 1997), though it had mixed acceptance among museum educators (Ebitz, 1989; Zeller, 1989).

Whatever the specifics, there was general acceptance for a kind of museum literacy based on knowledge and skills that could provide visitors with an optimal experience in their encounters with works of art in museums. At the same time, however, museum literacy and the emphasis on "personally significant experiences" were symptomatic of and helped encourage a paradigm shift from object-centered interpretation to visitor-centered learning in the 1990s (Stapp, 1992). Visitor-centered learning brought with it theories of learning based on

the psychology of the individual and more recently on individual experience within the larger sociocultural context.

Theories of Learning and the Psychology of the Individual

At conferences and workshops in the late 1980s and early 1990s, we were introduced to learning theories originating in the psychology of the individual, exposure few of us had had in our academic preparation. The theory of andragogy (Knowles, 1981) emphasized the kind of self-directed, experiential, life-long learning that adult visitors seek in museums. These adults expect to find some immediate value in their museum experiences, and our role as educators is to facilitate. Kolb's (1984) learning styles model identified four processes or learning styles that may be used to characterize learning: active experimentation,

reflective observation, abstract conceptualization, and concrete experience. Awareness of these learning styles and even more of the various human capacities embodied in the theory of multiple intelligences (Davis & Gardner, 1993; Gardner, 1985) suggested specific strategies to museum educators and empowered us to see museums as sites that could support the kinds of learning experiences not always available within the formal structure and physical limitations of school classrooms. And there are many more learning theories based on individual capacity and predisposition about which we knew and still know too little (Kearsley, 2006).

Closely related to learning theories were developmental and other psychological theories of the individual. Based on interviews of people viewing works of art, Housen (1987, 1992) presented a developmental theory of how aesthetic thinking progresses through stages from "accountive" to "interpretive" and "re-creative." Originating in her work, Visual Thinking Strategies (VTS) was introduced in the 1990s as a student-centered curriculum based on questioning strategies and critical thinking. VTS has found a place in schools and influenced practice in museums. Flow or the "psychology of optimal experience" (Csikszentmihalyi, 1990; Csikszentmihalyi & Hermanson, 1995) described the intrinsic motivation that results when a visitor's curiosity and interest are hooked, clear goals are set, and challenges of increasing complexity match a visitor's growing skills. Csikszentmihalyi and Robinson (1990) saw parallels between flow and aesthetic experiences that might be facilitated in museums.

These psychological theories continue to be influential today. I asked an audience of museum educators attending a presentation on theories in museum education at the NAEA's 2005 convention to write down and add check marks by the names of any theories or theorists that have informed their practice. As seen in Figure 1, Gardner's multiple intelligences and Housen's VTS were the most often cited. Gardner has also been a leading investigator in Harvard's Project Zero and has collaborated with both David Henry Feldman and Csikszentmihalyi in the production of ideas about cognitive and aesthetic development that together have had great impact on art museum educators. But we should also consider the location of the NAEA convention in Boston as a contributing factor to the popularity of theorists connected with Harvard. A theory's success depends on context. In addition, the participants indicated an interest in the early- to mid-20th-century theories of John Dewey, Jean Piaget, and Lev Vygotsky, an interest that has been growing during the past decade with the development of situated learning and constructivist models for museum education (Roschelle, 1995).

Theories of Making Meaning in a Sociocultural Context

Theories of situated learning and constructivist meaning-making place the individual within a sociocultural and physical context. Karp and others (Karp, Kreamer, & Lavine, 1992; Karp & Lavine, 1991) described the tension and conflict that emerge between individual and community and between community and community in the

performance and experience of or resistance to the kinds of identity formation that occur in such sites of public culture as exhibitions and museums. More specifically, Duncan (1995) characterized the art museum as a stage for performing cultural rituals that serve ideological needs and define our values and beliefs about social, sexual, and political identity.

In discussions of education and visitor experiences in museums, attention is shifting from the transmission of information about objects to the role of visitors and communities in making meaning. Silverman (1995) identified ways that visitors create their own meanings out of experiences in museums, influenced by their sense of self, their sense of community, and the personal agenda they bring to a museum visit. Visitors making meaning have been the focus of a cluster of related theories of education and learning in museums. Hein (1998) characterized theories of knowledge on a continuum from knowledge existing outside the learner to knowledge personally and socially constructed by the learner, and theories of learning on a continuum from transmission-passive absorption to active restructuring. From this discussion, Hein concluded that active participation of the learner is needed for learning to occur and that "the conclusions reached by the learner are *not* validated by whether or not they conform to some external standard of truth, but whether they 'make sense' within the constructed reality of the learner" (p. 34).

Hooper-Greenhill (1999) described a cultural approach as different from a transmission approach to communication in which communication relates to community as "a society-wide series of processes and symbols though which reality is produced, maintained, repaired, and transformed. ... a cultural process that creates an ordered and meaningful world of active meaning-makers" (pp. 16-17). In similar words, Roberts (1997) characterized museums as "idea-, experience-, and *narrative*-based institutions—forums for the negotiation and renegotiation of meaning" (p. 147). Garoian (2001) proposed ways in which "by performing the museum, viewers challenge the museum's monologic practices through the discourse of their memories and cultural histories thereby introducing narrative content that would otherwise remain ignored" (p. 237). The "post-museum," as Hooper-Greenhill imagined it (2000), will replace the modernist museum of architecture, collections, and exhibitions with "a process or experience," where "a cacophony of voices may be heard that present a range of views, experiences, and values" (p. 152). Remaining focused on the visitor, Hein (1998) proposed a "constructivist museum" that will address such basic questions as "What is done to engage the visitor?" and "How is the situation designed to make it accessible—physically, socially, and intellectually—to the visitor?" (p. 156).

The most comprehensive learning theory to inform the practice of museum education is the contextual model of learning developed by Falk and Dierking (2000). Like Hein's constructivist theory, the contextual model is grounded in efforts to make sense of visitor experiences and learning. Like Hooper-Greenhill's "post-museum," Falk and Dierking's contextual model has implications for the future of museums competing with other opportunities for leisure-oriented free-choice learning in the knowledge age (Falk & Sheppard, 2006). Their model is grounded in an understanding of the contexts in which learning takes place—the personal, the physical, and the sociocultural—and it gives full consideration to each.

Combining curriculum theory with experience as a museum educator, Vallance (2003) contrasted the nature of learning in a classroom with learning in a museum. She adapted a practical curriculum model that was proposed by Schwab (1973) in response to too much academic theorizing. This model attends to four "commonplaces" of schooling: subject matter, milieu or setting, teachers, and students. In her revision of these commonplaces for the museum setting, Vallance (2003) suggested that "milieu is the prime shaper of the sociocultural context of the learner's experiences, which in turn become part of the tacit teaching available in the museum environment" (p. 13).

Art museums have been slowest to respond to the calls for meaning making. As traditional sites for an appreciation of quality in the visual arts, they now confront and may well be overwhelmed or replaced by the fragmentary and insistent visual culture of the mass media that surrounds their walls,

recontextualizes their collections, institutes new virtual museums without walls, creates a consumerist culture of spectacle and display, and informs their visitors (Barker, 1999). Although visual culture has been much theorized in the past 10 years (Elkins, 2003; Freedman, 2003; Mirzoeff, 1999; Sturken & Cartwright, 2001), its full implications for the practice of museum education are just now being explored.

Constructing Transacting Theory

My review of theories has not been strictly chronological. Indeed, theories have overlapped and mutually reinforced as well as replaced each other as they have gained and lost currency over time. Yet, as I have implied in the succession of section headings in this review of theories, there has been a broad shift in focus over the past 20 years from the object and the disciplines used to interpret it to the individual and the psychology of learning and finally to the process of making meaning in context.

These theories may seem varied and diverse in their focus, but they have several features in common. First, they have been developed and brought to us from outside the field of art museum education. Though these theories resonate with our practice, they do not grow from that practice. Second, they all too often ignore the personal, historical, and structural tensions with which educators have struggled in the "contested arena" of education in art museums (Rice, 1995, p. 16). Third, visitor-centered theories in particular have yet to be fully integrated into the general culture

of the museums in which we work. As a result, they may not empower our practice beyond providing rationales that occasionally serve to rally our efforts and help gain us a voice where decisions are being made. Fourth, with the notable exception of Housen's VTS, Hein's constructivism, and Falk and Dierking's contextual model of learning, these theories are not associated with and do not lead to assessment and evaluation in museums. As Rice (2003) has argued, we need to move from projections of "an ideal viewer in the abstract" to a "theory of the viewer that emphasizes individual responses to both complex interior impulses and conflicting external messages" (p. 92).

These theories simplify, as most theories do. And, with the notable exception of meaning making, these theories share with each other a focus of attention on what might be called a fixed position, whether this position is the object, the disciplinary content and methods relevant to interpreting the object, or the individual and the sociocultural contexts of his or her experience. These theoretical positions can be summarized as centering on:

Object

Disciplines

Individual

Society

Context.

Where do we situate making meaning among these fixed theoretical positions? The theoretical notion of meaning making may be characterized as a more fluid process that flows in and around the positions to which the other theories attend, transacting between them to

generate new relations and meaning and new understandings of the positions themselves. In openings between these theories, we may discover processes that animate the relationships between the people and ideas and the objects and contexts on which these theories focus. These openings and what they contain are the focus of what I call transacting theory.[1]

To begin, what relations can we construct between the theoretical positions here? One possibility is to relate these positions to each other in a purely arbitrary manner as dualities or juxtapositions in order to see what understanding may emerge as we shift our attention from the fixed theoretical positions to the spaces opening between them. These arbitrary juxtapositions and the newly opened spaces that they create, visualized here as the openings between the slashes in the text, might include, for example:

Individual/ ? /Society

Individual/ ? /Context

Individual/ ? /Disciplines

Individual/ ? /Object

Object/ ? /Individual

Object/ ? /Disciplines

Object/ ? /Context

Object/ ? /Society

Disciplines/ ? /Individual

Disciplines/ ? /Society

Disciplines/ ? /Context

Disciplines/ ? /Object.

Where is meaning making among these juxtapositions? It is embodied in the transacting designated by the question marks situated in the ambiguous openings between the positions.

What transacting is possible in these openings? It may be expressed, for example, with the arbitrary insertion of present participles. These we generate by reflecting on the nature of a relationship or process that engages the two terms in each juxtaposed pairing, as, for example:

Individual/<--Embodying-->/Society

Individual/<--Participating-->/Context

Individual/<--Defining-->/Disciplines

Individual/<--Perceiving-->/Object

Object/<--Transforming-->/Individual

Object/<--Challenging-->/Disciplines

Object/<--Participating-->/Context

Object/<--Reflecting-->/Society

Disciplines/<--Guiding-->/Individual

Disciplines/<--Structuring-->/Society

Disciplines/<--Establishing-->/Context

Disciplines/<--Interpreting-->/Object.

Based on your own experience, what other transacting can you imagine occurring between these positions? In addition to perceiving, for example, what transacting goes on between an individual visitor and an object in the gallery? Anticipating (the visitor has just entered the Louvre and will finally get to see the *Mona Lisa*)? Appreciating? Explaining (the visitor has come with her friends)? Touching? Avoiding (that's not what the visitor came to see)?

We may initially think of the participles as identifying transacting going from the first position to the second, or left to right, as in "individual perceiving object." But why not imagine transacting flowing in both directions, as in "object perceiving individual"? What is this new "perceiving"? How does it affect our understanding of the object, now that the object gazes back? Do we need to retheorize the object? Is today's visitor-centered paradigm no more adequate as a theory of everything than the object-centered paradigm it replaced? The reverse in direction is in each case arbitrary, indicated by the insertion of bidirectional arrows. Contemplating transacting in reverse does, however, provide new and unexpected insight by revealing possibilities about the transacting and about the theoretical positions themselves that we did not think about in originally positioning the two terms. Imagine the object anticipating, appreciating, explaining, touching, or avoiding the visitor.

Transacting is not limited to openings between the positions that emerged from the summary of theories. Consider what transacting might occur within other kinds of juxtapositions, such as between terms linked on a concept map or between evaluation and practice:

Evaluation/<--Assessing-->/Practice

Evaluation/<--Informing-->/Practice

Evaluation/<--Advocating-->/Practice

Evaluation/<--Challenging-->/Practice.

Consider audiences transacting:

Audience/<--Reacting-->/Content

Audience/<--Transforming-->/Space,

or transacting in openings between stakeholders on museum staff:

Educator/<--Resisting-->/Curator

Educator/<--Collaborating-->/Curator

Educator/<--Embodying-->/Curator.

This transacting model and its visualization can be made as complex as we want it to be. For example, we can move from a single linear juxtaposition to an array of positions in two dimensions by combining all our original theoretical positions around "making":

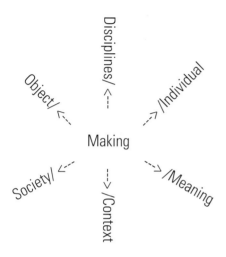

Think about how any one of these theoretical positions relates to any other through "making" and about how our understanding of the two positions and of "making" is changed by our thinking. For example, imagine society making the object, the disciplines, the individual, the meaning, and the context, and each of these in turn making the society. What meaning does "making" acquire? Try changing "making" to different transacting such as "resisting" or "transforming." Imagine even more complex arrays of arbitrarily chosen positions extended into three dimensions around transacting in the opening between them, in which the positions we choose and the nature of the transacting become ever more complex, rich, and messy.

Transacting Theory for Museum Education

Transacting is initiated and understood within the context of positions that we as educators arbitrarily define, although one position may imply or encourage the selection and placement of another. These positions can be linked in pairs or in multiples. Transacting goes both ways in a process of engagement within the arbitrary, fluid, and ambiguous openings between and among these positions. Transacting is not one of these positions, not the object, not the educator, not the learner, not the context, not the physical, not the social, not the conceptual, not the metaphorical. Transacting resists definition and can be embodied only in practice, in openings between contiguous roles of educator, curator, director, security guard, visitor, donor, and other stakeholders, and the objects, ideas, and contexts that are part of our lives in museums. Transacting does not produce meaning separate from itself. It embodies meaning as we are attending, improvising, and making something new in transacting. Transacting is a present participle, unfinished in an ongoing and open process. As my colleague John White suggested, the site of transacting is an open wound that does not heal.

What kind of theory is this? On the one hand, it is a structure with the potential to comprehend other theories, a meta-theory. On the other, it is a model or process to direct attention and encourage reflection. It may be a description of how the world out there really works, or it may be another story to make sense of it. In either case, the positions and transacting emerge from the experience and interest of museum educators putting the theory to work. The theory is arbitrary, but its application is grounded and gains meaning in practice.

Is transacting theory a good theory? We can revisit the criteria proposed at the beginning. Does it actually correspond or fit well with experience and practice? Is it coherent? Is it internally organized and consistent in its operations? Is it clear and compelling as an idea? Is it adequate? Does it explain for us enough of what we experience to do the work we want a theory to do for us? Is it fruitful in informing practice, encouraging reflection, focusing attention, and indicating new directions? Is transacting theory ethical, facilitating personally and socially responsible actions? Or, to use the theory itself, does:

Theory/<--Transacting-->/Practice?

REFERENCES

Alasuutari, P. (2004). *Social theory and human reality.* London: Sage.

Barker, E. (1999). Introduction. In E. Barker (Ed.), *Contemporary cultures of display* (pp. 8-21). New Haven: Yale University.

Bruner, J. (1986). *Actual minds, possible worlds.* Cambridge, MA: Harvard University.

Burbules, N. C. (2002). The dilemma of philosophy of education: "Relevance" or critique? part two. *Educational Theory, 52*(3), 349-357.

Clark, G. A., Day, M. D., & Greer, W. D. (1987). Discipline-based art education: Becoming students of art. *Journal of Aesthetic Education, 21*(2), 129-193.

Csikszentmihalyi, M. (1990). *Flow: The psychology of optimal experience.* New York: Harper Collins.

Csikszentmihalyi, M., & Hermanson, K. (1995). Intrinsic motivation in museums: Why does one want to learn? In J. H. Falk & L. D. Dierking (Eds.), *Public institutions for personal learning: Establishing a research agenda* (pp. 67-77). Washington, DC: American Association of Museums.

Csikszentmihalyi, M., & Robinson, R. E. (1990). *The art of seeing: An interpretation of the aesthetic encounter.* Malibu, CA: J. Paul Getty Trust. David, M. (2002). The correspondence theory of truth. In E. N. Zalta (Ed.), *Stanford encyclopedia of philosophy* (Summer 2002 ed.). Retrieved June 8, 2005, from http://plato.stanford.edu/archives/sum2002/entries/truth-correspondence/

Davis, J., & Gardner, H. (1993). Open windows, open doors. *Museum News, 72*(1), 34-37, 57-58.

Duncan, C. (1995). *Civilizing rituals inside public art museums.* London: Routledge.

Ebitz, D. (1988). Connoisseurship as practice. *Artibus et Historiae, 18,* 207 212.

Ebitz, D. (1989). The role of museum educators in DBAE. *In Education in art: Future building, Proceedings of a national invitational conference* (pp. 140-142). Los Angeles: J. Paul Getty Trust.

Ebitz, D. (2005). Qualifications and the professional preparation and development of art museum educators. *Studies in Art Education, 46*(2), 150-169.

EdCom Task Force on Professional Standards. (2002). *Excellence in practice: Museum education principles and standards.* Washington, DC: American Association of Museums Education Committee.

Eisner, E. W., & Dobbs, S. M. (1986). *The uncertain profession, observations on the state of museum education in twenty American art museums.* Los Angeles: Getty Center for Education in the Arts.

Elkins, J. (2003). *Visual studies: A skeptical introduction.* London: Routledge.

Falk, J. H., & Dierking. L. D. (2000). *Learning from museums: Visitor experiences and the making of meaning.* Walnut Creek, CA: AltaMira Press.

Falk, J. H., & Sheppard, B. K. (2006). *Thriving in the knowledge age, New business models for museums and other cultural institutions.* Lanham, MD: AltaMira Press.

Feyerabend, P. (1975). *Against method: Outline of an anarchistic theory of knowledge.* London: Humanities.

Freedman, K. (2003). *Teaching visual culture: Curriculum, aesthetics, and the social life of art.* New York: Teachers College.

Gardner, H. (1985). *Frames of mind: The theory of multiple intelligences.* New York: Basic.

Garoian, C. R. (2001). Performing the museum. *Studies in Art Education, 42*(3), 234-248.

Goodman, N. (1978). *Ways of worldmaking.* Indianapolis, IN: Hackett.

Hein, G. E. (1998). *Learning in the museum.* London: Routledge.

Hein, H. S. (2000). *The museum in transition, A philosophical perspective.* Washington, DC: Smithsonian.

Hirzy, E. C. (Ed.). (1992). *Excellence and equity: Education and the public dimension of museums.* Washington, DC: American Association of Museums.

Hooper-Greenhill, E. (1999). Education, communication and interpretation: Towards a critical pedagogy in museums. In E. Hooper-Greenhill (Ed.), *The educational role of the museum* (2nd ed.) (pp. 3-27). London: Routledge.

Hooper-Greenhill, E. (2000). *Museums and the interpretation of visual culture.* London: Routledge.

Housen, A. (1987). Three methods for understanding museum audiences. *Museum Studies Journal, 2*(4), 41-49.

Housen, A. (1992). Validating a measure of aesthetic development for museums and schools. *ILVS Review, 2*(2), 213-237.

Karp, I., Kreamer, C. M., & Lavine, S. D. (Eds.). (1992). *Museums and communities, The politics of public culture.* Washington, DC: Smithsonian.

Karp, I., & Lavine, S. D. (Eds.). (1991). *Exhibiting cultures: The poetics and politics of museum display.* Washington, DC: Smithsonian.

Kearsley, G. (2006). *Explorations in learning & instruction: The theory into practice database.* Retrieved June 6, 2006, from http://tip.psychology.org/

Knowles, M. S. (1981). Andragogy. In Z. W. Collins (Ed.), *Museums, adults and the humanities: A guide for educational programming* (pp. 49-78). Washington, DC: American Association of Museums.

Kolb, D. A. (1984). *Experiential learning: Experience as the source of learning and development.* Englewood Cliffs, NJ: Prentice-Hall.

Kuhn, T. S. (1962). *The structure of scientific revolutions.* Chicago: University of Chicago.

Law, J. (2004). *After method: Mess in social science research.* London: Routledge.

Macey, D. (2000). *The penguin dictionary of critical theory.* London: Penguin.

Mastering civic engagement: A challenge to museums. (2002). Washington, DC: American Association of Museums.

Mayer, M. M. (2005). Bridging the theory-practice divide in contemporary art museum education. *Art Education, 58*(2), 13-17.

Mirzoeff, N. (1999). *An introduction to visual culture.* London: Routledge.

Popper, K. (1959). *The logic of scientific discovery.* New York: Basic.

Rice, D. (1995). Museum education embracing uncertainty. *Art Bulletin, 77*(1), 15-20.

Rice, D. (2003). Museums: Theory, practice, and illusion. In A. McClellan (Ed.), *Art and its public: Museum studies at the millenium* (pp. 77-95). Malden, MA: Blackwell.

Roberts, L. C. (1997). *From knowledge to narrative, Educators and the changing museum.* Washington, DC: Smithsonian.

Roschelle, J. (1995). Learning in interactive environments: Prior knowledge and new experience. In J. H. Falk & L. D. Dierking (Eds.), *Public institutions for personal learning, Establishing a research agenda* (pp. 37-51). Washington, DC: American Association of Museums.

Schlereth, T. J. (1992). Object knowledge: Every museum visitor an interpreter. In S. K. Nichols (Ed.), *Patterns in practice, Selections from the Journal of Museum Education* (pp. 102-111). Washington, DC: Museum Education Roundtable.

Schwab, J. J. (1973). The practical: Translation into curriculum. *School Review, 81,* 501-522.

Silverman, L. H. (1995). Visitor meaning-making in museums for a new age. *Curator, 38*(3), 161-170.

Springgay, S., Irwin, R. L., & Wilson Kind, S. (2005). A/r/tography as living inquiry through art and text. *Qualitative Inquiry, 11*(6), 897-912.

Stapp, C. B. (1992). Defining museum literacy. In S. K. Nichols (Ed.), *Patterns in practice: Selections from the Journal of Museum Education* (pp. 112-117). Washington, DC: Museum Education Roundtable.

Starn, R. (2005). A historian's brief guide to new museum studies. *The American Historical Review, 110*(1), 68-98.

Sturken, M., & Cartwright, L. (2001). *Practices of looking: An introduction to visual culture.* Oxford: Oxford University.

Vallance, E. (2003). A curriculum-theory model of the art museum milieu as teacher. *Journal of Museum Education, 28*(1), 8-16.

Vergo, P. (Ed.). (1989). *The new museology.* London: Reaktion.

Villeneuve, P. (2003). From theory to practice made perfect. *Art Education, 56*(1), 4-5.

Weil, S. E. (2002). From being *about* something to being *for* somebody: The ongoing transformation of the American museum. In S. E. Weil (Ed.), *Making museums matter* (pp. 28-52). Washington, DC: Smithsonian.

Weinstein, J. (2000). The place of theory in applied sociology: A reflection. *Theory & Science 1*(1). Retrieved June 6, 2006, from http://theoryandscience. icaap.org/content/vol001.001/01weinstein_revised.html

Williams, P. B. (1992). Object contemplation: Theory into practice. In S. K. Nichols (Ed.), *Patterns in practice, Selections from the Journal of Museum Education* (pp. 118-122). Washington, DC: Museum Education Roundtable.

Wilson, B. (1997). *The quiet evolution: Changing the face of arts education.* Los Angeles: Getty Education Institute for the Arts.

Yellis, K. (2000). Paradigms shifted: Comprehending the meaning from without. In J. S. Hirsch & L. H. Silverman (Eds.), *Transforming practice: Selections from the Journal of Museum Education, 1992-1999* (pp. 182-186). Washington, DC: Museum Education Roundtable.

Young, J. O. (1996/2001). The coherence theory of truth. In E. N. Zalta (Ed.), *Stanford encyclopedia of philosophy* (Summer 2001 ed.). Retrieved June 7, 2006, from http://plato.stanford.edu/archives/sum2001/entries/truth-coherence/

Zeller, T. (1989). The historical and philosophical foundations of art museum education in America. In N. Berry & S. Mayer (Eds.), *Museum education: History, theory, and practice* (pp. 10-89). Reston, VA: National Art Education Association.

FOOTNOTES

[1] Readers attentive to grammar may wonder whether "transacting" is a present participle or a gerund. The confusion is intentional. The notion of openings in transacting was in part inspired by a method of arts-based research called a/r/tography (Springgay, Irwin, & Wilson Kind, 2005). I thank John White and James Rolling for their insights into the process of transacting and the participants in a workshop at the National Gallery of Canada in 2005 for giving me the first opportunity to put these ideas to the test.

What Research Says About Learning in Art Museums

Jessica J. Luke and Marianna Adams
Institute for Learning Innovation

Art museums are unique free-choice learning environments, offering visitors the opportunity to engage deeply and personally with original works of art and artifacts. However, little is known about the role that art museums play in people's lives. How do visitors learn in art museums? What do visitors learn in and from art museums? How does the art museum context influence learning? In this chapter we will address these broad conceptual questions by reviewing empirical research in order to describe what is known (and not known) about learning processes and outcomes in art museums, as well as the learning context.

Such a review is long overdue and much needed. Existing literature reviews have focused on empirical research in the arts (Fiske, 1999; Wilson, 1996) and in museums (Dierking, Ellenbogen & Falk, 2004; Falk & Dierking, 2000), but no review has concentrated on empirical research in art museums. As art museum educators, we believe that while there is value in considering a diverse range of research, the time has come to carefully examine studies in our context to advance the field of art museum education. In this essay, we review 15 articles published between 1984 and 2004. We used two search strategies to identify articles. First, we conducted a database search of PsycINFO and ERIC, using the terms "art education" and "museums." Articles describing results from empirical research were included in this review. Second, we examined key peer-reviewed journals—*Journal of Aesthetic Education, Visual Arts Research, Empirical Studies of the Arts,* and *Studies in Art Education*—to identify relevant articles that did not appear in the database search.

Our selection process included two significant criteria. First, we selected only studies related to the casual art museum visit. Research focused on school groups or program-based experiences brings with it a unique set of issues and is best reviewed elsewhere (Adams & Luke, 2000). Second, we reviewed only published studies. Although there have been a number of valuable technical reports written in the last two decades, they typically describe results from evaluation or applied-research studies, making it challenging to generalize beyond the particular problem or issue being investigated. We were most interested in research that would apply broadly to art museum educators. Furthermore, we did not review published articles that lacked sufficient description of methods because it was impossible to assess the overall contribution of such studies.

This chapter has three sections. First, we highlight the various theoretical and methodological approaches that researchers have used to study learning in art museums. Second, we examine the findings from these studies, discussing what is known (and not known) about learning in and from art museums. Finally, we look ahead, articulating how these studies inform the next decade of research and practice.

Approaches to Studying Learning in and From Art Museums

As we reviewed the studies, we were struck by the varying theoretical and methodological lenses researchers used to examine art museum learning. Given that these lenses affect the research results by forcing choices about

Table 1. Summary of Studies (Grouped by Area of Focus: Learning Processes, Learning Outcomes, and Learning Context).

Study	Theory	Design/Methods	Sample	Main Focus
Learning processes				
Stainton (2002)	Sociocultural	Descriptive Interviews & conversation recordings	N=12 visitor groups 9 adult groups; 3 family groups	Emphasis on nature of visitors' conversations, and relation to their prior knowledge & experience.
Gottesdiener & Vilatte (2001)	Cognitive	Quasi-experimental Interviews & observations	N=126 visitor pairs Children (6-14 years) Adults (age unknown)	Emphasis on strategies for enhancing social interaction.
Gay, Boehner, & Panella (1997)	Sociocultural	Comparative Focus groups, questionnaires & observations	N=10 visitors University students	Emphasis on museum as social space, importance of conversation.
Housen (1987)	Aesthetic	Descriptive Interviews	N=36 visitors Adults (20-40 years)	Emphasis on visitors' understandings across four aesthetic stages.
Weltzl-Fairchild, Dufresne-Tasse, & Dube (1997)	Cognitive	Descriptive Think-alouds	N=90 visitors Adults (25-65 years)	Emphasis on dissonance created around information, expectations, art work & personal taste.
Twiss-Garrity (1995)	Cognitive	Descriptive Interviews	N unknown Adults (age unkown)	Emphasis on visitors' understandings using a hierarchical taxonomy of thinking skills.
Csikszentmihalyi & Robinson (1990)	Aesthetic	Descriptive Interviews & questionnaires	N=89 art museum professionals	Emphasis on staff's multidimensional responses to works of art.
Learning outcomes				
Soren (2002)	Aesthetic	Descriptive Interviews, observations, comment cards & surveys	N=56 visitors (sample unknown)	Emphasis on aesthetic experience & outcomes.
Jeffers (1999)	Atheoretical	Descriptive Interviews & observations	N=17 visitor pairs Children (5-13 years) Teachers (age unknown)	Emphasis on learning subject matter & emotional reactions.
McManus (1993)	Atheoretical	Descriptive/Retrospective Written reflections	N=28 Children (8-15 years)	Emphasis on long-term personal outcomes.
Walsh (1991)	Atheoretical	Descriptive Focus groups & journaling	N=6 visitor groups at each of 11 museums Adults (age unknown)	Emphasis on range of outcomes including content, media & emotional reactions.
Learning context				
Knutson (2002)	Sociocultural	Ethnographic Interviews, field notes & document review	Focus on development of one exhibition	Emphasis on how visitor learning is defined within exhibit design team process.
Henry (2000)	Atheoretical	Descriptive/Retrospective Reflective essays	N=33 visitors University students	Emphasis on time, crowd levels, museum staff & prior knowledge.
Eisner & Dobbs (1988)	Atheoretical	Descriptive Case studies	N=31 museums	Emphasis on layout, orientation & signage.
Temme (1992)	Atheoretical	Quasi-experimental Written surveys & observations	N=172 visitors University students	Emphasis on labels.

how learning is defined and what methods are used to search for evidence of learning, we felt it was necessary to begin this review with a discussion of underlying assumptions, frameworks, and methods within the research. To ground this discussion, we have summarized the studies in a table that we will refer to throughout the chapter. Studies are grouped according to the primary focus of their research questions. In many cases, studies inform more than one category, but we categorized by the dominant focus in order to identify and articulate overarching themes within the research.

Definitions of Learning

In our attempts to identify definitions of learning within these studies, we encountered a significant problem. Most studies lacked a clearly articulated theoretical framework, requiring us to infer underlying conceptual assumptions. We concluded that six studies were largely atheoretical in nature. These atheoretical studies typically addressed practical issues and questions of learning in the art museum. For instance, in 1991 the Getty Center for Education in the Arts commissioned a nationwide study of visitors to art museums to learn how these institutions could better meet the needs of their visitors (Walsh, 1991). The investigation was not driven by one particular theory, but instead looked broadly at visitors' motivations for visiting art museums and their perceptions about learning outcomes. Studies such as this provide valuable insight into visitors' learning in art museums. However, to build credibility in the field of art museum education, we need

research that is grounded in explicit theoretical frameworks and researchers who clearly articulate their assumptions and approaches.

The remaining studies clustered around three conceptual perspectives: cognitive, sociocultural, and aesthetic. Studies that took a cognitive approach assumed knowledge is acquired through interaction with objects and people. Learning is facilitated by an existing knowledge base, relevant search strategies, a motivation to learn, and verbal cues that help a person interpret information about a work of art (Hein, 1998; Piscitelli & Weier, 2002). For instance, in an investigation of 90 visitors to the Montreal Museum of Fine Arts, Quebec, Weltzl-Fairchild, Dufresne-Tasse, and Dube (1997) argued that the viewing of art objects creates dissonance with a person's inner constructs or schema and that a person's inherent need to return to a state of consonance or equilibrium best characterizes art museum learning. Cognitive approaches such as this shed much-needed light on how visitors accumulate and integrate information in the museum. All theoretical approaches have their limitations, however. One drawback to a purely cognitive approach is that the social nature of learning is not always well addressed. For instance, Weltzl-Fairchild et al. (1997) asked individual visitors to "think aloud" as they looked at works of art in an exhibition, assuming that the art museum experience is largely a solitary one. A cognitive focus also tends to

separate cognition from affect, as though one could learn facts and ideas without attitudes, emotions, and intuition playing a part in the process.

Studies adopting sociocultural notions of learning in the art museum begin with the premise that all knowledge is socially and culturally constructed and that engagement in social practice is the fundamental process by which individuals learn and become who they are (Lave & Wenger, 1991). Learning is situated within specific contexts that are formed as individuals engage in their world; the art museum experience is conceptualized in terms of "people who are in conversation, literally and figuratively, with the artwork on display and with the curatorial intent" (Stainton, 2002, p. 14). In a study of 26 visitors at the Carnegie Museum of Art, Pittsburgh, Stainton recorded visitors' conversations as they moved through an exhibition of African art. Her definition of learning was rooted in the meaning that visitors created through conversation, with the museum and with each other. Such an approach focuses on the learning process and provides a basis of rich, contextual information that more accurately reflects how visitors actually engage in the art museum as pairs or small groups. However, in exchange for this richness, issues are raised about the unit of analysis. If learning no longer occurs at the level of the

individual, where does it occur? How do we reliably measure learning at the level of social or cultural groups?

Three studies focused on aesthetic appreciation, emphasizing not content learned but rather emotional, spiritual, and creative responses to works of art. For instance, in a study of 36 adults visiting the Institute of Contemporary Art, Boston, Housen (1987) employed her five-stage theory of aesthetic appreciation, characterizing art museum learning according to a novice-expert continuum along which visitors demonstrate their developing intellectual and emotional responses to works of art. Aesthetic approaches remind us that the art museum experience is often a contemplative one, inspiring a specific state of being. At the same time, however, this approach raises questions about whether all visitors have emotional responses to works of art and how much familiarity or interest is necessary to inspire such responses.

Methods for Assessing Learning
Most studies we reviewed were descriptive in design, focused on better understanding and documenting the nature of learning in art museums. For instance, Housen (1987) conducted interviews with 36 adults, Henry (2000) asked undergraduate and graduate students to write reflections on previous museum experiences, and the Getty (Walsh, 1991) employed focus groups with both art museum visitors

and nonvisitors. Two studies were quasi-experimental, attempting to isolate aspects of the art museum experience and measure their contribution to visitors' learning. Gottesdiener and Vilatte (2001) examined the influence of a game booklet on children's and adults' interactions, as well as children's subsequent learning, during a visit to an Impressionist exhibition at the Musée des Beaux Arts, Bordeaux, France. Results were compared to those of a control group who did not use the booklet. Temme (1992) conducted a series of studies examining the amount and kind of information preferred in art museum labels, using pencil-and-paper rating scales administered before and after an intervention. It is not surprising that art museum research is largely descriptive, using naturalistic methods. It is challenging for researchers to gain access to the exhibition design process or to design studies involving intervention within the process. However, the implication is that current research provides rich descriptions of art museum experiences, but little indication of cause and effect within these experiences.

In addition, two studies in this sample were retrospective. Henry (2000) investigated undergraduate and graduate students' memories of their most positive and negative experiences as museum visitors, asking students to write reflective essays that were then subjected to content analysis. McManus (1993) studied children's memories of their visit to Birmingham Museum

& Art Gallery, Birmingham, England, asking them to write about their memories 10 months after their museum experience. These studies serve as a useful reminder that learning occurs over time. Instead of asking "What do visitors learn in and from the art museum?," our research studies should ask "How do visitors integrate the art museum experience into the rest of their lives?" (Falk, 2004; Falk & Dierking, 2000). Long-term studies of learning are still relatively rare, especially in art museum research.

Information on the sample of visitors studied was often sparse and uneven. In many cases, descriptions of sample characteristics were missing altogether. This impedes our understanding of these research results and of the types of visitors that have been well-studied or under-studied in art museums. Art museum researchers need to ensure that research samples are carefully reported in published studies.

On the whole, researchers have taken varying approaches to the study of art museum learning. No one theoretical framework is dominant; rather researchers conceptualize learning in this context in different ways. This variation is not only interesting, but also healthy. No one theory can accommodate the complex, nonlinear, and multidimensional nature of learning in art museums. The use of multiple theories pushes us to think more creatively about how to define and assess visitors' learning. Equipped with an understanding of these conceptual and methodological issues, we now turn to a discussion of the research findings.

What Is Known About Learning in and From Art Museums

What does the research say about the nature of art museum learning? Equally important, what is *not* known about the learning that occurs in and from this context? To address these questions, we grouped studies according to their main area of focus, arriving at three categories: (1) studies that focus on *how* visitors learn, with an emphasis on the learning process; (2) studies that focus on *what* visitors learn, with an emphasis on learning outcomes; and (3) studies that focus on the *who, when,* and *where* of learning, with an emphasis on the learning context.

The Learning Process

Almost half of the studies we reviewed focused predominantly on how visitors learn in art museums (see Table 1 on page 32). Central to these studies was an acknowledgement (or an assumption, in some cases) that art museum learning is a highly social process. Stainton (2002) documented a host of social strategies employed by visitors, such as reading labels out loud to one another, sharing experiences and ideas with each other, and generally helping each other to interpret what they are seeing. Gay, Boehner, and Panella (1997) found similar results. In a study comparing undergraduate students' experiences with works of art during an online computer simulation designed to stimulate conversation and during a physical, in-museum experience, the authors found that students overwhelmingly emphasized the importance of social interaction in learning about works of art. Interestingly,

students felt that they could better engage socially online because in the museum they were not always assured of a "partner" to talk with and often felt as if the museum environment discouraged verbal interaction.

Most interesting to us in this group of process-based studies were those designed to develop or inform frameworks for explaining how people learn in art museums. Csikszentmihalyi and Robinson (1990) studied art museum professionals' responses to works of art, categorizing them according to one of four dimensions: (1) perceptual responses, which concentrated on elements such as balance, form, and harmony; (2) emotional responses, which emphasized reactions to the emotional content of the work and personal associations; (3) intellectual responses, which focused on the theoretical and art historical issues related to the work; and (4) communicative responses, wherein there was a desire to relate to the artist and his or her culture or time. Museum professionals interacted with works of art in more than one of these ways, suggesting that there are multiple and perhaps even overlapping aspects to people's experiences with works of art in the museum. Whereas this study provides useful insight into the range of possible responses to artworks, it does not shed light on how the general, less knowledgeable, or novice visitor fits within that range. Do general visitors engage in fewer dimensions, or do they hit more shallowly in all dimensions?

Twiss-Garrity (1995) examined visitors' responses to a single work of art—a Rococo Revival chair—from a different framework and found that visitors accessed the work through multiple dimensions, including description (identifying observable characteristics), classification (naming the object or giving it a style or date), association (connecting the object in tangible ways to other objects, people, or personal or historical settings or events) and evaluation (judging the object). How visitors accessed a work of art did not appear to depend upon their age, prior experience, knowledge, or familiarity with art or museums. It seemed to relate to personal preferences or interests. In addition, visitors might progress through several frameworks. For example, a visitor might look at a chair and recall a personal story about how Grandmother had a similar chair (association). Then the conversation might turn to evaluation, comparing the quality of Grandmother's chair with the one in the museum. To support this evaluation, the visitor might point out details (description).

Housen (1987) categorized visitors' interactions with works of art according to her stage theory of aesthetic development, where each stage represents one of five major steps in a progression from naïve to complex responses in viewing an art object. According to Housen, each stage represents a fundamental shift in the way a person perceives the

work of art, reasons about it, and constructs his or her experience of it. In Stage I, viewing is based on random and obvious observations; in Stage II, the viewer tries to build a framework for looking at works of art, matching her own experiences to what she sees in front of her. In Stage III, the viewer classifies the work of art, drawing less on personal history and more on knowledge of artistic elements such as color, line, and composition; in Stage IV, the viewer moves beyond classification to search for a more meaningful message, integrating previous knowledge and personal associations to focus on the figurative aspects of the work. Finally, in Stage V, the viewer makes equal use of all her faculties—perceptual, analytical and emotional—to look at the work of art from many different perspectives.

Taken together, how do these various frameworks help us understand the learning process in art museums? How do they inform research and practice in art museums? Consideration of similarities and differences, as well as strengths and weaknesses, between frameworks is a useful starting point. Csikszentmihalyi's framework (Csikszentmihalyi & Robinson, 1990) yields interesting insights about the diverse ways in which art museum professionals respond to works of art. However, his work is limited in that it seems unlikely that general visitors would respond to works of art in the same way that these experts did. Furthermore, we struggle with the assumption that the ideal art museum visit is one that results in "expert" viewing. Is it possible to engage richly and deeply with works of art but not be

considered an expert? If not, how do we move visitors to the point of being experts? These questions are largely unanswered within Csikszentmihalyi's research.

Housen's framework (1987) makes similar expert-novice assumptions. It assumes that there is an optimum end to aesthetic development (Stage V), a place for which all visitors strive. The implication is that lower stages are simply not good enough. What motivates visitors to become expert viewers? How do we account for docents who have logged countless hours in lectures and exhibition tours with highly knowledgeable experts, yet remain in the mid-range of Housen's stages? Perhaps the most valuable aspect of Housen's framework lies in its developmental approach. Art museum educators have long suspected that art viewing is largely a developmental process that depends on prior experience, knowledge, and interest. It is precisely because this framework is so well grounded in practice and intuition that it has been so well received in the field.

The strength of Twiss-Garrity's framework (1995) is that it suggests there is no right way to enter into and engage with a work of art. It allows for differences in interest, experience, and preference. This framework helps us assess the impacts of art museum programs, in particular (Adams, 1999; Adams & Luke, 2001). However, this framework may be vulnerable with regard to different types of art. For example, while looking at an exhibition of quilts, visitors might make more associations (e.g., "That looks just like Great-Grandmother's wedding quilt.") because it is likely that many visitors would have direct personal experience with quilts. On the other hand, when viewing contemporary conceptual

art, visitors may be more likely to enter into the experience through classification ("I've never seen anything like that.") or evaluation ("That doesn't take any skill to make. That's not good art.").

Learning Outcomes
Approximately one-third of the studies we reviewed focused on the outcomes that result from the art museum experience (see Table 1 on page 32). There has been much debate in the field over the last two decades regarding the educational role of art museums (Jeffers, 2003; Kindler, 1998; Lankford, 2002; Rice & Yenawine, 2002). Are works of art primarily to be enjoyed? Or do we expect visitors to better understand a particular artist, period, or style as a result of their time in the museum? More importantly, are enjoyment and learning necessarily in opposition?

Findings from these studies demonstrated a range of learning outcomes, reinforcing that the art museum experience is both broad and rich in its impact. For instance, an investigation sponsored by the Getty Center for Education in the Arts (Walsh, 1991) found that visitors identified several dimensions from their visit, including arousal of intellectual curiosity; increased understanding of content or subject; enhanced appreciation of the beauty, age, and craftsmanship of objects; increased understanding of technique and media; and opportunities for communication about related and unrelated subjects. Jeffers (1999) examined children's art museum experiences, studying their perceptions of the value of their visit after they had led a significant adult through the museum. She

Figure 1. Outcomes Framework Analysis.

Learning about content
Facts and information about creative process and media

Learning about ourselves and others
Inter- and intra-personal insights and connections

Learning how to engage in aesthetic perception
Nonintellectual response

Learning how to learn
How to access and retrieve needed information and experience

found that children and adults felt their awareness of the exhibition content had been expanded and their interest in and understanding of the artistic process heightened.

Reporting results from three different studies, Soren (2001) highlighted the importance of aesthetic, re-creative outcomes, such as personal feelings of nostalgia, relaxation, peacefulness, and tranquility. McManus (1993) found similar results. Studying children's memories of an art museum experience 10 months after their visit, she found that most of children's reflections consisted of personal, emotional connections that children had made to specific objects.

Although limited in its scope, research focused on learning outcomes supports the notion of expanded definitions of art museum learning. There are clearly a range of complex and overlapping outcomes that result from the art museum experience. We found that clustering these outcomes was a useful way to transition from research to practice.

Figure 1 illustrates four types of learning that emerged from the studies we reviewed, as well as from our own work (Adams, 1999; Adams & Luke, 2001). No learning dimension takes precedence over another. Rather, these outcomes hang together, like grapes, encouraging us to acknowledge the breadth and complexity of art museum learning.

Learning Context
The remaining studies focused predominantly on contexts that influence or facilitate visitors' learning (see Table 1 on page 32). These studies addressed conceptual/pedagogical and concrete/physical dimensions of learning. In discussing context-based findings, we also draw on some of the other studies in Table 1 that, although not directly focused on factors in the learning context, touched on these issues.

We first consider conceptual/pedagogical dimensions of learning, examining research on museum staff's perceptions of visitors, as well as research on visitor characteristics. In a year-long ethnographic study, Knutson (2002) examined the conversations

and decision-making processes of staff during the exhibition-development process, trying to better understand staff's beliefs and values about art and learning. She found that each member of the design team had different notions of visitors and visitor learning. Visitors were perceived by various staff members as a large undifferentiated group, as individuals with varied interests and with a range of learning preferences, and as shoppers picking through various parts of an exhibition. Similarly, the Getty study (Walsh, 1991) found that museum professionals hoped visitors would have rich, meaningful experiences viewing artworks. This highly open-ended approach to visitor learning led to vague expectations. Studies such as these suggest that vague expectations on the part of the exhibition design team may well lead to vague learning on the part of the visitor.

Although few of the studies we reviewed looked specifically at the influence of visitor characteristics on museum experiences, many flirted around the edges of this topic. Housen (1987) compared three types of data on visitors—demographic, attitudinal, and developmental. She found that while the first two characteristics provided interesting data, an understanding of visitors' interest, prior knowledge, and experience was most useful for informing art museum practice. Stainton (2002) reported similar results. In analyzing visitors' conversations during an exhibition of African art, she found that at least half of what visitors talked about was prompted by their prior knowledge and experience with the works of art. Perhaps not surprisingly, Stainton found that visitors with low knowledge of art and

museums tended to rely more heavily on the museum's supports to access a work of art. Similarly, participants in the Getty study (Walsh, 1991) wanted museum professionals to guide them to important objects that should not be missed. Taken together, these findings support Falk's (1998) notion that psychographic data—visitors' motivations, agendas, interests, prior knowledge and experiences—are more predictive than demographic data alone.

Although Henry (2000) did not intentionally look at psychographic factors, her findings address these factors. In recollections of positive and negative art museum experiences, undergraduate and graduate art education students acknowledged several ways they influenced the quality of their own experience. For example, one student said when she was fatigued on the day of the visit, she observed that she was easily disappointed. She also failed to find out which exhibitions were open and she was unhappy that the exhibition she hoped to see was closed. Several students commented that interactions with companions influenced their satisfaction as did the degree of familiarity with the museum or works on view. Like Csikszentmihalyi and Robinson's (1990) study with art museum professionals, Henry's study focused on art students who were experienced museum visitors. Although there is a good chance that inexperienced visitors are similarly or perhaps even more strongly affected by such contextual factors, we could find no studies to confirm this conjecture.

In addition, studies focusing on the learning context provide insight into concrete/physical factors influencing learning. Eisner and

Dobbs (1988) conducted a study, rating 31 different art museums across the country according to what they do to help visitors experience works of art. They found two broad problem areas: (1) orientation and introduction (general to the museum visit and specific to an exhibition), and (2) layout and installation. In the area of orientation and introduction, Eisner and Dobbs found that advance organizers that would help average visitors plan and navigate their visit are practically nonexistent. When object-related labels are provided, they generally give minimal information. When more information is provided either in labels or wall panels, the text is frequently laden with technical and specialized vocabulary, such as "oeuvre" and "provenance," that many visitors do not understand. Attempts at providing context and opportunities for comparison were largely absent. Similarly, many people in the Getty study (Walsh, 1991) reported getting lost, suggesting that advance organizers and better orientation systems are desperately needed in art museums. In addition, these visitors found maps confusing and did not easily discern differences between exhibitions or styles of art. What visitors liked best in this study were the period rooms because they provided a context for the art.

Temme's (1992) results support those of Eisner and Dobbs (1988) and the Getty study (Walsh, 1991). Studying the effect of labels on visitors' appreciation and satisfaction in three Dutch art museums, Temme found that infrequent museum visitors, who usually have little or no formal

background in art education, tended to voice more need for information than did frequent, art-knowledgeable visitors. The study also suggested that the optimum label length was between 350-650 characters (roughly 50-120 words), and the shorter end of that continuum tended to result in the longest time spent looking at the painting. He did not look at differences in the content or pedagogical approach of the label text itself. Weltzl-Fairchild et al. (1997) also saw evidence that when visitors were dissatisfied with their museum experience, they often asked for more information in the form of labels, texts, or audio guides. Walsh (1991) reported that visitors expressed great frustration when they perceived that important information was missing. In addition, these visitors complained about the "size, location, and lighting of object labels" (p. 25).

Henry (2000) noted comments about the effect of the physical exhibition environment in undergraduate and graduate students' reflections of museum visits. She found that conditions such as dim lighting and crowds seemed to cause the college students to feel rushed and constrained. Some students associated negative art museum experiences with unpleasant interactions with museum staff, in particular security guards. Similarly, Walsh (1991) found that while a pleasant exchange with guards or museum staff pleased visitors, those who had unpleasant or embarrassing experiences tended to remember them vividly.

Future Directions

Toward a Research Agenda

An examination of published research on art museum learning over the last two decades provides insight into not only where we have been as a field, but also where we need to go. We offer the following suggestions for future research directions:

- Investigate the range of learning outcomes that result from the art museum experience. Although the studies reviewed here hint at the broad and complex nature of these outcomes, further research is needed to discern these outcomes and to confirm where they overlap and in what ways. What do visitors learn from the art museum experience? How do learning outcomes differ depending on the nature of visitors' experience and the kinds of art they looked at?

- Conduct long-term learning studies. Art museum education needs research that goes beyond documentation of immediate learning outcomes to study learning that occurs over time and across contexts. What role do art museums play in people's lives over time? How is the art museum experience integrated into previous and subsequent experiences?

- Focus research on the "middle ground" of the art museum experience. Current studies tend to look either at experts or at infrequent visitors; there is little research on the learning experiences of the general art museum visitor. What motivates the general visitor to engage deeply with works of art? What is their learning process like, and how can art museum professionals best facilitate that process?

- Study the pedagogy of space. Research is needed that moves beyond basic label studies to look more meaningfully at what visitors really need and use in the art museum. Why do inexperienced visitors leave the art museum feeling unfilled or dissatisfied? How can we help a wider range of visitors to access works of art in the museum?

From Research to Practice

What does the research reviewed here suggest about our educational practice in art museums? How do these studies inform practice, and what specific recommendations emerge for art museum educators? The following suggestions arose for us in the process of reviewing this research. This is by no means a comprehensive list, but is intended to prompt dialogue about the collective practices within our field:

- Clarify learning goals for exhibitions. We cannot expect visitors to understand the main message(s) of an exhibition if we ourselves have not been clear from the outset about what we expect a successful visitor experience to be.

- Understand your visitors. Ideally, this means integrating exhibitor evaluations into the ongoing exhibition-presentation process, seeking feedback from visitors at crucial points throughout the process. Even "cheap and cheerful" evaluation studies can help ensure an exhibition is on course

- Develop a range of interpretive strategies that can work for novice, moderately experienced, and expert visitors. There is no one-size-fits-all solution in exhibition development. Accept that visitors need interpretive assistance, and develop strategies to help them build confidence in their natural abilities to look at, think about, and explore works of art. Find ways for visitors to connect with the art museum experience on their own terms.

REFERENCES

Adams, M. (1999). *Phase III summative evaluation: The Art of Looking interactive multimedia computer application at the Dallas Museum of Art.* Technical report. Annapolis, MD: Institute for Learning Innovation.

Adams, M., & Luke, J. (2000). *Multiple-visit museum/school programs in the arts: What do students learn?* Technical report. Annapolis, MD: Institute for Learning Innovation.

Adams, M., & Luke, J. (2001). *Evaluation report for the HeArt Project, Los Angeles, California.* Technical report. Annapolis, MD: Institute for Learning Innovation.

Csikszentmihalyi, M., & Robinson, R. (1990). *The art of seeing: An interpretation of the aesthetic encounter.* Malibu, CA: J. Paul Getty Museum and the Getty Center for Education in the Arts.

Dierking, L., Ellenbogen, K., & Falk, J. (2004). In principle, in practice: Perspectives on a decade of museum learning research (1994-2004). *Science Education, 88*(1).

Eisner, E., & Dobbs, S. M. (1988). Silent pedagogy: How museums help visitors experience exhibitions. *Art Education, 41*(4), 6-15.

Falk, J. (1998). Visitors: Toward a better understanding of why people go to museums. *Museum News, 77*(2), 38-43.

Falk, J., (2004). The director's cut: Toward an improved understanding of learning from museums. *Science Education, 88*(1), S83-S96.

Falk, J., & Dierking, L. (2000). *Learning from museums: Visitor experiences and the making of meaning.* Walnut Creek, CA: AltaMira Press.

Fiske, E.(1999). *Champions of change: The impact of the arts on learning.* Washington, DC: The President's Committee on Arts and the Humanities & The Arts Education Partnership.

Gay, G., Boehner, K., & Panella, T. (1997). ArtView: Transforming image databases into collaborative learning spaces. *Journal of Educational Computing Research, 16*(4), 317-332.

Gottesdiener, H., & Vilatte, J.C. (2001). Impact of a game booklet on a family visit to an art exhibition. *Empirical Studies of the Arts, 19*(2), 167-176.

Hein, G. (1998). *Learning in the museum.* London: Routledge.

Henry, C. (2000). How visitors relate to museum experiences: An analysis of positive and negative reactions. *Journal of Aesthetic Education, 34*(2), 99-106.

Housen, A. (1987). Three methods for understanding museum audiences. *Museum Studies Journal,* Spring-Summer.

Jeffers, C. (2003). Museum as process. *Journal of Aesthetic Education, 37*(1), 107-119.

Jeffers, C. (1999). When children take the lead in exploring art museums with their adult partners. *Art Education, 52*(6), 45-51.

Kindler, A. (1998). Aesthetic development and learning in art museums: A challenge to enjoy. *Journal of Museum Education, 22*(2), 12-15.

Knutson, K. (2002). Creating a space for learning: Curators, educators and the implied audience. In G. Leinhardt, K. Crowley, & K. Knutson (Eds.), *Learning conversations in museums* (pp. 5-44). Mahwah, NJ: Lawrence Erlbaum.

Lankford, E.L. (2002). Aesthetic experience in constructivist museums. *Journal of Aesthetic Education, 36*(2), 140-153.

Lave, J., & Wenger, E. (1991). *Situated learning: Legitimate peripheral participation.* Cambridge, England: Cambridge University.

McManus, P. (1993). Memories as indicators of the impact of museum visits. *Museum Management and Curatorship, 12,* 367-380.

Piscitelli, B., & Weier, K. (2002). Learning with, through, and about art: The role of social interactions. In S. Paris (Ed.), *Perspectives on object-centered learning in museums* (pp. 121-151). Mahwah, NJ: Lawrence Erlbaum.

Rice, D., & Yenawine, P. (2002). A conversation on object-centered learning in art museums. *Curator: The Museum Journal, 45*(4), 289-301.

Soren, B. (2001). Images of art museums: Quiet places we have known. *Journal of Museum Education, 25*(1/2), 9-14.

Stainton, C. (2002). Voices and images: Making connections between identity and art. In G. Leinhardt, K. Crowley, & K. Knutson (Eds.), *Learning conversations in museums* (pp. 213-257). Mahwah, NJ: Lawrence Erlbaum.

Temme, J.E.V. (1992). The amount and kind of information in museums: Its effects on visitors' satisfaction and appreciation of art. *Visual Arts Research, 18*(2), 28-36.

Twiss-Garrity, B. (1995). Learning how visitors learn: A Winterthur experience. In *The Sourcebook: Museums educating for the future* (pp. 102-109). Washington, DC: American Association of Museums.

Walsh, A. (Ed.). (1991). *Insights: Museums, visitors, attitudes, expectations: A focus group experiment.* Los Angeles, CA: J. Paul Getty Trust.

Weltzl-Fairchild, A., Dufresne-Tasse, C., & Dube, T. (1997). Aesthetic experience and different typologies of dissonance. *Visual Arts Research, 23*(1), 158-167.

Wilson, B. (1996). *The quiet evolution: Changing the face of arts education.* Los Angeles: J. Paul Getty Museum.

New Art Museum Education(s)

Melinda M. Mayer
The University of Texas at Austin

Is there a new art museum education? I pose this question in relation to the 30 years of changes occurring in art history, the field to which art museum education is so inextricably linked. Art history underwent a reexamination of theory and methodology that began in the 1970s and continues to grow in scope and influence. The label "new art history" became attached to this movement around 1982 (Bryson, 1988; Rees & Borzello, 1986). At the crux of these "crises in the discipline" (Preziosi, 1989) was the postmodern challenge then current in many fields of study asserting that knowledge is not a rational, objective truth bringing sense and order to our world, but is the socially constructed meanings we craft within the complexity of our culture. In art history, this entailed questioning the methods we used to attach meaning to artworks. Art historians reached beyond the discipline to theories associated with Marxism, feminism, cultural studies, and literary criticism to expand their understandings of meaning making (Harris, 2001). The movement quickly was labeled the "new art histories" because of these diverse sources of theory that resulted in many methods of interpretation. If art history was transforming, what was going on concurrently in art museum education? Following the lead of the new art histories, the question should be, "Are there 'new art museum educations'?" If so, what do they look like?

This chapter will explore these questions by looking at what the shift to the new art histories has represented to interpretation. Art historians have concerned themselves with issues regarding what these "new" notions meant for scholarly interpretation—but not for the meaning making of individual museum-goers, nor for art museum education (Mayer, 2005). If there are to be "new art museum educations" in a postmodern sense, art museum educators must examine the theories of meaning in the new art histories. We must study the implications of the new art histories for the meaning making of visitors to art museums before we declare the existence of emergent forms of art museum education. Rather than attempting to establish a cause-and-effect relationship between the new art histories and new art museum educations, this inquiry will identify and reflect on the theory development that could yield new forms of art museum education. Two postmodern discourses that will guide this exploration are (1) subjectivity and (2) meaning making as a social practice. Subjectivity deals with the formation of identity within culture (Foucault, 1982/1984). Meaning making as a social practice pertains to issues of interpretation and the educational enterprise, both of which must be recognized as based in culture, not in the discipline (Freedman, 2003; Trend, 1992). These concepts are discussed here.

The New Art Histories

From the vantage point of some 30 years of scholars' engagement with the new art histories, we can readily perceive the shift in methods of interpreting works of art. The new art histories opened the boundaries of the discipline, examined the ideological position of the interpreter, and challenged the notion of a historical "truth" as the definitive interpretation of a work of art (Harris, 2001). Meanings come from culture because seeing and thinking are culturally situated.

Interpretation is, therefore, a political act. It is a cultural narrative resulting from the encounter of the complex contexts of the artist, the artwork, and the interpreter.[1]

The modernist art historian worked within the canon of fine art to analyze and interpret objects in terms of connoisseurship, iconography, and influences affecting the creation and meaning of the work (Preziosi, 1989; Roskill, 1976/1989). Delving into theories and methods from other disciplines such as anthropology, archeology, sociology, or literature was necessary only if a direct connection to the artist and artwork could be documented and was, therefore, necessary to understanding its meaning (Roskill, 1976/1989). Yet, works of art function in culture by taking on and imparting meanings beyond those produced by the artist.

One of the earliest and most seismic shifts in art history theory and practice that became identified with the new art histories was the feminist critique of the very notion of a canon of great artists (Nochlin, 1971/1988). The feminist analysis of art history was directed at subjectivity in terms of who was defined as artist, representations of woman as subject, and how the institutions of art operate to exclude or diminish women's voices. Women were not the only people left out of the discourse. The many fields within cultural studies brought to awareness the institutional racism of art history (Berger, 1992; Harris, 2001). With the exposing of the canon as a constructed instrument of power reproducing dominant Western culture, examining the ideological

position of the interpreter became critical. The interpretations of art historians and others, no matter how carefully researched, are the products of subjective choices, not the unearthing of objective facts. The scholar needed to come out from beneath the cloak of objectivity, a premise underlying modernist scholarship.

As art historians crafted methods based in feminism, multiculturalism, and other genres of identity studies, they also turned to literary theory to examine the idea that a singular "truth" to the history of art was either possible or desirable. New art historians turned to literary discourses including intertextuality, deconstruction, narratology, and semiotics (Bal & Bryson, 1991). Semiotics, the study of signs and how they function, had long enjoyed a place in art history. Works of art function metaphorically and symbolically as systems of meaning, which is to say they act as signs. Semiotics, however, had shifted to post-structuralism. Whereas structuralism sought to pin down the meaning of signs within a syntactical system, post-structuralist semiotics conceived of the sign as "floating" Meaning was not an artifact of history, but a changing process resulting from the encounter of the perceiver with the object within the context of culture (Bal & Bryson, 1991; Barthes, 1977). This subjective nature of meaning making made

a single, definitive, and objective interpretation of an artwork impossible. Instead, interpretation became a chain of infinite possibilities.

Interpreting the New Art Histories for Art Museum Visitors

From this brief presentation of the new art histories, there are two notions that will guide this inquiry into new art museum educations. First, interpreting works of art is now viewed as a sociopolitical practice, as a way of seeing that occurs in the context of culture. Interpreting art is not a school-like problem that one gets "right" by figuring out or being told what the artist meant. When the artwork and the viewer come together in the art museum, a host of interpretive contexts come into play. These include the sociopolitical milieu of the artist, the history of interpretations of the object through time, the knowledge and experience of the viewer, and the institutional practices of the museum. Meaning making occurs as viewers, expert to novice, weigh, through the filter of their own experience, the information they derive from these sources. The new art histories bring to light the complex nature of interpreting meaning within these powerful and potentially competing cultural spheres.

Second, with the new art histories, the discourse of subjectivity becomes pervasive in meaning making (Harris, 2001). It is important to point out, however, that although interpretation is recognized as subjective in the new art histories, the concept of subjectivity in postmodern theory is viewed in relation to notions of power and how it acts to shape the identity of groups and peoples (Foucault, 1984). Moreover, subjectivity recognizes that identity is not complete and whole, but changing as we struggle with the contexts of culture. Regardless, the new art histories' emphasis on the subjective nature of meaning making is of great consequence for art museum visitors. Rather than enabling the complete relativity of interpretation, subjective meaning making opens a space in the field for all viewers to have access to the resources that produce informed interpretive decisions. Bal and Bryson (1991) note that the interpretations of the "everyday" people who viewed art in galleries are profoundly absent from the archives of art history. It would be unfortunate if postmodernism also excluded or diminished the meaning making of that group of people identified as "the average visitor" by excluding the subjective from the discourse of subjectivity.

What would interpreting objects look like for art museum visitors when taking into consideration these stances from the new art histories? Rather than being passive receivers of professional interpretations, art museum visitors become active builders of personally relevant meaning.

They also would be aware of the processes and sources through which they came to their interpretations. In other words, visitors would be self-reflective and deliberative in analyzing how their prior knowledge and life experience affect their meaning making. To augment their understanding of the sociopolitical context of the artist and artwork, art museum visitors would know how to access all of the institution's resources (Stapp, 1984/1992). They also would be adept at deciphering the museum practices that influence how visitors encounter and perceive objects. And they would skillfully and flexibly make connections between the cultural contexts of the work in its time and their own life experiences. These notions of meaning making would need to arise out of a practice that is responsive to varied ages and levels of experience.

This vision of visitors' interpretations presents a sizeable challenge for them and for art museum educators. Fully developed meaning making as presented through the new art histories is complex and appears to be hard work. Most visitors come to museums for social and leisure purposes (Falk & Dierking, 1992; Roberts, 1997). Increasingly, however, U.S. society has sought experiences that offer learning opportunities even as they provide enjoyment (Falk & Dierking, 2002). Exploring life's meanings through art and with friends or family can be immensely pleasurable. If

daunted by the complexity of the view of meaning making presented here, educators should remember that there was nothing simple about traditional methods of art historical interpretation; they were only familiar. What theories and practices of art museum education would support the conception of interpretation presented here and result in new art museum educations?

New Art Museum Educations
Like the new art histories, the new art museum educations would need to undertake a "turning within" to critically reflect on existing theories and methods. Yet, reaching beyond the field for models and theories to inform the critique and reconfigure methodology would need to occur simultaneously. This examination would need to move away from teaching about collections toward the purposeful integration of meaning making within life's social fabric. New art museum educational practices and programs would focus on the visitor's subjective interpretation of objects. Meaning making would be based in subjectivity, in the recognition that through making sense of art objects, visitors are redefining who they are in the world. The new art museum educations would be based on the belief that art, art museums, educators, and visitors are produced in culture.

The postmodern era threw museums into crisis. A biting critique of museums as socially irrelevant grew from the social and civil unrest of the 1960s and 1970s. To survive economically, museums needed to prove their value to the public (American Association of Museums, 1984). A burgeoning body of literature in museum education[2] in the late 20th century indicated that the field was responding. Educators were redefining theory and practice through two distinct avenues of inquiry. One group of museum educators traversed a path through social and literary theory while the other journeyed through the quasi-scientific fields of visitor study, audience research, and educational psychology. A step back in time to modernist art museum education helps discern how these discourses affected theory and practice.

Modernist Art Museum Education

The "walk-and-talk" lecture tour provides an archetype for art museum education practice under modernism (McCoy, 1989; Muhlberger, 1985). The goal of these tours was to transmit the expert information that would illuminate the works of art in the collections. Content typically included dates, factual information regarding the artist and his (gender intended) times, stylistic analysis, identification of symbolism, and comparisons among artworks (Grinder & McCoy, 1985; Muhlberger, 1985; Newsom & Silver, 1978). Other educational programs and practices paralleled the lecture tour in content and purpose. In this transmission model of art museum education, viewers were passive receivers of curatorially sanctioned interpretations.

During the 1970s, a move to interactive teaching methods was under way. Creative drama, writing activities, questioning strategies, looking games, storytelling, and hands-on techniques increasingly became a part of practice (Sternberg, 1989). Although this swing to a more active interchange might appear to signal the emergence of a new art museum education, the goal still was to transmit expert knowledge and the looking skills of curators (Hooper-Greenhill, 2000). Borrowing from media studies, art museum educators used the term "visual literacy" to describe their aims (Mayer, 2005). In addition to teaching how to see, visual literacy was meant to help visitors make personal connections to objects. Visitors were not, however, encouraged to build their own subjective interpretations. Meaning making was understood as a practice of the discipline of art history, not centered in culture. Visual literacy, even with the use of interactive teaching methods, was not a new art museum education.

As the case of visual literacy demonstrates, identifying whether or not new forms of art museum education materialized concurrently with the new art histories involves both theory and practice. The relationship of theory and practice should be symbiotic. Whether theory informs practice or practice transforms theory, the process should be integrated and reciprocal.

Into the Postmodern: Discourses of Museum Education

Museum education's first documented foray into the postmodern occurred in 1984 when Stapp (1984/1992) proposed the transformation of the educational goal of museums to what she called "museum literacy." The term goes beyond visual literacy in denoting the visitor's adept use of the language of interpretation, full access to and use of museum resources, and a sense of the museum as an institution that confers meanings of its own. The museum-literate individual is empowered. Drawing from cultural sociology, Stapp's vision for education saw museums as political entities that gave privilege to certain socioeconomic groups and their ways of knowing. Accordingly, interpretation of images is affected by the ideological position of those in authority. The educational practices leading to museum literacy would be directed toward visitors understanding the institutional codes of the museum and drawing on its holdings for their own purposeful meaning making. Educational practices designed to empower visitors, to foster museum literacy, would be both culturally situated and subjectively controlled. This reconfiguration of the goal of museum education provides a conceptualization for a new art museum education.

Roberts (1997) looked to literary theory to articulate a narrative approach to museum education. Iser's (1981) work in reader-response theory, a branch of literary theory, is one discourse that informed Roberts' view of what museum education should be. Like post-structuralist semiotics, reader-response theory bases meaning making in the subjective (Roberts, 1997). In adopting this theory, Roberts identifies museums as social instruments. Visitors construct narratives amid the competing messages they encounter. These messages could include the narratives of official, truthful art history or of an institution representing only the "best" of cultural artifacts (and what that excludes). The visitor brings her own narrative to the experience, as well. This theory of meaning making recognizes the malleability of identity and lets visitors narrate who they are in relation to the stories they interpret through their encounters with objects. Roberts' narrative approach constitutes a new art museum education.

From England, yet another new discourse of postmodernism is making its way into the field. Hooper-Greenhill (2000) proposed a new model of not only museum education, but also of museums—the post-museum. A main source for her theory development was the contemporary discourse of visual culture, which also is in play within art history. Depending on one's perspective, visual culture represents either an opening of fine art to include all forms and media that represent our visual experience of culture, the subsuming of fine art within visual media, or visualization as a way of knowing.

Hooper-Greenhill (2000) suggested that the post-museum represents the rebirth of the modernist museum, which was the rational instrument of objectivity bringing order to culture. Her use of the birth metaphor signaled that the post-museum embraces a feminine ethos. The post-museum will "negotiate responsiveness, encourage mutually nurturing partnerships, and celebrate diversity" (p. 153). Interpretation and education in the post-museum is based on a communication theory that is thoroughly cultural. Hooper-Greenhill used Giroux's (1992) critical pedagogy to understand that culture is the omnipresent framework of life, but with many borders within it. The educator in the post-museum would be a cultural worker joining the visitor in negotiating the many borders and languages of culture. Hooper-Greenhill's conception of museum education reflects the discourse of neo-Marxism, feminism, literary theory, and cultural studies, as do many of the new art histories. Education programs and practices created for the post-(art) museum would be derived from the notions of culture and subjectivity that would be present in new art museum educations.

The museum educational aims and theories put forward by Stapp (1984/1992), Roberts (1997), and Hooper-Greenhill (2000), when applied to the art museum, align with the definition of new art museum education presented earlier. Museum education theories arising from visitor studies and educational psychology are harder to pin down as sources for new art museum educations.

Stopping to Ask for Directions: Museum Education and Visitor Studies

The rise in visitor study during the 1980s demonstrated that museum professionals wanted to hear what people had to say about their experiences with museums. The Getty Center for Education in the Arts played an important role in raising the awareness of museum staffs to the value of seeking the public's point of view. In the late 1980s, the Getty Center sponsored focus groups in major art museums around the country (Walsh, 1991). Concurrently, museum educators pursued visitor and research studies to learn how to make museum visits as meaningful as possible. Out of this movement emerged the beginnings of two theories of museum learning, both of which could lead to new art museum educations. Falk and Dierking (1992, 2000) postulated the Interactive Experience Model, which evolved into the Contextual Model of Learning (CML) in the 1990s. Housen (1987, 2001) developed a stage theory regarding the aesthetic development of art museum visitors.

Falk and Dierking (2000) shaped the CML out of their years of experience in visitor study and program evaluation. The CML represents meaning as resulting from three interacting contexts—the personal, sociocultural, and physical. The personal context consists of the knowledge and experience the visitor brings to the museum. The sociocultural context is a broad conceptualization of the influence on visitors of culture, community, and media. Furthermore, this context accounts for visitors coming to the museum in social grouping, such as friends or family. The physical context includes all that the senses take in of a museum visit—the smells of the parking lot, the light and temperature of the galleries, the design of displays, the delectability of café offerings, and the abundance of gift shop cases. Cultural and biological definitions of human experience underlie these contexts.

In conjunction with the CML, Falk and Dierking (2000, 2002) identified museum learning as free-choice learning that they characterized as nonlinear, personally motivated, and self-regulated. A new art museum education might arise through the CML and free-choice learning because learning is subjective in that it starts with the person. Furthermore, Falk and Dierking (2002) presented meaning as occurring through the filter of

culture and social interaction. A cautionary note arises, however, when considering their view of subjectivity. Biology, not culture, accounts for the origins of the learner; therefore, the need to learn is genetically programmed. This scientific model is counter to the postmodern discourses that theorize identity and the body as being defined in culture (Linker, 1983/1984). Nevertheless, Falk and Dierking's (2000, 2002) theory of museum learning could result in a new art museum education in that it presents a synthesis of postmodern discourses affecting both humanistic and, to a lesser degree, scientific disciplines. The body is biologically generated, but the person is formed socioculturally.

Housen's (2001) theory of aesthetic development also resulted from a mix of scientific and humanistic sources. For 10 years she recorded, analyzed, and codified the ways people, from novices to experts, talked about art. The result of Housen's research was a stage theory of aesthetic development. Unlike traditional approaches to stage theory, which linked progressing ability to age, Housen grounded aesthetic growth in the viewer's concrete exposure to art and repeated practice of meaning making. With Falk and Dierking (2000, 2002), she shares the constructivist notion, discussed in greater depth below, that we make sense of the world through our prior knowledge and experience and in social settings (DeSantis & Housen, 2000). Although aesthetic development is not triggered

as the brain matures, Housen (2001) asserted that people move through the stages naturally. The recognition that art objects are cultural products and that culture influences the sense people make of them, however, appears only tangentially in the literature related to Housen's aesthetic development theory (Yenawine, 2003). Housen (2001) eschewed basing her research in abstract theories of aesthetics. Instead, she favored grounding it in the concrete experience of perception expressed through the words and phrases people use to talk about art. Concrete perception of objects mediated through social interaction is the source of meaning making, not culture. Talk of culture is an abstraction that should be left for viewers progressing beyond the beginning stages of aesthetic development, which would include most visitors, regardless of age, because they tend to be situated in those early stages (Yenawine, 2003).

With Yenawine and other colleagues, Housen created Visual Thinking Strategies (VTS), which translates her theory into educational practice. The goals of the VTS curriculum focus on developing visual literacy, language skills, collaborative problem solving, and respectful democratic discussion (Visual Understanding in Education, n.d.). Teaching methods are learner-centered and rely on a carefully researched questioning strategy. The discussions are subjective in that they arise solely from viewers' observations with no information provided by the facilitator. Imparting expert information has no place in VTS

for early-stage viewers. This is not a transmission model of education; it is constructivist. Housen embraces subjective aesthetic response. She also recognizes that we make sense of art through connecting perceptions in a social context— with others. Housen's aesthetic development theory and VTS cannot be identified as one of the new art museum educations as defined here, however, because concrete perception replaces culture as the framework of meaning making.

Hein (1998) did not fashion his own theory of museum learning. He adopted constructivist theory and practice after studying the growing body of literature on visitor behavior and learning. Elements of constructivist theory appear in both free-choice learning and VTS, but Hein comprehensively applies constructivism to both exhibition design and education practice. With constructivism, making meaning starts with the visitor and involves integrating prior knowledge with new experiences. In formulating his approach to constructivism, Hein (1998) referenced the work of educational psychologists Dewey (1938) and Piaget (1929) and sociolinguistic psychologist Vygotsky (1978). Vygotsky believed that learning is a cultural behavior that occurs in a social setting, such as a group of peers. Before learning is internalized individually, it is experienced socially. Vygotsky's theory is well suited to the informal character of museum learning. As Falk and Dierking (2000) pointed out, people come to the museum to interact with others while looking

at objects. Talking with friends, family, or other visitors enables meaning making to arise out of this socializing and then become learning. Hein (1998) affirmed, however, that museums are not simply neutral social backdrops for learning; as institutions of culture, they suggest meanings. Hein asserted that adopting constructivism requires museum professionals to acknowledge that exhibits portray interpretations, not truths, and to commit to aggressively pursuing the study of visitor meaning making. This application of constructivism, when carried out in art museums, would be a new art museum education.

Conclusion

Are there new art museum educations? Yes. Like the new art histories, the new art museum educations reach beyond our field for theories and methods of inquiry to reinvigorate the relevance and vibrancy of interpretation. A shift in values took place with the new art histories. Instead of object-based interpretation, practice became a matter of studying how objects are perceived and used; the dynamics of human experience in the context of culture replaced the object as the context of meaning making. Interpretation through the new art museum educations reflects these same values. Museum scholars have laid the foundation of theory

for the new art museum educations over the course of the past 30 years. Supporting and nurturing the museum literacy of visitors, however, is the current work of educators in the field creating programs and practices.

The practices of the new art museum educations should be even more numerous than the theory models. Art museum educators generating those programs and practices would, however, adhere to a set of commonly held beliefs regarding visitors' experiences. With the new art museum educations, meaning making is as open as the museum doors. Access is not only the opportunity to move freely through galleries, but also is intellectual, thereby unlocking the professional practices that influence visitor experience and meaning making. Tales of the past merge with the stories of lives lived in the present, and new narratives are told. The new art museum education programs and practices make available a wide spectrum of interpretive choices through which museum educator joins with visitors to nurture the construction of meaning.

REFERENCES

American Association of Museums. (1984). *Museums for a new century: A report of the Commission of Museums for a New Century.* Washington, DC: Author.

Bal, M., & Bryson, N. (1991). Semiotics and art history. *The Art Bulletin, 73*(2), 175-208.

Barthes, R. (1977). *Image-music-text* (S. Heath, Trans.). New York: Noonday.

Berger, M. (1992). *How art becomes history: Essays on art, society, and culture in post-new deal America.* New York: HarperCollins.

Bryson, N. (Ed.). (1988). *Calligram: Essays in new art history from France.* Cambridge, UK: Cambridge University.

DeSantis, K., & Housen, A. (2000). *A brief guide to developmental theory and aesthetic development.* Retrieved August 1, 2005, from http://www.vue.org/download_author.html

Dewey, J. (1938). *Experience and education.* New York: Macmillan.

Falk, J. H., & Dierking, L. D. (1992). *The museum experience.* Washington, DC: Whalesback Books.

Falk, J. H., & Dierking, L. D. (2000). *Learning from museums: Visitor experiences and the making of meaning.* Walnut Creek, CA: AltaMira Press.

Falk, J. H., & Dierking, L. D. (2002). *Lessons without limits: How free-choice learning is transforming education.* Walnut Creek, CA: AltaMira Press.

Foucault, M. (1984). The subject and power. In B. Wallis (Ed.), *Art after modernism: Rethinking representation* (pp. 417-432). New York: The New Museum of Contemporary Art. (Reprinted from *Critical Inquiry* 8, Summer 1982, pp. 777-795.)

Freedman, K. (2003). *Teaching visual culture: Curriculum, aesthetics, and the social life of art.* New York: Teachers College.

Giroux, H. (1992). *Border crossings.* London: Routledge.

Grinder, A. L., & McCoy, E. S. (1985). *The good guide: A sourcebook for interpreters, docents and tour guides.* Scottsdale, AZ: Ironwood.

Harris, J. (2001). *The new art history: A critical introduction.* London: Routledge.

Hein, G. E. (1998). *Learning in the museum.* London: Routledge.

Hooper-Greenhill, E. (2000). *Museums and the interpretation of visual culture.* London: Routledge.

Housen, A. (1987, Spring-Summer). Three methods for understanding museum audiences. *Museum Studies Journal,* 1-11.

Housen, A. (2001). *Eye of the beholder: Research, theory and practice.* Retrieved July 15, 2005, from http://www.vue.org/download_author.html

Iser, W. (1981). *The act of reading: A theory of aesthetic response.* Baltimore: Johns Hopkins University Press.

Linker, K. (1984). Representation and sexuality. In B. Wallis (Ed.), *Art aftermodernism: Rethinking representation* (pp. 391-415). New York: The New Museum of Contemporary Art. (Reprinted from *Parachute,* no. 32, Fall 1983, pp. 12-23.)

Mayer, M. M. (2005). A postmodern puzzle: Rewriting the place of the visitor in contemporary art museum education. *Studies in Art Education, 46*(4), 356-368.

McCoy, S. (1989). Docents in art museum education. In Berry, N. and Mayer, S. (Eds.), *Museum education: History, theory, and practice* (pp. 135-153). Reston, VA: The National Art Education Association.

Moxey, K. (1994). The practice of theory: Postsructuralism, cultural politics, and art history. Ithaca and London: Cornell University.

Muhlberger, R. (1985). After art history, what? A personal view of the shaping of art museum education. *The Journal of Aesthetic Education, 19*(2), 93-103.

Newsom, B. Y., & Silver, A. Z. (Eds.). (1978). *The art museum as educator.* Berkeley, CA: University of California.

Nochlin, L. (1971/1988). Why have there been no great women artists? In *Women, art, and power and other essays* (pp.145-178). London: Thames and Hudson. (Reprinted from *Art News, 69,* 1, 23-39, 67-71.)

Piaget, J. (1929). *The child's concept of the world.* London: Routledge and Kegan Paul.

Preziosi, D. (1989). *Rethinking art history: Meditations on a coy science.* New Haven, CT: Yale University.

Rees, A. L., & Borzello, F. (1986). *The new art history.* Atlantic Highlands, NJ: Humanities Press International.

Roberts, L. (1997). *From knowledge to narrative: Educators and the changing museum.* Washington DC: Smithsonian Institution.

Roskill, M. (1976/1989). *What is art history?* Amherst, MA: The University of Massachusetts.

Stapp, C. B. (1984/1992). Defining museum education. In *Patterns in practice* (pp. 112-117). Washington, DC: Museum Education Roundtable. (Reprinted from *Roundtable Reports, 9,* 1, 3-4.)

Sternberg, S. (1989). The art of participation. In N. Berry & S. Mayer, S. (Eds.), *Museum education: History, theory, and practice* (pp. 154-171). Reston, VA: National Art Education Association.

Trend, D. (1992). *Cultural pedagogy: Art/education/politics.* New York: Bergin & Garvey.

Vygotsky, L. S. (1978). *Mind in society: The development of higher psychological processes.* Cambridge, MA: Harvard University.

Visual Understanding in Education (VUE). (n.d.) What is VTS? Part One. Retrieved August 1, 2005, from http://www.vue.org/whatisvts.html

Walsh, A. (Ed.). (1991). *Insights: Museums, visitors, attitudes, expectations: A focus group experiment.* Los Angeles, CA: J. Paul Getty Trust.

Yenawine, P. (2003). Jump starting visual literacy. *Art Education, 56*(1), 6-12.

FOOTNOTES

[1] For a more in-depth presentation of the new art histories, see Harris (2001), Moxey (1994), Preziosi (1989), or Rees & Borzello (1986).

[2] I use the broader term "museum education" here to indicate that developments in art museum education theory in the last quarter of the 20th century and early-21st century often were initiated by scholars and educators of museum education who worked in universities or science museums, botanic gardens, history museum, etc.

Corroborating Knowledge: Curriculum Theory Can Inform Museum Education Practice

Julia Rose
West Baton Rouge Museum, Louisiana

Museums are the stewards of culture and have enjoyed the privilege of authorizing knowledge for centuries. *Curriculum theory* is a discipline committed to theorizing how and why knowledge is constructed and disseminated to learners. Curriculum theory, a subdiscipline of curriculum studies, is concerned with critically looking at educators' choices and actions in designing curriculum (Schwab, 1969). Curriculum is essentially a course of study, a planned collection of objects, words, and knowledge to be used to inform learners. Vallance (1995) contended that educators in museums use curriculum theory in their work in designing educational programs and interpretations. Vallance emphasized that museum educators are charged with shaping a "public curriculum" that is accessible to a broad and unpredictable audience.

The field of museum education is expanding into the realm of curriculum theory. Over the past three decades, curriculum theory has amassed theoretical scholarship that provides museum educators with analytical tools to critically approach museum education practice.

Museum educators are presently facing the challenges posed by postmodern forces that are blurring the distinctions between modernism and popular culture, high art and pluralism, and historicism and memory work (Huyssen, 1986). Hooper-Greenhill (1992), Pitman (1999), and others have contended that museums are more and more focused on giving voice to many experiences and points of view. Which stories do museums choose to interpret? Are museums' traditional interpretation efforts for consensus or objectivity—that is, bridging the disparities among sources of knowledge—or are they fueling personal and political tensions in meaning making?

Museum educators[1] have largely taken an empirical approach in assessing visitors' learning in museums (Falk & Dierking, 2000; Hein, 1998). This approach includes studies based on observing and tabulating visitors' behavior in museum learning settings.

More recently,[2] museum educators have started to look to social and critical theories for guidance in assessing different possible worlds (Roberts, 1997) in shaping a public curriculum.

Museum educators, who are charged with mediating knowledge from exhibitions to the public, now grapple with how knowledge construction relates to power. Chew (2004), a director of a Seattle museum, explained, "As a former journalist, I disdain the myth of objectivity. Museums need to deal with the fact that they are taking a political stand every day with what they present and how they present it" (p. 40). How do museum educators address pluralism, public access, and notions of objectivity? Museum educators are finding that they can improve their practice by analyzing their curriculum choices using ideas from curriculum theory.

Curriculum Theory and Museum Education Run Parallel

Museum education is positioned to embrace theoretical inquiry, a journey already begun by curriculum theorists to address the problems that come with the tremendous responsibilities of developing curriculum (Eisner & Vallance, 1974; Schwab, 1969). Critically thinking about how knowledge is constructed and including these ideas from curriculum theory can inform

museum educators' decisions on how to interpret objects and exhibitions. Curriculum theorist Banks (1995) explained that learners and educators who develop an understanding of how knowledge is constructed and how it relates to power will have the skills to construct knowledge in ways that can help the nation achieve its democratic ideals.

After two decades of enduring the dominance of Tyler's (1949) rationale for curriculum design, Schwab (1969) declared, in what sounds like utter frustration, "The field of curriculum is moribund, unable by its present methods and principles to continue work and desperately in search of new and more effective principles and methods" (p. 1). Schwab's declaration did not go unanswered. In the early 1970s, Eisner (Eisner & Vallance, 1974), Pinar (1975), Greene (1975), and Mann (1974) reinvigorated the theoretical component of curriculum studies.

Curriculum theory has called subsequent generations of its provocative thinkers who were compelled by the sociohistorical context of their times to reconceptualize curriculum theories' ideas (Pinar, 1975). Curriculum theorists have broadened the field, incorporating ideas from social and literary criticism, psychoanalysis, anthropology, aesthetics, and philosophy.

Curriculum theorists contend that one single theory cannot account for all the ways people know about the world (Pinar, Reynolds, Slattery, & Taubman, 1995). What can and should be taught to whom, when, and how depends largely on the ways these questions are posed and the assumptions behind them (Eisner & Vallance, 1974).

The privilege of choosing includes the responsibility of defending choices for new practices (Schwab, 1969). The art of making defensible choices can be grounded in theory when we recognize that knowledge touches individuals' lives in personal and political ways. The democratic responsibilities in choosing and shaping curriculum hark back to the early 20th-century educational progressives such as John Dewey and Jane Addams.

Education, a complex web of social and psychological interactions representing different values and epistemologies, affects individual learners in different ways. How are issues about class, race, religion, age, or gender, for example, addressed by a particular curriculum design? Democratic curriculum concerns for social justice, especially those regarding the obligation to respond to individual learners and for providing equitable access to education, are parallel concerns in curriculum theory and museum education.

In the 1970s, the curriculum field transitioned, shifting from a practical interest in developing curriculum to a theoretical and practical interest in *understanding* curriculum (Pinar, et al., 1995). Ethics, notions of democratic education, and concerns for

increasing public access to knowledge became fresh priorities in the field of curriculum studies, referred to as curriculum theory.

Increasingly, museum educators are following a similar path traversed by curriculum theorists to transform and expand theoretical groundwork toward humanistic, affective, and personalized education. Rice (2000) has encouraged museum educators to pursue theorizing the field. She explained that museum education has traditionally been engaged with practice, and colleagues in academic settings contend that theories are useful not only to justify practice, but also to reform, improve, and invigorate practice.

Rice echoed her contemporaries in curriculum theory who maintain that theory invigorates thought (Pinar, et al., 1995). Museum educators, wanting to stay current, have responded with an optimistic vision for providing a public curriculum.

Silverman (2000) argued that the paradigm of meaning making opens the door for museum workers to consider desperately needed expansion into theory. Munley (1999) contended that museum education must break with tradition and develop new approaches to program development that reflects museums' larger, diverse audiences and an expanded understanding of learning. Munley went on to say that museums, as public forums, community centers, and provocateurs for new knowledge, have the opportunity to address important societal issues.[3]

Museum educators grapple with curriculum in choosing what and how knowledge is presented. Williams (1999) offered an excellent example of a museum educator's curriculum dilemma: "My job, along with other staff, was to come up with an installation that would help visitors have personally meaningful experiences with these objects. Should I concentrate on the archaeological discovery of the objects, their aesthetic qualities, or the miracle of how they came into being? ... I kept thinking of connoisseurship and context in opposing tracks" (p. 63).

My experiences as a museum educator in American history museums have left me in the same curriculum quandary described by Williams. In the role of museum educator, I am entrusted to design a program, tours, and other tools to help people interpret an exhibit or object. What checks and balances are in place to ensure that my relationship to these objects is meaningful to other museum workers and visitors? How do museum educators, in the process of sharing knowledge, critically approach interpreting an exhibit's personal, ethical, and political issues?

Museum educators' primary responsibility is to provide visitors equal access to museum exhibitions and programs. In 1992, the American Association for Museums released a landmark report, *Excellence and Equity: Education and the Public Dimension in Museums*, which assessed the role of education in museums (Hirzy, 1992). The report outlined the central role museums play as educational institutions and highlighted museums' responsibilities to provide public service and leadership. More than 15 years later, museum educators continue to refer to this publication as a cornerstone to their educational philosophy and approach to programs and interpretation practices. This is an historic example of curriculum theory issues being embraced and articulated by museum educators.

Vallance (1995) coined the term "public curriculum" to mean curriculum developed for visitors' museum learning. Public curriculum design must take into account the museum's democratic mission where "public," according to Williams (1999), means the broadest possible spectrum of people in their communities. And "access" means visitors' physical and intellectual connections to artifacts, exhibitions, museum objects, and spaces. More than facilitating programs and tours, museum educators must determine what constitutes an equitable and meaningful museum experience. Roberts (1997) contended that the tasks for museum educators appear to go beyond interpreting objects and includes deciphering interpretations.

Museum education is positioned as the social conscience of the museum by reflecting on how knowledge is produced and disseminated. Museum educators have a toe in the murky pond of critical and social theory, willing yet tentative about how to dive into the work of disrupting meanings, challenging values, invigorating debate, and contending with conflict.

Curriculum Theory Informs Museum Education

In this section, I discuss two examples to illustrate the ties between curriculum theorists and museum educators. First, I briefly describe the issues surrounding the hotly contested contemporary art exhibition *Sensation: Young British Artists from the Saatchi Collection* that opened in 1999 at the Brooklyn Museum of Art (BMA) in New York. Second, I examine two articles from the *Journal of Museum Education* that investigate the notion of curriculum in the context of museum education.

The *Sensation* exhibition debate induced what modern art does best: reflects and stimulates the breakdown of norms to generate dialogues. The swell of conflict, in this instance, almost exceeded the realm of healthy debate and nearly closed the exhibition. The differing valuations of the art objects ignited the debates, but the extraordinary point of conflict centered on who had the power to determine what should be shown and how it should be interpreted in a publicly held museum.

Months before its scheduled U.S. debut, the press (with information from BMA staff) was promoting *Sensation* as an outrageous show intended to rouse social complacency. BMA Director Arnold Lehman said to the *New York Times*, "I like to think New Yorkers are incredibly sophisticated and believe, like I do, that they should be exposed to works that are emotionally engaging and ones that make us think" (Vogel, 1999).

Sensation, which ran from October 1999 to January 2000, was the largest exhibition in BMA's 102-year history. The 110 pieces were mostly collected during the 1990s by the British advertising mogul Charles Saatchi. *Sensation* first opened in London in 1997 to tremendous crowds, followed by an opening in Berlin, and then in New York at the BMA. The National Gallery of Australia rescinded an earlier decision to present the show (Rosenthal, 1998).

The exhibition featured the work of 44 young British artists. The social themes in the paintings, photographs, sculptures, textiles, and multimedia works of art explored sexual identity, feminism, religious identity, and social criticism. The works of art that received the most critical publicity included Marc Quinn's *Self* (1991), which was a sculpture of a human head made of frozen blood; Damien Hirst's *The Physical Impossibility of Death in the Mind of Someone Living* (1991), which consisted of a large glass and steel tank containing a dead tiger shark floating in a solution of 5% formaldehyde; and Chris Ofili's *The Holy Virgin Mary* (1996), which was one of the exhibition's five Ofili paintings made of similar materials, including paper collage, oil paint, glitter, polyester resin, map pins, and elephant dung on linen.

Art critic Rosenthal (1998) explained that the *Sensation* artists used serious and humorous metaphors to capture a new and radical attitude to realism that mirrored contemporary problems. Kimball (1999) contended the art works were intended to disturb and outrage viewers. Supporters of *Sensation* argued that "it has always been the job of artists to conquer territory that hitherto has been taboo" (Rosenthal, 1998, p. 11).

Preview descriptions of the pieces so disturbed viewers that word about *Sensation* reached New York City Hall. Mayor Rudolph Giuliani responded to descriptions of the *Sensation* artworks with demands to prevent the show from opening and threatened to withdraw city funds from BMA. Mayor Giuliani argued that public funds should not be used to support offensive and blasphemous work. After 6 months of litigation, the courts found the museum would continue receiving city support and the museum was entitled to exhibit *Sensation* under the First Amendment guarantee for the freedom of expression.

Some viewers became upset when confronting the artists' renderings of social critique; consequently, the museum's funding was put at risk. Many offended viewers and artists were vocal in their dismay. Exhibition supporters contended that by closing the show, the city government would acquiesce to those individuals offended by the artworks that challenged their beliefs and their valued traditions, thereby silencing the artists' attempts at social criticism. When art changes from a venue for dialogue to a stage for vested interests (Rosenthal, 1998), museum workers must ask themselves who is to benefit from such exhibitions.

Rothfield (2001) explained that controversial art can encourage healthy debate, and dissent can raise issues that need to be addressed. However, personal outrage in confronting art can incite a learning crisis that forces individuals to deal with "difficult knowledge" (Britzman, 1998). Bhabha (2001) contended that the BMA controversy connected us as a community in need of discussions and exchanges about the "kind of wounding" (p. 94) the art incited.

The New York City mayor and his supporters, in trying to remove the offensive images, were merely avoiding the social crises the artists had brought into view. Shutting down intellectual debate would have created an unbalanced account of the diverse audiences the museum serves. Britzman (1991) explained that while silences can be imposed in educational settings, social crises are not immutable. The struggle for voice, according to Britzman, is implicitly a political one marked by power struggles of resistance and domination.

In the context of designing school curriculum, Mann (1974) reflected on the power dynamic in curriculum design. He explained that both the practice and the sociopolitical process of making curriculum choices is a crucial part of the educative experience and, in this way, choice is power in motion. The transformation of the museum from sanctum to forum forces museum workers, especially educators, to reassess their roles as cultural stewards. At the same time, many museum workers vigorously retain the privileged responsibility of authorizing knowledge, which has been their enterprise for over two centuries. Even though museum workers have long held authority to produce knowledge, they need to recognize that their acts of choosing content and shaping interpretations influence museum curriculum.

Quinn and Roberts (2004), in a literature review of museum education, found that while museum theorists and practitioners commonly address relationships between cultural institutions and communities, little attention is given to the kinds of critical analyses important to curriculum studies. When curriculum theory is more ardently applied to current museum education practice, I predict intellectual floodgates will open for museum workers who are presently searching for analytical tools.

Chance Meetings? Curriculum Theory Used in Museum Education

The museum education literature came onto the scholarly scene in the 1970s—around the same time that curriculum studies turned toward social and critical theories as part of the field's reconceptualization. Beer (1987/1992) argued that museum curriculum is not comparable to school curriculum, saying that either we unfavorably compare museum curriculum to school curriculum or we declare that museum curriculum looks like the "real thing"—that is, school curriculum. Beer made an effort to disassociate curriculum in museums from the mechanistic use of the word "curriculum" she saw in schools. She apparently had the same discomfort with the word that early curriculum theorist Harold Rugg had when he wrote curriculum is "an ugly and academic word" (quoted in Jackson, 1992, p. 4).

In contrast to AAM's findings in *Excellence and Equity* (Hirzy, 1992), which explain the paramount role education plays in developing relationships among visitors and museums, Beer (1987/1992) found a disconnect between the museum staff's curriculum design and the visitors' museum experiences. Beer wondered if the museum workers' curriculum choices truly targeted the museum's audiences. More recently, however, I find that museum educators resolutely contend that they have specific objectives for interpreting exhibitions that are intended to engage visitors in reflective meaning making and conversations (Henderson & Kaeppler, 1997; MacDonald & Fyfe, 1996). Beer (1987/1992) compared the goals of museum curricula to those of school curricula when she wrote, "Museum staff want visitors to enjoy themselves and appreciate the collection—two goals that teachers and students probably do not hold for schools" (p. 210).[4] Beer's writing demonstrates the limited parameters museum educators were working within when the museum education field restricted itself to an insular practice.

Vallance (2003) has contended that curriculum is a familiar word that offers museum workers a language to describe education in museums. She described museum curriculum as both a "public curriculum" (see also Vallance, 1995) designed by museum workers and as "an experience curriculum" that is constructed by visitors who interact with the museum setting. Vallance (2003) cited Schwab's (1973) school curriculum model as a way to analyze curriculum in museums and as a way to describe museum learning experiences. The model has four elements: subject matter, milieu or educational setting, teachers, and learners.

Vallance (2003) explained that museums employ a silent pedagogy that guides visitors' choices. The task for museum educators is to capitalize on the many possibilities that emerge when visitors see the milieu, which may present alternative narratives for consideration. Vallance asserted that museums hold an explicit curriculum regarding collections and a tacit curriculum embedded in the museum's milieu that informs visitors. In this way, museum workers are positioned as a unified authoritative voice in the learning environment. Vallance found that the curricular process of knowledge construction in museums has not been made available to visitors and, as a result, the curriculum content displayed in the galleries may seem to be presented as received truth.

Museum education, traditionally a field for practitioners, is expanding to include critical analysis and theorizing practice. Curriculum theorists no longer see the problems of developing curriculum and teaching as technical problems, that is, problems of "how to" teach or interpret knowledge. The contemporary curriculum field regards the problems of curriculum and teaching as "why" problems (Pinar, et al., 1995)—*why* are particular views or content selected for a particular curriculum?

Curriculum theory demands deliberation and critical analysis about ethics, accessibility, accountability, and power within curriculum design. The movement toward more responsible cultural stewardship will help uncover and articulate social forces that control the museum milieu that will, in turn, guide visitors' choices. To justify their interpretation choices, today's museum educators must be more reflective and critical than their predecessors.

Intersections Between Museum Education and Curriculum Theory

The following five subsections illustrate key theoretical concerns shared by museum educators and curriculum theorists.

Analysis of Knowledge Production

Like curriculum theorists before them, museum educators are recognizing knowledge as a productive endeavor and are asking more politically minded questions to make museum exhibitions available to broader audiences. Rice (1999) explained that instead of merely presenting an institutional perspective to visitors, educators attempt to navigate between the museum's construction and the visitors' ways of knowing.

The social forces that work to legitimate knowledge as truth in museums and schools are vulnerable to inspection. Foucault (1977) explained, "Each discursive practice implies a play of prescriptions of its exclusions and choices" (p. 199). Peshkin (1992) referred to curriculum designers as cultural agents who encourage social change or maintain the status quo by promoting certain aspects of a particular cultural orientation in an educational activity. The exhibition *Sensation* was intended to inspire conversations about social change, but the message incited a learning crisis for viewers that nearly silenced productive conversations.

Adherence to a Democratic Ideal for Equal Access and Representation

Intellectual and physical access to knowledge has become central to the task of designing curricula in museums and schools. Museum educators and curriculum theorists share the challenge of social reform. Educators in both fields recognize that selected knowledge serves the interests of the curriculum designers. They are more likely to question the powers embedded in "radically posed" knowledge[5] in order to effectively open exhibitions and classrooms to the communities they serve. In *Sensation*, the BMA museum workers were expressing their interests in displaying the artworks' social commentary and rousing social complacency. Although the museum staff considered multiple voices in interpreting the art collection, the New York City government was forced by the courts to allow the art museum to fulfill its traditional role of giving a forum to new artworks.[6]

The Art and Act of Choosing

Choosing knowledge in designing curriculum for museums and schools is a discursive art form used to construct interpretations (explanatory methods, materials, and texts). Interpretation involves selecting from possible representations organized by aesthetic, political, and institutional judgments aimed at satisfying the curriculum designer's desire for a good fit (Peshkin, 1992).

Curriculum is composed of artistic innovations used for choosing objects and scripting interpretations. Eisner (2002) considered curriculum design to be an art form that is open to critique. Vallance (1991) described ways curriculum manifests as an art form. She argued that curriculum and art are: (1) products of human construction; (2) a means of communication; (3) a transformation of knowledge; (4) products of problem solving; (5) dependent on audience response.

Curriculum as Text

Museum education and curriculum theory are both "word worlds," to use a term by Grumet (1999), that are analogous to the literary role of interpretation in writing and criticizing texts. Roberts (1997) argued that museum interpretations are expressed through narratives poised as texts. Her notion of knowledge as narrative mirrors curriculum theorists' description of curriculum as symbolic representations of discursive practices (Pinar, et al. 1995). Conceiving of curriculum as text further opens museum and school curricula to analysis and criticism, where knowledge is no longer a certainty but open to possibilities.

Ethics of Representation, Interpretation, and Engagement

Museum workers Yeingst and Bunch (1997) warned that curators are given the power of choice and the power to convey meaning— power that should be used judiciously and openly. Theorists continue to critically assess the outcomes of *Sensation*, analyzing whether harm was inflected or avoided in the exhibition (Lewis & Brooks, 2005; Rothfield, 2001).

In reference to curriculum theory, Greene (1971) explained that the work of curriculum development is one of disclosure, reconstruction, and generation. Roberts (1997) emphasized the curricular obligations of museum interpretation. These include the responsibilities to clarify the basis and criteria for their interpretations. The "ethics of interpretation" refers not just to the presence of interests and values in museum activities, but also to a museum's responsibility to acknowledge its role in and assumptions behind the messages it does not include. Educators are responsible for recognizing that museums present *an* interpretation, not *the* interpretation.

Today, museum workers and visitors are more often challenging the exclusions and inclusions within museum curriculum. Curriculum theory offers museum educators a growing collection of theories and rhetoric to critically analyze and theorize the work of public curriculum design.

Disconnections Between Museum Education and Curriculum Theory

A clear disconnect between museum education and curriculum theory is the museum educators' reluctance to apply the word "curriculum" to their work. Roberts (1997) never used "curriculum" in her book on museum interpretation. Beer (1987/1992) regretted the need for applying the word to theorize museum education. In addition, there are no listings for curriculum in any of the indexes in the three anthologies of the *Journal of Museum Education* (Hirsch & Silverman, 2000; Museum Education Roundtable, 1992; Nichols, 1984). The word "curriculum" is not presently part of museum educators' working vocabulary.

Another disconnect is the conflicting types of elitism in the fields. Informal education in museum settings is often disdained by school educators as being supplemental to classroom learning. On the other hand, formalism in school learning is knocked by museum educators as being mechanistic, distant from learners' lived experiences, and a venue for cursory exposure to content.

A third disconnect is the lack of doctoral programs in museum education in the United States. A doctoral program in museum education would demand extensive research that would engage scholars in interdisciplinary investigations—further bonding curriculum theorists and museum educators in their shared journey into understanding curriculum.

Concluding Remarks

Approaching museum education through the discourse of curriculum theory pushes museum education beyond the expert-novice dichotomy to challenge ways museums voice authority, improve accessibility, and prompt ethical responses to collections and visitors. MacDonald (1996) asserted that theoretical developments are needed to tackle broad questions about the changing nature of museums, the specific content of museum exhibits, and visitors' narratives. Curriculum theory has amassed scholarship that can provide museum educators with analytical tools to scrutinize museum interpretations and to critically approach museums' public curriculum.

REFERENCES

American Association of Museums. (2005, May). Russian museum staff convicted in hatred charge. *Aviso, 31*(5), 1 & 6.

Banks, J. A. (1995). The historical reconstruction of knowledge about race: Implications for transformative teaching. *Educational Researcher, 24,* 5-25.

Beer, V. (1987/1992). Do museums have curriculum? In Museum Education Roundtable, (Ed.), *Patterns in practice: Selections from the Journal of Museum Education* (pp. 209-214). Washington, DC: Museum Education Roundtable.

Bhabha, H. K. (2001). The subjunctive mood of art. In L. Rothfield (Ed.), *Unsettling "Sensation": Arts-policy lessons from the Brooklyn Museum of Art* (pp. 93-95). New Brunswick, NJ: Rutgers University.

Britzman, D. P. (1991). *Practice makes practice: A critical study of learning to teach.* Albany, NY: State University of New York.

Britzman, D. P. (1998). *Lost subjects, contest objects: Toward a psychoanalytic inquiry of learning.* Albany, NY: State University of New York.

Chew, R. (2004). Taking action! *Museum News, 83,* pp. 39-41.

Eisner, E. W. (2002). *The educational imagination: On the design and evaluation of school programs* (3rd ed.). Upper Saddle River, NJ: Merrill Prentice Hall.

Eisner, E. W., & Vallance, E. (1974). *Conflicting conceptions of curriculum.* Berkeley, CA: McCutchan.

Falk, J. H., & Dierking, L. D. (2000). *Learning from museums: Visitor experiences and the making of meaning.* Walnut Creek, CA: AltaMira Press.

Foucault, M. (1977). *Language, counter-memory, practice: Selected essays and interviews by Michel Foucault.* Ithaca, NY: Cornell University.

Goodlad, J. I., Klein, F., & Tye, K. (1979). *Curriculum inquiry.* New York: McGraw Hill.

Greene, M. (1971). Curriculum and consciousness. *Teachers College Record, 73,* 256-269.

Greene, M. (1975). Curriculum and consciousness. In W. Pinar (Ed.), *Curriculum theorizing: The reconceptualists* (Rev. ed. 2000) (pp. 299-317). Berkeley, CA: McCutchan.

Grumet, M. R. (1999). Word worlds: The literary reference for curriculum criticism. In W. Pinar (Ed.), *Contemporary curriculum discourses: Twenty years of JCT* (pp. 233-245). New York: Peter Lang.

Hein, G. E. (1998). *Learning in the museum.* London: Routledge.

Hein, G. E. (2005). The role of museums in society: Education and social action. *Curator, 40*(4), 357-363.

Henderson, A., & Kaeppler, A. L. (Eds.). (1997). *Exhibiting dilemmas: Issues of representation at the Smithsonian.* Washington, DC: Smithsonian Institution.

Hirzy, E. C. (Ed.). (1992). *Excellence and equity: Education and the public dimension of museums.* Washington, DC: American Association of Museums.

Hirsch, J. S., & Silverman, L. H. (Eds.) (2000). *Transforming practice: Selections from the Journal of Museum Education 1992-1999.* Washington, DC: Museum Education Roundtable.

Hooper-Greenhill, E. (1992). *Museums and the shaping of knowledge.* New York: Routledge.

Huyssen, A. (1986). *After the great divide: Modernism, mass culture, postmodernism.* Bloomington, IN: Indiana University.

Jackson, P. (1992). *Handbook of research on curriculum: A project of the American Educational Research Association.* New York: Macmillan.

Kimball, R. (1999). The elephant in the gallery, or the lessons of 'Sensation.' *New Criterion, 18,* 4-5.

Lewis, G. B., & Brooks, A. C. (2005). A question of morality: Artists values and public funding for the arts. *Public Administration Review, 65,* 8-17.

MacDonald, S. (1996). Theorizing museums: An introduction. In S. MacDonald & G. Fyfe (Eds.), *Theorizing museums: Representing identity and diversity in a changing world* (pp. 1-20). Oxford, UK: Blackwell.

MacDonald, S., & Fyfe, G. (1996). *Theorizing museums: Representing identity and diversity in a changing world.* Oxford, UK: Blackwell.

Mann, J. S. (1974). Political power the high school curriculum. In E. W. Eisner & E. Vallance (Eds.), *Conflicting conceptions of curriculum* (pp. 147-153). Berkeley, CA: McCutchan.

Munley, M. E. (1999). Is there method in our madness? Improvisation in the practice of museum education. In B. Pitman (Ed.), *Presence of mind: Museums and the spirit of learning* (pp. 133-140). Washington, DC: American Association of Museums.

Museum Education Roundtable. (1992). *Patterns in Practice: Selections from the Journal of Museum Education.* Washington, DC: Museum Education Roundtable.

Nichols, S. K. (Ed.). (1984). *Museum education anthology 1973-1983: Perspectives on informal learning a decade of Roundtable Reports.* Washington, DC: Museum Education Roundtable.

Peshkin, A. (1992). The relationship between culture and curriculum. In P. Jackson (Ed.), *Handbook of research on curriculum* (pp. 248-267). New York: Macmillan.

Pinar, W. F. (Ed.) (1975). *Curriculum studies: The reconceptualization* (Rev. ed. 2000). Troy, NY: International Educators.

Pinar, W. F., Reynolds, W. M., Slattery, P., & Taubman, P. M. (1995). *Understanding curriculum.* New York: Peter Lang.

Pitman, B. (1999). Places for exploration and memories. In B. Pitman (Ed.), *Presence of mind: Museums and the spirit of learning* (pp. 21-30). Washington, DC: American Association of Museums.

Quinn, T., & Roberts, P. A. (2004). *The buying and selling of museums, or why we need a critical museum studies.* Paper presented at the meeting of the American Association for the Advancement of Curriculum Studies, San Diego, CA.

Rice, D. (1999). In B. Pitman (Ed.), *Presence of mind: Museums and the spirit of learning.* Washington, DC: American Association of Museums.

Rice, D. (2000). Constructing informed practice. In J. Hirsch & L. Silverman (Eds.), *Transforming practice: Selections from the Journal of Museum Education 1992-1999* (pp. 222-225). Washington, DC: Museum Education Roundtable.

Roberts, L. (1997). *From knowledge to narrative: Educators and the changing museum.* Washington, DC: Smithsonian Institution.

Rose, J. (Ed.). (2006). Expanding conversations: How curriculum theory can inform museum education practice. *Journal of Museum Education, 31*(2).

Rosenthal, N. (1998). The blood must flow. In B. Adams & N. Rosenthal (Eds.), *Sensation: Young British Artists from the Saatchi collection* (pp. 8-12). London: Thames and Hudson with the Royal Academy of Arts.

Rothfield, L. (Ed.). (2001). *Unsettling "Sensation": Arts policy from the Brooklyn Museum of Art controversy.* New Brunswick, NJ: Rutgers University.

Schwab, J. J. (1969). The practical: A language for curriculum. *School Review, 78,* 1-23.

Schwab, J. J. (1973). The practical 3: Translation into curriculum. *School Review, 81,* 501-522.

Silverman, L. H. (2000). Making meaning together: Lessons from the field of American history. In J. Hirsch & L. Silverman (Eds.), *Transforming practice: Selections from the Journal of Museum Education 1992-1999* (pp. 230-239). Washington, DC: Museum Education Roundtable.

Tyler, R. W. (1949). *Basic principles of curriculum and instruction* (Rev. ed. 1969). Chicago: University of Chicago.

Vallance (1991). Aesthetic inquiry: Art criticism. In E. Short (Ed.), *Forms of curriculum inquiry* (pp. 155-172). Albany, NY: State University of New York.

Vallance, E. (1995). The public curriculum of orderly images. *Educational Researcher, 24,* 4-13.

Vallance, E. (2003). A curriculum-theory model of the art museum milieu as teacher. *Journal of Museum Education, 28,* 8-16.

Vogel, C. (1999). Outrageous show of YBAs heads to Brooklyn Museum. *New York Times, 8 April.* Retrieved February 1, 2005, from http://www.nytimes.com.

Williams, P. (1999). Critical issues for making art museums effective educational institutions. In B. Pitman (Ed.), *Presence of mind: Museums and the spirit of learning* (pp. 61-70). Washington, DC: American Association of Museums.

Yeingst, W., & Bunch, L.G. (1997). Curating the recent past: The Woolworth lunch counter, Greensboro, North Carolina. In A. Henderson & A. Kaeppler (Eds.), *Exhibiting dilemmas: Issues of representation at the Smithsonian* (pp. 143-155). Washington, DC: Smithsonian Institution Press.

FOOTNOTES

[1] A few academics are encouraging museum educators to engage in critical pedagogy (e.g., Hooper-Greenhill, 1992; Quinn & Roberts, 2004).

[2] See Rose, J. (Ed.). (2006). Expanding conversations: How curriculum theory can inform museum education practice. *Journal of Museum Education,* 31/2.

[3] Museum educators' long-running affinity with the notion of a constructivist museum has limited discussions of other theoretical positions.

Hein (1998), for example, supported constructivism as the overarching theory for learning in museums, a position that focuses on visitors' relationships to museum exhibitions. Museum education can be more critically considered, beyond *how* people learn in museums, by asking *what* people are exposed to in museums and *why* particular artifacts are interpreted and used to represent certain knowledge. Hein (2005) recently expanded his work into curriculum theory.

[4] Beer (1987/1992) referred to Goodlad, Klein, and Tye (1979) for a curriculum model.

[5] Foucault (1977) asserted that, "selfish interest is radically posed as coming before knowledge, which it subordinates to its needs as a simple instrument; (the) original connection (of knowledge) to truth is undone once truth becomes merely an effect ..." (p. 203).

[6] A similar suit against a museum showing a contentious art exhibition in Russia was recently settled with different results (American Association of Museums, 2005). In March 2005, a Moscow court convicted a museum director and a curator for inciting religious hatred for organizing *Caution! Religion*, which included religious symbols and popular culture imagery to comment on present Russian society.

A Summary of U.S. Museum Policy From 1960 to the Present

Betty Lou Williams
University of Hawaii at Manoa

Since their inception in the late 19th century, U.S. museums have overtly or covertly defined education as a central goal in their statements of purpose (Cherry; 1992; Zeller, 1989). However, the educational motivations of American museums have often been subtle and pursued in informal ways. Historically, the central preoccupation of U.S. museums has been more closely related to their function as repositories of culture than to educating the masses. Education, as applied to museum aims and operations, has frequently been regarded as an ambiguous concept by museum directors and educators. In reality, the dominant philosophies of museums can most often be detected by their operations and programs, rather than by their written treaties and policy statements (Eisner & Dobbs, 1986).

Throughout the history of American museums, the term "education" has meant different things. In the late 19th century, U.S. museums believed that their educational mission was to serve the needs of industry, history, and scientific inquiry and to provide enculturation and aesthetic appreciation. During the first half of the 20th century, goals expanded to include moral uplift, the interdisciplinary humanities, social reform, creative expression, cultural history, and patriotism, along with other educational philosophies that reflected the concerns of society throughout the decades. In conjunction with these educational objectives, museums have attempted to establish strong ties with academic institutions including libraries, schools, colleges, and universities, as well as other civic or public organizations. U.S. museums have not only catered to the social and economic forces that have shaped the 20th century, but also have tried to comply with dominant concurrent movements in general education (Zeller, 1989). The most significant era for policy development affecting museums has been from the 1960s to the present. A chronology of the major events and documents from the period follows.

The Climate of Museums During the 1960s and 1970s

By the 1960s, in the aftermath of the Cold War, divisions of power in U.S. society had resulted in a climate of controversy. During this period of political, economic, and social reform, museums, along with other public and private institutions, were accused of being deliberate perpetrators of Euro-Western culture, promoting oppression and misinformation, alienating minority involvement, as well as omitting accurate representations of cultural diversity (Zeller, 1989). The U.S. public called on museums to include individuals, topics, themes, and cultural traditions formerly omitted from the dominant canon. During the 1960s, museums were also scrutinized by public and private funding sources that offered support only if museums could demonstrate social concern (Newsom & Silver, 1978).

Museums were forced to redefine their relationships and obligations to the public (American Association of Museums, 1984). In response, museums began to recruit formerly marginalized audiences, including minorities, persons with disabilities, the elderly, the incarcerated, and the poor; increase minority representation through exhibitions; and expand and diversify educational services to provide greater outreach opportunities for the public. During the 1960s and 1970s, numerous museums

developed mobile facilities, neighborhood galleries, senior citizen projects, and other civic-oriented educational programs (Newsom & Silver, 1978). In conjunction with these efforts, the National Endowment for the Arts (NEA) funded numerous community-based museum projects to serve both lower socioeconomic strata and under-represented segments of society.

In the 1960s and 1970s, there was demographic redistribution in the United States that resulted in the rapid expansion of suburbia while the inner cities became mostly inhabited by low-income and minority populations. (Most U.S. museums have historically been located in the inner cities.) By the 1970s, the involvement of previously marginalized groups had significantly increased in museums. This change was largely attributed to the many grassroots minority movements in urban areas at that time and museums' active pursuit of audiences previously ignored (Newsom & Silver, 1978).

By the 1960s and '70s, the role of the museum educator was that of public communicator, distinguished from the curator who was the content expert. During this two-decade period, departments of museum education were established to organize programs to promote curatorial information through tours, lectures, and other activities primarily intended for elementary school groups. Educational programs and services for non-school-affiliated individuals or adult visitors were not commonly available (Newsom & Silver, 1978).

Major Policies and Publications Affecting U.S. Museums From 1960 to the Present

Several noteworthy publications have influenced museum education missions, policy, and tactics during the past four decades. The first of these, *America's Museums: The Belmont Report* (Robbins, 1969), was commissioned by the federal government and published by the American Association of Museums (AAM). *The Belmont Report* was tied to the Tax Reform Act of 1969 that enabled government support for public institutions whose mission was declared as educational. This historical event provided a financial incentive for museums to turn their attention to educational pursuits through changes in policy and practice to secure much-needed government funding (Zeller, 1989). However, throughout the contents of *The Belmont Report*, definitions and references to the use of the word "education" remained unclear (Robbins, 1969).

In 1978, the Council on Museums and Education in the Visual Arts, sponsored by the Edward John Noble Foundation, the National Endowment for the Arts, and the Rockefeller Brothers Fund, published *The Art Museum as Educator* (Newsom & Silver, 1978), documenting 103 diverse and innovative programs and services at 71 U.S. art museums. While not designed as a prescription for education in museums, the publication served as a resource guide for program and policy development for education departments in art museums and other types of museums. Although the publication was intended to increase the status of education within the museum profession, the Council concluded that museum education had two

fundamental shortcomings: an absence of research and a lack of consistent academic preparation for practitioners. The Council stated that, "Each generation seems to start over again, repeating rather than building on the mistakes and successes of the past" (p. 3).

The Climate of Museums During the 1980s

Throughout the 1980s, the federal budget for the arts, education, and the humanities was drastically reduced, which resulted in a decrease of government funding for U.S. museums. In response, museums had to increasingly compete for public money with other special-interest groups while simultaneously being faced with the challenges of increased national and international art market values, higher operational and exhibition expenses, escalating insurance fees, changes in the tax laws regarding donations, and staff shortages from decreasing budgets and a shrinking volunteer work force. During this period of economic hardship, U.S. museums responded in two ways: They came to rely on both private and public funds consisting of a combination of government funding, corporate sponsorship, private support, business subsidies, grants, endowments, and earned revenue; and they turned their attention from adding to their collections to increasing educational services and programs for the public—and placing greater emphasis on their permanent collections (Zeller, 1989).

Several other important changes in museums took place during the 1980s. There was an increased awareness among museum professionals of their civic responsibilities. Museums had created a strong sense of pride in their communities, attracting businesses and investments, as well as increasing tourism and cultural diversion. In addition, older systems of hierarchical management in the United States were gradually replaced by group or consensus-based decision-making. This change in managerial style affected museums, making possible a system of networking that encouraged collaboration and partnership between for-profit and nonprofit organizations. In addition, a reform movement in education culminated during the 1980s, emphasizing criteria-based standards, competency, testing, and demonstration of academic achievement levels in U.S. public schools. Between 1983 and 1984, several reports called for a revision of educational standards in U.S. schooling, including: *A Nation at Risk* (1983), published by the National Commission on Excellence in Education, that detailed the deficiencies of U.S. schools; *High School* (Boyer, 1983), published by the Carnegie Foundation for the Advancement of Teaching, that described the deterioration of our nation's high schools; and *Educating Americans for the 21st Century* (1984), sponsored by the National Science Board Commission, that assessed math and science competencies and proposed the involvement of museums in the active reform of these subjects through informal learning opportunities (AAM, 1984).

The educational reform movement significantly affected the role of education in museums. By the 1980s, a period of reassessment in museum education was fully under way. As an outgrowth of *The Belmont Report* (Robbins, 1969), the AAM appointed the Commission of Museums for a New Century, to examine how sociopolitical factors, demographics, and economics could influence the future of museums. In addition, the Commission looked at the priorities and functions of museums and reevaluated their obligations and options. The Commission recommended, in *Museums for a New Century: A Report of the Commission of Museums for a New Century* (AAM, 1984), that education become mandated as the overt mission of museums. The Commission emphasized the need for research on teaching and learning in museums and the critical importance of building museum-school partnerships. The publication included an assessment of U.S. museums' relationships to the community and society, an evaluation of existing policies and operations, and a prognosis. *Museums for a New Century* addressed the restructuring of the roles and responsibilities of museum educators, the changing educational objectives in museums, and the importance of policy to support these educational measures.

Two dominant themes emerged in the report: a pronounced commitment to education as the primary mission of museums and museums' obligation to serve and meet the needs of the general public (AAM, 1984). The Commission outlined seven topics and 16 recommendations for museums, based on these themes:

- The growth, organization, and care of collections
- The potential for educational commitment
- The restructuring of systems of governance
- The need for greater understanding of the benefits of museums
- A desire for greater diversity among patrons and staff
- The absence of a professional profile
- The need to cope with economic challenges facing museums

The Climate of Museums During the 1990s

Beginning in the 1980s but continuing to the present, museums have concentrated on teacher training, greater civic involvement through community service, the use of technology and distance learning, as well as more in-service professional development for museum educators. Museums were—and still are—in critical need of both public and private funding because of limited financial support from government, public, and corporate sources; competition for financial support among special interest groups; and the need to attract even broader audiences. Although the assets of major collections were astronomical in

value, operational funds in most cases were barely sufficient to maintain proper conservation, storage, exhibitions, and research efforts, and to provide educational services for the public. A number of U.S. museums, including the Brooklyn Museum and the Metropolitan Museum of Art, have closed galleries, reduced staff, shortened operation hours, cut back on educational amenities, and postponed maintenance and conservation endeavors. Spurred by these realities, museums further reassessed their identity, purpose, and self-scrutiny (Williams, 1994).

The methodological approach of U.S. museums shifted from a position where the objects assumed the greatest priority to an approach involving a contextual examination of artifacts in relation to their origin and culture, incorporating a variety of contrasting perspectives and methods of inquiry. In addition, museums acknowledged the viewer's response, personal narrative, feedback, and involvement as significant components of the museum's commitment to public service (Roberts, 1997).

As a follow-up to *Museums for a New Century* (1984), in 1992 the AAM published a landmark document entitled *Excellence and Equity: Education and the Public Dimension of Museums* (Hirzy, 1992). This report was developed by an AAM task force that examined the educational role of museums and proposed strategies for furthering museums' educational mission. The publication represented the AAM's most aggressive effort to advance the educational mission of museums. The term "excellence" signified an expectation for improved standards of scholarship, and the term "equity" underscored

an emphasis on the recruitment and broadest representation of culture and society possible in all aspects of U.S. museums. The purpose of *Excellence and Equity* (Hirzy, 1992) was to:

- Designate education as the central mission of museums

- Apply the educational mission of museums to newer research methodologies

- Entrust the responsibility of educating the public to all departments working collaboratively within the museum

- Help educate policy makers, trustees, and sponsors about the public dimension of museums

- Encourage collaboration with other educational institutions and organizations within the community

- Support the museum's commitment to serving the broadest spectrum of society

- Incorporate technology and distance learning

The task force outlined 10 recommendations designed to shift museums to a position of advocacy and action to help overcome serious shortcomings. Other concerns listed in *Excellence and Equity* (Hirzy, 1992):

- The lack of public service provided by museums

- A pervasive public alienation toward museums

- An omission of diverse ethnic, cultural, and socioeconomic representation among board members, museum professionals, and museum patrons

- The need for greater curatorial scholarship to accompany exhibitions and programs

- An absence of effective methods to evaluate visitor-response measures

- Overlooked opportunities for networking and unnurtured partnerships with other educational institutions

- The shortage of sound pedagogical models for education in museums

- The underutilized potential for integration between education and museums

- The dearth of research and literature related to teaching and learning in museums

- The need to increase opportunities for professional preparation and ongoing development for museum educators

- Decreases in museum staffing and budgets from loss of funding that has resulted in further cutbacks in museum services and programming for the public

There were three major issues expressed in this report: education must become the central mission of museums, and this pursuit must be supported by every facet of the museums' efforts; museums must reflect cultural plurality and diversity in the development of programs and operations, and the cultivation of new audiences; and museums must reaffirm their commitment to public service

through leadership, networking, and professional development (Hirzy, 1992). These goals were intended to enhance collection policies and the display of artwork, as well as improve museums' educational programs and activities.

In the executive summary (Hirzy, 1992), the task force outlined 10 guidelines for the implementation of the report:

- Acknowledge that education is the central responsibility of museums

- Increase diversity of participants

- Understand audiences better

- Appreciate cultural variety

- Improve interpretive processes

- Foster collaborative efforts and educational partnerships

- Assess decision-making processes

- Diversify staff

- Provide professional development for museum staff

- Encourage greater professional commitment to strengthen the public dimension of museums

Intended as a companion to *Excellence and Equity* (Hirzy, 1992), *New Visions: Tools for Change in Museums* was published in 1995 by the AAM to encourage museums to increase the effectiveness of the role of the museum board and staff members. The text, designed as

a toolkit, consisted of assessment instruments, worksheets and checklists, and resources, products, and services. AAM later published *Mastering Civic Engagement: A Challenge to Museums* (AAM, 2002) based on the recommendations of a steering committee, a national advisory committee, and a national field committee comprising museum specialists and outside experts. The publication discussed the relationships between museums, education, society, and commerce. *Civic Engagement* called for rethinking and restructuring the meaning of collaboration; cultivating endowments and funding; emphasizing researching, teaching and public commitment; responding and engaging in conversations in and out of the museum community; and testing creative solutions for public programming that fosters life-long learning possibilities for the broadest spectrum of society. This utopian vision of the museum at the center of community life and learning called for greater exchange between museums and the communities in which they serve, yet there has been a steady decline in museums' civic involvement during the recent past, which seriously hinders the aspirations and objectives of this report.

Conclusion

Preservation and education are two long-standing goals of U.S. art museums that appear in most mission statements. However, there traditionally has been a polarity in museums between "the roles of expert, keeper, authority at one end of the spectrum and public servant, communicator, community participant at the other" (Franco, 1992, p. 9). The balance between these two roles has generated debate for more than a century and continues to do so in theory and in practice. However, the meaning of the term "education" is still not certain, as demonstrated by the lack of consensus among museum directors about the definitions, implications, and interpretations of teaching and learning. Some believe that collecting, researching, displaying, or selling reproductions fulfill a museum's obligation to educate the public (Eisner & Dobbs, 1988).

Numerous authors have observed that learning in museums has recently signaled a paradigm shift. There is movement away from a former position of emphasizing retainable factual knowledge to the development of the individual narrative supported by contextual understanding and personal experience (Falk & Dierking 1992; Hein, 1998; Leinhardt, Crowley & Knutson, 2002; Paris, 2002; Roberts, 1997). In this new paradigm, education in museums is not a subsidiary measure; rather it has become central in policy and practice. This philosophy represents the

most significant change to come about in the history of U.S. museums. Although education was previously pronounced as the essential objective of U.S. museums in *Museums for a New Century* (AAM, 1984) and mentioned in vague terms in *The Belmont Report* (Robbins, 1969), earlier attempts at promoting an educational mission for U.S. museums fell short of action. By comparison, *Excellence and Equity* (Hirzy, 1992), *New Visions* (AAM, 1995), and *Mastering Civic Engagement* (AAM, 2002) are all succinct in nature, unlike earlier policy documents outlining lengthy, vague, and often redundant objectives and goals. The newer mandates are supported with strategic plans, an evaluation component, follow-up measures, and feedback available from AAM.

Because of the impact of *Excellence and Equity* (Hirzy, 1992) and *Mastering Civic Engagement* (AAM, 2002), there is greater professional cooperation among museum departments. Although the concept of interdepartmental professional collaboration was introduced in *Museums for a New Century* (AAM, 1984), changes in the museum profession have been slow. The responsibility of educating the public in museums now requires the combined efforts of not only museum educators, but also collections curators, exhibition designers, museum administrators, and trustees. The goal of this interdepartmental effort is intended to fuse scholarship with interpretation, while cultivating lifelong learning opportunities for diverse audiences. As a result of these changes, the status and role of museum educators will continue to increase in the museum profession (Williams, 1994, 1996, 1997).

Unfortunately, U.S. museums are still often viewed as occupying positions of luxury and considered to be an unjustified expense of public money. Conversely, most people in the United States regard education as being a legitimate concern and a justified expense of public money. Therefore, the status of museums will become increasingly secured through greater attachment to education (Bloom & Mintz, 1992). Stapp (1992) reflected that the mission of education in U.S. museums has taken on new priority because of the perceived "failings of the American educational system and pressures from diverse voices among the American population" (p. 4). Educational reform efforts in the United States continue to struggle with issues regarding standards, curriculum, evaluation, and brain research, in addition to multiculturalism, censorship, school violence, and the uses and abuses of technology.

Despite apparent enthusiasm behind the current educational reform in U.S. museums, there is also widespread disagreement about how to distribute public money for the arts. Although most major museums are categorized as public institutions, over the past several decades museums have had to draw increasing financial support from private sources. Museums are competing for the same funds as other tax-exempt organizations, including hospitals, churches, universities, and social welfare organizations. Swank (1992) concluded that museums, now

more than ever, "have an obligation to mirror social reality in terms of their future collecting, board and staff composition, and public programming" (p. 94).

During the last decade, U.S. museums have made a serious effort to become active in their communities by developing partnerships in public and private sectors. *Excellence and Equity* (Hirzy, 1992) and *Mastering Civic Engagement* (AAM, 2002) require that museum educators evaluate the effectiveness of their collaborative partnerships, programming, and services to ensure that their projects meet with the educational objectives set forth in their museums' mission statements.

U.S. museums have historically been in the business of acquiring, conserving, and exhibiting material objects and works of art. Now museums are struggling to define to what extent they can—or should—become all things to all people. Museums are preoccupied with how to reach diverse audiences, increase minority representation and involvement in appropriate ways, and translate the scope and sequence of their collections to the public at large. As in educational research, theory, and practice, changes in museums have happened more slowly than those in mainstream society (Paris & Hapgood, 2002; Williams, 2001).

Over the past several decades, there has been a major change in the educational focus of U.S. museums. *Excellence and Equity* (Hirzy, 1992) and *Mastering Civic Engagement* (AAM, 2002), coupled with the vast socioeconomic, global, and technological changes, provoked museums to reconsider their educational role. One downfall of museums in the past has been, as Yellis (Landau, 1992) pointed out, that "museums are essentially introspective. We always work from the inside out, focusing on collections first and developing programs from there" (p. 56). Cherry (1992) noted that "although many museum educators have dedicated their careers to learning in museums, the field of museum education has developed primarily in response to social pressures and to help institutions survive" (p. 295). Yellis (Landau, 1992) recommended that "to formulate a new theory of museums, institutions need to work from the outside in, emphasizing service to the public" (p. 56). The public dimension of the museum is tailored differently by every institution to meet the needs of both the individual museum and its audience. As public institutions, museums are obligated to reflect major changes in society and to respond to the general consensus through a process of dialogue.

Currently, the desired outcome is to better integrate the museum into U.S. society through education. The underlying presumptions in *Excellence and Equity* (Hirzy, 1992) echo the central tenets of democracy. Museums now more than ever are public domain: they are of the people, by the people, and for the people. An important criterion for the success of democracy is the ability of leadership to represent the masses. The question now is: how well trained are museum education directors—let alone specialists from other museum departments—to carry out the educational responsibilities now assigned to museums? The policy initiatives outlined in *Excellence and Equity* (Hirzy, 1992) will require new standards for the professional training and ongoing professional development based on sound educational theories and practices for museum educators and other museum professionals if this plan is to succeed. Professional museum training standards have not been adequately addressed or put into effect, and available research materials and publications in this area are inadequate. Only after undertaking a commitment to developing standards for professional training and development in museums can there be successful partnerships between museums and the public for the purpose of furthering an educational mission. If that task is fulfilled can we achieve the deeper purposes of democracy—to break down barriers of class, race, gender, age, religion, socioeconomic status, and ability that have historically been obstacles to the progress of U.S. society, education, and museums.

REFERENCES

American Association of Museums (AAM). (1984). *Museums for a new century: A report of the Commission of Museums for a New Century.* Washington, DC: Author.

American Association of Museums (AAM). (1995). *New Visions: Tools for change in museums.* Washington, DC: Author.

American Association of Museums (AAM). (2002). *Mastering Civic Engagement: A Challenge to Museums.* Washington, DC: Author.

Bloom, J., & Mintz, A. (1992). Museums and the future of education. In *Patterns in practice: Selections from the Journal of Museum Education* (pp. 71-78). Washington, DC: Museum Education Roundtable.

Boyer, E. (1983). *High school: A report on secondary education in America.* New York: Harper & Row.

Cherry, S. (1992). A history of education in American museums. In *A history of art education: Proceedings from the Second Penn State Conference, 1989,* (pp. 292-295). Reston, VA: The National Art Education Association.

Eisner, E., & Dobbs, S. (1986). *The uncertain profession: Observations on the state of museum education in twenty American art museums.* Los Angeles, CA: The Getty Center for Education in the Arts.

Eisner, E., & Dobbs, S. (1988). Silent pedagogy: How museums help visitors experience exhibitions. *Art Education, 41*(4), 6-15.

Falk, J., & Dierking, L. (1992). *The museum experience.* Washington, DC: Whalesback Books.

Franco, B. (1992). Evolution of the field: Historical context. In *Patterns in practice: Selections from the Journal of Museum Education* (pp. 9-11). Washington, DC: Museum Education Roundtable.

Hein, G. E. (1998). *Learning in the museum.* London: Routledge.

Hirzy, E.C. (Ed.). (1992). *Excellence and equity: Education and the public dimension of museums.* Washington, DC: American Association of Museums.

Landau, J. (1992). Key issues. In *Patterns in practice: Selections from the Journal of Museum Education* (pp. 55-57). Washington, DC: Museum Education Roundtable.

Leinhardt, G., Crowley, K., & Knutson, K. (Eds.). (2002). *Learning conversations in museums.* Mahwah, NJ: Lawrence Erlbaum Associates.

National Commission on Excellence in Education. (1983). *A nation at risk: The imperative for educational reform.* Washington, DC: U.S. Government Printing Office.

National Science Board Commissions on Precollege Education in Mathematics, Science and Technology. (1983). *Educating Americans for the 21st century.* Washington, DC: National Science Foundation.

Newsom, B.Y. & Silver, A.Z. (Eds.). (1978). *The art museum as educator: A collection of studies as guides to practice and policy.* Berkeley, CA: University of California.

Paris, S. G. (Ed.). (2002). *Perspectives on object centered learning in museums.* Mahwah, NJ: Lawrence Erlbaum Associates.

Paris, S. G., & Hapgood, S. E. (2002). Children learning with objects in informal learning environments. In *Perspectives on object centered learning in museums* (pp. 37-54). Mahwah, NJ: Lawrence Erlbaum Associates.

Robbins, M.W. (1969). *America's museums: The Belmont report.* Washington, DC: American Association of Museums.

Roberts, L. C. (1997). *From knowledge to narrative: Educators and the changing museum.* Washington, DC: Smithsonian.

Stapp, C. B. (1992). Defining museum literacy. In *Patterns in practice: Selections from the Journal of Museum Education* (pp.112-117). Washington, DC: Museum Education Roundtable.

Swank, S. T. (1992). Museums' social contract. In *Patterns in practice: Selections from the Journal of Museum Education,* (pp. 93-94). Washington, DC: Museum Education Roundtable.

Williams, B. L. (1994). An examination of art museum education practices since 1984: In the context of the evolution of art museum education in America. *Dissertation Abstracts International.* The Florida State University, Tallahassee, FL.

Williams, B. L. (1996). An examination of art museum education practices since 1984. *Studies in Art Education, 38*(1), 34-49.

Williams, B. L. (1997). Recent changes in museum education with regard to museum school partnerships and discipline-based art education. *Visual Arts Research, 23*(2), 83-88.

Williams, B. L. (2001). Recent developments in the policy of American museums from 1960 to 2000: Where do we go from here? *The Journal of Arts, Management and Society, 30*(4), 316-32.

Zeller, T. (1989). The historical and philosophical foundations of art museum education in America. In N. Berry & S. Mayer (Eds.), *Museum education: History, theory and practice* (pp. 10-89). Reston, VA: National Art Education Association.

PART 2

Ourselves

A Day in the Life: The Qualifications and Responsibilities of an Art Museum Educator

Yi-Chien Chen Cooper
Richland, Washington

In the 21st century, the definition of the term "museum" has reached well beyond the traditional conception of a place to show and store art. One important change is that art museums have become places that bring art and people together (Eskin, 2001), "places for explorations and memories" (Pitman, 1999, p. 27) that offer a safe learning environment. Art museum educators share a great responsibility for making art museums more accessible and facilitating positive museum experiences that are key to a successful museum education program. But who are these museum professionals, and how do they fulfill their important roles? This chapter looks at the desired qualifications for art museum educators, documents a typical day's activities, and describes art museum educators' perceptions of the content and value of their role in the fast-changing museum field. In addition, their experiences can be applied to training future art museum professionals.

Qualifications of Art Museum Educators

It is difficult to map out what is needed for a successful career in art museum education. One approach is to look at what qualifications are required to obtain an art museum education position. Two studies (Chen, 2003; Ebitz, 2005) discussed the preparation of museum professionals by analyzing the content of position openings listed in *Aviso*, a publication of the American Association of Museums. I (Chen, 2003) used six issues of *Aviso*, dating from April 2001 to September 2001, to identify current requirements for five key positions in art museums: directors, curators, development officers, museum educators, and registrars. Based on the opinions of art museum professionals and the actual demands of employers in the art museum job market, I further discussed the possible criteria for museum training content and provided suggestions to strengthen museum studies programs. Among 255 job openings listed in *Aviso*, 47 related to art museum education. I found that most of the art museums preferred a candidate with an advanced degree or a master's degree in art history. Using similar research methods, Ebitz (2005) analyzed 109 art museum education

job listings from *Aviso*, dating from January 2002 to December 2003, to determine what qualifications were in demand for art museum educators. Ebitz also concluded that candidates majoring in art history seemed to have a greater advantage in obtaining positions in museum education. However, I (Chen, 2003) noted that art museums have begun to recognize other preparation because majors such as museum education (25.5%), museum studies (23.4%), art education (23.4%), education (19.1%), and fine arts (12.8%) were frequently included in the announcements.

The data gathered from *Aviso* also provided a list of skills that are important for museum education positions. Communication skills and proficiency in writing seemed to be the top requirements (Chen, 2004) (see Figure 1). There was also a high demand for computer literacy and organizational skills. My findings revealed that educational programming, community outreach, curriculum design, and docent training were the key responsibilities for art museum educators (see Figure 2).

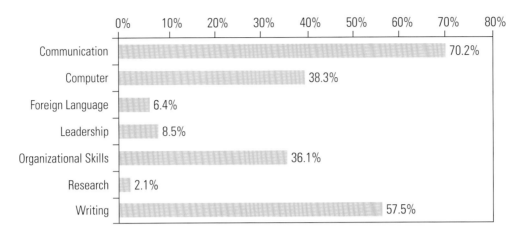

Figure 1. Percentage of Required Skills for Museum Education Positions Listed in 47 Art Museum Job Descriptions in *Aviso* Between April and September 2001.

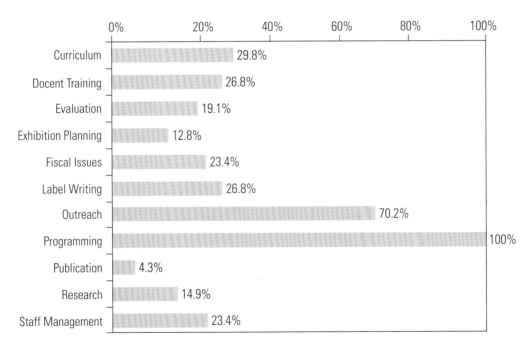

Figure 2. Percentage of Responsibilities Associated With Museum Education Positions Listed in 47 Art Museum Job Descriptions in *Aviso* Between April and September 2001.

Nora Christie

Amon Carter Museum

One of the challenges for today's museum educators is to avoid the pitfalls of trying to be everything to everyone. Educators should focus their energies on a few quality programs that mesh the museum and visitors' expectations. Programs that succeed in achieving this grow without overextending the already-overworked museum educators.

A Typical Day

For a deeper understanding of the qualifications, responsibilities, and the roles that art museum educators play at art museums, I sought opinions directly from art museum education professionals (Chen, 2003). Twenty-eight respondents listed their involvement in the following responsibilities: educational programming (92%), museum outreach (92%), docent training (89%), research (74%), museum tours (64%), fund-raising (53%), exhibition planning (50%), maintaining the museum website (28%), and collections care (10%).

Based on the responses, a normal day for an art museum educator consists of educational and administrative duties (Chen, 2003). The educational duties include docent recruitment, program planning, writing educational materials, giving tours, and teaching in the galleries. One art museum educator in my study described her typical museum day as follows: "Twenty percent communication with staff and docents and colleagues,

20% research and meetings, 20% teaching, 10% working with publications, 30% unique projects [such as] audio guide, gallery guides, outreach, etc." Administrative work mainly consists of staff management issues, such as "motivating problem solving, advising human resources, [and] communicating with colleagues museum-wide." In addition, there are many meetings and a great deal of correspondence on planning "special projects, exhibitions, [and] development." Many museum educators expressed their frustrations with the number of meetings, including one who said, "The day mostly is filled with meetings, meetings, and more meetings."

These real-life examples from respondents in my study illustrate that art museum educators face various responsibilities in any workday. As one explained: "Typically my job is heavy on administration as opposed to program implementation, [including] designing mission and vision for programming for contract staff to carry out; identifying financial resources [for] and consultants to provide programming such as lectures, artists, [and] guest speakers, etc."

Another educator summed up her day as:

Some deskwork: e-mails, correspondence, phone calls, outside inquiries—10%

Staff supervision: checking answering machine, questions, addressing problems—10%

Attend meetings internally—20%

Writing educational materials: packets, brochures, and videos—20%

Planning future programs or attending current events—20%

Training [or] working with docents—10%

Research [or] reading [on] future exhibitions (usually done at home)—10%

Challenges and Rewards

Many art museum educators find their jobs rewarding even though their schedules may be, as one respondent said, "crazy all of the time." According to my survey (Chen, 2004), most respondents found working at art museums enjoyable because they were surrounded by art (82.1%) and they were able to interact with people (89.3%). Others enjoyed creative tasks (57.1%) in museum settings. Many educators (78.6%) reported satisfaction knowing that what they do benefits communities (see Figure 3).

Respondents also shared the challenges they faced in their work. They expressed frustrations concerning resources, collegiality, the work environment, public relations, and self-improvement. The biggest frustrations involved a lack of resources in funding, time, and staff. "Too much work, not enough time" was a typical response. Many observed that meetings and unnecessary paperwork impeded a productive

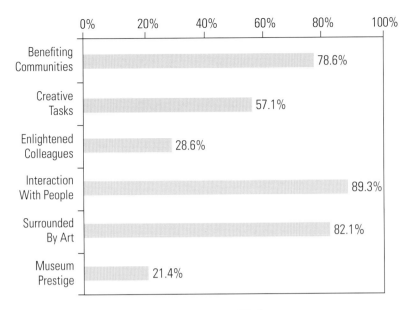

Figure 3. The Joys of Museum Work.

workday. Lacking energy was another concern. Many art educators used the term "burnout" to describe their frustrations. Some were also afraid of not being able to come up with new ideas for advocating their needs because it is difficult to "have time for reading" and "attend professional development classes."

Inadequate staffing was another source of stress among respondents. One museum educator shared her frustration: "I am a full-time staff member [with] only a 20-hour-per-week graduate assistant and intern to assist in preparing interpretive projects and programming." Because of staff shortages, sometimes art

museums faced consequences such as cutting programs. As one museum educator admitted, "[We do not] have enough staff in my department to offer the variety and quantity of programs that I would like to offer." Indeed, art museum educators complained that they are simply "wearing too many hats" to meet the changing demands. One art museum educator said, "I know multitasking is the job of a manager, but sometimes I feel that I am juggling too many balls, and I am afraid I am going to drop them." As a result, it is hard to find "a balance between the workload and the time you have in the day."

Many art museum educators were frustrated by issues related to a lack of communication. They revealed that weak departmental or collegial collaboration sometimes made their jobs difficult to complete. Many of them felt they were underappreciated by other divisions. One art museum educator found it difficult to "promote collaboration or balance among the various entities of the museum." Some also recognized that some communication breakdowns were from the organizational politics in museum work.

Many respondents pointed out that public misconceptions of the functions of art museums and audiences' expectations of art museum experiences also made museum work stressful. Some art museum educators felt that "audiences increase [their] focus on entertainment" rather than art, making it difficult to prepare meaningful educational programs.

Keys to Success as Art Museum Educators

White (1999) underscored two critical requirements for effective educational programs in art museums. First, museum professionals should be truly committed to education. Second, museum professionals should maintain high standards for developing educational programs, exhibitions, and research. In light of the needs of most art museums today, how should future art museum professionals be trained? The results from *Aviso* suggest that the education division of an art museum tends to seek candidates with a master's degree (66%) in art history (68.1%). Among the job listings sampled, good communication skills (70.2%) were highly sought. In addition, candidates with at least 3 years of

Amy K. Gorman
The Muscarelle Museum of Art

In a 2006 NAEA presentation entitled *Graduate Study in Art Museum Education: Programs, Content, and Competencies*, Pat Villeneuve and I recommended that preparation for art museum educators encompass comprehensive study in the fields of art, education, and museums.

museum experience (29.8%) were preferred. When asked what skills were necessary to fulfill the role of art museum educator, respondents highly recommended the following: communication, organization, management, and people skills. A solid knowledge of art history and scholarly skills such as writing were also emphasized. They also valued hands-on museum experience and museum connections (Chen, 2003, 2004).

Art history's high marks do not come as a great surprise, mainly because that discipline has been the foundation of curatorial work. The emphasis on art history among art museum professionals can be traced to the turn of the 20th century when some prestigious universities and colleges began to offer courses for people who wished to enter the museum work force. For example, the Fogg Art Museum at Harvard University and Wellesley College both made art history an integral part of training for museum work (Coleman, 1939). Thus, art history has long been seen as the key to a successful career in the curatorial division, as well as in overall art museum work wherever connoisseurship, interpretation, and acquisitions are of paramount importance.

However, my study (Chen, 2004) revealed that besides art history, majors such as museum education, arts education, and education are receiving greater attention from art museums. The emphasis on candidates with a proper education background suggests that art museum education is increasingly becoming a profession of its own. Art museums are gradually acknowledging that knowledge of art and of effective instructional methods for nonclassroom settings are necessary for raising audience awareness and appreciation of

art. For example, Floyd (2002) urged museums to produce interdisciplinary curricula for museum visitors, a suggestion that would require museum educators to have knowledge of learning theories and curriculum design.

Some art museum educators who participated in my survey stated that they would include education courses in their own training. One of the interviewees strongly recommended that students who wish to be art museum educators obtain knowledge in museum education. He described his ideal candidate for museum educator as "someone who did his or her undergraduate degree in art history and attended a graduate program in museum education" (personal communication, 2004).

Demanding good communication skills implies that art museums have become places that value teamwork. Studies of *Aviso* job listings (Chen, 2003, 2004; Ebitz, 2005) confirmed that art museums were seeking candidates with good communication skills who were willing to collaborate daily with other divisions or agencies. In fact, many respondents in my study indicated that their normal day mostly involves attending meetings and making phone calls to ensure healthy relationships among museum divisions. Therefore, good communication skills and people skills are important to maintain healthy working environment.

Many art museum educators stated that a major part of their daily tasks were administrative duties (Chen, 2004). As a result, they heavily rely on good communication skills. Indeed, good communication skills have become especially critical in

our time, as art museums strive to establish ongoing collaborations with other community-based agencies and organizations (Skramstad, 1999). The increasing need for curators to consider elements of exhibitions other than aesthetic concerns has made art museum education a significant part of the collaboration.

Recommendations

Today, art museums are no longer isolated institutions. Art museums are active members of their greater communities. This change in self-identity requires art museum staff to cultivate community connections in order to form stronger community partnerships. As Conwill & Roosa (2003) pointed out, besides funding and great leadership, the key to a successful community partnership is the ability to listen and respond to the needs in the community. Thus, art museums and museum professionals at large should recognize the important role of museum education. In addition, each museum division should be able to establish a common ground that encourages open communication without hierarchal or political discriminations. Finally, museum professionals should work as a team to expand the reach of museums, such as using the Internet to establish a global network that would serve museum audiences beyond local boundaries.

REFERENCES

Chen, Y. (2003). The education of art museum professionals: Voice from Aviso and its implications to the practice of museum training. In. P. Sahasrabudhe (Ed.), *International conversations through art: InSEA member presentations, papers and workshops CD-ROM*. New York: Center for International Art Education.

Chen, Y. (2004). *Educating art museum professionals: The current state of museum studies programs in the United States.* Doctoral dissertation, Florida State University, 2004.

Coleman, L. V. (1939). *The museum in America: A critical study* (vol. 2), Washington, DC: American Association of Museums.

Conwill, K. H., & Roosa, A. M. (2003). Cultivating community connections. *Museum News, 82*(3), 41-47.

Ebitz, D. (2005). Qualifications and the professional preparation and development of art museum educators. *Studies in Art Education, 46*(2), 150-169.

Eskin, B. (2001). The incredible growing art museum. *ARTnews, 100*(9), 138-149.

Floyd, M. (2002). More than just a field trip: Making relevant curricular connections through museum experiences. *Art Education, 55*(5), 39-45.

Pitman, B. (1999). Places for explorations and memories. In B. Pitman (Ed.), *Presence of mind: Museums and the spirit of learning* (pp. 21-30). Washington, DC: American Association of Museums.

Skramstad, H. (1999). An agenda for American museums in the twenty-first century. *Dædalus, 128*(3), 109-128.

White, J. (1999). Some thoughts on improving education in museums. In B. Pitman (Ed.), *Presence of mind: Museums and the spirit of learning* (pp. 53-60). Washington, DC: American Association of Museums.

Moralizing Influences: The Feminization of Art Museum Education

Dana Carlisle Kletchka
Palmer Museum of Art, The Pennsylvania State University

As a graduate student in the mid-1990s, I attended my first National Art Education Association conference and noted that most of the attendees at sessions for art museum educators were women. They seemed to share several characteristics—well-educated, relatively young, white—and they spoke in earnest of their efforts to garner respect for their profession. The experience made me wonder if women had always constituted the majority of art museum educators and whether their work had historically been perceived as subordinate to curatorial work. As a professional art museum educator and doctoral student, I began to explore and problematize the intricate historical connections between women and art museums as they existed in the realm of education. In this chapter, I use a feminist lens to suggest that a number of gendered ideologies shaped the burgeoning profession of art museum education into a feminized field, which it remains to this day.

In 1986, Marc Pachter, currently director of the Smithsonian's National Portrait Gallery, stated that "once it became allowable for women to work in an intellectual arena, they naturally came to museums because, in American society, cultural work is traditionally women's work" (Weber, 1995, p. 33). Women were initially considered to be ideal educators in art museums because education, particularly for young children, was not thought of as an intellectual arena but simply an extension of the nurturing, educative role ascribed to women—a role firmly woven into America's ideological fabric and the practices of Progressive education. Historical views of females as motherly teachers, cultural guardians, and saintly workers intersected to create opportunities for women in the art museum context. Additionally, because women have been the traditional volunteers in educational capacities in art museums, the conception of teaching in art museums as women's work was further cemented. While women provided a significant source of assistance in museums, their presence undermined the respectability of education departments in the eyes of the rest of the museum staff who surmised that if the educational work that volunteers performed was important enough, a trained professional would have been hired (and paid) to do it (Arth, 1994).

The definition of "feminization" varies depending on its context. According to Weber (1995), "in its older and pejorative sense, feminization meant lower wages and esteem" (p. 33). Prentice and Theobald (1991) defined the feminization of teaching as "the gradual increase in the numbers and proportions of women teaching in most state school systems, along with their low status and pay within those systems" (p. 5), whereas Sugg (1978) wrote that "feminization was identified with professionalization of education and was thus a qualitative and ideological as well as a quantitative phenomenon" (p. 3). Here, feminization encompasses those definitions while considering the dominant ideologies and historical events that shaped and supported this phenomenon in art museums. Historically, educational efforts in art museums have been associated with women who occupy a lower position in the museum hierarchy (McClellan, 2003; Rice, 2003). And although the ideological and societal discourses that shaped the profession have changed dramatically since the mid-19th century, the gender and professional status of art museum educators have not.

19th- and Early-20th-Century Ideologies

To examine the current status of art museum educators, we need a foundational understanding of the social concepts of gender and labor in the late 1800s and early 1900s. The late 1800s were a time of great change in the United States. Art museums, the beneficiaries of vast fortunes made in industry and finance, grew in size and in numbers of art objects (Sherman & Holcomb, 1981). The nation's transformation from a largely agrarian work force (particularly in the Northeast) to an industrial economy changed both the nature of work and the division of labor (Beechey, 1988). Whereas American women had always contributed to their family's economic production through labor done in and for the home, the definition of work was by the time of the Civil War limited to wage-earning occupations, which were severely restricted for women (Boydston, 1990). Teaching in the art museum was one of a small number of occupational opportunities accessible to women by the early 1900s, although a few professions that were previously offered exclusively to men had already opened up to women, particularly those who were educated, middle class, and white. These professions, primarily within labor and industry, came to be ascribed as women's work, despite the fact that female paid laborers worked within a masculine sphere of conduct. Certain professions, including teaching and librarianship, began with an entirely male work force but soon largely consisted of white, female practitioners (Williams, 1995).

Ideology of Domesticity

The Ideology of Domesticity defines women as "essentially maternal and domestic" in nature (Williams, 1995, p. 25). This pervading ideology encompassed the many discourses about femininity in the 19th and 20th centuries, including the following: women's sphere of influence, True vs. Real Womanhood, women as ideal teachers, and women's labor as a form of missionary work.

Women's Sphere

The notion that men and women occupied distinctly different, gender-specific places in society in post-Revolutionary America was widely held, and the largely private spaces that were socially acceptable for women became commonly known as the "women's sphere" (Cott, 1977). The notion of an appropriate sphere for females severely limited professional opportunities for women. The view of educational spaces as "private" and therefore acceptable for women began in the 17th century with "school dames," or women who provided rudimentary reading and writing instruction to children before those children moved on to public instruction in Latin and other subjects (always taught by a male teacher, often a specialist in Latin). Initially these classes were held in private homes, and the teacher's own offspring were part of the class; later, women were hired by town governments to provide initial instruction to young children. Thus, women moved from the private, domestic sphere of private homes to a more public, educational space. In time, women began teaching the subjects of reading, spelling, math, writing, and geography during the summer to younger children (generally ages 4 to 10) in addition to providing instruction in the domestic arts to female students (Perlmann & Margo, 2001). Eventually, educational work performed in classrooms, libraries, and museums was socially acceptable for women even though they were ostensibly public locations; their educational mandate automatically ascribed them as private, secure spaces.

A mechanism that further permitted women to work outside their "proper" sphere was the bureaucratization and male supervision of their labor. In education, this was demonstrated clearly by the common school reform movement that called for a bureaucratic model of schooling, including uniform standards, performance grades, standardized curriculum, and student progression from one grade to the next in a gendered, hierarchical system of organization. Unlike pupils in the earlier one-room schoolhouse, elementary students began to be sorted into eight different grade levels and placed in self-contained classrooms that were headed by a female teacher but supervised by a male principal. Eventually, male superintendents supervised entire districts (Spring, 2001). A similar phenomenon was evident in librarianship, wherein

male workers occupied top positions (Garrison, 1974), and in art museums, where women held little authority until well into the 20th century (Glaser & Zenetou, 1994; McCarthy, 1991; Sherman & Holcomb, 1981).

True vs. Real Womanhood

The Cult of True Womanhood, a concept that emerged in the Victorian era, placed women firmly in their homes and prescribed marriage and the care of children over work outside the home. While the Victorian ideology of the Cult of True Womanhood was reflected in much writing about women during the period of 1840 to 1880, a very different vision of Victorian womanhood was reflected in the popular literature and magazines of the time. This contradictory notion was referred to as the Ideal of Real Womanhood, which contended that model women were rational, intellectually equal to men, and irresponsible if they did not develop their minds (Cogan, 1989). Both of these ideologies informed developing educational opportunities for women at this time. The Cult of True Womanhood all but prohibited education for women in the academic sense (i.e., the subjects that men studied), whereas education for the Real Woman was seen as a means not to an end but as preparation for future womanly obligations. The public debate over education for women vacillated, as some physicians claimed that women were intelligent enough to learn any subject but would

sacrifice their ability to bear children if they experienced the rigors of higher education. Other members of society insisted that a well-rounded education would help preparing women for motherly and wifely duties, from choosing a suitable spouse to running a household to teaching culture and morality to their children (Boas, 1935). Eventually, academic and "domestic" education became compatible and authors began to assert that learned women could change society for the better through a sort of sacred influence. The ideal of Real Womanhood faded after 1880, while the notion of True Womanhood continued until well into the 20th century (Cogan, 1989). Nonetheless, women with adequate financial resources and family support began to enroll in colleges.

Early-20th-century women who did attend college frequently took the courses in art history and art production that were increasingly offered to female students in a gendered curriculum (Boas, 1935; Sherman & Holcomb, 1981). Additionally, some universities, particularly colleges for women, began to offer courses that provided a foundation for working in museums. An art museum training course at Vassar College prepared young women to become assistants in museums and included art museum education as an area of study from 1911 to 1917 and again in the 1920s (Ramsey, 1938; Stankiewicz, 2001). Wellesley College also began offering a museum training program in 1910 to 1911, roughly the same time as the Pennsylvania Museum (later

the Philadelphia Museum of Art) (Downs, 1994) began offering museum training. The Newark Museum instituted a museum course in 1925 that was run by a woman after John Cotton Dana, the original teacher (and director of the museum) died (Sherman & Holcomb, 1981).

Women as Ideal Teachers

Horace Mann, the first secretary of the Massachusetts Board of Education in 1837, actively encouraged the employment of women because of his beliefs about education, morals, and the character of women. Mann considered education a Christian endeavor that would provide grace and salvation to society at large and characterized teaching as a holy mission. Women, because they were societally designated as caring, gentle, pure, moral, and natural nurturers, were seen as the ideal providers of a loving education to young students. Eventually, the number of women teachers in Massachusetts outnumbered male teachers more than two-to-one. Other arguments for hiring women teachers during Mann's tenure included the societal perception of women's nature as maternal and therefore particularly empathetic with the needs of young children (only men were employed as teachers for post-primary-grade boys until the Civil War), and the fiscal benefits of employing women, who earned anywhere from one-third to one-quarter of the salary of their male peers—making it easier to convince the public that their tax money was well spent (Sugg, 1978). Ultimately, teaching became a woman's profession because both status and pay for teachers, male and female, were limited. The

salary for male teachers was not comparable to other professions that might take an equivalent amount of preparation and education; therefore, salary was not a significant incentive to enter the field of teaching. This was not a problem for young women, who typically taught school for a few years before they married, although some practical wives viewed the profession as a potential source of income once their children grew up or in the case of a spouse's untimely death (Clifford, 1991).

The vestiges of Romantic-era thought deemed art an appropriate subject for women to teach to the young because children were perceived as naturally possessing qualities such as intuition, imagination, and emotion (Sherman & Holcomb, 1981). These qualities were recognized as desirable for teaching in the museum context, as well, as evidenced in the following description of the ideal "club leader" for after-school art programs in this quote from *Museum News*, a publication of the American Association of Museums:

She must be a composite personality, alive, dynamic, a born leader. She must be natural above all else; for children are quick and keen to detect a false enthusiasm. She must really enjoy the work that is going on, must in reality go questing with the children she wants to guide. The club leader must be one of them, and that gift cannot be acquired by any amount of will power or training—it is something that one has or has not. (Ramsey, 1938, p. 112)

Women's Labor as Missionary Work

The social construction of labor as a "saintly mission" is intimately tied to both the Protestant church and the concept of women's benevolence. After 1820, the status of male ministers and women was sentimentalized, wherein both groups were displaced from their traditional roles and had to actively pursue acceptance from the dominant society. For ministers, this included refraining from any controversial political discourse that might steer away potential church members and focusing their public energies on reforming "acceptable" private problems, such as alcohol consumption and lack of faith. Their vehicles for accomplishing such work were women, who joined moral societies that ostensibly enabled them to work toward eradicating such problems. Thus began a tradition of women embarking on saintly missions toward the improvement of society (Douglas, 1977).

The notion of art museums as cultured and refined spaces complemented the rhetoric of benevolence that emerged after the Civil War. Women in upper-middle and upper classes had long been expected to engage in charitable endeavors, such as feeding the poor, advocating temperance, and converting the masses to Protestantism. However, during the post-Civil-War Gilded Age,

many women of the benevolent elite began to base their actions on protecting class interests rather than a sense of morality. The postwar generation of women seemed less concerned about human suffering and sought not to assist those who were afflicted with poverty and all its manifestations, but to instead control and limit the behavior of the underclasses (Ginzberg, 1990).

Educational labor in the United States has long been regarded as a form of missionary work for women (Sugg, 1978). Women's benevolence in the form of accepting low wages was a well-established tradition in teaching, even in the seminary schools for girls of the 1800s (Boas, 1935). Working in an educational capacity in an art museum surely would have been perceived as an appropriate, class-based benevolent activity that elevated society, or at least a segment of society that was viewed as needing improvement. The work of art museum educators was viewed as a noble educational pursuit, which partially explains why women continued to occupy such positions despite a lack of institutional respect and lower pay than their curatorial peers (Low, 1948; Ramsey, 1938).

Implications

The historical intersections of these ideologies created an opportunity for women to work as educational practitioners while concurrently keeping their status as feminine and therefore secondary in a gendered institutional hierarchy. When one considers these foundations, it is possible to better understand

the trajectory of art museum education as a profession, thereby creating possibilities for reform by practitioners. Art museum educators rarely have the time to examine their professional status; however, developing a critical consciousness is an important step in provoking reconsideration of the prospects and possibilities for the profession. One might begin by reading the histories and accounts of art museum educators of the past (Dana, 1917a, 1917b; Gilman, 1923; Godwin, 1936; Harris, 1991; Low, 1948; Newsom & Silver, 1978; Ramsey, 1938) to become familiar with the issues and challenges faced by our predecessors. Actively engaging in activities that are outside of the normal parameters of the profession may challenge prevailing conceptions about the field, reveal new possibilities for the profession, and create additional opportunities for art museum educators. Such activities include:

• Conducting research to further the body of knowledge about the field of art museum education or your institution in particular

• Publishing articles in journals and magazines affiliated with the field, such as *Art Education, Curator: The Museum Journal, Museum News, Journal of Museum Education, Studies in Art Education,* or *Visual Arts Research* or reviewing manuscripts for publications

• Curating exhibitions at your institution or other gallery spaces

• Presenting theoretical as well as practical sessions at local, state, and national art, art education, and museum conferences

• Teaching museum studies or museum education courses at the college or university level or presenting sessions to existing classes

• Serving on professional or educational committees such as the local parent-teacher organization or school board or state and national art education and museum organizations

• Volunteering for advisory boards for local arts organizations

REFERENCES

Arth, M. (1994). Interpreting gender perspectives. In J. R. Glaser & A. Zenetou (Eds.), *Gender perspectives: Essays on women in museums* (pp. 97-99). Washington, DC: Smithsonian Institution Press.

Beechey, V. (1988). Rethinking the definition of work: Gender and work. In J. Jenson, E. Hagen, & C. Reddy (Eds.), *Feminization of the labor force: Paradoxes and promise* (pp. 45-62). New York: Oxford University Press.

Boas, L. S. (1935). *Woman's education begins: The rise of the women's colleges.* Norton, MA: Wheaton College Press.

Boydston, J. (1993). *Home & work: Housework, wages, and the ideology of labor in the early republic.* New York: Oxford University Press.

Clifford, G. J. (1991). Daughters into teachers: Educational and demographic influences on the transformation of teaching into "women's work" in America. In A. Prentice & M. R. Theobold (Eds.), *Women who taught: Perspectives on the history of women and teaching* (pp. 115–135). Toronto, Ontario, Canada: University of Toronto Press.

Cogan, F. B. (1989). *All-American girl: The ideal of real womanhood in mid-nineteenth-century America.* Athens, GA: University of Georgia Press.

Cott, N. F. (1977). *The bonds of womanhood: "Woman's sphere" in New England, 1780-1835.* New Haven, CT: Yale University Press.

Dana, J. C. (1917a). *The gloom of the museum.* Woodstock, VT: Elm Tree Press.

Dana, J. C. (1917b). *The new museum.* Woodstock, VT: Elm Tree Press.

Douglas, A. (1977). *The feminization of American culture.* New York: Knopf.

Downs, L. (1994). A recent history of women educators in art museums. In J. R. Glaser & A. A. Zenetou (Eds.), *Gender perspectives: Essays on women in museums* (pp. 92–96). Washington, DC: Smithsonian Institution Press.

Garrison, D. (1974). The tender technicians: The feminization of public librarianship, 1876–1905. In M. S. Hartman & L. Banner (Eds.), *Clio's consciousness raised: New perspectives on the history of women* (pp.158-178). New York: Harper & Row.

Gilman, B. I. (1923). *Museum ideals of purpose and method.* Cambridge, MA: Harvard University Press.

Ginzberg, L. D. (1990). *Women and the work of benevolence: Morality, politics, and class in the nineteenth century.* New Haven, CT: Yale University.

Glaser, J. R., & Zenetou, A. A. (Eds.). (1994). *Gender perspectives: Essays on women in museums.* Washington, DC: Smithsonian Institution Press.

Godwin, M. O. (1936). *The museum educates.* Toledo, OH: The Toledo Museum of Art.

Harris, N. (1991). Thomas Munro: Museum education 1931–1967. In E. H. Turner (Ed.), *Object lessons: Cleveland creates an art museum* (pp. 126–135). Cleveland, OH: The Cleveland Museum of Art.

Low, T. L. (1948). *The educational philosophy and practice of art museums in the United States.* New York: Teachers College, Columbia University.

McCarthy, K. D. (1991). *Women's culture: American philanthropy and art, 1830–1930.* Chicago: The University of Chicago Press.

McClellan, A. (Ed.). (2003). *Art and its publics: Museum studies at the millennium.* Malden, MA: Blackwell Publishing.

Newsom, B. Y., & Silver, A. Z. (Eds.). (1978). *The art museum as educator: A collection of studies as guides to practice and policy.* Berkeley, CA: University of California Press.

Perlmann, J., & Margo, R. A. (2001). *Women's work? American schoolteachers, 1650–1920.* Chicago: University of Chicago Press.

Prentice, A., & Theobald, M. R. (Eds.). (1991). *Women who taught: Perspectives on the history of women and teaching.* Toronto, Ontario, Canada: University of Toronto Press.

Ramsey, G. F. (1938). *Educational work in museums of the United States: Development, methods, and trends.* New York: H. W. Wilson Co.

Rice, D. (2003). Balancing act: Education and the competing impulses of museum work. In G. Nosan (Ed.), *Museum education at the Art Institute of Chicago* (pp. 6–19). Chicago: The Art Institute of Chicago.

Sherman, C. R., & Holcomb, A. M. (Eds.). (1981). *Women as interpreters of the visual arts, 1820–1979.* Westport, CT: Greenwood Press.

Spring, J. H. (2001). *The American school: 1642-2000.* New York: McGraw-Hill.

Stankiewicz, M. A. (2001). *Roots of art education practice.* Worcester, MA: Davis Publications.

Sugg, R. S., Jr. (1978). *Motherteacher: The feminization of American education.* Charlottesville, VA: University Press of Virginia.

Weber, J. (1995). Changing roles and attitudes. In J. R. Glaser & A. Zenetou (Eds.), *Gender perspectives: Essays on women in museums* (pp. 32–36). Washington, DC: Smithsonian Institution Press.

Williams, C. L. (1995). *Still a man's world: Men who do women's work.* Berkeley, CA: University of California Press.

Docents as Meaning Makers: The Frontline of the Museum Learning Experience

Barbara Zollinger Sweney
Columbus Museum of Art
Columbus, Ohio

Benjamin Ives Gilman at the Museum of Fine Arts, Boston, was the first to introduce a docent service in the United States in 1907. He hired a paid docent[1] whose function it was to act as a companion rather than a guide to visitors. The docent was to "kindle admiration" and "awaken interest" in works of art (Zeller, 1989, p. 45). In the 21st century, volunteer docents play a critical part in many art museum educational programs. I think of docents as museum teachers with a set of pedagogical and performance skills adapted to the museum setting. They provoke dialogue and mediate meaning making for museum visitors. They are also frequently involved in pre-tour school visits and presentations to civic and cultural groups and other community organizations, including retirement homes. In this chapter I present reasons for the importance of docents in promoting museum learning, the need for more research on docent contributions to museum learning, and suggestions on how to train and maintain an effective docent corps.

I contend that authentic objects assert power and importance that reproductions do not and when an object is removed from its original context, something is lost. The challenge for the museum staff is to reinvigorate the object and provide resonance with the lives and ideas of museum visitors. Even for those works of art always intended for museum exhibition, there is the challenge of presenting them advantageously, even forcefully, and in a manner that will connect with visitors.

Few gallery installations create an intuitive learning experience for visitors. Providing extensive wall texts, timelines, quotations, questions, maps, diagrams, audio guides, books, and comfortable places to sit, look, and reflect offers visitors opportunities to make choices that fit their learning styles. Art museum professionals have observed the success of children's museums and science centers, and the interactivity observed in these venues has gained currency in the art museum world. Computer stations, videos, and do-it-yourself gallery games and activities now appear regularly in museums. However, I contend that the best interactivity an art museum can provide is the sort provided by human contact. A trained docent, engaged in listening closely to a small group of visitors and making lively conversation, can help them make connections between works of art and their own experiences.

Thoughtful conversations help visitors value works of art. Artist William Pope L. suggested, "Artists don't make art, they make conversations. They make things happen. They change the world" (Bessire, 2002, p. 22). If we agree with Pope L.—and I do—then helping visitors participate in these conversations is a vital human activity. A talented docent can help visitors discover that thinking and talking about art is enjoyable and worth doing.

Current Knowledge on Training Docents

Since the middle of the 19th century, docents and their training have slowly gained attention from museum educators. However, the scholarly literature and research about docents is scanty. New docent educators are frequently given *The Good Guide: A Sourcebook for Interpreters, Docents and Tour Guides* (Grinder & McCoy, 1985). Although still useful, this book is showing its age in our rapidly advancing field. Frequently, museum educators work with volunteer docents to develop a handbook for docents that includes guidelines for gallery education as well as the museum's philosophy. These handbooks can be extensive or rudimentary.

After conducting doctoral research on student learning on docent-led tours, I introduced annual workbooks (Sweney, 2000, 2003). The books provide one page of prompts including key concepts and essential questions relating to specific thematic tours offered by the Columbus Museum of Art (CMA). The workbooks are just that: working documents intended to provide consistency but not a scripted tour.

In 1981, recognizing the desire to organize a forum for the exchange of ideas among docents, guides, and interpreters, the docents of the Indianapolis Museum of Art organized the first nationwide docent meeting. These now biannual docent meetings have produced three handbooks. The first was published in 1985 by the docents of the Oakland Museum of California (*Extending Connections*, 1985). A second handbook was compiled and written by Daryl Fischer (1992), director of education at the Indianapolis Museum of Art, and published by the docents of the Denver Art Museum. Working from these two previous handbooks, the National Docent Symposium Council published a new version of *The Docent Handbook* (Keller & Kramer, 2001). The texts are thoughtful, well organized, and are intended to address common issues that volunteer docents face in all kinds of museums. From 1991-2003, Alan Gartenhaus published the *Docent Educator* journal. An index to the journal is available on the Museum-Ed website (http://www.museum-ed.org).

Docents and Museum Learning Research

Perkins (1994) of Harvard's Project Zero offered an argument for the value of works of art in building intelligence by pointing out that they also provide instant access and personal engagement. He defined instant access as something "you can check … with a glance, point with a finger" (p. 83). Works of art, Perkins stated, offer personal engagement because they "… invite and welcome sustained involvement" (p. 85). One of the best examples I have witnessed of instant access and personal engagement came from an eighth-grade, male student who had just completed the *Art and Poetry* tour at CMA. His teacher told me that he was a poet, so I said to him, "I understand you are an excellent poet. How did you feel you did today?" He responded, "I wrote my best poems ever." I asked, "Why was that?" "Because I had something to write about," he said.

Museums offer opportunities for visitors to take full advantage of the sensory anchoring, instant access, and personal engagement that Perkins (1994) attributed to works of art. Tishman (1999), also with Project Zero, suggested that museum educators can build on these opportunities by providing for reflective awareness and deliberate and mindful connection making through guided visitor experiences. One means for art museums to be valued as educational institutions is for them to demonstrate that docent-guided tours facilitate connection making and engagement and provide a visitor learning experience that can be assessed.

I agree with Perkins that objects provide a sensory anchor that helps focus attention and can help motivate students and visitors. However, I also hold that human intervention, such as having a docent facilitate the experience in a thoughtful way, can help transform a visit to an art museum into a measurable learning experience. Vygotsky's (1978) research resulted in his theory of the "zone of proximal development." In this construction zone, the child can participate in cultural practices slightly above his or her own capabilities. Successful participation can lead to internalization. In Vygotsky's account, the primary resources for restructuring prior knowledge come from culture. Moreover, the restructuring process itself occurs externally, in social discourse; children share, negotiate, and try out meanings in social experience, and adults can shape those meanings by bringing them into the framework of cultural practice (Roschelle, 1999).

Docents can take advantage of this zone of proximal development to help school visitors shape understandings from their experiences. We may assume that the opportunity exists on any given tour and that well-trained docent teachers could take advantage of it to advance visitor learning.

Hein (1998) is a proponent of constructivist learning: "the idea that learners construct knowledge for themselves—each learner individually (and socially) constructs meaning—as he or she learns. Constructing meaning is learning: there is no other kind" (p. 1). Connecting to a visitor's prior knowledge is an essential element in providing a learning experience in the museum. Docent-directed inquiry can facilitate these

Lori Eklund
Amon Carter Museum

A Case for Hiring Professionals to Teach Students in the Galleries

In 2001, I began to hire part-time education staff at the Amon Carter Museum to conduct student tours, which for years had been performed by docent volunteers. The museum had just reopened after a building expansion and had a strong desire not only to increase the number of student tours, but also to raise the quality of the tour experiences, educational outcomes, and curricular associations. Using volunteers made these goals very difficult to achieve in a cost-effective and timely manner. I proposed to my supervisor that if we hired six qualified, part-time staff, the museum would have a better program that could accommodate more students than it was currently doing with 50 volunteers.

The proposal was approved, and by hiring staff with teaching experience and credentials in relevant disciplines, we saw quick and meaningful change. Training time decreased tremendously, while reliability, consistency, and accuracy of the tour content increased. Most important, museum education staff could now assure school administrators and teachers that the museum learning experience was closely tied to state teaching objectives. With the installation of the gallery teacher program, the numbers of student tours began to rise as did satisfaction, both internally and with schools. Today, six gallery teachers tour 20,000 students annually.

With gallery teachers, trained in the disciplines of the museum and the classroom, we have content consistency and accountability—the teachers are required to teach a curriculum determined by museum and school educators. Perhaps the best outcome of this program is students' experience in the galleries. Children do not come to museums of their own accord; adults make museum-going choices for them. The field trip is a crucial initiation into the world of museums for these students, and it is imperative that they have great, not just good, experiences. I contend that museums are much more likely to see students return to visit as adults if they have positive experiences in the museum as students, especially if they have the opportunity for repeat visits.

Numerous points of contact occur with schools and teachers before their students step into the galleries, which helps the gallery teachers be as responsive to each group as possible. The gallery teachers are required to conduct tours in a highly interactive format focused on prescribed learning objectives, while simultaneously taking advantage of the particular needs and interests of each group of students. However, while gallery teachers lead tours with specific questioning strategies, students are encouraged to express their opinions, support them, and to listen and interact with their peers.

Over the last several years, the gallery teacher program at the Amon Carter Museum has evolved to include writing activities in the galleries, as well as pre- and post-visit classroom-learning experiences that incorporate reading, writing, art, history, and science into the tour. Program costs and salaries, since inception, have been underwritten by grants from a variety of funders. Formative and summative program evaluation informs content and delivery. The experiences students have with gallery teachers are affirming, positive, and age and ability appropriate. Simply put, the program promotes the love of learning, especially in museums, while building the audiences of tomorrow.

and other connections, including interdisciplinary ones schools value. Given the clamor to assess student and school performance and the demand to demonstrate that learning takes place in a museum, research that seeks to demonstrate that measurable learning can take place in an art museum is needed.

Falk and Dierking (1992) have also influenced the direction of learning research in museums with their model of the museum experience. Their interactive model values the social, physical, and personal aspects of the visitor's experience, and their definition of learning in museums considers each of these areas. An effective docent can affect all three aspects of a visitor's experience.

The Need for More Research on Docents and Learning

Volunteer docents provide one of the most important public faces of an art museum. They are essential to the successful implementation of a museum's educational mission, especially as it applies to school-age visitors. A 2003 online survey of 85 art museum education programs indicated that 97.65% of them offered group tour programs and 91.76% of them had docent programs (Wetterlund & Sayre, 2003). Despite the popularity and longevity of docent programs and the growth in research into museum education since the publication of *Excellence and Equity: Education and the Public Dimension of Museums* (Hirzy, 1992), there is still little research about the learning that might or might not take place on a docent-led tour.

Leinhardt and Schuable (1998) proposed a research model in which they defined museum learning as a "conversational elaboration between identity, explanatory engagement, and learning environment" (p. 5). For my master's and doctoral research, I looked at the role of docents (Sweney, 1995, 2003), and in investigating student learning on a thematic docent-led tour at CMA, I found evidence that students demonstrated learning by connection making and expanding concepts.

Shortly before his death in 2005, Stephen Weil, scholar emeritus at the Smithsonian Institution's Center for Education and Museum Studies, spoke about the importance of docents. In a lecture entitled "Art as Mirror and Gateway: The Role of the Docent," he noted the importance in current learning theories of dialogue and a shared social experience. He commented:

Translated to art museum terms, this suggests that the most powerful learning experiences might occur when a "more capable peer"—a well-trained docent—is able to meet, and preferably on a recurring basis, for discussion or conversation with small groups of visitors. Such encounters may not only be enriching for those who actively participate—the docent included—but as several researchers have pointed put, even for those who simply watch and listen. Ultimately it may not matter whether a docent leads a conversation throughout, or simply serves to inaugurate it. That different visitors will bring different backgrounds, assumptions, standards, and insights to such encounters can only make those encounters richer. (Weil, 2005)

Considerations for an Effective Docent Teaching Program

In 1993, during an internship at the Wexner Center for the Arts in Columbus, Ohio, I was given the freedom to comb through the center's files on museum docent programs and to contact museums throughout the United States. I sought out museums that were reputed to have model programs or that received National Endowment for the Arts grants in the previous 2 years and found that in all the programs contacted there was extensive commitment on the part of at least one paid museum staff member to ongoing docent training. Most of the formal docent candidate training programs emphasized art history. However, there were also sessions on touring techniques including different approaches to questioning, methods for learning to look, and sensitivity to the special needs visitors of different ages, abilities, or disabilities might have. The training was often at least 9 months to 1 year. Volunteer docents were asked to commit at least 1 year after their training to regular touring. A more recent online survey of supervisors of docent programs indicated that the programs remain strong and the initial education remains close to 1 year for midsize and larger museums. Smaller museums or those without extensive collections often require much shorter initial education.

Recommendations for Recruitment, Screening, and Documentation

I often refer to docents as "professional volunteers," by which I imply that although docents are volunteers, they should be regarded as professionals with a set of teaching skills that demands training and expertise. In my experience, it is a term that docents both understand and appreciate. The practices that a museum's human resources department uses to recruit and screen professional staff should also apply to the processes the education department uses to recruit docents. Formal applications, recommendations, interviews, and even contracts are a good idea. Many museums now require that docents must pass a security check much like those that teachers and child-care providers must pass.

Docents are often the best recruiters of other docents. When a museum's docent corps is diverse and reflective of the community, it is more likely that the program will be lively and healthy. Applicants need good communications skills, an interest in art, and an ability to inspire an interest in art in others. I have not found that a particular educational level is required.

Docents should be considered an extension of the museum education office, and there should be an ongoing program of evaluation. Written records should be kept on each docent, and if incidents occur, they should be recorded. Teachers often write to recognize the skills of a particular docent, and these letters and other forms of special recognition should be recorded in a docent's file. If a docent has to take a leave of absence for health reasons, a written, return-to-work statement from the physician should be required. If docents fail

to meet their obligations, there should be some means of placing them on probation, asking them to leave the program, or encouraging them to retire. Resources relating to volunteer program administration (Energize, Inc, n.d.; Kuyper, Hirzy, & Huftalen, 1993) provide useful guidance. An alumni docent or emeritus program that allows docents to cease touring but continue attending trainings can be particularly valuable. Because health issues are often the reason that docents resign, such an option can allow them to stay connected to their friends and to the museum.

Museum administration must remember that docents are volunteers who give freely of their time, and a museum must have a means of recognizing them and compensating them for their efforts. Discounts equivalent to employee discounts in the museum store and food service areas are a good beginning. Free admission to programs including lectures, film series, seminars, and artmaking opportunities will help build a better-educated and more committed docent corps just as it contributes to the growth of the paid staff. A museum should consider the ongoing professional development of the docent corps to be just as important as it does for the paid staff.

Initial Education Requirements and Ongoing Professional Development

Instead of the term "training," I prefer to talk about the initial docent education and ongoing professional development. Docents are, after all, expected to have the knowledge and skills necessary to be a vital part of a museum education department and to be responsible in meeting their obligations in a timely and professional manner. Consider that anything you as a museum educator find useful for your own professional development should, if possible, also be offered to docents. Remember that they, too, are museum educators.

The initial docent education must include modeling of the behavior expected of docents in the gallery. No museum educator should be surprised if a docent candidate subjected to 1 year of "art-in-the-dark" lectures gives tours to bored visitors in the galleries. The first year of docent education must, of course, include extensive information on the museum's collection, programming, and mission. Curators can provide training on the collection and the history of art as it relates to the museum's collection. There are many possible art history texts, but I prefer *Art History* (Stokstad, Cateforis, & Addiss, 2005) because it is an approachable and inclusive text. A section called "Starter Kit," timelines, and features called "The Object Speaks" have proved popular with docents. Docents should also be introduced to current approaches to art history, including Marxist, feminist, queer theory, critical theory, and social art history. Familiarity with recent and current art education theories and practices is essential for their work with schools.

Requiring docent candidates to read Hein (1998), Falk and Dierking (1992), Perkins (1994) and Tishman (1997, 1999), followed by lots of discussion and practice in the galleries, will be useful. There should be many opportunities to practice touring techniques in the galleries with staff educators and experienced docent mentors. Some theatrical training can be helpful because successful touring includes an ability to perform in front of an audience. During the first 5 weeks of education for the docents, I teach them an accelerated version of a course developed by Terry Barrett at The Ohio State University based on his book *Criticizing Art: Understanding the Contemporary* (Barrett, 2000). Barrett's (2002) more recent publication focused on interpreting art should also prove useful to museum educators. *Learning from Objects* (Durbin, Morris, & Wilkinson, 1993) is a handy guide for learning how to explore the many potential dimensions for dialogue an object provides. The point of this introductory section is to prepare docents to participate in and lead lively discussions about works or art.

Other elements of this initial education should include hands-on opportunities to work with artists' materials. The product is not important; it is familiarity with the process that contributes to docent understanding of the nature of materials and challenges that artists face. Artist demonstrations and field trips to artists' studios and other museums should be part of initial and ongoing docent learning opportunities. Understanding how to accommodate the special needs of visitors of different ages, abilities, and disabilities should also be included. How to skillfully manage visitor behavior and misbehavior should be introduced in a docent's initial education.

Tours: Who Shapes Them? What Makes a Successful Tour?

The docent, the visitors, the art, and the conversation during the tour shape a tour experience. The tours for which I train docents generally fall into three categories: introductory, themed, and process. Introductory tours tell the story of the museum, introduce collections and exhibitions, and help visitors find their way around. Theme-based tours are frequently the backbone of the school tour program, and at CMA they are usually interdisciplinary. Process tours might involve game playing, poetry-writing activities, or simply observing, describing, and interpreting works of art. These activities are employed independent of a particular theme or exhibition as a means of teaching visitors skills that they can use on their own or with friends.

The number of visitors accompanying a single docent on a tour should start with four or five for young children in grades K-2 and graduate to larger numbers as the age of the visitor increases. Because it is important for every visitor on a tour to have the opportunity to add to the conversation several times, groups should not exceed 12.

Tishman (1999) proposed five elements for creating an active learning experience on a tour. I have adapted her proposal to three elements: making connections to what people already know; personalizing every tour by responding to, acknowledging, and honoring visitors' questions; and providing for critical, ongoing self-reflection on one's own learning process and on the key concepts of the learning experience. To structure a theme-based tour so that it can be shaped to include these elements, it is important to find authentic themes, key concepts, and essential questions that connect to visitors' lives and to the works of art. A theme must serve the visitor as well as the museum. I find interdisciplinary and cross-disciplinary themes are most adaptable. An authentic theme must, as the name implies, make authentic connections to people's lives. It should deal with fundamental patterns and apply pervasively throughout a topic. It should reveal similarities and contrasts and, most importantly, it should have the potential to fascinate. An effective theme will often deal with a big idea worth examining. An essential question is an organizer, a means of framing and guiding learning. It is a declaration of intent that on this tour we will be examining a question worth trying to answer. A question suggests investigation and inquiry and offers a clear message to visitors that the docent will be probing with them. Learners of all ages should be encouraged to raise and consider essential questions. Key concepts are the ideas implicit in an essential question.

By shaping tours around authentic themes that naturally deal with key concepts and essential questions, a museum tour program can meet its obligations to connect to school curriculum while also focusing on the authentic works or art and the museum exhibitions. Themes will also be useful in developing authentic learning outcomes by which to measure the effectiveness of your docent and tour program. A successful tour might be based on the theme "Art and Community." An essential question might be, "What would be different if there were no artists in a community?" A key concept would be that art and artists make a difference in a community. This question and concept work well in examining works by local artists, landscapes, cityscapes, and photographs. I have found that this theme works with almost every work of art in our collection or in a special exhibition. Strong questions for use with socially conscience art might be, "Can artists bring about social change?" or "Does racism still exist?" Be imaginative and collaborate with other museum educators, docents, and teachers in developing themes and questions. Test and revise them.

Museum educators are eager to share their successes. Schedules of available tours are posted on almost every museum website. In developing tour themes, look at the museum's collection, the tours offered by other art museums, history museums, and children's museums, and study closely the standards and benchmarks that students are expected to meet in every subject and at every grade level. A diagram of elements for a successful docent-led tour might look like the illustration shown here.

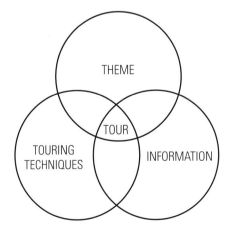

Circlegram of Successful Museum Tours as developed by Barbara Zollinger Sweney (1998).

A combination of a powerful theme that connects to people's lives—coupled with effective touring techniques including essential questions worth asking, personalizing every tour, providing ongoing reflection, and finally inserting important information to help further the conversation—will produce a successful tour. My favorite way to add information is to ask, "What if I told you that...?"

Process tours are those that engage with works of art through docent-led activities such as writing poetry or short stories and playing games such as those that involve visitors in role-playing different people or objects within the work of art. These tours build language and presentation skills but also create visitor ownership of particular works of art, a familiarity that will bring them back to revisit the work. Techniques that playfully engage visitors with a work of art are part of a good docent's skill set.

Coordinating a Docent Program

Mutual respect is essential between paid staff and volunteer docents. A mature docent program usually has established guidelines, practices, and leadership. In such groups there may already be trained docents taking pre-tour information to schools. Study groups and other educational and social programs will probably be in place. A staff person assigned to a mature docent group should observe and learn before starting new initiatives. Changes in existing docent programs should be approached by building consensus with the leadership and

membership. There is a great deal a staff museum educator can learn from listening to docents who have been working at the museum before your arrival. Docents are often some of the best teachers of other docents. They mentor each other. Wise museum educators allow themselves to take advantage of the collective knowledge of docents in an established program.

Initiating a docent program is challenging, but a good place to start is looking at programs that are working and remembering that docents, like you, are museum educators. Start small and let the program grow gradually.

Ongoing Evaluation and Recognition

Docents should begin a program of self-evaluation from the beginning of their candidacy. This will help them keep an eye on the goals of their efforts and their success in meeting them. A simple self-evaluation tool is the most likely to be used. For example, a single sheet of paper with a few questions will head a new docent in a productive direction:

1. Reflecting on today's tour, do you feel you were effective and successful? What questions did you ask to help visitors bring their own experiences to the discussion?

2. What do you feel were the main highlights of this tour for the visitors? Describe what was happening, and why it was successful.

3. If you were to do this same tour again, how might you change it?

4. Write about something you learned on this tour.

Docents naturally discuss their tours with other docents. Taking the time for self-reflection will help make these docent interchanges more fruitful in terms of professional growth.

Evaluation of both paid and unpaid staff must be ongoing. Most paid staff members are given an annual evaluation to consider their strengths and weaknesses and to plan for their future personal and professional development. While docents are unpaid, their conduct and contribution are expected to be professional. If it is possible, an annual staff-conducted evaluation of each docent is productive and educational for both paid staff and docents. Following a docent-led tour is one of the best professional development opportunities a museum educator has available. And maintaining docent evaluation as a staff responsibility, where confidentiality can be assured, is ideal. However, many docents are needed to provide the best possible service to visitors, and if the museum does not have sufficient experienced staff to evaluate each docent, a docent-to-docent program is the next choice. If a successful docent mentor program has been established, these mentors can be a great source of docent evaluators. A docent-to-docent evaluation program needs to be

developed in collaboration with the docents and their leadership. Clear guidelines and standards must be set down in writing, and all parties must respect confidentiality. A docent needs to know from the beginning what is expected and what criteria will be used to evaluate performance. An ongoing self-evaluation program introduced in a docent's initial education is perhaps the best way of ensuring a docent's self-reflection and professional growth.

Visitor questionnaires online or by mail and interviews are helpful evaluation tools. It is important that your evaluation tools align with the goals and outcomes of your docent and tour program. Goals for your program might involve changes in visitors' skills, knowledge, behavior, or attitude. Outcome-based evaluation is demanding. There are increasing resources including publications and consultants to assist with this. One helpful guidebook is published by the Minnesota Department of Human Services (Eystad, 2005).

Recognition programs can be simple or complicated. I prefer simple programs that recognize years of service at appropriate intervals such as 5, 10, or more years and that offer docents many of the same perks employees might get. Because docents are expected to regularly attend ongoing professional development sessions and be available for tours, their attendance on these occasions should be documented and used as a means of recognition. Docent social events planned by the docents themselves or provided by the museum are important to morale. For the most part, docents take great joy in learning and in touring, and that is their greatest reward. However, it is important that every museum staff and board member recognize the contribution docents make and take advantage of opportunities at museum gatherings, in publications, and in other encounters to recognize and thank them for the effort they make to ensure that the museum is a place of learning. One of the best ways to recognize the contribution of docents to learning in a museum is for the museum's leadership to make it mandatory that each new staff or board member takes a docent-led tour. What a great way to introduce new staff and board members to the museum's educational mission.

REFERENCES

Barrett, T. (2000). *Criticizing art: Understanding the contemporary* (2nd ed.). Mountain View, CA: Mayfield Publishing.

Barrett. T. (2002). *Interpreting art: Reflecting, wondering, and responding.* New York: McGraw-Hill.

Bessire, M. H. C. (2002). *William Pope L.: The friendliest Black artist in America.* Cambridge, MA: MIT Press.

Durbin, G., Morris, S., & Wilkinson, S. (1993). *Learning from objects* (4th ed.). London: English Heritage.

Energize, Inc. (n.d.) *Especially for leaders of volunteers.* Retrieved March 29, 2007, from http://www.energizeinc.com/

Extending Connections. (1985). Oakland, CA: Oakland Museum Docent Council.

Eystad, M. (Ed.). (1997). *Measuring the difference volunteers make: A guide to outcome evaluation for volunteer program managers.* St. Paul, MN: Minnesota Department of Human Services. Retrieved March 29, 2007, from http://www.serviceleader.org/new/documents/articles/2005/03/000255.php

Falk, J., & Dierking, L. (1992). *The museum experience.* Washington, DC: Whalesback Books.

Fischer, D. K. (1992). *New frontiers in touring techniques: A handbook of the 1991 National Docent Symposium.* Denver, CO: Denver Art Museum.

Grinder, A. L., & McCoy, E. S. (1985). *The good guide: A Sourcebook for Interpreters, Docents, and Tour Guides.* Scottsdale, AZ: Ironwood Press.

Hein, G. E. (1998). *Learning in the museum.* New York: Routledge.

Hein, G. (1991). The museum and the needs of the people. Paper presented at the CECA (International Committee of Museum Educators) conference, Jerusalem, Israel, October 1991.

Hirzy, E. C. (Ed.). (1992). *Excellence and equity: Education and the public dimension of museums.* Washington, DC: American Association of Museums.

Keller, H., & Kramer, C. (2001). *The docent handbook.* National Docent Symposium Council. Washington, DC: American Association of Museums.

Kuyper, J., Hirzy, E., & Huftalen, K. (1993). *Volunteer program administration: A handbook for museums and other cultural institutions.* Washington, DC: American Association for Museum Volunteers.

Leinhardt, G., & Schuable, L. (1998). *The Museum Learning Collaborative: Phase 2 proposal, November.* Retrieved November, 2002, 1999, from http://mlc.lrdc.pitt.edu/mlc/Proposal-p@entirety.html

Perkins, D. N. (1994). *The intelligent eye: Learning to think by looking at art.* Santa Monica, CA: The Getty Center for Education in the Arts.

Roschelle, J. (1999). *Learning in interactive environments: Prior knowledge and new experience.* Retrieved March 30, 2007, from http://www.astc.org/resource/education/priorknw.htm

Stokstad, M., Cateforis, D., & Addiss, S. (2005) *Art history.* Upper Saddle River, NJ: Pearson Prentice Hall.

Sweney, B. Z. (1995). *Museum missions: A comparison of a children's museum and an art museum.* Unpublished master's thesis, The Ohio State University.

Sweney, B. Z. (2000). *Columbus Museum of Art docent tour workbook.* Columbus, OH: Columbus Museum of Art.

Sweney, B. Z. (2003). *Student learning in an art museum: A study of docent-led tours and changes in docent training to improve visitors' experiences.* Unpublished doctoral dissertation, The Ohio State University.

Tishman, S. (1997). Thinking dispositions and museum learning. *Journal of Education in Museums, 18,* 8-9.

Tishman, S. (1999, March). Five design elements of active learning experiences in art museums. Paper presented at the National Art Education Association Museum Division preconference, Washington, DC.

Vygotsky, L. (1978). *Mind in society: The development of higher psychological processes.* Cambridge, MA: Harvard University Press.

Weil, S. (2005, April). Art as mirror and gateway: The role of the docent. Paper presented at docent training, Columbus, Ohio.

Wetterlund, K., & Sayre, S. (2003). 2003 Art museum education programs survey report. Retrieved March 30, 2007, from http://www.museum-ed.org/research/surveys/2003mused/index.shtml

Zeller, T. (1989). The historical and philosophical foundations of art museum education in America. In N. Berry & S. Mayer (Eds.), *Museum education: History, theory, and practice.* Reston, VA: National Art Education Association.

FOOTNOTES

[1] The term "docent" is derived from the Latin verb *docere,* meaning "to teach."

The Emerging Role of the Educator in the Art Museum

Glenn Willumson
University of Florida

Art museums have undergone dramatic changes in the last 30 years, and much of that transformation took place in activities that are traditionally associated with museum education. For most of the 20th century, education was considered an addendum to the principal work of the art museum—the acquisition, care, and exhibition of aesthetically pleasing objects. Since the 1980s, however, educators have found themselves increasingly moved into leadership positions as museums struggle to refine their voices in a world of changing demographics, institutional priorities, and political and economic challenges (American Association of Museums, 1984, 2002; Hirzy, 1992). There has been a corresponding shift in the role of the museum curator, traditionally the centerpiece of art museum practice. For most of the 20th century, curators' subject-area expertise and their understanding of the history

and the physical qualities of art objects helped define the mission of the art museum. Over the last quarter century, however, curatorial practices have been challenged externally from the discipline of art history and internally from the administrative halls of the museum (Rosenfeld, 1996).[1] The historical circumstances surrounding curators' loss of their traditional audience and the challenge to their expertise have led to a collapse of the historical hierarchy within the museum, to renewed calls for general public access to exhibitions, and, more broadly, to a reorientation of the museum's mission from objects to audiences (Weil, 2003).[2] These factors, and others, have led to a rise in the status and responsibility of the art museum educator.

In this chapter I trace this shift over the last 25 years and show that the present situation provides new opportunities for constructive engagement within the art museum. As cultural institutions direct more attention to the needs of their audiences, art educators must address how and where subject expertise is valued. I believe that museum education's new status offers opportunities for museum educators to work with their curatorial colleagues to shape art museum practice so that curators can share their knowledge with

the enlarged audiences of the 21st century and educators can find new opportunities to engage museum visitors with the resources provided by curatorial expertise.

Among contemporary cultural critics, the art museum finds itself assailed from both sides of the political spectrum. Challenged by contemporary theorists as elitist anachronisms and by traditional scholars as pandering to a mass populace, art museums are sites of increasing contention. The self-referentiality that has characterized the practice of art history for the last several decades has been directed only recently to practices within museums.

From outside the institution, critics challenged the seemingly intentional ignorance of the museum as it acts as a space of neutral objectivity where quality is rewarded through exhibition. Disputing this romanticized notion of the museum, these critics pointed out the ways that museums structure experience and reception—such as buildings constructed as secular temples and museum visitors shaped into specific states of receptivity by the museum's interior spaces (Duncan, 1995). These critics reminded us of the fiction of the museum as a coherent representational universe, demanding instead that we engage the museum as a site of heterogeneity. The museum's primary public product, the

exhibition, is similarly tainted. Displays of fine art are always problematic when they present objects as a seamless tapestry of some pre-existing "real" history that is separate from its presentation in the space of the museum (Ferguson, 1996). Critics, such as Preziosi (1998), pointed out that exhibitions are not about the recovery of past artistic genius. Instead, he argued, we must understand exhibitions to be about the present and the construction of the past as evolutionary so that we can locate the present moment as the natural outgrowth of a progressive, chronological movement of culture. As such, the objects within the museum must be understood as ideologically laden, shaped by environmental and social conditions that determine their status (Ferguson, 1996). The art, like the museum itself, shapes the understanding of our historical condition and of ourselves, but the museum's insistence on a single, unified narrative fails to acknowledge the contemporary world in which subjects are contingent and positions are contested.

Traditionalists, on the other hand, criticized the ways that the museum's desire for financial stability and the pressure to increase visitation have turned the institution into an entertainment arena, or worse, into a high-end shopping mall (Munson, 2000). As a locus of immense cultural power, they argued, the museum has abandoned its tradition as a place of personal contemplation of

transcendent objects in favor of a social responsibility to its audience and surrounding communities (Cuno, 2004; De Montebello, 2004). They argued that effecting social change is an impossible task and far outside the mission of the art museum. As museums attempt to provide a space for visitors to find their places in the institution, museums are paying closer attention to educational outreach than to the objects that are the cornerstones of their institutions. More subtle is the way that the emphasis on funding encourages self-censorship to avoid displeasing corporate donors or board members (Haacke, 1987). Exhibitions become sites of institutional boosterism that overwhelm any possibility of self-critique. These traditionalists suggested that museums have lost their way, drifting from their primary responsibility as locations in which objects of the highest quality are selected and preserved for the public. Instead, they argued, museums have too easily accepted their new role as social institutions. This conflict over the proper function of the museum has isolated the curator within the institution and, at times, isolated the curator from her or his traditional audience and from the discipline of art history.

Before the 1970s, it was universally understood that the museum's primary responsibility was the acquisition, care, preservation, and exhibition of its fine art collections. As long as this was the principal mission of the museum, the curator was a central figure because of her or his understanding of the history of art and the acquired

skills of connoisseurship. This latter designation is considered by many to be the foundation of curatorial expertise. The support for this function of the curator was institutionalized in the United States in the museum course taught by Paul Sachs at Harvard University between 1922 and 1947 (Alexander, 1997; Kantor, 2002). Entitled "Museum Work and Museum Problems," this course trained most museum directors and curators in the United States. The curriculum included a general understanding of the history of art, specialized knowledge of a particular time and place, and a thorough grasp of the bibliography of art history. In addition, Sachs encouraged his students to cultivate personal contacts with dealers and to develop acute visual recall. The latter was particularly important to Sachs because he believed that curators must first use their eyes, then their knowledge from books. The course did not have a rigid syllabus. Instead, graduate students met in the informal setting of Shady Hill, Sachs' historic and distinctive home, where they were asked to comment on a series of practical problems that Sachs had selected from his previous week's work as assistant director of the Fogg Art Museum. Perhaps the most famous aspect of the class, however, was the exposure students received to his personal collection of objects. He required that every student learn to observe, to describe, and to assess the quality of a series of artworks that he gave them for analysis (Sachs, 1961). This attention to the aesthetic quality of the isolated object was the foundation of connoisseurship and, Sachs believed, a necessity for work in an art museum (Tassel, 2002).

As scholars of museum history have noted, emphasis on the primacy of the object in museum practice can be traced to the 19th century (Conn, 1998; Joachimides, 2000). Sachs' class regularized curatorial activity for most of the 20th century. Most art museums were collecting institutions that understood their social role to be as caretakers of historically and culturally significant objects. Their visitors came to look, wonder, and admire the finest works of, primarily, Western civilization. The collections they formed and the exhibitions they produced reflected the deep interests and personal expertise of curators. Exhibitions were object focused and developed for a number of institutional and personal reasons, but most often with little knowledge of the concerns of museum visitors.[3] Exhibitions were the result of the scholarly activities of the curator whose intended audience was the academic community and others knowledgeable about and interested in the history of art. Curators and their exhibitions were expected to add to the cumulative art historical knowledge about a culture, artistic master, or historical era. Within this model, the exhibition was an individualistic exercise akin to academic scholarship but with original objects at its center (Cuno, 1997).[4] Given this mandate, it is not surprising that curators were not overly concerned with the general public. This audience was outside their purview and was instead the domain of the museum educator.

Educators within this model brought visitors into the curatorial conversation, opened up the exhibition to those outside the discipline of art history, and engaged visitors less knowledgeable about the subject of curatorial enterprise (Zeller, 1989). To help further this communication, curators might supply educators with relevant texts and label copy, provide lectures for docents, or give gallery talks. In most cases, this interaction took place shortly before or after the exhibition opening. Seldom were educators involved in preliminary conversations about the content or development of the intellectual argument for the exhibition. It was assumed by both curator and educator that the primary audience for the exhibition was the scholarly community and that the conversation that the best exhibitions generated should be shared with, but not affected by, the public. This institutionalized "top-down" model—from curator to educator to public—was predominant for most of the 20th century.

By the 1980s, however, the traditional museum hierarchy generally, and the role of the curator in particular, came under increasing pressure (Hudson, 1998). On the surface, the duties associated with curatorial practice did not seem to have changed. The selection and care of objects and their presentation to the public in the form of exhibitions remained the locus of curatorial activity, just as they had for more than 100 years. Nonetheless, as even a cursory glance at the recent history

of museums will show, the authority of the curator among her or his audience and within the institution of the museum began undergoing significant changes because of several factors, including challenges within the discipline and external pressures on the art museum to more actively engage a broad public audience (Cuno, 1997).

The emerging academic practice of art history in the late 20th century—for example, theoretical approaches based on the positions of semiotics, reception, and gender-based criticism—has offered a challenge to those engaged in museum work (Bal, 1996; Preziosi, 2003).[5] This move opened up the field of art history to a productive explosion of scholarship that offered new insights into even the most thoroughly researched works of art. By framing their arguments conceptually, academic practitioners moved away from the primacy of the original object as the centerpiece of academic discourse. For these contemporary academics, objects were often of secondary importance to the ideas and the critique that their methodology could bring to bear on visual culture (Rogoff, 1998). For example, challenging the canon, art history scholars called into question the distinctions between fine and popular art. Furthermore, many of these approaches did not insist on considering a specific original but used a variety of interchangeable objects to illustrate their theoretically rooted arguments. Despite these shifts in the discipline, museum curatorial practice continued to be based on the efficacy of the original object and the methodologies of connoisseurship and formal analysis. The challenge

Troy Smythe
Smythe Consulting

For me, one of the most intriguing aspects of museums is the friction that results when the necessarily risk-adverse philosophies of collection and preservation bump against the typically more audience-centered and experimental philosophies associated with education today. The degree of distance between these two philosophies within an institution may predict the degree of harmony to be experienced while working there as well as the amount of work one side or the other finds it is able to complete. As a profession, it seems we are becoming more aware of "fit" when it comes to deciding which museums are best suited to our philosophical perspectives and values.

of contemporary theoretical approaches to the history of art, at best, rendered less paramount the connoisseurship that had been the basis for much collecting and curatorial practice for over a century, and at worst, disparaged curatorial practice altogether (Haxthausen, 2002).

In addition to these pressures from the discipline of art history, curators found that within their institutions the museum's attention and resources were gradually shifting away from objects and toward an emphasis on audience (Weil, 1999). The American Association of Museums' (AAM) publication of *Museums for a New Century* (1984) called on member institutions throughout the United States to integrate education into all aspects of museum operations. Eight years later, *Excellence and Equity: Education and the Public Dimension of Museums* (Hirzy, 1992) insisted that museums recognize their social role, engage the broadest cross-section of their communities, and reach out to underserved populations. Most recently, yet another AAM publication, *Mastering Civic Engagement: A Challenge to Museums* (2002), called for museums to directly engage their

communities. Following *Excellence and Equity*, educators worked hard to encourage public visitation, particularly among disenfranchised communities. *Mastering Civic Engagement* insisted that this effort didn't go far enough. It asked cultural institutions to engage community members in a fundamental way and to discuss how the museum might best serve the social, political, cultural, and economic needs of the community.

There were many reasons for the AAM's insistence that museums turn their attention to visitors. In 1973, AAM chartered a special executive committee that focused on education. This recognition meant that, for the first time, educators were represented on the AAM council. Museum education was also acknowledged as a separate function in AAM's programming, publications, and regional and national meetings; as a result, special conference sessions were devoted to educational concerns (Lusaka, 2003). It was more than simply a case of educators having a seat at the AAM table, however, that caused the organization to

focus its significant institutional resources on the importance of the educational role of the museum. Other factors were the increasing attendance at public and private museums and the financial challenges of the 1970s and 1980s. Although it is difficult to say for sure whether public outreach or increased visitation came first, it is undeniable that the last two decades of the 20th century saw a tremendous upsurge in museum visitation. This new public was, for the most part, not the art museum's traditional support group of financial benefactors and donors knowledgeable about art. Consequently, museum education departments throughout the United States began to produce programming that would interest these new visitors and would encourage them to return to the museum. Perhaps the most important factors in this reordering of priorities, though, were the economic pressures exerted on the art museum.

As Harris (1999) has pointed out, art museum budgets, relatively stable for most of the post-World War II period, were sharply eroded by inflationary pressures and a steep rise in utility costs during the 1970s. At the same time, the factors that brought about a rise in labor and operating costs also eroded the return on endowments that had supported museums' independence. In the face of these financial shortcomings, art museums turned to federal, state, and local governments for support. The increase in public funding, however, included expectations that the museums would justify this

external support by serving a broad cross-section of the general public. Because this service was initially measured in terms of museum attendance, many art museums soon turned to large, "blockbuster" exhibitions that appealed to the mass public and, often, had the added benefit of increasing membership. Organizing and hosting such large and expensive exhibitions, however, brought new financial pressures that were met by turning to corporate sponsorship to subsidize the travel costs and loan fees. In their attempt to reach both broad and target audiences, the museum administration looked to educators whose role had always included outreach to the public. These outside pressures—organizational, political, methodological, and economic— have gradually reoriented the museum from object to audience.

Too often in the past, museums have responded to, rather than anticipated, change. If museums are to be proactive in accommodating this shift of emphasis to audience, they must assume a leadership position. Curators must continue to engage the discipline of art history and to represent the collections with which they have been entrusted. It is from their place within the museum that one finds the expertise necessary for informed exhibitions. However, the skills involved in the reconfiguration of the museum in the 21st century— understanding and respecting

the knowledge of the museum audience and collaboration—reside in the portfolio of the museum educator (Zolberg, 1994).

Not only have museum educators been the constituency within the museum that has been the voice of the general public, but their understanding and training as educators also gives them a perspective that curatorial preparation lacks. Educators have been trained in a philosophy and methodology of education, not as a "top-down," "teacher-centered" exercise, but as a "student- or visitor-centered" dialogue that, in the art museum, can embrace both the expertise of the curator and the intelligence of museum visitors (Rice, 1995). Few curators have this training. This does not mean a hierarchical replacement of the "objects-curator" by the "audience-educator." Instead, the old hierarchical, curator-centered administrative model needs to be replaced with a collaborative model. Again, museum educators are in a unique position to facilitate a rethinking of the traditional organizational hierarchy of museums. Not only does their educational training put an emphasis on teamwork, but so does their museum practice. Educators have always worked collaboratively with docents, visitors, teachers, school groups, and curators, to name just a few of the educational constituencies. Curators, on the other hand, have been trained as scholars and rewarded for a largely isolated practice that has generated significant art historical

insight. Their expertise is hard-won, but largely personal. A healthy collaboration between educators and curators holds the promise of expanding the curatorial audience and of unlocking varied approaches to the artwork.

Museum educators, with their special training and their tradition of speaking for the visitor, offer the best hope of establishing an institutional model of collaboration that values the expertise of both the curator and the visitor. By working collaboratively, educators and curators can answer the criticism of those who seek a more traditional museum experience and of the academic critique, but they must be given a chance. This newly emerging model will be successful only if institutions place a higher value on internal collaboration and provide time for both curators and educators to engage in this dialogue. Too often, administrators expect collaboration to take place automatically as part of the daily activity of the museum. Inevitably, discussion does take place, but too often it does so within the limitations of the separate spheres of museum practitioners. Museum educators must have time to think of themselves as curators, and curators must have time to think of themselves as educators. What is necessary is a fundamental reordering of museum practice to tie it more closely with the evolving reorientation of the art museum's priorities. The art museum must be proactive and not simply reactive. If leadership is to come from within the institution, educators and curators must have time to develop new leadership models and to rethink how the art museum wants to engage its visitors and how its object collections are instrumental in this effort.

REFERENCES

Alexander, E. (1997). *The museum in America: Innovators and pioneers.* Walnut Creek, CA: AltaMira Press.

American Association of Museums. (1984). *Museums for a new century: A report of the Commission of Museums for a New Century.* Washington, DC: Author.

American Association of Museums. (2002). *Mastering Civic Engagement: A Challenge to Museums.* Washington, DC: Author.

Bal, M. (1996). The discourse of the museum. In R. Greenberg, B. W. Ferguson, & S. Nairne (Eds.), *Thinking about exhibitions* (pp. 201-215). London: Routledge.

Conn, S. (1998). *Museums and American intellectual life, 1876-1926.* Chicago: University of Chicago Press.

Cuno, J. (1997). Whose money? Whose power? Whose art history? *Art Bulletin, 79*(1), 6-9.

Cuno, J. (2004). *Whose muse? Art museums and the public trust.* Princeton, NJ: Princeton University Press.

De Montebello, P. (2004). How museums risk losing the public trust. *Chronicle of Philanthropy, 16*(11), 61-3.

Duncan, C. (1995). *Civilizing rituals: Inside public art museums.* London: Routledge.

Ferguson, B. (1996). Exhibition rhetorics: Material speech and utter sense. In R. Greenberg, B. W. Ferguson, & S. Nairne (Eds.), *Thinking about exhibitions* (pp. 175-190). London: Routledge.

Haacke, H. (1987). Museums: managers of consciousness. In Hans Haacke, *Hans Haacke: Unfinished business* (pp. 60-72). Cambridge, MA: MIT Press.

Harris, N. (1999). The divided house of the American art museum. *Daedalus, 128*(3), 38-43.

Haxthausen, C. (Ed.). (2002). *The two art histories: The museum and the university.* Williamstown, MA: Sterling and Francine Clark Institute.

Hirzy, E. C. (Ed.). (1992). *Excellence and equity: Education and the public dimension of museums.* Washington, DC: American Association of Museums.

Hudson, K. (1998). The museum refuses to stand still. *Museum International, 50*(1), 43-50.

Joachimides, A. (2000). The museum's discourse on art: The formation of curatorial art history in turn-of-the-century Berlin. In S. Crane (Ed.), *Museums and memory* (pp. 200-218). Palo Alto, CA: Stanford University Press.

Kantor, S. (2002). *Alfred H. Barr, Jr., and the intellectual origins of the Museum of Modern Art.* Cambridge, MA: MIT Press.

Lusaka, J. (2003). Equal footing: EdCom turns 30. *Museum News, 82*(5), 12, 52-55.

Munson, L. (2000). *Exhibitionism: Art in an era of intolerance.* Chicago: Ivan R. Dee.

Preziosi, D. (1998). The art of art history. In D. Preziosi (Ed.), *The art of art history: a critical anthology* (pp. 507-525). New York: Oxford University Press.

Preziosi, D. (2003). *Brain of the earth's body: Art, museums, and the phantasms of modernity.* Minneapolis. MN: University of Minnesota Press.

Rice, D. (1995). Museum education embracing uncertainty. *Art Bulletin, 77*(1), 15-20.

Rogoff, I. (1998). Studying visual culture. In N. Mirzoeff (Ed.), *The visual culture reader* (pp. 14-26). London: Routledge.

Rosenfeld, D. (1996). Are we having fun yet? *American Art, 10*(1), 2-5.

Sachs, P. (1951). *The pocket book of great drawings.* New York: Pocket Books.

Tassel, J. (2002). Reverence for the object: Art museums in a changed world. *Harvard Magazine, 105*(1), 48-58.

Wallach, A. (1998). *Exhibiting contradiction: Essays on the Art Museum in the United States.* Amherst, MA: University of Massachusetts Press.

Weil, S. (1999). From being about something to being for somebody: The ongoing transformation of the museum. *Daedalus, 128*(3), 129-162.

Weil, S. (2001). Whose intolerance is it? *Museum News, 80*(3), 37-43.

Weil, S. (2002). *Making museums matter.* Washington, DC: Smithsonian.

Weil, S. (2003). Five meditations. *Museum News, 82*(1), 27-31, 44-7.

Zeller, T. (1989). The historical and philosophical foundations of art museum education in America. In N. Berry & S. Mayer (Eds.), *Museum education: History, theory, and practice* (pp. 10-89). Reston, VA: National Art Education Association.

Zolberg, V. L. (1994). An elite experience for everyone: Art museums, the public, and cultural literacy. In D. J. Sherman & I. Rogoff (Eds.), *Museum Culture: Histories, Discourses, Spectacles* (pp. 49-65). Minneapolis, MN: University of Minnesota Press.

FOOTNOTES

[1] Rosenfeld provides a highly informative but slightly different perspective, discussing the divergence of concerns between those of the curator and those of the director.

[2] Weil was the most widely published and articulate spokesperson for this position. In addition to this *Museum News* article, see also Weil (2002) for the most recent compilation of his essays.

[3] For a history of exhibition practices in the United States, see Wallach (1998).

[4] This traditional understanding of the curator's pivotal role in the museum is widespread in the literature (Cuno, 2004; De Montebello, 2004; Haxthausen, 2002; Kantor, 2002; Munson, 2000; Tassel, 2002; and others).

[5] This split between academic art history and the practice of art history in the museum has a prehistory in 19th-century Germany (Joachimides, 2000).

PART 3

Audiences and Collaborations

Adolescents in the Art Museum: Key Considerations for Successful Programs

Catherine Arias and Denise A. Gray
The Museum of Contemporary Art, Los Angeles

Although museum education programs that focus on teens used to be rare, offerings for adolescents have increased dramatically over the last 10 years (Schwartz, 2005). Still, not much has been documented about these programs, particularly as they pertain to art museums. General reports on teen museum education programs are provided anecdotally, through presentations at annual conventions of the National Art Education Association and the American Association of Museums or through assembling research from colleagues, as former Museum of Modern Art Deputy Director for Education Deborah Schwartz did for a 2005 *Museum News* article. Our attempts to search major education and humanities databases for combinations of the keywords "teens," "art," "adolescents," and "museums" yielded few results written in the last 20 years. Indeed, a librarian at the Library of Congress suggested that we would need to create documentation through careful surveys of individual institutions' practices.

Without offering such a definitive survey here, we provide an overview of art museum programs for teens[1] and outline key considerations, presented as a set of questions, for practitioners interested in developing, evaluating, and reframing programs for adolescents. Our description of a program at the Museum of Contemporary Art, Los Angeles, supplies a lens through which practitioners may view their methods.

Museums and Teens: A Complex Match

Increased abstract thinking and sexual maturation link teens to their adult selves. As they transition from childhood, adolescents struggle to form individual identities while experimenting with different social roles (Biehler & Snowman, 1997). Put in perspective, adolescents "go through great emotional, cognitive, and social transformations. Out of these changes emerges a pattern of thought and volition that defines the self. Erik Erickson … has called it ego identity; when successfully achieved it is a stable feeling of confidence that one knows who one is" (Csikszentmihalyi & Larson, 1984, p. 8).

What can art museums offer teens that no other institution can? The answer depends on a variety of factors, including the museum's institutional culture, community needs, and participating teens' interest. Teens and museums are arguably an awkward match, as this description by a Los Angeles student in her university newspaper suggests: "Your stiff leather shoes squeak on the linoleum, breaking the reverent hush. Wisps of timid conversation circle the room as sterile and white as a hospital bed sheet, then float up to the 20-foot ceiling. Two men in crisp black suits frame the doorway and caress their walkie-talkies as you pass by. Is this an FBI showdown at St. Mary's Church? No, it's just another Sunday at the local museum" (Fiore, 1997, ¶ 1).

This student's choices of imagery, vividly evoking not only the heavy hand of law enforcement, but also the hospital-like sterility and the sense of awe found in sacred spaces, humorously captures the range of intimidating associations that museums can provoke for young people. As museum educators, we are acutely aware of this potential within our institutions, yet equally attuned to the rich possibilities that encounters with works of art can offer. As a RAND Corporation report puts it, "The 'distinctive fruits' of interactions with art are the development of the individual's capacity to perceive, feel, and interpret the world of everyday

experience" (McCarthy, Ondaatje, Zakaras, & Brooks, 2004, p. 47). The report goes on to describe how aesthetic experiences, through deep engagements with works of art, offer individuals an "extended capacity for empathy" (p. 47) as well as cognitive growth.

Through sustained contact with teens, the museum can provide opportunities for them to practice adult roles. Youth involved in *You Want to Be a Part of Everything: The Arts, Community, & Learning,* a report from the 2003 Arts Education Partnership forum said, "In a successful community, young people have an opportunity to take on adult roles and responsibilities and, with mentoring, prepare to negotiate the world they will inherit as adults" (Smyth & Stevenson, 2003, p. 12). As museum educators, we understand these benefits to be particularly well suited to a youthful audience who seek ways to make sense of their world and avenues to participate in it. But how can we create spaces and experiences that will ensure that teens get the most out of the time, effort, and risks they take to participate? Museums have answered this question in a variety of ways.

A Look Across the Landscape of Art Museum Teen Programs

Acknowledging that programs and endeavors may overlap, we have created a short list of common museum teen program formats. We outline these program types to show the many avenues museums have for teen participation. Other formats that might belong on this list are more typically found under the categories of school or community programs, such as tours or residencies. Each of these program emphases addresses any of a range of characteristics, including different levels and durations of commitment by teens and staff, varying objectives and outcomes, and changing levels of involvement within each museum and its broader community.

1. *Classes or workshops in art history or studio art* are available at many institutions around the country, including New York's Metropolitan Museum of Art, Solomon R. Guggenheim Museum, Museum of Modern Art (MOMA), Bronx Museum of the Arts, Cooper-Hewitt National Design Museum, and Studio Museum of Harlem, as well as the Los Angeles County Museum of Art (LACMA) and Museum of Fine Arts, Houston. These offerings complement school-based art education in settings that allow participants to interact with original works of art. Some classes geared toward curatorial or conservation careers offer an onsite glimpse into museum operations.

2. *Juried or open-call student exhibitions* provide opportunities for teens to display their artwork and learn about the processes involved in planning, marketing, installing, and staffing exhibitions at institutions like the San Francisco Museum of Modern Art, Contemporary Arts Museum Houston, SITE Santa Fe in New Mexico, and Hunter Museum of American Art in Chattanooga, Tennessee.

3. *Projects directed or advised by teens* offer opportunities to work collaboratively on publications, websites, or public programs. Walker Art Center's well-known teen advisory council takes on an array of highly visible programs and projects, including artist residencies, student exhibitions, and workshops in Minneapolis and St. Paul. Boston's Institute of Contemporary Art hosts both a teen council and a video production program. In New York, the Museum of Modern Art's Red Studio and Whitney Museum of American Art's Youth2Youth.org projects extend the museum experience to the Internet. In Pittsburgh, teens involved in different programs at the Andy Warhol Museum "take over" the museum in a week-long series of events and create publications. The art lab program of the Aldrich Contemporary Museum of Art in Ridgefield, Connecticut, involves students in projects over the course of a school year. At both the Museum of Contemporary Art, Los Angeles (MOCA) and the Whitney Museum, teen interns plan events including evenings for teens.

4. *Events created for teens* may or may not be organized by students, but they are open to the larger teen community. A single event allows teens to explore a museum, often with special features such as music, artmaking, and refreshments, without making a long-term commitment. In addition to those mentioned above, MOMA's film series for teens and MOCA's Teens of Contemporary Art offer drop-in activities.

Elizabeth Mackey

Los Angeles County Museum of Art

Participants in LACMA's High School Internship Program have been providing tours to their peers and younger students since 1998. The content and presentation of tour training has evolved over the years. Currently, the intense, seven-session preparation covers developing key themes or ideas; researching and compiling related and appropriate supporting information about the art and artists; designing a short sequence of engaging, open-ended questions; and practicing skills needed to facilitate informal experiences. This past year, the interns described what they were doing as "directed conversations." They commented that when their tone and approach were more conversational, their groups seemed more comfortable and engaged. The interns felt these were genuine experiences rather than ones shaped by a script or predetermined outcome.

5. *Volunteer and paid internships,* such as those found at MOCA and LACMA, the Aldrich, San Francisco's Yerba Buena Center for the Arts, the Studio Museum, the Whitney, the New Museum, MOMA, and SITE Santa Fe allow teens to join museum staff as long-term participants in the work of the museum. These programs typically involve mentoring and professional skill development as well as activities to encourage critical thinking. We take a more detailed look at the MOCA Apprenticeship Program later in this chapter.

6. *Teen docents* conduct tours, usually to school groups, at a number of institutions including the Aldrich, Whitney, Bronx Museum, Brooklyn Museum, Hudson River Museum, Palm Springs Art Museum, and LACMA. Participants gain knowledge of artworks on view, training in educational philosophies and methodologies, public speaking skills, and work experience.

Determining the format and content of an art museum teen program depends on several factors, including funding, staff, and facilities; the position of the education department within an institution; and the voices of teens to shape the program. In our experience, teen program managers have sought us out as a "sounding board" for changes they contemplate making to inherited programs they find are poorly matched with either their institutions or their participants. We have also met with a number of educators who direct inspiring, visible, high-impact programs that both their institutions and participants embrace. We turn our attention now to key questions that program managers must consider for effective implementation and evaluation.

Key Considerations

No one strategy will work for all settings, nor should one format remain in place forever. Over time, the mechanics of a program may shift to reflect changes in its aims.

We present these considerations as a set of questions about audience needs and characteristics, museum culture and intentions, and resource limitations and possibilities. These considerations may be revisited at any time during the teen program to assess and articulate its goals, impact, and direction. We conclude with a description of our own MOCA Apprenticeship Program, not to offer a model to be emulated, but to provide a lens through which practitioners might view their own decisions and plans.

Meeting Audience Needs and Characteristics: A Checklist
Understanding the teen audience requires sensitivity to its diversity. While some teens may seek an introduction to a creative community, others may be looking to refine their knowledge of art through professional experience. Such differences spring from teens' individual and community histories, including their access to creative resources and to people who encourage cultivation of their interests. Museum educators must be mindful that such everyday issues as transportation, program cost, competing activities, and required commitment play roles in the decision of each teen to participate. As the SURDNA Foundation report *Powerful Voices: Developing High-Impact Arts Programs for Teens* explains, these realities inform recruitment and retention strategies as well as program format and content. "Program leaders must be willing to undertake a labor-intensive approach to recruiting and retaining students— especially those from communities

and families under stress" (Levine, 2002, pp. 7-8). The level of a teen's commitment to a program should be proportional to the benefits he or she stands to gain from it.

Needs assessment:
• What needs do teens in the community have that are not served by other organizations? Which of these needs might the museum be uniquely situated to serve?

Brevity for greater numbers versus depth for fewer:
• Drop-in, public programs may generate larger numbers but involve briefer commitment while long-term, core-group-based programs entail sustained relationships with fewer participants. Is one format more appropriate or feasible than the other?

• Might a combination be desirable?

Benefits of participation:
• Why should teens want to participate?

• What benefits do they stand to gain, whether or not they are aware of or can articulate these benefits ahead of time?

Teen involvement in planning:
• What role do participants have in determining program goals and direction?

Requirements for participation:
• Are special skills or qualifications necessary to participate?

• What is the best way to screen for these skills or qualifications?

Demographic representation:
• Should participants hail from diverse ethnic, cultural, and socioeconomic backgrounds; educational and arts experiences; and different genders?

• Or, instead, should participants represent a specific segment of a community's teens?

School involvement:
• Will schools be involved in recruiting teens for the program?

• If so, how will the program differentiate itself from, or associate itself with, school activities?

Timing:
• When is the best season and time of day to involve teens?

• How does a museum program fit into teens' other schedule demands?

Duration and retention:
• How long should teens remain involved to benefit from the program?

• What strategies are necessary to retain teens for that period?

Size:
• How many participants can the program sustain? Is there room for growth?

Museum Culture and Intentions: A Checklist

Art museums may have many agendas for reaching teens: to develop underserved audiences, to build future generations of art enthusiasts and patrons, or even to be perceived as "cool" destinations (Leimbach, 2005; Schwartz, 2005). How well the goals of a teen program dovetail with those of the institution determines the program's prominence. For many, such as the programs described in *Powerful Voices*, "program leaders have had to work hard to articulate the importance of their goals within the context of a larger organization.

Where they have succeeded, it is because their programs play a vital role in connecting their institutions to the larger community" (Levine, 2002, p. 10).

Institutional commitment:
• How committed is the institution to the teen audience? What is the nature of that commitment?

Benefits for the museum:
• What benefits does the museum stand to gain by attracting teens?

• How might a teen program support the museum's mission and strategic plan?

Institutional history:
• What historical and current educational and exhibition programming relates to the institution's work with teens?

• What marketing, visitor services, and audience development initiatives might relate to teens?

Advocates:
• Who are the potential stakeholders of a teen program outside of the education department but within the museum staff?

Facilities:
• What access to space and facilities can program participants have?

Difficulties:
• What potential obstacles or pitfalls might a teen program encounter within the museum?

Research:
• Are there resources to track participants' museum involvement over time?

Resource Possibilities and Limitations: A Checklist

We see the resources within and available to this audience as multilayered, encompassing relationships with museum staff; institutional support though funding, spaces, and supplies; and, perhaps most important, the input of teen participants. While advocacy for a teen program within an institution may result in increased resources, taking stock of what is realistically available will help determine the possibilities for program activities and sustainability. Educators must consider what resources the teens themselves find most valuable. Such investigation may lead to creative uses for existing resources.

Available resources:
- What staff resources—both intangibles ones such as expertise, experience, and interest and concrete variables like time and money—can be dedicated to the management of a teen program?

Expertise:
- Has staff researched and gained experience in adolescent development issues as well as techniques in group facilitation and evaluation?

Funding:
- Are there resources for expenses, including supplies, transportation, and food?

- What ongoing funding commitments can ensure long-term impact?

Access to professionals and objects:
- What access to collections, staff, artists, or other speakers might be granted to teens?

Community resources:
- What resources exist in the museum's immediate surroundings?

- How might these be marshaled for teens?

- What relationships does the museum have with external institutions and individuals involved with teens, such as schools and teachers, arts organizations, and community agencies?

Evaluation plan:
- How might success be assessed and evaluated?

Visibility:
- What opportunities for immediate and far-reaching visibility might the program have?

Key Considerations of the MOCA Apprenticeship Program

Emerging from a broader community outreach program, the MOCA Apprenticeship Program (MAP) began in 1995 with a group of students from one nearby high school. Since then, its curriculum, format, and the role of program managers have evolved.

Apprentice Needs and Characteristics

At present, apprentices include a group of 16 high school students from a broad cross-section of Los Angeles area schools, including public and private, small and large, in low-income and affluent neighborhoods. We select apprentices through a process of applications and interviews, seeking teens who express high motivation for learning about contemporary art and museums, as well as for joining a creative cohort of peers. Skills such as artistic technique are less important than the potential to benefit from and contribute to the projects, discussions, and social fabric of the apprentice group. Weekly meetings throughout the school year are like seminars or committee meetings with exhibition explorations, art and career discussions, and

events planning. The apprentices are official MOCA staff members with museum badges and an hourly wage and often take on optional work projects in various museum departments. For many apprentices, the program offers their first work opportunities, such as joining staff meetings, representing an institution to the public, and receiving a paycheck. In an anonymous program evaluation, one former apprentice identified these aspects as her most important program experiences, because they led to "feeling a part of the museum."

The apprentices have abundant differences, but the program offers a setting where they choose to be with others who share their focus on art. At their best, and with guided facilitation by two adult program managers, apprentices capitalize on the importance of their peer relationships to form a diverse, supportive group in which each member thrives. Challenges such as unbalanced participation and communication issues arise, but a range of cooperative learning techniques and activities that address multiple learning modes can help minimize frustration, encourage openness, and build community as apprentices gradually get to know each other. Groups of teens who gather together consistently can become resources for each other, building a network of "social capital" that girds their group affiliation and individual identity. Robert Putnam, Harvard University professor of public policy, found that social capital brings "a civil society together around common pursuits founded on mutual trust. Three elements

characterize situations where social capital is likely to develop: *bonding* among individuals of like interest; *bridging* between individuals of diverse backgrounds, cultures, or assumptions; and *repetition* of activity, wherein close interaction takes place on a regular basis" (Levine, 2002, p. 18).

MOCA Institutional Culture and Intentions

Apprentices identify themselves as serious art enthusiasts or artists (whether visual, performing, or literary), a match that fits with the museum's artist-centered mission. MOCA's Chief Curator Paul Schimmel commented, "One thing that defines a contemporary art museum in contrast to other kinds of museums is what is at its center. For us … the artists are at the center. We are there to serve their vision" (Lord, 2003, p. 12). This perspective is important for us to recognize as we evaluate and merge apprentices' goals with those of the museum.

Viewing and discussing contemporary art offers novel and multifaceted opportunities to explore topics our teens rarely learn about in school. In the galleries, apprentices examine works by constructively contemplating questions like, "Why is this art? What does this mean? How am I supposed to respond? Why should I care?" Consequently, MAP's focus is not exclusively on conveying content supplied by museum objects, but on creating a stimulating context in which teens consider the art. Apprentices become attuned to the constructs of the museum—its white walls, for example, or the information it provides (or does not provide) about its objects, point of view, or intended messages. They question, like many contemporary artists do, why works are culturally significant, or whether certain works, movements, or artists are merely "hyped" through art historical and critical practices. Contemporary art, then, becomes rich inspiration for powerful discussion and debate.

MAP Resource Possibilities and Limitations

MAP's budget provides for apprentice wages, supplies, and activities. However, the program relies strongly on museum staff, community partners, program participants, collections, and exhibitions to allow a comprehensive look into the art and museum world. Guest presenters offer another bridge to the adult world and show apprentices that careers in the arts span a wider range than they might have guessed. After meeting with a curator, one apprentice wrote, "I began to see myself as a curator, and I asked myself, 'What kind of exhibitions would I make?' I could see them in my head, and I really liked the ideas I had."

Adolescents gain entrée to an adult creative community when they have opportunities to learn directly from a range of arts professionals who demystify the world of art, humanize artistic efforts, and bring up influences and challenges in their fields. After a period of familiarization with contemporary art and the museum, apprentices often seek to share its resources. Planning, implementing, and evaluating longer-term projects collaboratively and independently create opportunities for both reflection and action. Expanding the program's reach to include hundreds of teenagers and other community members, past apprentice activities have included a family event featuring artmaking, face painting, and piñatas; a panel discussion and live painting demonstration and workshop; and an evening event offering high school students exclusive access to museum galleries, live entertainment, an open-call student exhibition, and refreshments. Not only do these experiences tie MAP to MOCA's broader institutional profile, but they are also highly motivating learning processes for the participating teens. "The National Research Council report (1999) *How People Learn: Brain, Mind, Experience, and School* states, 'Social opportunities … affect motivation. Feeling that one is contributing something to others appears to be especially motivating. … Learners of all ages are more motivated when they can see the usefulness of what they are learning and when they can use that information to do something that has an impact on others—especially their local community" (quoted in Smyth & Stevenson, 2003, p. 13).

Conclusion

Museums are poised to offer adolescents deep and rewarding engagement with works of art, career and personal development, and identity-building experiences. Teens, in exchange, can enrich and expand a museum's audience and community presence. As these programs continue to proliferate and evolve, participants and managers must increase ways of sharing their experiences and results with colleagues and the broader community. In our view, a more informed dialogue will not only enrich our institutional practices, but also broaden opportunities for the youth we seek to serve.

REFERENCES

Berk, L. (1993). *Infants, children, and adolescents.* Needham Heights, MA: Allyn and Bacon.

Biehler, R., & Snowman, J. (1997). *Psychology applied to teaching* (8th ed.). Boston: Houghton Mifflin.

Csikszentmihalyi, M., & Larson, R. (1984). *Being adolescent: Conflict and growth in the teenage years.* New York: Basic.

Fiore, K. (1997, September 22). From ivory towers to hipper hangouts. *Daily Bruin.* Retrieved September 26, 2005, from http://www.dailybruin.ucla.edu/DG/issues/97/09.22/ae.museums.html

Leimbach, D. (2005, March 30). To get teenagers into the gallery, turn up the heat. *The New York Times.* Retrieved September 26, 2005, from http://www.nytimes.com/2005/03/30/arts/artsspecial/30teen.html

Levine, M. N. (2002). *Powerful voices: Developing high-impact arts programs for teens.* New York: SURDNA Foundation Report.

Lord, M. G. (2003, April 23) A city where locals are welcome. *The New York Times,* p.12.

McCarthy, K., Ondaatje, E. H., Zakaras, L., & Brooks, A. (2004). *Gifts of the muse: Reframing the debate about the benefits of the arts.* Santa Monica, CA: RAND Corporation.

Schwartz, D. F. (2005). Dude, where's my museum? Inviting teens to transform museums. *Museum News, 84*(5), 36-41.

Smyth, L., & Stevenson, L. (2003). *You want to be a part of everything: The arts, community, & learning.* New York: Arts Education Partnership. Retrieved November 15, 2005, from http://www.aep-arts.org

FOOTNOTES

[1] When we use the terms "teen" or "adolescent" here, we refer to high school students. In educational and psychological literature, adolescence refers to a stage of human development that may span the ages of 11 through 21 (Steinberg, 1989, as cited in Berk, 1993). Although developmental characteristics of this stage factor into practitioners' pedagogical choices, and while some programs designed for youth serve middle school and college-age audiences, our focus is the unique circumstances of teens in high school.

Beyond the Field Trip

Margaret K. Burchenal and Sara Lasser
Isabella Stewart Gardner Museum

The class trip to the art museum—what do you remember about yours? A standard feature of museum education programs, the field trip is still extensively used by schools and community groups to introduce young people to museums. Most art museums devote enormous resources to these visits, even though they are commonly planned as self-contained events with little connection to the classroom curriculum. At the same time, many museums have developed partnership programs that involve administrators, teachers, students, and their families in extended experiences—either throughout the course of a single school year or over the course of many years. Because of the Isabella Stewart Gardner Museum's primary focus on developing and sustaining partnerships with area schools and community groups, we use it here to illustrate and explore the nature of successful partnerships. We will discuss the benefits of professional development, collaborative curriculum development, and family involvement.

Why Partnerships?

Partnership programs usually develop out of a desire, primarily on the part of museum staff, to create more meaningful connections with young people and their teachers. Dissatisfied with the traditional one-shot museum visit, museum educators across the country have initiated programs that promote deeper ties with schools and community organizations. These partnership programs feature a series of lessons (often divided between the classroom and the museum) that make the museum an extension of the classroom (Newsom & Silver, 1978). Students and teachers alike have benefited from the learner-centered teaching strategies that museum educators have developed over the past 30 years (Mayer, 2005), and museum educators have learned about school and community group culture through the ongoing dialogue of collaboration. While the specific outcomes need to be studied more closely (Adams & Luke, 2000; Falk & Dierking, 1997), the perceived benefits have been significant enough to sustain the many existing partnerships nationwide and to encourage the formation of new ones on a regular basis.

"MANY VOICES"

Cass Fey
Center for Creative Photography
at the University of Arizona

As a museum educator, you cannot underestimate the importance of teachers as collaborators in conveying the possibilities of learning from original works of art in the museum. To encourage teachers to experience the museum as a resource for learning, I create guides for educators about particular exhibitions or works from our collection. The guides are not written for particular grade levels or subjects; they are written for the average interested and curious teacher who culls the offerings of aesthetic, biographical, contextual, and social information for connections to her curriculum. The educators' guides are supplemented with workshops and training sessions for teachers in the museum where we pool our knowledge to develop strategies for learning both in the museum and in the classroom. Not surprisingly, the teachers who invest in this kind of partnership are energetic, and they reward your efforts with insights into student learning and development.

Partnership programs bring museum and school staff together to make something wonderful happen for kids. By visiting a museum multiple times, students have opportunities to see a variety of art works and to practice their skills of making meaning from actual art objects. In addition to museum visits, true partnerships include:

• Professional development for teachers

• Artist programs

• Outreach to families and the community

As a result, the museum becomes an exciting extension of the classroom. Partnerships help young people and their teachers feel comfortable in the museum and build strong ties with their families and the community at large.

Today's emphasis on standardized testing has caused many schools to focus almost exclusively on activities perceived as leading to better test performance, often leaving arts programs to languish. But for some schools, museum partnerships that promote visual learning offer a range of experiences that can help students learn important concepts in new and engaging ways. A recent survey found that the primary goal of most multiple-visit programs is to help students learn how to look and that many museum educators see art-looking as an important critical thinking skill (Adams & Luke, 2000). Many museum educators believe that sustained art-looking experiences (like multiple-visit or partnership programs) help

students develop fundamental critical thinking skills that can be applied to subjects across the curriculum (especially reading and writing) (Deasy, 2002; Fiske, 1999). Although the claims that art programs positively affect the cognitive development of students has been disputed (Winner & Hetland, 2000), current research is developing support for this belief. Housen (2002) demonstrated a strong link between a classroom-based art-looking program and higher standardized test scores in the Byron, Minnesota, school district, and two quasi-experimental research studies looking at this issue have been conducted at the Gardner Museum in Boston and the Solomon R. Guggenheim Museum in New York City (Burchenal & Grohe, 2007).

What Do Partnership Programs Look Like?

School-museum partnerships come in many different shapes and sizes (Hirzy, 1996; Newsom & Silver, 1978; Pitman & Hirzy, 2004). Recent years have even seen the formation of museum schools where the entire curriculum is museum based (Takahisa, 1998). The Gardner program is an example of the most common kind of partnership program, in that it primarily involves:

• Students in grades 3-5

• Classroom and museum experiences

• Three to four museum visits

• Ongoing professional development for teachers

• A strong emphasis on family involvement

The formation of a partnership signals the interest of both museum and school staff in collaborating on a long-term basis to achieve shared goals. The Gardner's School Partnership Program, for instance, grew out of the museum's interest in working more closely with neighborhood schools. At the same time, the schools were interested in broadening opportunities for their students by making the museum an integral part of their curriculum. A look at the track of three fourth-grade classes from the Farragut School in Boston illustrates the School Partnership Program.

The Gardner Museum-School Partnership Program

The school partnership program at the Gardner serves five public schools within walking distance of the museum. Because we work with third-, fourth-, fifth-, and eighth-grade students and their classroom teachers, many students participate in the program over several years.

In the fall, we meet with all of the school partnership teachers by grade level to discuss goals for the school year and to schedule classroom and museum visits. A typical discussion starts with ideas based in the school curriculum and then expands to incorporate museum goals. For instance, when we met with the Farragut fourth-grade teachers at the beginning of the 2004-05 school year, they expressed a strong interest in museum visits connected to their mythology unit. To avoid having the collection become simply an illustration of a classroom concept, we expanded the general theme for the year to stories in art. This more-inclusive theme met the needs of the teachers and at the same time brought us closer to our goal of fostering careful observation and lively discussion.

In addition to this collaborative curriculum planning, we provide opportunities for formal and informal professional development throughout the year, including a day-long teachers' institute in the fall, a half-day teachers' retreat in the spring, invitations to lectures and other public programs at the museum, and a holiday reception for school and community partners. Time for thoughtful planning is one of the most critical components of the partnership process. Flexibility is another key component, as the lesson plans for the partnership program tend to evolve throughout the year with input from both the museum educator and the classroom teacher.

Students visit the Gardner three or four times a year (sometimes more often); each museum visit is preceded by a preparatory classroom lesson led by a museum educator. Our teaching philosophy is based on the Visual Thinking Strategies (VTS) curriculum developed by Housen and Yenawine (2000). This open-ended inquiry method promotes the use of critical thinking skills and encourages active group discussion to make meaning from works of art through careful looking.

Each museum visit is preceded by an hour-long classroom lesson led by museum staff. Although activities vary during these hour-long lessons, students typically engage in a series of VTS discussions about images from the collection that relate to the theme of the upcoming museum visit. During most classroom visits, Farragut fourth graders discuss three or four slide images over the course of the hour, practicing observation and communication skills. In addition to image discussions,

Elizabeth Gerber
Los Angeles County Museum of Art

Evenings for Educators, started by the Los Angeles County Museum of Art in 1977, continues to be a well-received professional development program for K-12 educators. One of the strengths, and I think a reason for its success, is the program's continued commitment to providing intrinsically motivated, self-selected learning opportunities. Participants, choosing from a range of sessions, can attend scholarly lectures, gallery tours, studio workshops, and film screenings, while also having the option of using the museum's Teacher Resource Center or exploring permanent collection galleries on their own. While many teachers attend the program for professional development credit, to receive curriculum materials, or to learn new teaching techniques, educators overwhelmingly indicate that they participate for their own personal growth.

the class might also participate in a reading or writing project or explore noncollection objects that students can touch. Regardless of the activity, the teaching method is open-ended questioning.

Museum visits generally last about 2 hours and take place before the museum is open to the public. Students spend the first hour in the galleries looking carefully at and discussing two or three works of art with a museum educator. As these conversations unfold, the museum educator listens carefully for themes that emerge in the students' shared thinking. We frequently offer students the opportunity to sketch or write about what they see in the galleries. We use our observations of responses to these activities to develop future studio projects based on students' interests.

The second hour of the museum visit takes place in the studio focusing on an artmaking project that directly relates to themes explored in the galleries. For example, all of the Farragut fourth graders' studio projects this year were based on the idea of storytelling. Using a variety of materials, students made characters that they later brought back to the classroom to use as inspiration for stories. As one of their last projects, they learned how to create accordion books for the stories they had written.

Family involvement is encouraged throughout the year by providing free admission buttons to participating students and teachers. To celebrate the partnership, each school works with museum staff to organize their own family night in the spring when students and their families are invited to a special evening at the Gardner. Students proudly showcase the artwork that they have created over the year and engage their

guests in short activities and active image discussions similar to those they have experienced with their classes. This is a great opportunity for parents and museum staff to meet each other and share their experiences and ideas about the partnership program. For many parents, family night is the first time they have ever come to the museum or have seen the artwork their children have created through the partnership program.

As the school year comes to a close, teachers, school administrators, and museum educators come together to discuss the year's activities. These meetings give us a chance to reflect on our shared goals and determine whether they were met, as well as to generate ideas for next year's curriculum.

Deepening Partnerships Through Artists-in-Residence Programs

One of the key components of several school partnership programs, the Gardner's included, is an artist-in-residence program (Burchenal, 2000). In these programs, artists, after careful planning with museum and school staff, work with students over an extended period of time on a collaborative project. The benefits of residency programs are many, but in our view, the primary purpose is to give students the chance to work closely with adults who have devoted their lives to the creative process.

Although artist-in-residence programs vary, most depend on local artists who have consciously developed skills in working with K-12 students in classrooms or museums. Other museums commission artists to engage the surrounding community (Henry, 2004). Each year, the Gardner's residency program, designed primarily to support emerging artists, brings five or six artists in a variety of disciplines (not just visual artists but writers, composers, choreographers, etc.) to live and work at the museum for a month. Education and contemporary department staff work together to identify the artists who would be best suited to return the following year to work with young people in either the school or community partnership program.

For example, photographer Abelardo Morell was the catalyst for programs with fifth-grade classes from two of our partnering schools. The program began with a visit to an exhibition of Morell's photographs at the museum in which students learned about the special kind of equipment that Morell uses and the way he approaches making pictures. He set up his view camera and invited students to peer at a painting through the lens of the camera—and of course they were surprised to see the image upside down.

Students were then given disposable cameras and asked to photograph their own lives—as Morell had—with the eyes of an artist. Through this activity, they gained a better understanding of the choices artists make. Later Morell visited both classrooms to

talk individually with the students about their photographs. Each student then chose one picture to be enlarged, matted, and shown at the neighboring Massachusetts College of Art gallery in an exhibition called *The Artist's Eye*. Students titled their photographs and wrote short labels explaining the significance of their works.

Community Partnerships

In addition to school partnerships, many museums form partnerships with community organizations. The Gardner Museum has developed a collaboration called *Art à la Carte* with the nearby Museum of Fine Arts and Federated Dorchester Neighborhood Houses to serve local teens. In this multi-visit program, participants go behind-the-scenes at the two institutions to learn how museums work. The teens also visit local artists' studios and commercial galleries, work together on group projects, learn the basics of gallery administration, and design their own end-of-the-year exhibition.

As in all partnerships, planning time and ongoing communication are essential. Museum staff and teachers from the community organization meet three times in early September to discuss the program's theme, curriculum, and schedule for the school year. For a theme on nature and the environment, students explored how ancient and contemporary artists used symbols of nature in their art. Through museum explorations and studio projects, the program brings students together over the course of the school year to look at art, discuss ideas, practice various artmaking techniques, and develop their own opinions about images.

Why Museums Partner With Schools and Community Organizations

Successful partnerships benefit everyone involved—museums, schools, and community organizations. Developing sustained, multi-year relationships with students and teachers creates satisfying, interesting experiences for museum educators that single-shot field trips usually do not. These relationships also provide museum staff with unique opportunities to explore schools' cultures and needs in depth, ultimately resulting in richer, more effective programming.

Working closely with a group of teachers over time helps museums expand their educational capacity. By training teachers how to use art in their lessons, sharing teaching strategies, and continuing to foster teachers' personal interests in art and museums, museum educators can start a chain reaction with students. As teachers begin to build connections between the museum and their curriculum outside of partnership visits, they reinforce the value of the museum and advocate for it as a resource for learning and pleasure in a much more effective way than a museum educator could alone. In addition, museum educators have long held that long-term, multiple-visit partnerships encourage young people to feel at home in museums and use them as resources for life-long learning (Adams & Luke, 2000).

One of the biggest goals of such partnerships is to engender a group of young people who possess the skills they need to navigate any art museum. Teachers, parents, and young people alike relate that through participation in the programs, students from a variety of backgrounds have developed a sense of belonging in museums, a comfort level in talking about art and sharing sometimes divergent ideas with each other, and an eagerness to make personal connections to works of art. Because we work with our surrounding neighborhood, these experiences can help create support for the museum throughout the community.

In addition to developing the museum-based skills of learning to make meaning from works of art, young people in partnership programs have the opportunity to explore aspects of the museum that are typically off limits to regular school or community groups. By observing educators, conservators, and curators at work, students learn that museums provide a wide variety of jobs, offer creative ways to understand and interpret the past, and present novel ways of addressing contemporary issues. One example is a lesson taught by a conservator using a fragile textile from storage. After a period of careful looking, the fifth-grade students immediately started asking questions, making suggestions for treatment, and debating the pros and cons of these options. When the conservator pointed out to the students that their conversation had been exactly like one that a group of conservators would have about

the textile, the students exhibited a real sense of pride. Students left the museum empowered, envisioning that they could someday hold that kind of position in a museum.

Why Develop Museum Partnerships?

Teachers, parents, and young people themselves all tell the same story: participation in partnership programs profoundly affects their attitudes towards art and museums (Carr, 2003). Students from diverse backgrounds learn to feel comfortable in the museum environment and develop the important skills of looking at, thinking about, and making personal connections to works of art. "This partnership program has brought the community together around art and has welcomed the community into the museum," said one school principal. Said another, "This collaboration creates innovative ways for teachers to help meet city and state learning standards and a supportive and stimulating environment in which students are encouraged to express their opinions and ideas."

Museum partnership programs offer schools creative solutions to real educational needs, providing satisfying professional development for teachers and important skill development for students. As the partnership progresses, classroom teachers who initially relied on museum staff for guidance may create their own ways to use the museum. For instance, a history teacher uses a Renaissance artist's version of an ancient Roman legend to illuminate how a series of events can spark public outcry when her students explore the causes of the American Revolution, and an English teacher brings her students to the museum for a project in which students write stories inspired by paintings. Barry and Villeneuve (1998) and

Villeneuve, Martin-Hamon, and Mitchell (2006) documented similar faculty use of a university art museum.

Our engagement in the school and community partnership programs have shown us the students' museum experiences can:

• Develop critical thinking skills that transfer to other subject areas (Housen, 2002);

• Make a curriculum concept more vivid

• Promote active learning and discovery

• Offer a learning environment that is distinctly different from the classroom, and provide ways of learning that reach students in different ways—frequently students who are less engaged in the classroom will shine at the museum

• Provide professional development models that focus on constructivist educational philosophy

Assessing the Success of Partnership Programs
Because most successful partnerships build thoughtful reflection into their annual activities, the assessment process might range from year-end debriefing sessions to evaluation by outside experts. Assessment activities typically look at the partnership as a whole or student outcomes.

During the first 4 years of the Gardner School Partnership Program (1996-2000), an outside evaluator worked closely with school and museum staff to look at how the partnership was developing and to suggest improvements.

We are currently involved in a more ambitious research project designed to demonstrate exactly how our school partnership program helps students develop critical thinking skills. Along with projects at the Solomon R. Guggenheim Museum[1] in New York and the Wolfsonian Museum in Miami, the Gardner is attempting to define and measure critical thinking skills developed through an art-looking program.

Recommendations for Creating Successful Partnerships
Partnership programs can offer satisfying, enriching experiences for all participants, but they require a significant amount of time and energy to develop (Hirzy, 1996). The most successful partnerships grow out of an enthusiastic commitment to collaboration and the conviction that partnering is the most effective strategy to achieving certain goals. To develop a successful partnership:

• Start small: be realistic about what you can achieve in the allotted time

• Understand the needs of your partner(s)

• Identify and seek partners that share pedagogical approaches that are similar to your own programming

• Make sure you get buy-in from key constituents: ensure that everyone knows what the partnership is and why it is important to both sides

• Document your activities in a variety of ways so you can share the excitement with administrators and parents

• Invest in the time necessary to develop shared goals and review them regularly

• Remain flexible: plan as much as you can, but be prepared to change as necessary

• Remember to have fun!

Challenges of Partnership Programs
Like any relationship, partnerships need ongoing attention; after the initial excitement of getting together subsides, the hard work of keeping things interesting begins. If you keep your communication open and honest, problems can be quickly solved, and new ideas can regularly surface for discussion and implementation. Keeping things fresh is made easier because museums themselves change regularly through special exhibitions, gallery reinstallations, or artist residencies.

Partnerships that set clear goals and strategically document annual activities and achievements are more likely to survive personnel changes at either the museum or school. While new staff may adjust goals or activities to reflect their own needs and interests, careful documentation promotes a sense of shared history and understanding of what has worked (or not) in the past.

Even once a partnership is well established, it is important to make time for experimentation, reflection, and assessment. Every year offers the opportunity to try something different and to evaluate results. Perhaps that is one of the major benefits of partnership programs for museums and schools: as partners we share in the excitement of working together in new ways to create deeper and more meaningful arts experiences for young people.

REFERENCES

Adams, M., & Luke, J. (2000). *Multiple-visit museum/school programs in the arts: What do students learn?* Annapolis, MD: Institute for Learning Innovation.

Barry, A. L., & Villeneuve, P. (1998). Veni, vidi, vici: Interdisciplinary learning In the art museum. *Art Education, 51*(1), 16-24.

Burchenal, M. (Ed.). (2000). *The eye of the beholder: Contemporary artists and the public at the Isabella Stewart Gardner Museum.* Boston: Isabella Stewart Gardner Museum.

Burchenal, M., & Grohe, M. (2007a). *Thinking through art: The how and why of an urban school/museum partnership at the Isabella Stewart Gardner Museum.* Boston, MA: Isabella Stewart Gardner Museum.

Burchenal, M., & Grohe, M. (2007b). Thinking through art. *Journal of Museum Education, 32*(2), 111-122.

Carr, D. (2003). *The promise of cultural institutions.* Walnut Creek CA: AltaMira Press.

Deasy, R. J. (Ed.). (2002). *Critical links: Learning in the arts and student academic and social development.* Washington, DC: Arts Education Partnership.

Falk, J. H., & Dierking, L. D. (1997). School field trips: Assessing their long-term impact. *Curator, 40*(3), 211-218.

Fiske, E. B. (1999). *Champions of change: The impact of the arts on learning.* Washington, DC: Arts Education Partnership.

Henry, D. (2004). Artists as museum educators: The less told story, *Museum News, 83*(6), 44-47.

Hirzy, E. (Ed.). (1996). *True needs, true partners: Museums and schools transforming education.* Washington, DC: Institute of Museum Services.

Housen, A. (2002). Aesthetic thought, critical thinking, and transfer. *Arts and Learning Journal, 18*(1), 99-132.

Housen, A., & Yenawine, P. (2000). *Visual thinking strategies: Learning to think and communicate through art.* New York: Visual Understanding in Education.

Mayer, M. (2005). Bridging the theory-practice divide. *Art Education, 58*(2), 13-17.

Newsom, B., & Silver, A. (Eds.). (1978). *The Art Museum as Educator.* Berkeley, CA: University of California.

Pitman, B., & Hirzy, E. (2004). *New forums: Art museums and communities.* Washington, DC: American Association of Museums.

Takahisa, S. (1998). A laboratory for museum learning: New York City Museum School. *Journal of Museum Education, 23*(2), 5-8.

Villeneuve, P., Martin-Hamon, A., & Mitchell, K. (2006). University in the art museum: A model for museum faculty collaboration. *Art Education, 59*(1), 12-17.

Winner, E., & Hetland, L. (Eds.). (2000). The arts and academic achievement: What the evidence shows. *Journal of Aesthetic Education, 34*(3-4).

FOOTNOTES

[1] For a report, see http://www.learningthroughart.org/research_findings.php

Family Learning in Art Museums

Karen C. Gerety Folk

Nerman Museum of Contemporary Art
Johnson County Community College

Families are a potentially large portion of art museum audiences. Demographic studies reveal that 60% of science museum visitors are families with children (McManus, 1994), and researchers have studied families in various types of museums over the past several decades. However, there is no published research at present specifically for art museum educators to reference when developing programs for family visitors. This essay includes practical suggestions based on a review of the literature on families and museum learning, a discussion of my own research study of current practices in art museums related to family education, and a conclusion with recommendations for further research.

What Is a Family Group?

According to Leichter, Hensel, and Larsen (1989), families are unique social groups because they come to museums with shared personal history, special relationships, and a sense of comfort. They discuss museum objects in terms of prior knowledge, experience, and memories (Falk & Dierking, 2000). However, defining "family" in practical terms for educational programming remains problematic. To construct a definition, I asked 134 staff members from midwestern art museums for their definitions of family groups, and responses fell within two general categories: Some individuals wrote definitions broad enough to include school groups as "adults with children," and others specified various personal connections, with conditions such as living together or having a role in a child's upbringing outside of school (Gerety, 2005). Families might have children of various ages, from preschoolers to teenagers, but when they have at least two intergenerational members, family groups most likely bring a range of education and life experience to their museum visits. In this chapter, then, I will consider family groups as intergenerational individuals who share personal connections.

Families Visiting Museums

From the beginning, motivation plays a factor when individuals decide to visit museums (Csikszentmihalyi & Hermanson, 1995). Museums compete with a variety of leisure-time activities that might entice families, and, according to Hood (1989), parents and children tend to go to museums primarily for social interaction and entertainment. Once families enter installation and exhibition spaces, though, they might enjoy cognitive challenges as they try to understand and appreciate the objects they encounter. Therefore, art museum educators might consider visitors' motivations to learn, to have fun, or both, when developing family programs.

Every member in a family group might have different art educational experiences, and museum educators might aim to help people with different types of prior knowledge to form connections with art objects. In her study of visitors to an exhibition of African art at the Carnegie Museum of Art in Pittsburgh, Stainton (2002) discovered that groups with more previous experience were able to focus on aesthetic issues, to view the exhibition as a whole, and to make culturally based observations of the art objects. According to Stainton, these visitors could grasp themes easily because

they already had a foundation of basic knowledge. When developing programs with family groups in mind, then, educators might consider how some people will have an interest in art history, and they might have already developed the conceptual frameworks necessary to put art into context. Some children might ask their parents questions about the works they encounter, and parents may or may not know the answers, while some children might have more art education than their parents.

In addition to varying degrees of art education, individuals in a family group might have different learning styles and cognitive abilities. These psychological factors might influence visitors' behavior in art museums, including tendencies to read wall labels, use self-guided materials, participate in interactive spaces, or even discuss works of art. Researchers in cognitive psychology have identified types of learners, and these types might describe individuals in a family group. McCarthy's (1997) 4MAT system delineates cognitive patterns typical of four kinds of learners: affective, analytic, spatial, and dynamic. Following McCarthy's model, art museum educators might accommodate different learning styles by providing opportunities for visitors to construct their own learning experiences, engage in verbal and spatial exploration, and form personal connections with works of art.

According to Gardner's (1999) theory of multiple intelligences, everyone is born with the potential to excel in various cognitive areas: linguistic, logical-mathematical, musical, spatial, bodily-kinesthetic, intrapersonal, interpersonal, and naturalist. Gardner (1988) argued that there is no single track that visitors must follow to learn in museums, so educators should develop a variety of ways to engage those visitors. In accordance with Gardner's theory, Davis (1996) and Harvard's Project MUSE developed a set of cards to help museum visitors look at works through narrative, quantitative, foundational, aesthetic, and experiential frames corresponding with various cognitive aptitudes. As the models suggest, art museums can become places where individuals with different dominant types of intelligence are nurtured simultaneously. Educators offering learning experiences for a cognitively diverse population might be more likely to reach individual family members.

Meanwhile, research has shown that family groups demonstrate certain behavioral patterns during museum visits, and art museum educators might acknowledge this innate behavior when developing programs. As science museum educators have found, some family groups separate while others stay together (Dierking, 1989). Some family members work as coordinated teams (McManus, 1994), and individuals might reunite to talk about their experiences and develop a collective understanding of the museum visit (Ash, 2003). Families

might have personal conversations relating to the museum visit that continue at home (Ellenbogen, 2002). Behavioral studies of families at other types of museums might inform art educators and help them structure programs to better suit their visitors. Offering a range of options, with some programs more structured than others, might appeal to a broader base of families visiting art museums.

Current Practices in Art Museum Education

Family education in art museums is a relatively new endeavor, and professionals in institutions across the country have been experimenting with various approaches that have yet to be documented in a general publication. To examine current practice and elicit ideas that might influence future practice, I conducted a descriptive research study (Gerety, 2005). I selected 134 individuals representing every art museum in the midwestern region to participate in a survey, and I interviewed 7 of the 48 individuals who returned questionnaires. From the study, I collected both qualitative and quantitative data revealing common practices, ideals, and circumstances related to family education in the region's art museums. Research questions focused on identifying family visitors, types of programs, educational goals, staffing, and administrative support. The following paragraphs include a discussion of results.

First of all, survey results showed that families were visiting art museums, but they made up only an average of 20% of museum audiences (Gerety, 2005). Although a minute subgroup at some art museums, families were a majority of the visiting public at others. Overall, an average of 33.6% of program attendees were family groups, and an average of 46.6% of family groups attending programs were repeat visitors. These figures collectively suggest that family education is a relevant endeavor for art museum staff to consider, and perhaps it is possible to build a large audience base by targeting families.

Most individuals surveyed indicated that at least some of their programming was family-oriented, and 92% reported that they had at least one type of family program on the checklist provided on the questionnaire (Gerety, 2005). However, a closer look at the types of programs participants described revealed some discrepancies regarding target audiences. Five survey respondents specified that their "family" studio classes were for children, and six others described summer programs for children as studio classes offered to family groups. A few individuals cited adult-oriented films as "family" programs, and some stated that they had speakers for adult audiences.

Despite age-related discrepancies, looking at the types of materials and programs museums were offering with families in mind might reveal directions educators currently are taking as they strive to better meet their visitors' needs as social units. "Family days" were among the most common type of educational program offered

Table 1. Type of Family Programs and Materials.

*Note: Among the 21 "other" types of programs, performances, poetry readings, and puppet shows were recurrent types

Type	f	%
Family Days	33	68.8
Studio Classes	26	54.2
Self-Guided Materials	35	72.9
Tours	34	70.8
Interactive Spaces	20	41.7
Films	17	35.4
Speakers	22	45.8
Online Materials	20	41.7
Other*	21	43.8
None	4	8.3

to families, along with tours and self-guided materials (see Table 1). According to the brief descriptions given, family days typically were scheduled less than once a month and included a variety of programs such as studio components, performances, tours, and films.

To investigate educational content of programs geared toward families, I collected printed self-guided materials from interviewees, and I developed an evaluation checklist using Villeneuve's (1996) criteria for youth activity sheets as a model. One activity I received had both basic art appreciation questions as well as artists' biographical information (Gerety, 2005). The questions were generally sophisticated as they encouraged visitors to look carefully at details, such as texture, and to consider the artist's vantage point. Another activity sheet included a "children's worksheet" section with questions about the work and comments relating to the overall thematic concept, followed by an

"information for parents" section with art historical information and ideas for further discussion. These types of activities with different approaches to art learning and multiple levels of difficulty might serve to engage each individual in a family group, not just the more naïve family members.

In addition to educational content, the structure and scope of gallery activity sheets might be tailored to facilitate family learning. Presenting family groups with options might allow them to maintain their innate social dynamic as they choose objects and customize their museum experiences. Allowing visitors to map their own paths might make activities more appealing to family groups with individual members who have different interests. Some activities I collected were part of a series, which is another way for educators to address multiple interests and to encourage

subsequent visits (Gerety, 2005). Creating multiple activities would require more work for museum staff, but self-guided materials do not necessarily have to be graphically designed; two of the samples I collected were made on word processors and printed on plain paper, indicating that activity sheets could be an inexpensive yet educationally valid option to offer family visitors.

Related to self-guided materials and family days, a few museums had family membership programs to encourage subsequent visits (Gerety, 2005). One museum encouraged families to use a series of activity sheets, obtain credit for program attendance, and win art-related prizes. Although this particular program seemed to be designed primarily for preschoolers, it could serve as a model for educators wanting to unify multiple types of programs that appeal to both children of all ages and adults in family groups.

Interactive spaces were not as common as self-guided materials among the institutions surveyed, but as technology becomes increasingly prevalent, more art museum educators might look for ways to incorporate interactive elements into gallery spaces. These spaces have proven to be successful for family learning in natural history museums (Borun,

Chambers, Dritsas, & Johnson, 1997). Indeed, four survey respondents indicated that they planned to add interactive elements to their galleries in the future, and some participants already offered interactive spaces varying from "20 interactive areas designed to stimulate interests of different kinds of learners" to simple "computer terminals" (Gerety, 2005).

The Internet might also be explored as a medium through which to educate families planning to visit art museums. Some survey respondents said they already provided basic information online, and others mentioned interactive activities or online guides for families (Gerety, 2005). One museum had a printable tour for families, which included object images, art historical information, and child-centered questions. Visitors might look over the script at home and then bring it with them to the museum for a self-guided or a docent-led tour. Another museum offered a virtual tour feature on the website, and a third museum had still images of people in the interactive galleries, giving visitors a visual preview of what to expect when they visit. One museum had "Tips for a Family Visit" on the website, with practical information, pointers for looking at art, and activity ideas to keep family members focused on the works of art in the galleries. As these four web sites indicated, educational components online might help adults and children familiarize themselves with what a museum has to offer prior to their visit.

Although not all participating museums offered family programs at the time of the survey, their educational philosophies and missions may indicate the types of programs that they might develop in the future. As responses suggested, many museum staff members were thinking about various ways to engage visitors in looking at art while promoting social interaction (Gerety, 2005). Individuals' comments regarding their educational philosophies generally reported a solid educational basis upon which family programming might be built, particularly as most participants recognized social aspects of museum learning and maintaining a focus on art objects as essential to museum education. Audiences with different learning styles, art education as a process, discipline-based educational paradigms, and a concern for general accessibility were included in participants' educational philosophies. All these components could contribute to the development of quality educational family programming.

While the educational foundation is an important first step toward facilitating family learning in art museums, administrative variables might impede educators trying to reach out to new audiences. Half of all participants surveyed commented on their financial situations. Some made positive remarks, but others reported difficulty developing family programs due to funding (Gerety, 2005). Most of the individuals who mentioned staffing as an administrative issue did not have sufficient personnel to develop family programs. Thirteen participants said that their

"MANY VOICES"

Lauren Brandt Schloss
Queens Museum of Art

Museums need also to be mindful of the range of English-language abilities within a single family. The Queens Museum of Art is located in a county that has the current distinction of being the nation's most diverse. In this borough of New York City, over 120 languages are spoken and over half the households are headed by people born outside the United States. Seven of 10 residents are immigrants or children of immigrants. We have observed that the English-language level of the children is often higher than that of the parents and that the children therefore often serve as a point of entry into the museum experience for their parents.

Further, we have learned that in order to develop transformative experiences for immigrant adults within the museum, we need to develop programs that are multigenerational. We have observed that social and recreational activities undertaken by immigrant adults are usually family activities involving their children and their own parents. We have also observed that immigrant adults tend to privilege the education of their children over their own. Family programs geared towards New Americans should make apparent the value of the learning experience for the child(ren) and can then captivate the attention of the parents and offer meaningful learning experiences to them as well.

priorities lay elsewhere; seven said that family programming was not supported because they were university museums. In contrast, the other nine participants working at university museums did offer some type of family programming, and they thought of families as part of their communities at large. Therefore, the survey results demonstrate that having a target audience does not necessarily prevent university art museums from reaching out to the general public.

The survey results also suggested that the size of the institution is not necessarily a restriction, as the majority (62.5%) of survey respondents worked in small

museums with budgets under $3 million, and many small museums had at least some family programs (Gerety, 2005). Furthermore, the interviewees from small museums demonstrated that even one person could successfully develop and implement various educational opportunities for family groups. These individuals collaborated with other staff members, including curatorial and membership departments, and they brought in volunteers to help implement family programs. Even art museums with small staff and little funding might find creative ways to educate families.

Implications for Future Programming and Recommendations for Research

One way to identify the needs and interests of current and prospective museum visitors is to ask people what they think. Focus groups could help art museum educators engage families in their community, as some survey participants used focus groups for program planning, in effect expanding their constituencies from the onset (Gerety, 2005). General feedback from the community might even serve as evidence of the need for family education at institutions with other priorities.

After identifying a target audience, art museum educators might turn to other institutions as models. As the interview results showed, some educators were working on fine tuning their existing family programs, and other museums might benefit from their experimentation. For instance, while two educators thought their programs were offered frequently enough, two individuals mentioned having fewer but more intensive programs. In regards to future programming for families, three individuals would like to overhaul their museums' resources for families by adding either activity packs or an entire resource room designed for family learning. On a smaller scale, one participant would simply like to improve the self-guided activity sheets offered to families.

The survey and interviews yielded descriptions of many practical examples of family programs, ranging from complex, large-scale initiatives to simpler endeavors (Gerety, 2005). Therefore, I recommend that art museum educators consult other art museum professionals to see how various formats and structures have worked for them. At the same time, educators should keep in mind that content and scope of programs will vary with each museum collection and facility. Identifying what their museum has to offer families, that is, whatever makes their museum a location where families can have an aesthetic experience unlike anywhere else in the community, might be a good place to begin. One survey participant stated, "Sharing art together is a unique kind of family experience, different from other recreational or leisure activities. The art museum should attempt to make the most of that experience."

Furthermore, conducting case studies of art museums with high family attendance in other regions might help educational researchers to assess current practices on a national level. My study allowed me to describe general practices in art museum education for family groups in the midwestern region, and different results might surface through a study of practice in other regions. Researchers might also take a critical look at specific family programs, such as tours, looking for trends in thematic content and structure.

Conclusion

While some aspects of family education might seem intuitive, further research can help art museum staff develop educational programs and materials that meet the needs of families while fulfilling their museums' missions. The art educational content of museum programs might be carefully examined considering family members of all ages, with various degrees of prior art knowledge, and with different learning styles. Understanding the social dynamic families bring to the museum might help educators design practical and accessible programs. Perhaps someday the majority of art museum visitors will be families, as is the case for science museums, but an institution-wide committed effort toward reaching a diverse general public is an important initial goal to have in place. I contend that developing programs and materials for families will open art museums to all learners, and opening art museums to all learners will attract more families.

REFERENCES

Ash, D. (2003). Dialogic inquiry in life science conversations of family groups in amuseum. *Journal of Research in Science Teaching, 40*(2), 138-162.

Borun, M., Chambers, M., Dritsas, J., & Johnson, J. (1997). Enhancing family learning through exhibits. *Curator, 40*(4), 279-295.

Csikszentmihalyi, M. & Hermanson, K. (1995). Intrinsic motivation in museums: Why does one want to learn? In J. Falk & L. Dierking (Eds.), *Public institutions for personal learning: Establishing a research agenda* (pp. 67-77). Washington, DC: American Association of Museums.

Davis, J. (1996). *The MUSE book.* Cambridge, MA: The President and Fellows of Harvard College.

Dierking, L. (1989). The family museum experience: Implications from research. *Journal of Museum Education, 14*(2), 9-11.

Ellenbogen, K. (2002). Museums in family life: An ethnographic case study. In G. Leinhardt, K. Crowley, & K. Knutson (Eds.), *Learning conversations in museums* (pp. 81-101). Mahwah, NJ: Lawrence Erlbaum.

Falk, J. & Dierking, L. (2000). *Learning from museums: Visitor experiences and the making of meaning.* New York: AltaMira Press.

Gardner, H. (1988). Challenges for museums: Howard Gardner's theory of multiple intelligences. *Hand to Hand: Children's Museum Network, 2*(4), 1-7.

Gardner, H. (1999). *Intelligence reframed: Multiple intelligences for the 21st century.* New York: Basic Books.

Gerety, K. (2005). *Family learning in art museums.* Unpublished master's thesis, University of Kansas.

Hood, M. (1989). Leisure criteria of family participation and nonparticipation in museums. In B. Butler & M. Sussman (Eds.), *Museum visits and activities for family life enrichment* (pp. 151-169). New York: The Haworth Press.

Leichter, H., Hensel, K., & Larsen, E. (1989). Families in museums: Issues and perspectives. In B. Butler & M. Sussman (Eds.), *Museum visits and activities for family life enrichment* (pp. 15-50). New York: The Haworth Press.

McCarthy, B. (1997). A tale of four learners: 4MAT's learning styles. *Educational Leadership, 54*(6), 46-51.

McManus, P. (1994). Families in museums. In R. Miles & L. Zavala (Eds.), *Towards the museum of the future: New European perspectives* (pp. 8l-97). New York: Routledge.

Stainton, C. (2002). Voices and images: Making connections between identity and art. In. G. Leinhardt, K. Crowley, & K. Knutson (Eds.), *Learning conversations in museums* (pp. 213-257). Mahwah, NJ: Lawrence Erlbaum Associates.

Villeneuve, P. (1996). True to the object: Developing museum youth activity sheets that educate about art. *Art Education, 49*(1), 6-14.

Moving Beyond the Classroom: Learning and the World of the Art Museum

Gillian S. Kydd

Roberts Creek, British Columbia, Canada

The Open Minds program, which began in Calgary in 1993, allows teachers to move their classrooms to a community site such as a museum, zoo, or nature sanctuary for an entire week. The week is a catalyst for a long-term study developed by the classroom teacher. An educator at the site assists teachers in planning a week that fits their needs and those of their students, and thus each week is unique. The main characteristics of the program are the following:

- Students are immersed in the site all day, every day, for a week, allowing them to slow down and take ownership of their surroundings.

- The classroom teacher is in charge and plans experiences that fit into a long-term curriculum-based plan.

- Students and teachers are offered choice and are viewed as independent learners.

The school field trips in most museums are very different from this alternative concept. Typically, the students come for only one day, and often for a half day or less. A staff person or volunteer guides the class, and the classroom teacher remains in the background. Because the teacher has little ownership of the experience, often there is not much done at school before or after that relates to the field trip. Michèle Gallant from the Glenbow Museum, an Open Minds site, commented:

Traditionally, school programs are based on a museum educator's interpretation of the school curriculum, and sometimes, but not always, on consultation with teachers or curriculum specialists. Rarely is a program co-developed, assessed, and continuously refined, or even rewritten by museum educators and teachers working together in a symbiotic relationship. In lacking meaningful collaboration, the programs may be based on the museum educator's beliefs and perceptions of what teachers want and need. (Gallant & Kydd, 2005, p.74)

This chapter describes the Open Minds program, using examples of student learning at the Glenbow Museum and other sites.

Mark and His Class

This room is filled with imagination and beauty. The feeling I got is under the sea. I like the reflection of these bubbles. The bubbles are like dream bubbles. Bubbles near the edge look like hearts. There are lights to make the reflections.

Eight-year-old Mark wrote those words as he lay on the floor in an installation called *Release*. His grade-three class was immersed for a week in the world of the Glenbow Museum in Calgary, Alberta, Canada. There were long periods of time for the students to visit exhibitions that appealed to them, and a surprising number of children chose to revisit each day the room they called the "bubble room." The installation, by artist Sophia Isajiw, consisted of light sources hitting glass spheres suspended at various heights with many reflections on the ceiling, walls, and floor of a small space. Each afternoon we found six or seven children sitting or lying there, writing and drawing in their journals. During sharing time, their teacher, Susan, linked their observations of the light beams and the heart shapes at the corners with content from their geometry and science classes.

Nora Christie
Amon Carter Museum

While the programs highlighted in this section sound wonderful, budget cuts and stricter teacher-accountability measures within U.S. school districts have made it almost impossible for teachers to bring their students to area art museums more than once a year, if that. Perhaps it is time for museum educators to look for more opportunities to integrate the museum into the classroom. Many museums have already begun to experiment with offering distance learning programs and online curriculum guides. What other programs can we develop to break down the barriers between classroom and museum and help students develop their thinking skills?

Another group gathered daily at the foot of the sculpture called *Aurora Borealis* that soars upward within the central staircase at the museum. James Houston created this twisting column of prisms that shimmers and seems to dance just like the northern lights. The feeling is reinforced by music that is heard every half hour. Luke wrote: "I never noticed that the *Aurora Borealis* the first time I came to Glenbow was so big. The *Aurora Borealis* was made of crystals while the Glenbow was being made but it had to be made inside the Glenbow. The *Aurora* has come to life. I can hear the music but it's very low. The lights change every second."

This ability to slow down, to really see, and then to record their ideas does not happen with every child in an art museum. What happened with this class to give them those skills—those habits of mind? Why are those skills important, and how can we help every child to learn in this way?

How Did This Happen?

Susan and her class came all day, every day, to the museum for a week, and each day included a mixture of programs and long periods of time when the students could choose where to write and draw in their journals. Susan had planned the week long in advance with guidance from an experienced educator at the museum who acted as a facilitator. The week was part of a long-term interdisciplinary study; since September Susan had been teaching her students the skills of descriptive writing and drawing and how to look at art and objects using Feldman's (1967) critical viewing process. They had been studying Alberta's history in social studies, and thus they knew much about the historical exhibits at Glenbow before they arrived. In science, they had been studying geology, and so the rich mineralogy exhibit of the museum reinforced the concepts learned at school. They had taken trips to a natural area near the school that overlooked the center of Calgary so they could see where the museum was. During their week downtown, Susan took them along a street that has many historical buildings, and they went up a tower to gain another perspective of the geography of the city. After returning to school, Susan's class created their own class museum using exhibition techniques they had learned. There was an evening celebration for family members, and other classes in the school toured during the day.

The Calgary program now operates at 11 sites, with 6,500 students taking part each year (Savill, 2006). The concept has spread to other cities in Canada (Vancouver, British Columbia; Edmonton, Alberta; and London, Ontario), to Michigan (The Big Lesson at seven sites near East Lansing) and to Singapore (Canadian International School). In total, 12,000 students per year are learning in this way in their communities. Cheryl Babin, an Open Minds program coordinator, wrote from Singapore:

*The Asian Civilisations Museum is wonderful, and the opportunities for students to be highly engaged are exceptional. Indian dancing, playing Indonesian gamelan music, creating their own **bas reliefs**, and a phenomenal array of artifacts to write about and draw during journal times are all part of this week-long experience. The grade-three focus was on art in Singapore so we also incorporated the history of the architecture and the bronze sculptures displayed along the river outside of the museum. Student background knowledge of different types of art and religion helped them to feel comfortable going into the galleries. One of our Muslim teachers taught the students about Islam and the fundamentals of the religion. They even had the opportunity to write their names in Arabic. They were able to recognize the symbol of Allah in the*

Arabic calligraphic pieces in the West Asia gallery. Our students are from all over the world, and many have traveled to the countries of Asia. They felt tremendous ownership for pieces that came from their own countries. One student from Myanmar, named Minh, found that he could explain the symbolism and Buddhist images to his classmates. For Minh, this was his first chance to be an expert in our English-speaking school. What a brilliant success story for him! (personal communication, 2004)

Learning

Key writers have informed the philosophy and practices of the Open Minds program. Eisner (1998) talked about the importance of learning to see, of slowing down, of becoming the connoisseur and critic. Duckworth (1996) stressed the importance of providing interesting primary experience and the time to value wonderful ideas. She said that if we give people experiences that engage them, that evoke a sense of wonder, and if we give them the opportunity to explain their ideas, then those thoughts will lead to further ideas and questions. Gardner's (1991) theory of multiple intelligences emphasized that humans see the world through different lenses and learn in different ways.

Falk and Dierking (2000) presented the contextual model of museum learning that considers the museum experience from personal, sociocultural, and physical contexts.

The personal context covers areas such as how motivated visitors are, whether they can make links to prior knowledge, and how much choice they are given to pursue what interests them. The sociocultural context describes how people learn in groups and through mediation. This is where the opportunity to talk and to share is so important. The physical context addresses the actual setting, the structure, and the concrete objects and experiences. Important in this context is the notion of novelty. When humans are in new situations, they may be too anxious to be able to slow down and learn. Appropriate orientation information provided ahead of time can lessen the uncertainty and enable them to focus.

Falk and Dierking (2000) acknowledged the importance of time. Much more learning can occur when the museum visit extends over several days. The novelty effect is decreased, and there is more time to revisit chosen exhibitions, more time to really "see." As Holtschlag (2000) said about her experiences with her program in Michigan, which is based on the Calgary concept, "Students take time at the museum. … taking time to process information is a key to remembering and a key to making meaning" (p.17).

The Open Minds programs in Calgary and other communities that have used a similar concept have placed these learning theories into practice. Such long-term study at an art museum—or another site, such as a wetlands, zoo, or city hall—provides these common elements:

- Teachers and museum educators work together. The art museum visit is part of a long-term interdisciplinary study at school designed by the teacher.

- Students are given extended periods of time, usually a week, to become immersed in their surroundings, overcoming the "novelty effect."

- Students make sense of installations and pieces of their choosing, enhancing critical viewing, descriptive writing, and drawing skills acquired at school.

- Teachers are given their own learning opportunities at the museum before the visit. They are equipped to help their students acquire the necessary skills, and they also become powerful role models.

Why Are Art Museums and Other Community Resources Vital to Education?

The world of the art museum could and should be playing an integral role in the education of our children. School-based educators and others often mistakenly view museum visits as peripheral experiences to what happens in the classroom, where they believe "real" learning takes place. Many educators, however, are beginning to realize that even the most

creative teachers are limited by the environment of the classroom and that deep learning takes place when children are immersed in rich experiences in the community. The art museum is an ideal catalyst for the habits of mind that help students to be creative, curious, and thoughtful. The results of giving students and teachers these experiences include:

- Learning to slow down and see the world in all its nuances

- Enhanced writing skills

- In-depth learning in many curriculum areas

- Increased independence of thought and critical thinking skills

- Growth in awareness of diversity

- Increased student ownership of art institutions

If one thinks about Mark, the student in Susan's class, and considers what was happening for him that year, it becomes more obvious why we should be teaching children in this way. As far as the museum was concerned, there were positive results. Mark was focused on a piece of contemporary art. He knew how to slow down and interpret the piece thoughtfully. He learned to value museums—and that learning extended to his family and to other museums. A year later his mother described how their family had visited the Provincial Museum in Edmonton, how much they had enjoyed the exhibits, and how they had all written and drawn

in their journals (Kydd, 2004). When he is an adult, Mark will likely visit museums frequently and take his children there.

But what has happened to Mark in more general terms from this experience, and is that of value to our society? Let's consider something as basic as writing skills. Since the program began, the classroom teachers have observed that their students' writing skills improved. Children wrote more— and more descriptively—when they had these experiences. To investigate this further, Cochrane (2000) carried out a research project that focused on the writing skills of students who had participated in Open Minds. She tested 12 classes of grade-three students from both major school districts, half of whom were taking part in the program at Glenbow Museum School, Zoo School, or Bird Sanctuary School. She tested each class in the fall with an open-ended writing task. Four months later, after six of the classes had been at a site, she administered a second writing task. All the writing was marked using the Alberta grade-three writing test rubric. Cochrane found that the control group, those who had not been part of the program, had an increase of 6% in writing achievement, not uncommon for a 4-month time span. The test group, however, showed an increase of 24% in writing achievement. As Cochrane suggested, this is not simply the result of spending a week at a site, but is rather the outcome of months of work in the classroom on learning how to observe and to write descriptively.

Gaining knowledge is another area that most people think is basic to education. How can Mark's hours in the "bubble room" enhance his knowledge acquisition? Remember how he noticed how the beams of light made heart shapes in the corners and how he used the word "reflection" in his writing? As noted earlier, his teacher used those observations to make connections to the science topic of light and to their study of geometry. For learning to be more than superficial, children must be able to see connections between abstract concepts and real life. Mark was also connecting many other school topics with his experiences that week, such as geology in the rocks exhibit and Canadian history as he sat in the railway exhibit.

But even more important is that Mark and the other students were learning how to learn. All year Susan had been helping them with thinking skills: she modeled curiosity and the thirst to find out more. Making choices, slowing down, really looking, and wanting to find out more are critical in our society. The abilities to learn and to think critically are essential when knowledge is changing so rapidly that it is impossible for our students to leave school with all that they need to know.

Recommendations for Practice

The essential factors that create this depth of learning include the following:

- The visit to the museum is a catalyst for an extended study at school.

- The visit is several days, preferably a week.

- The teacher is "in the driver's seat"—he or she is integral to the planning and teaching.

- The experiences at the museum are planned to fit with the needs of each teacher and his or her class.

- The teacher learns how to teach viewing, writing, and drawing skills.

Museum Educators

It isn't always possible to incorporate all those elements into student visits. Even if a museum's programming consists of half-day or one-day visits, the following can improve learning:

- Don't always focus on older students; younger students tend to be more open and more willing to slow down. Older students are products of an education system that often gives them little choice and few skills for approaching something new. The dreams start early, and that is where you can have more impact.

- Value teachers. Recognize that most are creative people who know their students. Have museum staff act as facilitators and resources and allow the classroom teacher to be the leader.

- Provide time and choice for students. When they have the skills and the interest, they have longer attention spans than adults.

- Realize that programs have value, but limited value. It is the observation time that students remember, and that is where the power lies.

- Work with teachers ahead of time through planning meetings and in-service training. Find out what their needs are.

Teachers

- Take your students to community sites like art museums as frequently as possible and try to be there for several days in a row. In our experience, repeat visits spread over weeks or months don't have the same results, likely because the novelty effect is present to some extent with each visit.

- Choose sites carefully and incorporate the necessary skills and knowledge into your teaching. Visit the site ahead of time and provide your students with information such as a map, what is planned for the visit, where the toilets are, and where they will eat lunch.

- Teach your students how to write descriptively in a journal and how to draw, building these habits into regular classroom activities.

- Model journal writing yourself.

- Invite parents to join the class and value their assistance.

- Give students choice and time; small groups work better than a large group.

- Work with museum staff as colleagues. Be confident of your own knowledge and skills and respect theirs.

It is time to break down the barriers between the world of the museum and the world of the classroom. School as we know it today is a fairly recent phenomenon where children are separated from the community to learn. Teachers cannot be expected to educate them well in a vacuum. There are rich resources and expertise in our communities that could be an integral part of our education system. Both sides—the museum world and the school world—must work together, valuing each other's strengths and basing every decision on what we know about how people learn. Then we may see more work like this from a grade-six student in Calgary:

Inukshuk[1]

Though it has no eyes to see,

no ears to hear, and no mouth to speak,

it is the guardian of the People

They build it to mark where they have been and to bring good

fortune or bad. On the spot it stands.

It is the Inukshuk, built by the Inuit people

If you cannot understand its silence, you will not understand its words.

REFERENCES

Cochrane, C. (2000). *Creating thoughtful writers: A study of the Campus Calgary/Open Minds program.* Unpublished master's thesis, University of Portland, Portland, OR.

Cochrane, C. (2004). Landscapes for learning. *Educational Leadership, 62*(1), 78-81.

Duckworth, E. (1996). *The having of wonderful ideas.* New York: Teachers College.

Eisner, E. (1998). *The enlightened eye.* Upper Saddle River, NJ: Prentice-Hall.

Falk, J., & Dierking, L. (2000). *Learning from museums.* Walnut Creek, CA: AltaMira Press.

Feldman, E. (1967). *Art as image and idea.* Englewood Cliffs NJ: Prentice Hall.

Gallant, M., & Kydd, G. (2005) Engaging young minds and spirits: The Glenbow Museum School. In R. Janes & G. Conaty (Eds.), *Looking reality in the eye: Museums and social responsibility* (pp. 71-84). Calgary, Alberta: University of Calgary.

Gardner, H. (1991). *The unschooled mind.* New York: Basic Books.

Holtschlag, M. (2000). The big history lesson. *Visitor studies, 3*(3), 15-17.

Kydd, G. (2004). *Seeing the world in 3D: Learning in the community.* Victoria, BC: Trafford.

Savill, P. (2006). *Open Minds/ Campus Calgary annual report.* Calgary, Alberta: Calgary Public Board of Education.

FOOTNOTES

[1] An *inukshuk* is a human-shaped stone cairn built on high ground by Eskimo/Inuit people.

Non-Expert Adults' Art-Viewing Experiences: Conjugating Substance With Struggle

Richard Lachapelle
Concordia University

For many decades now, I have taken to jogging several times a week. However, I've never run a marathon—or any kind of race, for that matter. I'm just not interested in the competitive aspect of the sport. I would never dare to compare myself to an elite runner, neither in terms of my abilities, nor in terms of my potential to develop as a runner. Yet I enjoy running immensely and almost always look forward to doing it. It is clear to me that running provides several benefits: more peace of mind, weight control, and other health-related advantages. If I were to submit to rigorous testing based on some standard of "expertise" to evaluate my performance in running, the outcome would no doubt be discouraging. I could never measure up to a Donovan Bailey or a Maurice Greene.

Comparing such disparate levels of performance in running seems absurd and misplaced. Yet, in the art museum community, we apply such inappropriate standards regularly and prejudicially to a large segment of the museum-going public. Art historians and museum curators sometimes refer disparagingly to attempts to reach out and connect meaningfully with non-expert publics as "dumbing down." In itself, use of this expression in describing the museum audience reveals a bias that wrongly assumes that art historical and philosophical approaches are the only ways to respond intelligently to a work of art. I contend that nothing could be further from the truth. In the course of my many years of research with museum visitors, I have often marveled at the intelligence and imagination that many non-expert viewers demonstrate in formulating interpretations of works of art that are adept, creative, and appropriate to the content addressed by the work itself. It is my position that the study of non-expert viewers should focus on identifying the strengths as well as the weaknesses of non-expert responses to works of art. It should take into consideration what these responses really are: the attempts of intelligent viewers

to engage with, to understand, and to appreciate works of art. Non-expert viewers' responses often have substance. Yet, as most museum educators know from experience, non-experts often struggle when they try to respond to more challenging works of art. The ultimate objective of research into non-expert museum visitors is to provide a reliable basis on which museum educators can prepare and provide assistance that is both welcomed and considered useful.

This chapter, then, discusses selected aspects of the aesthetic experiences of a specific category of art museum visitor: the non-expert viewer. This is not intended as an exhaustive survey of all the promising avenues explored on this research topic in the past decade or so. Rather, it focuses on a few key issues: research findings relating to expertise, bodies of knowledge, cognitive flexibility, cursory viewing, and tacit knowledge.

The Non-Expert Viewer
The terms "non-expert viewers" or "non-expert visitors" are used here to designate members of the art museum public who have no university-level training in the fine arts. This definition does not preclude the possibility that non-experts may have attended museums previously, at varying levels of frequency, or that they may have received studio art or other fine art training, either at the secondary school level or on

a recreational basis. However, this definition deliberately excludes from consideration all professionally trained artists or fine art scholars including those in the performing and other, non-visual, creative arts: dancers, musicians, art educators, art historians, studio artists, poets, and so on. Furthermore, it is essential to acknowledge that many non-expert viewers are well educated and may have university-level training in a non-fine-art discipline (Lachapelle & Douesnard, 2006).

Non-expert art museum visitors, as a group, are very heterogeneous and demonstrate a wide range of art-viewing skills and museum experience. Whereas some members of this group are indeed true neophytes when it comes to responding to works of art, others can be highly skilled. Previous museum attendance and the extent of previous art viewing experience account for these differences (Housen, 1983; McDermott-Lewis, 1990).

Conceptions of Expertise

Research into the notion of expertise, or its absence thereof, has a short but interesting trajectory. Initially, expertise was seen mainly as one of the two poles that define the transmission learning process. In this model, learning is understood as a one-way trajectory where knowledge originating from an expert (the teacher) is transferred to a novice (the student). Although this understanding of expertise is still quite prevalent, it is not the definition of expertise that I intend to explore in this chapter.

In the last two decades, educators have used various approaches for studying art-related expertise. Some researchers, for example Csikszentmihalyi & Robinson (1990), have conducted studies focusing exclusively on experts (i.e., museum professionals). Other researchers, such as Koroscik (1996), have focused on the study of novices as they engaged in art-related tasks. Still others, such as Gromko (1993) and Lachapelle (1994, 1999), have conducted comparative studies in which both experts and non-experts engaged in similar activities. In undertaking such studies, these researchers have attempted to identify what it is that experts do well that novices need to learn in order to improve their performance.

Knowing How, But With What?

It was once thought that we would eventually find significant differences in the psychological processes that experts and novice viewers use to structure their art viewing experience. However, so far, research results do not support this idea. Overall, the psychological functioning that is the basic orientation of different adults' approaches to exploring and understanding museum exhibitions appears to be remarkably similar among all types of adult viewers regardless of levels of education or expertise. Dufresne-Tassé and Lefebvre (1995) found that all of the 45 adult visitors in their study adopted essentially a cognitive approach during their museum visits. Mental operations with a cognitive orientation accounted for 63.3% of the total production of operations, while 21.3% of operations had an imaginative orientation, and only 15.4% were

affect-laden operations. When the two researchers examined sociocultural factors including educational level, age, and gender, they were surprised to find no significant differences among subgroups according to these determinants. The researchers had expected to obtain a more cognitive-oriented response from the more educated subjects and an overall affective-oriented reaction in subjects with less education. Neither of these expectations was found to be true (Dufresne-Tassé & Lefebvre, 1995; Hein, 1998). In a smaller study using multiple case studies, I obtained similar results: my expert and non-expert informants approached the works of art largely using a cognitive orientation. However, other differences did surface between the two groups of informants: imagination was more prevalent in the expert group's use of mental operations, and, as a group, the expert informants also formulated more hypotheses about the work of art (Lachapelle, 1999). Upon closer examination of the comments made by the informants in my study, I concluded that there were noticeable differences in the types of information that the expert and non-expert participants used to construct an understanding of the work of art. Non-expert informants relied on their everyday, experience-based knowledge whereas expert informants used more disciplinary knowledge such as art history, criticism, and production (Lachapelle, 1994).

It appears that there are differences in the types of knowledge that non-experts refer to in order to formulate interpretations of works of art. When their knowledge of art is limited, non-expert informants may have little choice but to resort to personal, everyday experience as a way of informing

124 **Richard Lachapelle** | Non-Expert Adults' Art-Viewing Experiences: Conjugating Substance With Struggle

their interpretations. At times, this may work well as an interpretation strategy and, at other times, it may prove less than satisfactory. For example, in a recent study, one non-expert informant—an engineering technician—did an outstanding job in identifying and deconstructing the industrial processes used in the fabrication of a large, structurally complex, steel sculpture. However, at the same time, he was unable to formulate an overall understanding of what the sculpture might be about (Lachapelle, 2005).

Koroscik (1993, 1996) reported that novice learners differ from experts in terms of the amount of knowledge that they have about art. Also, she found that the strategies novices use to acquire knowledge are also different from those used by experts. Koroscik identified some of the misconceptions and problems that hinder novices' learning. In regard to knowledge, novices may hold prior beliefs that, as concepts, are poorly considered, poorly differentiated, compartmentalized, and distorted. They may be further challenged by a use of cognitive strategies that are too narrowly focused, lack direction, and remain inflexible. As regards their dispositions, novice learners often experience problems with perseverance; they may seek only to confirm their preconceived notions, and they tend to be performance oriented instead of self-motivated (Efland, 2002; Koroscik, 1996).

Experts, on the other hand, have more strategies for acquiring new knowledge (Efland, 2002) and, therefore, are probably better able to adapt their learning approaches to the specific demands of a particular work of art. According to Efland, "Expertise shows up in the organization of the knowledge base. Access to prior knowledge is an important factor in determining the ways that new learning is acquired. Knowledge that is clearly organized and categorized is easier to retrieve than knowledge organized in a haphazard way" (p. 108).

In sum, we now believe that non-expert viewers are no different from expert viewers in terms of their cognitive functioning (i.e. the use of cognitive operations); however, differences have emerged about the knowledge base that non-expert viewers work with to formulate their responses to works of art. Non-experts generally have less knowledge about art, and, to compound the challenges that presents, what they do know is often poorly organized and, therefore, difficult to retrieve when needed (Koroscik, 1993). Perkins and Salomon (1988) and Koroscik (1996) have made strong arguments for the importance of transfer in the educational process. Transfer is also an important factor in art interpretation. Koroscik defined transfer as "the ability to recycle knowledge acquired in one context for constructing new understandings in another context. Cognitive learning theorists agree that transfer is the hallmark of intellectual development and the ultimate goal of education" (p. 11).

Cognitive Flexibility and Fluidity

To make effective use of transfer in constructing new knowledge about works of art, learners need to be able to identify when particular transfers are appropriate. Learners also need to remain open to the new possibilities for learning offered by novel circumstances, such as those encountered in many art exhibitions. Expert viewers may experience less difficulty in regard to transfer since they already dispose of a range of different strategies for interpreting the work of art. Selecting the right strategies may very well be an essential first step in facilitating the transfer process. However, Efland (2002) reported that novices most often resort to using learning strategies that are "unidimensional" (p. 116). He argued that students need to learn to "generate cognitive representations of knowledge in ways that capture real-world complexities" (p. 83): "Cognitive flexibility is a quality of mind that enables learners to use their knowledge in relevant ways in real-world situations. It involves a capacity on the part of the learner to represent knowledge (concepts, ideas) in multiple ways. Cognitive flexible students take learning to be multidirectional, involving the formation of multiple perspectives" (p. 82).

Research into a related concept, one that describes cognitive functioning in terms of crystallized and fluid intelligence, may explain why cognitive flexibility might be such an elusive and challenging goal for many adult learners. Psychologist Raymond Cattell (1963) proposed this conception of intelligence, which he supported with additional research during the next several decades. Basically, his theory proposes that a distinction needs to be made between two principal factors of intelligence that evolve and change over the human lifespan. These are known as *crystallized intelligence* and *fluid intelligence.* Crystallized intelligence is the product of our previous

learning and experience; we solicit this type of intelligence when we need to work on a cognitive task that we have completed before. In contrast, Horn and Cattell (1966) defined fluid intelligence as "the processes of reasoning [used] in the immediate situation in tasks requiring abstracting, concept formation and attainment, and the perception and education of relations" (p. 255). We solicit our fluid intelligence when a learning situation is new and unfamiliar, and in cases where our experiential knowledge is no longer sufficient. The challenge that adult learners face is that the abilities of fluid intelligence decline with age, starting in the early 20s: "During the adult years there is a general pattern of change in which crystallized abilities continue to increase with experience, while fluid intelligence tends to decay. The older the adult, then, the greater the likelihood of relatively high crystallized intelligence and relatively low fluid intelligence" (Hayslip, 1993, p. 249).

Cattell's work may provide an explanation for the difficulties of adaptation that many non-expert viewers experience when they encounter new and enigmatic artworks, such as contemporary art (Lachapelle, 2005). It is certainly plausible that novel and challenging works of art require a response that depends at least in part on cognitive flexibility and fluid intelligence. Since non-expert viewers have previously acquired little domain-specific knowledge, they cannot depend on their crystallized abilities to understand such works. To compound the situation, the older the viewer, the less likely he or she is to be able to call upon fluid intelligence to compensate for a lack of art-related

knowledge. Yet, these are precisely the types of situations in which fluid intelligence should play a greater role. There is, however, promising research into improving fluid intelligence by training older adults in the use of problem-solving techniques (Hayslip, 1993).

Finally, an aesthetic experience begins with a choice. Having the opportunity to make choices about one's learning usually leads to increased motivation (Paris, 1998). When viewers select a work of art that closely matches their viewing abilities, they enhance the likelihood of a successful viewing experience (Csikszentmihalyi & Robinson, 1990). However, if the selection also provides a reasonable challenge, then viewers can maximize as well the potential that their choices may have on their personal aesthetic growth (Lachapelle, 2003a). Ideally, viewers should seek out viewing opportunities that balance the extent to which their crystallized and fluid cognitive abilities are challenged. Research into the viewing choices of non-expert viewers may well lead to a better understand of choice as a determining factor in the outcome of aesthetic experiences (Lachapelle, 2003b).

Time Is on Our Side
Related to the point above is the fact that non-expert viewers sometimes experience difficulty in making choices about works of art to view. Non-expert viewers often have less museum experience and, therefore, may feel compelled to give equal consideration to every work encountered in the gallery. This behavior certainly indicates a high degree of openness on

the viewer's part but, as a viewing strategy, it may also be self-defeating if, as a result, less time can be devoted to each exhibit.

There is considerable evidence to support the conclusion that satisfactory viewing experiences require a significant investment in time (Csikszentmihalyi & Robinson, 1990; Hein, 1998; Henry, 2000; Perkins, 1994). Herein lies a major problem: Museum visitors, particularly non-expert visitors, spend very little time actually looking at each work of art. In a recent study, I gave volunteer non-expert viewers the freedom to select works of art and to spend as much time with them as they wished. In many cases, participants devoted less than 10 seconds to some works and only rarely exceeded a total viewing time of 2 or 3 minutes per work (Lachapelle, 2005).

Examining every object in a large exhibition can be a considerable drain on the amount of total time and energy any viewer can spend before museum fatigue sets in. Furthermore, hurried viewing can lead to only superficial and partial appreciation of works of art. As a viewing strategy, cursory viewing is a major obstacle to satisfactory aesthetic experiences: one that all viewers should avoid. Museums, however, often compound the problem of cursory viewing when they present large blockbuster exhibitions as a strategy to entice people to visit.

Perkins (1994) identified hasty viewing as one of four "intelligence traps" that viewers frequently and inadvertently fall into. The other three are looking and thinking that

are narrow, fuzzy, and sprawling. However, he also proposed four opposite dispositions that can favor more successful and critical aesthetic experiences: looking and thinking that are unhurried, broad and adventurous, clear and deep, and organized.

In my most recent study (Lachapelle, 2005), my research assistants and I recruited 51 non-expert viewers to respond to works of public contemporary art installed in a parkland sculpture garden. We asked our volunteers to engage in two different art-viewing activities. The first activity was intended to simulate a self-directed visit to a museum. For this reason, we asked our informants to select and view as many or as few sculptures as they wished during a 15-minute, uninterrupted, viewing period. In the second activity, we hoped to verify the optimal performance of our informants by asking them to select a single work of art, look at it carefully (in silence) for 5 minutes and, then, respond to it out loud for at least 5 minutes. In terms of aesthetic dispositions, the second activity was structured in such a way as to encourage unhurried looking and thinking (Perkins, 1994). We used two different methods to analyze our data.[1] A team of three judges assigned each participant's various overall responses to operationalized categories corresponding to Perkins' cognitive traps and dispositions. In addition, the team of judges examined the transcripts of each informant's verbal responses for the presence of hypotheses. This second analytic procedure assumes that, in order to meaningfully interpret a work of art, viewers need to formulate hypotheses

about the possible meaning of a work. Finally, we compared the results of the first activity with the results for the second. During the second activity, in which informants were encouraged to adopt an unhurried disposition, we witnessed a noticeable decrease in cognitive traps and a corresponding increase in affirmative dispositions. As regards the informants' production of hypotheses, we noticed a dramatic increase in the production of the type of hypothesis that points to new insights about the overall meaning of the work of art. These findings led us to conclude that, for our non-expert informants, a simple change in viewing strategy (i.e., taking a less hurried approach) resulted in dramatic improvements in overall responses to works of art. We also remarked that, in many instances, when left to their own devices—that is during the self-directed activity—our informants did not perform to the full extent of their abilities. Quite the contrary, they underperformed. However, it should be understood that an unhurried disposition was not a panacea for every challenge encountered by our non-expert informants. They still encountered problems that they were unable to resolve. Nonetheless, an unhurried approach helped them to better organize their cognitive strategies, and, as a result, their responses improved considerably.

In Conclusion: The Problem With Tacit Knowledge

Most non-expert viewers and possibly many expert viewers learn art viewing and understanding strategies on their own through repeated museum or gallery visits. This is a good example of a situation where "know-how" is put to use. Wagner (2000), in

discussing his team work with fellow psychologist Robert Sternberg, reported that practical intelligence can be defined as a "facility for acquiring tacit knowledge, a practical know-how that is required to succeed in daily life including most career pursuits *yet is rarely taught directly*" [emphasis added] (p. 267). Herein lies the problem with relying on such a haphazard approach to learning about art appreciation strategies. When learners are left entirely to their own devices, opportunities abound for the acquisition of misconceptions about art. Such misunderstandings can persist and interfere with art learning for several years. What we now know about non-expert viewers should prompt us to the realization that strategies for understanding art can indeed be taught and, more importantly, *they should be taught.* Museum educators need to move away from an over-reliance on one-shot educational activities (e.g., talks, tours, workshops) and instead commit to developing a longer-term educational relationship with their adult audiences. No one wants museums to become like schools. However, notwithstanding this reservation, short courses designed to teach art viewing strategies— offered perhaps over a period of several weeks—could go a long way in helping many non-expert viewers to advance in their use of art appreciation strategies. We have seen in this chapter that the notion of the non-expert viewer, as a defining category for a segment of the art museum audience, is a complex one. It is a heterogeneous category that encompasses a range of skill levels. It identifies a class of adult museum visitors whose art-viewing experiences can be characterized as often having substance yet are, at times, tinged with struggle.

REFERENCES

Cattell, R. B. (1963). Theory of crystallized and fluid intelligence: A critical experiment. *Journal of Educational Psychology, 54*, 1-22.

Csikszentmihalyi, M., & Robinson, R. E. (1990). *The art of seeing: An interpretation of the aesthetic encounter.* Malibu, CA: The J. Paul Getty Trust.

Dufresne-Tassé, C., & Lefebvre, A. (1995). *Psychologie du visiteur de musée.* Ville Lasalle, Quebec: Éditions Hurtubise HMH.

Efland, A. D. (2002). *Art and cognition.* New York: Teachers College.

Gromko, J. E. (1993). Perceptual differences between expert and novice music listeners: A multidimensional scaling analysis. *Psychology of Music, 21*, 34-47.

Hayslip, B. (1993). Intelligence—Crystallized and fluid. In R. Kastenbaum (Ed.), *Encyclopedia of adult development* (pp. 248-253). Phoenix, AZ: Oryx.

Hein, G. A. (1998). *Learning in the museum.* New York: Routledge.

Henry, C. (2000). How visitors relate to museum experiences: An analysis of positive and negative reactions. *Journal of Aesthetic Education, 34*(2), 99-106.

Horn, J. L., & Cattell, R. B. (1966). Refinement and test of the theory of fluid and crystallized intelligence. *Journal of Educational Psychology, 57*, 253-270.

Housen, A. (1983). *The eye of the beholder: Measuring aesthetic development.* Unpublished doctoral dissertation, Harvard University.

Koroscik, J. S. (1993). Learning in the visual arts: Implications for preparing art teachers. *Arts Education Policy Review, (94)*5, 20-25.

Koroscik, J. S. (1996). Who ever said studying art would be easy? The growing cognitive demands of understanding works of art in the information age. *Studies in Art Education, 38*(1), 4-20.

Lachapelle, R. (1994). *Aesthetic understanding as informed experience: Ten informant-made videographic accounts about the process of aesthetic learning.* Unpublished doctoral dissertation, Concordia University.

Lachapelle, R. (1999). Comparing the aesthetic responses of expert and non-expert viewers. *Canadian Review of Art Education, 26*(1), 6-21.

Lachapelle, R. (2003a). Aesthetic understanding as informed experience: The role of knowledge in our art viewing experiences. *Journal of Aesthetic Education, 37*(3), 78-98.

Lachapelle, R. (2003b). Controversies about public contemporary art: An opportunity for studying viewer responses. *Canadian Review of Art Education, 30*(2), 65-92.

Lachapelle, R. (2005). [Le regardeur non initié et l'art contemporain public: Un programme de recherches]. Unpublished raw data.

Lachapelle, R., & Douesnard, M. (2006). Public contemporary art and the non-expert viewer. In P. Gosselin & F. Gagnon-Bourget (Eds.), *Proceedings of the 2004 Colloquium on Research in Art Education* (pp. 33-40). Montreal, Quebec: Éditions CRÉA.

McDermott-Lewis, M. (1990). *The Denver Art Museum Interpretive Project.* Denver, CO: The Denver Art Museum.

Paris, S. G. (1998). Situated motivation and informal learning. *Journal of Museum Education, 22*(2-3), 22-26.

Perkins, D. N. (1994). *The intelligent eye: Learning to think by looking at art.* Santa Monica, CA: Getty Center for Education in the Arts.

Perkins, D. N., & Salomon, G. (1988). Teaching for transfer. *Educational Leadership, 46*(1), 22-32.

Wagner, R. K. (2000). Practical intelligence. In A. Kazdin (Ed.), *Encyclopedia of Psychology* (Vol. 6, pp. 266-270). New York: Oxford University Press.

FOOTNOTES

[1] Results presented here are based on the analysis of 34 of the total of 51 research sessions.

Working Together: Collaboration Between Art Museums and Schools

Wan-Chen Liu
Fu-Jen Catholic University, Taipei

In North America, art museums have rendered services to schools from the early 1900s until the present. In the past decades, several surveys (Clark, 1996; Herbert, 1981; IMLS, 1996, 1998, 2002; Museum-Ed, 2003) examining the programs provided by museums and the relationships between museums and schools in the United States or Canada showed the trend, among art museums, toward expanding the scope and number of services for schools. However, although art museums and schools have potential for becoming ideal art educational partners through various kinds of interaction, the nature of the art museum-school collaborative relationship can be problematic. To enhance museum education practice, this chapter theorizes museum-school relationships by analyzing the status quo of such relationships. The following six models resulted from asking, "Who initiates the interaction?" and "How do school and art museums communicate with each other?" Degrees of collaboration are also considered.

Model I: The Provider and the Receiver

The term "relationship" may be defined as "a particular type of connection existing between people [or agencies] related to or having dealings with each other," "collaboration" as "work[ing] together, especially in a joint intellectual effort," and "partnership" as "a relationship between individuals or groups that is characterized by mutual cooperation and responsibility."[1] Thus, the existence of a relationship between an art museum and a school does not necessarily imply that the two institutions maintain what would amount to a collaborative partnership. The literature reveals that the art museum-school relationship is one of the oldest components of art museum education. Still, it is not possible to assume that successful collaborative relationships between art museums and schools are common. The model of the classroom teacher, the ultimate implementer of much of the school curriculum, in active and equal partnership with the art museum educator in program design and implementation is more prototype than archetype. Indeed, it is still common for art museums to design programs for students and teachers and for school teachers to bring their students to museums—without further communication and discussion with museums regarding teaching and learning (Figure 1).

Model II: Museum-Directed Interaction

Most art museum resources and materials for school have been traditionally designed by art museum educators without teacher participation. However, some museums have begun to share the responsibility with school teachers for finding ways to use museums as curriculum resources. From a giver-recipient model to one of shared responsibility, the museum-directed model, art museums invite school teachers to participate in

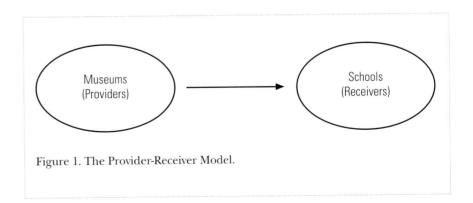

Figure 1. The Provider-Receiver Model.

workshops and related activities and then continue to communicate with participant teachers before finally working together with them as curriculum partners to develop programs for schools (Figure 2).

The Learning through Art at the MFAH project developed by the Museum of Fine Arts, Houston, is a good example for this museum-directed interaction model. In 1992, the museum arranged a university museum education course and a series of intensive training programs about docent skills, art history, and collections for a group of elementary school teachers who had strong motivation to work with the museum. Then, those teachers were asked to guide tours as interns during the summer vacation to gain art museum education experience. After their internships, the teachers who were familiar with the way to use museum exhibitions and materials worked with museum educators to design the Learning Through Art at the MFAH project for elementary schools and then tested their curriculum and materials with kids (MFAH, 1994). The kit with video and slide package was published by the museum for local elementary schools and then was widely used by schools in Texas. The teachers' active involvement was an important component in this successful museum-school relationship, which serves as an example of the museum-directed interaction model.

Model III: School-Directed Interaction
In a third type of interaction between museums and schools, school teachers play an active role, initiating curriculum ideas and developing materials for their kids

with the help of museum educators (Figure 3). Garoian (1992) envisioned K-12 teachers using both institutional and human resources to design a series of activities related to art museums, including pre-visit, museum-based, and post-visit activities, to enrich students' learning.

The Dulwich Picture Gallery in England makes the involvement of the classroom teacher in planning the museum visit a requirement. This gallery maintains a firm policy of not offering pre-planned lessons or tours for groups: no museum visit is arranged without careful consultation with the classroom teacher. Instead, gallery educators plan, research, and prepare each talk and art activity in collaboration with teachers (Durant, 1996). The Museum School in the Glenbow Museum, Calgary, Alberta, Canada, is another example of this model. The museum does

not provide prepared tours or activities for schools; instead, they accept teachers' proposals and collaboratively plan learning activities (Liu, 1999).

Model IV: Museum as School
With the philosophy of facilitating learning beyond conventional classroom and textbook approaches and the support of government educational reform policy, the New York City Museum School opened in September 1994. Designed to take advantage of the wealth of resources housed in the museums of New York City, its partners include the American Museum of Natural History, the Brooklyn Museum of Art, the Jewish Museum, the Children's Museum of Manhattan, and the South Street Seaport Museum.

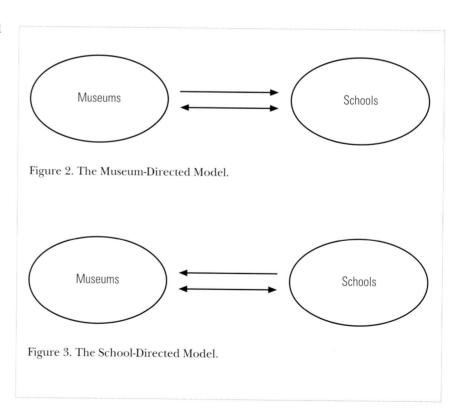

Figure 2. The Museum-Directed Model.

Figure 3. The School-Directed Model.

Working with 18 full-time teachers certified in their subject areas and several professionally trained museum educators, the grades 6-12 museum school students follow a rigorous interdisciplinary curriculum that incorporates the arts into major themes of history, language arts, and science while allowing for independent research, project development, and exploration. On Tuesdays, Wednesdays, and Thursdays, students travel to a designated museum where each class works during a particular 8-week module. On Mondays and Fridays, students have full days of classes at the home base. During each module, every student develops and presents a major project (Klein, 2004; Takahisa, 1995). In this community-based museum school, museum education is not an extension but rather the core of the school curriculum, and its teachers play a key role in this partnership with museums (Figure 4).

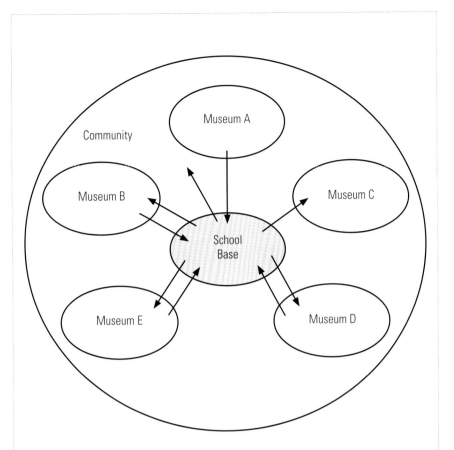

Figure 4. Museum-as-School Model.

Model V: School in Museum
Charter schools are a U.S. educational innovation. Typically established by a group of parents, teachers, administrators, and community leaders or organizations to encourage innovative teaching practices, charter schools provide choices for parents and students within the traditional public school system (U.S. Charter Schools, 2006). A few of the 3,400 charter schools across the United States have been established in museums to broaden students' arts learning experiences with the abundant physical space, collections, exhibitions, and staff resources available there. Charter schools located within museum "campuses" are a unique model of collaborative relationship created by museums and schools (Figure 5).

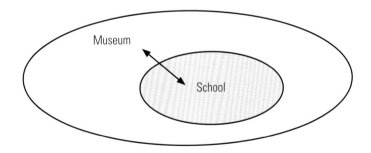

Figure 5. School-in-Museum Model.

The Henry Ford Academy of Manufacturing Arts & Sciences was created in 1996 by the Ford Motor Company, the Wayne County (Michigan) Public Schools, and the Henry Ford Museum & Greenfield Village where the academy is located. Around 400 grade 9-12 students become an integral part of the museum's daily life. This partnership model benefits from the joint resources of a global corporation, public education, and a cultural institution (Henry Ford Academy, 2004; IMLS, 2005; Pittman & Pretzer, 1998). Another example is a tuition-free public charter high school, Flagstaff Arts and Leadership Academy (FALA), founded in 1996 and located on the grounds of the Museum of Northern Arizona. Students immerse themselves in a variety of rigorous academic, visual, and performing arts classes, including creative writing, dance (jazz, ballet, modern), music (choral, strings, composition, instrumental), theater, and visual arts (drawing and painting, mixed media, photography). As FALA expressed on its website:

Flagstaff Arts and Leadership Academy is part of a unique partnership that includes the Museum of Northern Arizona and The Peaks Senior Living Community. … One example of how this partnership is working is through our Sustainable Agricultural and Greenhouse Initiative, a native plant restoration project involving FALA students and residents from the Peaks, with Museum land and cooperation. (FALA, 2006)

These two school-in-museum examples suggest the potential of museum-school collaboration.

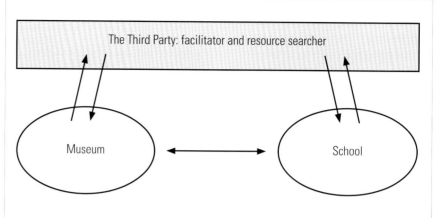

Figure 6. Museum-School Interaction Through the Facilitator Model.

Model VI: Museum-School Interaction Through a Third Party

Museums and schools operate in different systems and sometimes have little opportunity to interact. Therefore, a third party playing the role of matchmaker or facilitator can encourage relationships. Sometimes, the third-party institution can also provide or garner abundant resources for art museums and schools (Figure 6).

In the United States, the Institute of Museum Services, a federal grant-making agency dedicated to creating and sustaining a nation of learners by helping museums serve their communities, was established in 1977 and expanded to the Institute of Museum and Library Service (IMLS) in 1996. In the past three decades, the agency has supported 15,000 U.S. museums and encouraged partnerships with schools in communities (IMLS, 1999). IMLS works as a third party to promote art museum-school collaboration. In addition, from 1987 to 1998, the Getty Center for Education in the Arts, dedicated to art education theory and practice, contributed to art museum-school collaborations by providing

financial and professional support in the form of conferences, workshops, publications, and curriculum implementation projects (Berry, 1993; Getty Trust, 1990, 1998).

As a catalytic agent, the third party sometimes plays a crucial role in the development of museum-school collaborative relationships. Examples of museum-school interaction through the facilitator model can also be found in countries beyond the United States. For example, the Museums, Libraries and Archives Council, MLA, a national development strategic agency working for and on behalf of museums, libraries, and archives in the United Kingdom, recently promoted the Renaissance in the Regions project. The program sought to transform regional museums by setting up a Regional Agency for Renaissance in nine regions and by encouraging national museums to share their skills and collections with local museums to meet people's changing needs. From 2003 to 2006, with £12,200,000

of financial support from the Department of Culture, Media, and Sport and the Department for Education and Skills, MLA established a framework of regional "hubs" consisting of a national museum and up to three or four local partners that work together to promote excellence in practice and provide comprehensive service to schools (MLA, 2006).

Third-party support of museum-school collaborations can yield noticeable effects on the professional development of museum staff and teachers. Some projects are designed to enhance school teachers' understanding, knowledge, and competence for making connection with museums. For example, since 1993 the Canadian Museum Association (CMA), primarily supported by the National Literacy Secretariat of the Government of Canada, has carried out Reading the Museum (RtM), a program of demonstration projects, workshops, and information-sharing activities to encourage literacy in and through museums. Since one of its main goals is to make museums more accessible to literacy learners, some workshops and projects have been designed for literacy teachers working in community organizations who seek to collaborate with museums. From 2000 to 2004, the RtM program encouraged development of connections between museums and literacy teachers and studies were presented at related conferences and symposiums (Canadian Museums Association, 2005; Literacy Council of Fredericton, & York-Sunbury Museum, 2000).

Another example is provided by the Philadelphia Museum of Art Institute (PMAI) to support elementary and secondary teacher use of the museum collection. Funded by the Pennsylvania Department of Education, this statewide program helps generalist teachers develop knowledge about art and ways to apply this knowledge to children's interdisciplinary learning. The Joslyn Art Museum in Omaha, Nebraska, the Ringling Museum of Art in Sarasota, Florida, and the Museum of New Mexico have founded similar programs to help generalist teachers integrate the visual arts into the basic school curriculum (Katz, 1984).

Educational institutions sometimes also play the role of a third party to facilitate and encourage museum-school collaboration. For example, the Canadian College of Teachers, the only national, membership-based teacher organization in Canada, in collaboration with the Canadian Museums Association (CMA) and the Canadian Museum of Nature, sponsors the national *Museum & Schools Partnership Award* to recognize excellent partnerships between schools and museums for educational programs that enrich students' understanding and appreciation of Canada's cultural and natural heritage. The award is open to any Canadian school or school board in collaboration with any Canadian public, nonprofit museum or museum group, with the exception of institutions employing members of the awards committee (Canadian College of Teachers, 2006).

Another example is the North Texas Institute for Educators on the Visual Arts (NTIEVA) at the University of North Texas. NTIEVA received a grant from the Getty

Center for Education in the Arts to establish as its specialty program the National Center for Art Museum/School Collaborations. Since 1995, the Center has focused on collaborative programming between art museums and schools in a comprehensive approach to art education and has served as a clearinghouse for information about successful programs and practices by conducting and collecting research, maintaining a database of information, organizing regional and national conferences, developing a program of publications, and creating electronic and print networks for information retrieval on the subject of art museum and school collaborations (Berry, 1998; NTIEVA, 2006).

In addition to a national institution as the third party to facilitate museum-school collaboration, local institutions can make things different in their communities. For example, the Chicago Board of Education initiated Museums And Public Schools (MAPS), a new approach for creating a lasting impact on teaching and learning by strengthening the educational relationship between nine museums (Chicago Children's Museum, the Art Institute of Chicago, the Peggy Notebaert Nature Museum of the Chicago Academy of Sciences, Chicago Historical Society, DuSable Museum of African American History, the Field Museum, Mexican Fine Arts Center Museum, Museum of Science and Industry, and the John G. Shedd Aquarium) and the Chicago public schools. A design team composed of school and museum educators worked together

to develop grades 2-6 instructional units that integrate museums' resources with the Illinois Learning Standards (Chicago Board of Education, 2006). MAPS shows the potential role of the third party in establishing museum-school network and connections.

Degrees of Collaboration

Although collaboration between schools and art museums is an effective strategy to improve the quality of art education, challenges can occur throughout the process. Several studies in the United States (American Association of Museums, 1984; Harrison, 1988; Harrison & Naef, 1985; Henry, 1995/1996; *Museum USA*, 1974; Newsom & Silver, 1978; Williams, 1996) and Canada (Herbert, 1981; Julyan, 1996) document the lack of communication between museums and schools. In contrast, the results of a survey involving 145 museum educators from 107 art museums conducted by the National Center for Art Museum/ School Collaborations in 1996 showed what their researchers identified as a significant change in the way art museums cooperated with schools: 62% of responding U.S. art museum educators indicated that both museum staff and school personnel initiated collaborative programs, 63% reported that museum staff and school personnel cooperatively determined the educational content of collaborative programs, and 83% claimed to collaborate with teachers on a regular basis (NCAMSC, 1996).

Underlying factors and limitations can influence the nature of collaboration between schools and art museums. Chesebrough (1998) delineated partnerships between institutions into

Table 1. Partnership Between Institutions.
(Note: Table 1 is a summary of Chesebrough's [1998] analysis.)

	Cooperation	Coordination	Collaboration
Authority	Own respectively	Own respectively	Decide together
Risk	No	Higher	Increasing
Resource	Own respectively	Shared	Shared
Reward	Own respectively	Mutually recognize	Own together
Common Task	No	Try to understand and implement	Full commitment and responsibility
Forming new organization structure for completing the common task	No	No	Yes
Relationship	Informal	Formal, clear, and continued	Continued and strong

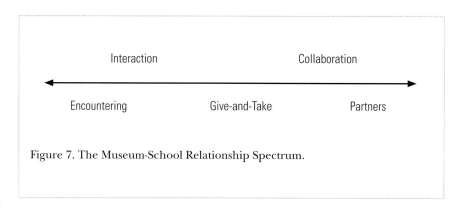

Figure 7. The Museum-School Relationship Spectrum.

three categories according to the extent of involvement: cooperation, coordination, and collaboration. *Cooperation* is an informal relationship in which each institution owns its authority, resources, and reward and shares only related information with the cooperating institution. *Coordination* represents a formal, clear, and continued relationship in which each institution has its own authority with the mutual understanding of each side's give-and-take task, organization structure and planned efforts, but shares the resources and

rewards. *Collaboration* is a stronger continued relationship in which each institution offers its resources and reputation and accepts a new organizational structure for a common task with full commitment and responsibility (Table 1).

Using Chesebrough's (1998) distinctions, there seems to be much cooperation between art museums and schools but little real coordination or true collaboration. Art museums mostly develop activities without the involvement of

the schools, and teachers generally accept a more passive role in their interactions with museums. It is not yet commonplace for art museums and schools to develop strong and continued relationships with shared responsibility and commitment. I have developed a spectrum to illustrate the range of museum-school relationships (Figure 7).

Conclusion

The existence of a relationship between an art museum and school does not necessarily imply that the two institutions maintain a collaborative partnership. As the six models and different levels illustrated here show, there are various types of existing and developing museum-school relationships. The results of a 1997 survey of 292 museum directors showed these elements of successful partnership: mutual benefit, mutual trust, open communication, clear roles and responsibilities, clear objectives, and competent partners (Chesebrough, 1998). At a 2004 conference workshop hosted by IMLS to examine the intersections of museums, libraries, and K-12 education, around 70 participants, leaders from diverse professions, expressed their belief that:

… identifying and mastering the salient characteristics of successful collaborations would play an essential role in enabling museums, libraries and schools to make a positive and sustained difference in K-12 education. Strong collaborations are characterized by committed institutions with results-focused leaders and clear definitions of roles, both within and among partner organizations. (IMLS, 2005, p.12)

The criteria for selection used for the Museum & Schools Partnership Award in Canada include vision, heritage, collaboration, partnership, synergy, and relevance. These criteria can also help us reflect on how to successfully make art museums and schools work well together (Table 2).

Art museums and schools working together for education is not only an approach, but it is also a good strategy. However, effective collaboration depends on active participation of all involved parties, and there is no one formula for developing museum-school relationships. Each museum and school has to work out an appropriate way to build a partnership based on each organization's strengths, weaknesses, limitations, and core competencies. Art museums and schools can and should be partners by sharing resources, risks, and rewards.

Table 2. Criteria for Selection for Museum & Schools Partnership Award. Source: Canadian College of Teachers (2006).

Vision	Advances the possibilities of what museums and schools can achieve together
Heritage	Enriches and expands students' understanding of and appreciation for [Canadian] cultural and natural heritage
Collaboration	Demonstrates how museums and school can work effectively together
Partnership	Shares authority, investment of resources, and risk-taking
Synergy	Realizes an educational opportunity neither partner could achieve without the help of the other
Relevance	Demonstrates relevance of the project/program to the communities served and to the advancement of museum and school practice

REFERENCES

American Association of Museums. (1984). *Museums for a new century: A report of the Commission of Museums for a New Century*. Washington, DC: Author.

Berry, N. (1993). Students prepared by DBAE. *The Docent Educator, 2*(4), 8-10.

Berry, N. (1998). A focus on art museum/school collaboration. *Art Education, 51*(2), 8-14.

Canadian College of Teachers. (2006). *Museums & schools partnership award*. Retrieved December 20, 2006, from http://www.cct-cce.com/

Canadian Museums Association. (2005). *Annual report 2004*. Retrieved December 20, 2006, from http://www.musees. ca/media/Pdf/cma_ann_rpt_ 2005_en.pdf

Chesebrough, D. E. (1998). Museum partnership: Insights from the literature and research. *Museum News, 77*(6), 50-53.

Chicago Board of Education. (2006). *MAPS (Museums and Public Schools): A new direction for teaching Chicago's children*. Retrieved December 20, 2006, from http://www. museumsandpublicschools. org/index.html

Clark, C. (1996). *A report: Survey on art museum/school collaborations*. Denton, TX: University of North Texas National Center for Art Museum/School Collaboration.

Durant, S. (1996). Reflections on museum education at Dulwick Picture Gallery. *Art Education, 49*(1), 15-24.

FALA (2006). *Flagstaff Arts and Leadership Academy (FALA) partnerships*. Retrieved Dec. 18, 2006, from http://www.fala. apscc.k12.az.us/Credibility.htm

Garoian, C. R. (1992). Art history and the museum in the schools: A model for museum-school partnerships. *Visual Arts Research, 18*(2), 62-73.

Getty Trust (1990). *Special issue: Art museum education, 5*(2). Santa Monica, CA: The J. Paul Getty Trust Bulletin.

Getty Trust (1998). *Information: Getty Education Institute for the Arts*. Los Angeles: The Getty Education Institute for the Arts.

Harrison, J. (1988). The effects of educational programs in art museums on the artistic perceptions of elementary school children. *Journal of Research and Development in Education, 21*(3), 44-52.

Harrison, M., & Naef, B. (1985). Toward a partnership: Developing the museum-school relationship. *Roundtable Reports, 10*(4), 9-12.

Henry, E. (1995/1996). Art teachers in museums. *The Docent Educator, 5*(2), 5-7.

Henry Ford Academy (2004). *Henry Ford Academy annual report 2003-2004 school year, PA-25/NCLB*.

Herbert, M. (1981). *A report on Canadian school-related museum education*. Unpublished master's thesis, University of Nova Scotia.

Hicks, E. C. (1986). *Museums and schools as partnerships.* (ERIC Document Reproduction Service No. ED 278 380)

IMLS. (1996). *True needs true partners: Museums and schools transforming education*. Washington, DC: Institute of Museum and Library Services.

IMLS. (1998). *True needs, true partners: 1998 survey highlights*. Washington, DC: Institute of Museum and Library Services.

IMLS. (1999). *1999 programs*. Washington, DC: Institute of Museum and Library Services.

IMLS. (2002). *True needs true partners: Museums serving schools*. Washington, DC: Institute of Museum and Library Services.

IMLS. (2005). *Charting the landscape, mapping new paths: Museums, libraries and K-12 learning*. Washington, DC: Institute of Museum and Library Services.

Julyan, L. (1996). *The schools & museums integration project: Phase one final report*. Victoria, BC: British Columbia Museums Association.

Katz, T. H. (1984). *Museums and schools: Partners in teaching-the Philadelphia Art Institute, 1982-1984*. Philadelphia: University of Pennsylvania.

Klein, J. I. (2004). *2003-2004 annual school report: Region 9—NYC Museum School*. New York: New York City Public Schools.

Literacy Council of Fredericton, & York-Sunbury Museum. (2000). *Reading the museum—A resource handbook*. Retrieved December 20, 2006, from http://www.nald.ca/library/ learning/museum/index.htm

Liu, W. C. (1999). *The Museum School in the Glenbow Museum, Calgary, Alberta, Canada.* Unpublished field study report.

MFAH (1994). *Curriculum kit: Learning through art at the Museum of Fine Arts, Houston.* Houston, TX: Museum of Fine Arts, Houston.

MLA. (2006). *Regional museum hub two-year plan summaries.* Retrieved December 18, 2006, from http://www.mla.gov.uk/webdav/harmonise?Page/@id=73&Document/@id=18592&Section[@stateId_eq_left_hand_root]/@id=4332

Museum-Ed. (2003). *2003 art museum education programs survey.* Retrieved December 18, 2006, from http://www.museum-ed.org/joomla/content/view/63/53/

Museum USA. (1974). Washington, DC: National Endowment for the Arts.

NCAMSC. (1996). A report: Survey on art museum/school collaborations. Denton, TX: University of North Texas, National Center for Art Museum/School Collaboration.

Newsom , B. Y., & Silver, A. Z. (Eds.) (1978). *The art museum as educator.* Berkeley, CA: University of California.

NTIEVA (2006). National Center for Art Museum/School Collaborations. Retrieved December 18, 2006, from http://www.art.unt.edu/ntieva/ncamsc/index.htm

Pittman, W., & Pretzer, W. S. (1998). The most public of public schools. *Museum News,* 77(5), 40-47.

Takahisa, S. (1995, April). *Addressing goals 2000: The museum/school partnership.* Paper presented at the meeting of the National Art Education Association, Houston, Texas.

U.S. Charter Schools (2006). *Overview of charter schools.* Retrieved Dec. 18, 2006, from http://www.uscharterschools.org

Williams, P. B. (1996). An examination of art museum education practice since 1984. *Studies of Art Education,* 38(1), 34-49.

FOOTNOTES

[1] *The American Heritage Dictionary of the English Language* (3rd ed.). (1992). Houghton Mifflin. Electronic version licensed from INSO Corporation.

Enabling Education: Including People With Disabilities in Art Museum Programming

Rebecca McGinnis
The Metropolitan Museum of Art

"Our museum is accessible: we have ADA compliant restrooms." "It's too expensive to make the museum accessible to such a small minority." "There's nothing for a blind person in an art museum."

These types of comments from people working in museums reveal commonly held misconceptions about people with disabilities and their place in museums. So who are people with disabilities? Why should art museums be opening their doors to this underrepresented museum audience? And how can art museum educators break down barriers, involving and empowering people with disabilities in the experience of art in a museum setting?

Who Are People With Disabilities?

Some 54 million people in the United States, or about one in six, have disabilities (U.S. Census Bureau, 1997). This number increases daily as the population ages. In fact, people with disabilities constitute the largest and fastest growing minority in the United States. One in eight Americans is over 65 today; by 2030, the proportion will be one in five.[1] About 40% of those over 65 have some kind of physical, sensory, cognitive, psychiatric, or other

disability, and 46% of people with disabilities report having multiple disabilities (U.S. Census Bureau, 1997). These numbers represent a large percentage of the art museum-going public. And, of course, millions of younger people also have disabilities, whether they are born with them or acquire them. Unlike most other minority communities, anyone can join the disability community at any time, either temporarily or permanently.

What Do We Mean by Disability?

Definitions of disability vary in different circumstances, ranging greatly in their level and degree of inclusion and their perspective on the nature of disability. The Americans with Disabilities Act (ADA) (1990) defines a person with a disability as someone who has "a physical or mental impairment that substantially limits major life activities; has a record of such an impairment; or is regarded as having such an impairment" (ADA Title 42, Chapter 126, Section 12102, [1990]), whereas the *American Heritage Dictionary* (2000) defines it as "incapacity; ... a disadvantage or deficiency, especially a physical or mental impairment that impedes normal achievement; ... something that hinders or incapacitates."

These different definitions reflect divergent models of disability: the dictionary definition situates disability outside the realm of "normal," dichotomizing "disability" and "normality." It equates disability with deficiency and incapacity and offers disability as a cause for lack of achievement. This definition reflects our society's persistent attachment to the medical model of disability, which links disability to illness and all the trappings, including a need for diagnosis and cure, situating the "problem" of disability within the individual's body. The ADA definition also espouses a medical perspective on disability, referring to "impairment" and resulting limitations, thus individualizing disability. However, the ADA definition also recognizes that society can disable people and therefore includes those who are "regarded as having such a disability."[2]

The perceptions of society and individuals within a society and the resulting physical and intellectual environments can create more barriers for people with disabilities than their "physical or mental impairments." The fact that only about 32% of people with disabilities of working age are

employed, as opposed to 81% of those without disabilities, is evidence of these barriers (National Organization on Disability, n.d. a). The reasons for underemployment likely stem as much from discrimination due to prejudice and stereotyping as to lack of accessible resources (Donoghue, 2003).

To illustrate the difference between these two models, consider the case of a wheelchair user. The problem here, according to the medical model of disability, is the injury or physical condition that necessitates the use of the wheelchair, whereas the social model situates the problem or barrier outside the individual and within society and its manifestations. Therefore, according to the social model, deliberately designed and created structures such as stairs and narrow doorways are disabling—not the individual's physical condition, and not the wheelchair he or she uses (wheelchairs are enabling, not disabling). And these structural barriers are not only physical, but also organizational and attitudinal. Consider the museum graphic design style that imposes small print and poor color contrast—or the policy requiring tour bookings by telephone only.

But even the social model does not fully encompass and validate the experiences of people with disabilities. Through choices in collecting and programming, museum educators and curators can encourage the view of disability as difference rather than disadvantage. We can harness the authoritative voice of the museum to convey images of disability that promote a positive social identity. This can be achieved, for example, by involving people with disabilities in planning programming that reflects multiple perspectives; displaying and interpreting objects

The Prevalence of Disability in the United States

- About 54 million people have disabilities (U.S. Census Bureau, 1997)

- About 46 million have arthritis (Arthritis Foundation, n.d.)

- About 31 million have some degree of hearing loss (League for the Hard of Hearing, 2007)

- About 25 million report having difficulty walking (Maryland Commission on Human Relations, 2004)

- One in six people (17%, or 16.5 million) 45 years of age or older reports some form of vision impairment even when wearing glasses or contact lenses (Lighthouse International, 2006)

The Aging Population

- There are 77 million baby boomers in the United States.

- Between 2010 and 2030, the number of Americans 65 and over will grow by more than 70%, to constitute 20% of the U.S. population.

- Of people over age 65, 30% to 40% have some degree of hearing loss.

- By the year 2010, when all baby boomers are age 45 and older, 20 million will have some form of vision impairment. The proportion of adults reporting vision loss increases dramatically with age (15% aged 45-64, 17% aged 65-74, and 26%--or one in four—aged 75 and older). The vast majority of those middle-aged and older who report vision impairment are *partially sighted* rather than *totally blind*. Only 2% of all Americans age 45 and older report blindness in both eyes (Lighthouse International, 2006).

Also see the Administration on Aging, www.aoa.gov/prof/Statistics/statistics.asp

and works of art relating to, representing, or made by people with disabilities; and discussing the impact of disability on the lives of artists.

To add further complexity to our definition of disability, we cannot always know whether people have disabilities or if they consider themselves to be people with disabilities. Where is the line between disability and nondisability? I would argue that

the definition of disability and the dividing "line" is of little relevance to policies and practices of inclusiveness in museums.

Clearly, museums can have no effect on a person's impairment. Rather, a focus on removing barriers, based on the social model, rather than on disability status, will be more effective in planning for inclusiveness in museum programs,

interpretation, information, exhibitions, and buildings. Museum educators and their colleagues have the power to remove many barriers, or even prevent them from occurring in the first place. An assessment of the actual or potential physical, psychological, and attitudinal barriers in the museum, followed by a plan to avoid, remove, or circumvent them, is the first step towards creating an inclusive museum. This is not a new recommendation; the literature on museum accessibility discusses access planning at length.[3] But I would assert that, in addition, we must embrace disability as diversity and celebrate difference rather than trying to cover it up. The experience of disability among our visitors and the artists represented in our collections adds richness to the museum equation. People with disabilities can contribute more to our work than just their feedback about accessibility. Educators are in an ideal position, between art and the visitor, to acknowledge these experiences and raise the profile of people with disabilities and the experience of disability.

Why Open Doors to This Audience?

"Everyone has the right freely to participate in the cultural life of the community, to enjoy the arts and to share in scientific advancement and its benefits." (United Nations, 1948)

The reasons for including people with disabilities in the museum experience are numerous. First and foremost, every person with a disability has the same right to participate in the life of museums as every nondisabled person, as visitor or employee.[4] And because reaching as many different audiences as possible is a prime goal of art museum education, isn't this reason enough to focus attention on inclusive educational programming?

With one in six Americans in this fast-growing minority, the business case for inclusion is no less powerful. The aggregate income of people with disabilities exceeds $1 trillion, with $220 billion in discretionary spending power. Almost one-third of the nearly 70 million families in the United States include at least one person with a disability (National Organization on Disability, n.d. b). As we know, people often visit museums in groups of family or friends, so excluding individuals with disabilities has a broad impact as there are plenty of other, more accessible options for recreation and education.

If these reasons are not compelling enough, the Americans with Disabilities Act (1990)[5] and other legislation protect the civil rights of people with disabilities and make accessibility a legal requirement in areas including employment, state and local government, and public accommodations such as nonprofit service providers and businesses. This includes museums, their websites, and the information and programs they offer, as well as their employment practices.

Finally, there is another inherently persuasive reason to make museums accessible to and inclusive of people with disabilities: The process will benefit everyone, disabled and nondisabled alike. We are all familiar with examples from outside the museum world. Who uses curb cuts? Roller bladers, skateboarders, people with luggage or baby strollers … and wheelchair users. Accessible restrooms are another example. Stand-alone, unisex restrooms, designed for people with disabilities, are popular with parents with small children, especially when parent and child are of the opposite sex. In the airport, who wouldn't prefer a larger, "accessible" stall that can accommodate luggage?

And this trend continues in museums. Large, clear type on labels is appreciated by the millions of people who wear bifocals, those reading from a distance because of crowding or low light levels, and people who don't have English as a first language, as well as people who are partially sighted or have reading or learning disabilities. Seating helps avoid or alleviate "museum feet" for everyone, but is particularly appreciated by older people and others who have difficulty standing or walking for long periods. When assistive listening systems are in use, no one has to strain to hear gallery lecturers over background noise. Lecturers don't need to raise their voices, and others nearby don't have to listen to the talk if they don't want to. And, of course, people who are hard of hearing can hear better. As these examples illustrate, we are all "disabled" by museums in some way, at some point. Language, lighting, signage: all these can put anyone at a disadvantage. So museums that implement accessibility for visitors with disabilities create more enjoyable and appropriate environments for all. This means more visitors, with everyone better served.

Beyond Accessibility: How Can Museums Include People With Disabilities?

Many museums offer accommodations such as assistive listening devices, large print and braille information, sign language interpretation, and wheelchairs. These services are important, but they are too often conceived of as add-ons, rather than an integral part of what museums have to offer. Instead, we must consider these accommodations as core services and plan and budget for them accordingly. This requires support on all levels and appropriate resources. Those who design galleries and exhibitions must also change their mindset, moving beyond accessibility to inclusion.

The concept of Universal Design is a useful framework on which to build inclusive physical and programmatic environments. Ron Mace, founder of the Center for Universal Design at North Carolina State University, described Universal Design as "the design of products and environments to be usable by all people, to the greatest extent possible, without the need for adaptation or specialized design" (Center for Universal Design, 2007, ¶ 1). Arising from a social model of disability, in which the environment—rather than the individual—is the disabling force, this paradigm goes beyond mere accessibility. Universal Design emphasizes the need to create products, environments, and educational opportunities with all potential users in mind. In this context, people with disabilities do not deviate from the "norm" but are instead just part of the rich diversity of humanity. Universal Design anticipates human diversity. Variation in ability is ordinary, not special—it affects everyone at some time in life (Ostroff, 2001).

Central to the principles of Universal Design is the elimination of the need for adaptations and specialized design (Center for Universal Design, 2007). The aim is one environment or suite of programs that everyone can use, without requiring or expecting everyone to fit one pattern, in terms of learning style, cultural and educational background, means of mobility or communication, etc. In an exhibition setting, this means, for example, that information is presented in several formats (such as large, clear print, audio, and braille), works of art can be seen as clearly by tall visitors as by wheelchair users and small children, and there are opportunities for tactile and audio as well as visual exploration.[6]

Depending on the size and practices of the art museum, educators may influence these exhibition elements to a greater or lesser degree. To complete the picture, learning opportunities such as education programming and publications, as well as the information presented in the galleries, must also be universally designed. This is perhaps where most art museum educators can have the greatest impact on the inclusiveness of their museums. By designing these experiences with all visitors in mind, everyone will benefit, not just those with disabilities. In addition, delivery of programs will be more seamless and straightforward, without the need for add-ons and last-minute scrambles for accommodations.

I see the role of the museum educator as pivotal in this much-needed paradigm shift. As an advocate for all museum visitors, the museum educator can represent their needs in the wider museum forum. As mediator between individual visitors, works of art, and the museum institution, the educator is well placed to understand and implement this holistic approach to inclusion. Universal Design is a more appropriate, effective, all-encompassing way of thinking than

The Seven Principles of Universal Design

- Equitable use
- Flexibility of use
- Simple and intuitive use
- Perceptible information
- Tolerance for error
- Low physical effort
- Size and space for approach and use

(Source: The Center for Universal Design, North Carolina State University, www.design.ncsu.edu/cud/)

accessibility, compliance, or even barrier-free design, in architecture, exhibition design, programming, planning, and employment. This model suits the collection of activities and services that make up the multifaceted art museum.

Training is an essential element in this shift in conceptualization of disability and accessibility for all museum staff. Everyone throughout the institution has a responsibility to plan for and monitor the inclusiveness of exhibitions, publications, environments, and learning opportunities, whether or not the museum has a designated access specialist on staff. Knowledge of appropriate terminology, communication strategies, and access in the museum, as well as a high degree of comfort with those with disabilities, will be particularly crucial to those with regular contact with visitors.

Education Programming and Universal Design

In a programmatic context, Universal Design means building in flexibility and variety, providing multiple ways to engage the learner. Museums offer an ideal environment for multimodal learning and expression. The flexibility of the museum setting, combined with the object as the basis for learning, make multimodal learning, or learning through a variety of senses, especially effective and appropriate in museums. Multimodal learning is a long-popular strategy in science museums, where interactive exhibits provide experiential learning opportunities. Art museums are beginning to incorporate interactivity and

Some key features of universally designed museum programming:

- Programs are **inclusive**, open and welcome to all visitors.
- Programs are also **tailored** to meet particular needs and preferences.
- **Choices** are offered.
- Teaching methods take into account the **diverse** needs of the audience.
- Educators are **flexible** in their use of teaching strategies and in the structuring of programs—they can "think on their feet" and adapt as needed.
- Programs incorporate **multimodal** approaches to learning.
- Program design and delivery **challenge** assumptions and expectations.
- Museums **collaborate** with one another and with their audiences.
- Museums take an active role in the **community**.
- The museum is in **dialogue** with its audiences.
- Interpretation **connects** collections and audiences.

multimodal approaches to learning, such as audio guides and opportunities to touch works of art. This new look at interactivity has led to a redefinition of multisensory learning, stemming from advances in cognitive psychology and neuroscience that have helped us to understand how the senses in combination contribute to our perceptions and learning. Everyone can benefit from the same information being provided and reinforced through various modalities.[7]

A universally designed suite of programs and services incorporates multimodal learning opportunities in both formal and informal settings. This does not mean that every program will serve every need. One size does not fit all. Visitors with disabilities have the same variety of preferences as those without disabilities, in terms of format, subject, style of presentation, drop-in versus

scheduled program, and group size. A range of educational programming may include, for example:

- Opportunities to touch works of art, artist's materials, tactile pictures, and high-quality casts or reproductions of works of art
- Offerings involving alternatives, such as sketching or other artmaking, creative writing, creative movement, or other forms of expression
- Flexibility in presentation mode to adapt to attention spans; multisensory needs; mobility needs; cognitive abilities; or educational, cultural, and social background (e.g. the audience may need to have information presented through touch or in sign language; they may need more time to look at a work of art or more active encouragement in the process of looking; they may need more time to get from one work of art to the next or need to be shown objects

near one another to avoid excessive traveling; or language or perspective may need to be adapted according to their cognitive abilities or their backgrounds.)

- Perspectives of educators with disabilities (e.g., deaf educators teaching deaf students in their own common language, American Sign Language, rather than through an interpreter, facilitates better communication and also serves as a positive role model for audiences.)

- Programs by request, at times that suit the individual, as well as scheduled programs. Some people prefer an experience tailored to their individual interests; others would rather be part of a group. Design both settings with the needs of audiences in mind.

Flexibility and Choice

Flexibility and choice are key to universally designed programming. The range of programs at The Metropolitan Museum of Art for people with visual impairments will serve as an example of this important aspect of inclusion. Visitors who are blind or partially sighted may choose from a range of possible program formats, including guided and self-guided touch tours; one-to-one descriptive tours by request; handling sessions; regularly scheduled workshops for adults and families; large-print labels; audio guides; tactile art books; photography courses; and offsite programs.

This variety of programs offers individuals a menu of options from which to choose, depending on their individual preferences and needs. This approach has met with approval from audiences with visual impairments; attendance for these and other programs designed with this audience in mind has tripled in the past 5 years, and we receive many letters and phone calls of appreciation.

In 2003, the Metropolitan published *Art and the Alphabet: A Tactile Experience* (Sanchez & McGinnis, 2003). This children's book incorporates braille, large print, and tactile line drawings superimposed using a silkscreen technique over high-quality, color reproductions of works of art from the museum's collections. The aims of the book were to introduce young braille learners to tactile pictures at the same time as they are developing their tactile skills; to introduce art to young visually impaired people—something often not made available to them; and to create an inclusive experience for sighted and visually impaired people to have together. And we wanted to create something that is beautiful for everyone, through sight and touch. This book demonstrates a multisensory, inclusive approach to museum publications.

The Metropolitan Museum's alphabet book is meant to have accompanying descriptions from a sighted fellow reader or an educator. Taking things a step further, Touch Graphics, Inc. has developed tactile diagrams with an audio component that enable people with visual impairments to use tactile graphics more

independently. The *Talking Tactile Tablet* allows visually impaired individuals to access graphic imagery that would otherwise be unavailable to them. Instead of using braille, which the majority of visually impaired people do not read, users hear descriptions of each part of an image (Touch Graphics, n.d. b).

These are examples of various programming options for one audience. There are also impressive examples of flexibility and choice in the realm of interpretive exhibits. For example, the New York Hall of Science has recently installed two bronze scale models of the actual rockets displayed outside the museum. The exhibit serves as an interactive legend for the rockets; when a visitor touches one, the name of the part they are touching plays from a speaker, and a close-up image of the actual rocket is displayed on a video screen, along with captioned text. A wealth of further supporting information is also available. This exhibit appeals to several senses: sight, hearing, and touch; and it offers many levels of information suitable for different ages, interest levels, and abilities (Touch Graphics, n.d. a).

At the Art Institute of Chicago, a touch gallery invites visitors with and without visual impairments to touch a selection of busts in bronze and marble from the museum's collection. The introductory text panel begins "The gallery gives visitors the rare opportunity to experience how their sense of touch can enrich their appreciation of art. Through touch we can discern an artwork's form, line, size, style, temperature, and texture in ways that sight alone cannot provide." Indeed, it is still a rare opportunity to touch works of art in a museum, especially for

fully sighted people. Deprived of a tactile experience, a means of engagement and representation other than vision, this audience is unable to gather information about the works of art such as their texture, weight, and temperature, except second-hand, from curators or visually impaired friends.

Creating a Welcoming Environment

Museum visiting is generally a voluntary activity, so we first have to convince people to come through our doors. Individuals with disabilities are even more likely than the rest of the population to find museums intimidating, or at least to perceive the museum as an inaccessible place that is not for them.

Many museums, including the Metropolitan, are aiming to counteract this perception of physical and attitudinal exclusiveness through various programs and initiatives. The following examples highlight some of the ways museums are encouraging people to become museum visitors by appealing to their individual interests and showing them the range of experiences available. These include social events, formal and informal learning opportunities for all ages, and new and manifold means to express themselves.

For the past 11 years, the Metropolitan has hosted *The Lighthouse at the Met* concert. Musicians and singers with visual impairments from the Lighthouse Music School perform music related to a special exhibition or some aspect of the permanent collection. Slides of works of art are shown between musical sets, and descriptions of each work are presented. The concert is free with museum admission and open to

all. In 2006, the "Old New York" themed concert attracted 450 people, many of whom were blind or partially sighted. Each year, the concert brings people with visual impairments into the Met who have not previously been to the museum, and we encourage them to come back, giving them large-print and braille brochures about our programs and inviting them to a workshop on the same theme as the concert.

Deaf people are another audience that the Metropolitan has worked hard to welcome and involve in the life of the museum. The museum began offering sign-language-interpreted gallery talks regularly in the 1970s, and in the 1980s developed a group of deaf volunteer guides who gave tours in American Sign Language (ASL). But attendance by deaf people was low. So we borrowed the "deaf night" model successfully employed in some New York restaurants, periodically inviting the deaf community to the museum on a Friday evening for *An Evening of Art & ASL*. Begun in 2000, this innovative series brings hundreds of deaf people into the museum each year. The evenings begin with a gallery talk either sign-language-interpreted or in sign language with a voice interpreter, followed by a reception. This format encourages the deaf community to gather at the museum to learn about art and socialize in their own language. It also offers museum staff the opportunity to communicate informally with this audience, to learn about their needs and interests, and to gain valuable feedback about our programs and services. Our audience of deaf visitors has increased and

diversified tremendously since we began this initiative, and feedback has been positive. In fact, this audience expressed such a desire for more involvement with the museum that we began a training program in 2003 for deaf people to become museum educators.

People with learning and developmental disabilities are yet another audience that is often underrepresented in museums. *Discoveries* is a Metropolitan Museum family program for children and adults with learning and developmental disabilities, including severe to mild cognitive disabilities, autism, Down syndrome, cerebral palsy, and a variety of learning disabilities, including a high percentage of children with attention-deficit disorder. Family members and friends are encouraged to participate in this program.

The educators who teach *Discoveries* are flexible and use many different methods to reach the widest number of people. Tactile materials are incorporated into the workshops and used to reinforce the theme. Many of the participants, such as children with learning disabilities, autism, and visual impairments, are tactile learners and having objects or materials to touch is beneficial. Even parents have commented that they, too, find the tactile elements of the workshops interesting and helpful. *Discoveries* is unusual because it offers an experience for the entire family, but caters to the needs of the individual with a learning or developmental disability.

The Museum in the Community

Discoveries also has an offsite component for adults with developmental disabilities in group homes or at other types of gatherings, such as vocational training programs or leisure groups that meet on a regular basis. Offsite *Discoveries* presents art to an audience who may not normally have access to it and encourages creativity through a hands-on art activity. Follow-up tours at the Museum are offered for all offsite visits.

In another example, Metropolitan educators worked with a school in Long Island, just outside New York City. The students there have severe physical disabilities or medical conditions and are not able to come to the Museum. We first went to their school and introduced the Museum and ancient Egypt through slides and handling objects to 40 students in fourth through sixth grades. The following week, an educator presented a virtual tour of the Egyptian Art galleries to the same group of kids. She spoke to the students on a hands-free cell phone. A cameraman followed her on the tour, and the image was transmitted live to the school. The children loved this experience and were full of questions and observations. The details they could see on their screen at school were often far clearer than they could see on a school tour in the galleries. This was the first such tour at the Metropolitan, although we plan to use this type of technology in the future to bring the museum to people who cannot travel to us.

Challenging Assumptions, Expectations, and Stereotypes

Some solutions for including people with disabilities are more obvious than others. Making assistive listening devices available for gallery talks is an obvious accommodation for visitors who are hard of hearing; offering visitors an opportunity to *see* and *feel* sounds is a solution that challenges us to think creatively about accessibility and universality of design. Inviting visitors who are blind to touch sculpture is not unusual, but encouraging them to take photographs of works of art is not so common, and evokes the need to challenge barriers, both attitudinal and physical.

In an impressive interactive experiment offering multiple sensory avenues for obtaining information, the Science Museum of Minnesota has developed an exhibition called *Wild Music: Sounds and Songs of Life*. The exhibition includes tactile opportunities for all, including a touchable reed spectrum analyzer, a player for touchable 3-D spectrograms of bird songs and animal sounds, a set of sound blocks that allows visitors to create their own soundscapes, and sound pads that allow people with hearing difficulties to experience sound. In addition, all text is in English and Spanish; all audio is captioned, and there are braille and audio descriptions covering exhibit navigation and content for visitors with visual impairments (J. Newlin, personal communication, 2006).[8]

At the Metropolitan, to further diversify our offerings for visitors with visual impairments, we wanted to make opportunities available that challenge assumptions and expectations about what a blind person might be able to do in a museum, or, in fact, anywhere. We have worked with a collective of photographers with visual impairments called *Seeing with Photography*, providing photography courses to high school students and adults with visual impairments. These courses have been rewarding and empowering to participants who have been encouraged to do something that most people would tell them they could not do.

In another initiative at the Metropolitan, educators have mentored two individuals with disabilities, one with severe cerebral palsy and the other with a developmental disability, to train them to give museum tours. The individual with cerebral palsy, who uses an electric wheelchair and is completely nonverbal, uses a laptop computer attached to her wheelchair to communicate, which she controls by pressing a switch on her headrest with the back of her head. Having worked with Metropolitan educators for several months, this year she ran two offsite workshops and gave a tour in the Egyptian galleries.

The other individual, who has a developmental disability, has given a tour to his peers at a day program he attends regularly at a local disability organization, focusing on van Gogh. He then ran a follow-up workshop back at the day program.

I have just discussed initiatives involving training people with disabilities to give tours, as examples of challenging assumptions and expectations. However, they are equally applicable to the next important factor in universally designed museum programming: collaboration.

Collaboration With Colleagues and Audiences

Collaboration can be rewarding in many aspects of museum work, but it is especially important as we all try to reach audiences with disabilities who have not traditionally been museum-goers. As we try out new ideas and methods, if we share what we learn with our colleagues in other museums, we will be more likely to serve our visitors effectively.

In 2005, the Metropolitan collaborated with the Museum of Modern Art (MoMA) on a two-part workshop for adults with visual impairments. The hugely popular workshops focused on modern art in the two museums' collections. This experience gave us the opportunity to work more closely with our counterparts at MoMA, sharing teaching techniques, introducing our regular audience to a new museum, and attracting new visitors to the Metropolitan. We collaborated with MoMA on a second program last year, offering a two-part *Discoveries* workshop for people with developmental and learning disabilities, again on the theme of modern art. Such collaborations are important for two reasons: they open up a new institution to our participants and also act as a model for the partner institution. The Museum of Modern Art began their own program for audiences with developmental disabilities this year.

Collaborations between many museums, disability organizations, and individuals can also be fruitful. In New York, we have the Museum Access Consortium (MAC), a group of representatives from museums throughout the New York City area and members and representatives of the disability community. MAC strives to enable people with disabilities to access cultural facilities of all types. We take as a basic tenet that increasing accessibility for people with disabilities increases accessibility for everyone. Members of MAC exchange information, ideas, and resources and provide a network of mutual support, through meetings, mailings, and an international listserv, and other networking opportunities.

Art Beyond Sight Awareness Month (October) is another example of museums, disability organizations, and individuals collaborating to achieve inclusion of people with disabilities in the arts and culture. *Art Beyond Sight* is an opportunity for schools, museums, libraries, agencies for the blind, and individuals to join together to raise public awareness about making art and culture a part of life for children and adults with visual impairments. A consortium of over 150 institutions, organizations, and individuals offer programs relating to this initiative, from many countries across the world (Art Education for the Blind, 2006; Axel & Levent, 2002).

The Museum in Dialogue With the Audience

We must also collaborate *with our audiences.* They are best placed to tell us what they want from the museum experience and to help us spread the word. Only by working *with* people with disabilities, through advisory boards, evaluations, and focus groups, for example, can we truly call ourselves inclusive. Inclusion encompasses not just accessibility and availability to all, but also the involvement of all. Inclusion is not just about museums making their collections accessible to people with disabilities, but also making their staff, collections, and interpretation reflective of all audiences, including people with disabilities.

The Nassau County Museum of Art on Long Island is a small art museum in a historic house with extensive gardens and a sculpture park. The museum invited collaboration by strengthening relationships with nearby schools and organizations for people with disabilities. They ran focus groups for students and adults with disabilities, asking them to comment on their plans to make the site more accessible. The result was a wider and better informed audience of people with disabilities, who felt involved in the work of their local museum, and also a great deal of valuable advice for developing the museum's inclusiveness. In addition to some much-needed physical alterations to the building and grounds, there is now a kiosk in the sculpture garden with pictures, text, and audio information on sculptures that are not physically accessible; tactile diagrams and descriptions of works of art and touch tours; and many other features enabling visitors with disabilities to participate in a rewarding museum visit (Richner, Prezant, & Rosen, 2006).

At the Metropolitan we were inspired by the positive response and desire for more involvement from the deaf community in our conversations with them during the *Art & ASL* events described above. Taking the idea of inclusion to a further level, we devised a training program, called *Met Signs,* to teach deaf people to become museum educators, using their first language, ASL. We ran an extensive one-year training curriculum for the group, concentrating on

planning a tour, working with different audiences, as well as art historical content, and one-to-one mentoring. We then offered the interns opportunities to give gallery talks to a deaf audience. The aim of this initiative is to provide deaf people with an opportunity that is not readily open to them under typical educational circumstances. The result has been a more diverse and skilled pool of educators that is more representative of the audiences we serve. Three interns are now paid museum educators at the Metropolitan, giving gallery talks, tours, family programs, and other types of education programs, working with deaf and hearing audiences of all ages.

One deaf educator has taught regularly in a *Metropolitan Art Partners* offsite program at a school for deaf children. This program involves an ongoing series of classes at the school as well as visits to the museum. Feedback from teachers of deaf students at the school has been overwhelmingly positive. It is a new and unprecedented experience for the students to have a deaf educator come to their school from a museum and teach them about art in their own language. This response has been echoed by our adult audiences who come regularly to gallery talks given by deaf interns and educators. A deaf educator is now also teaching family programs, using a voice interpreter to communicate with hearing children. Hearing children have been fascinated by the use of sign language, and hearing parents have expressed appreciation for this exposure. There has been tremendous interest from the deaf community to continue this effort. A new group of deaf interns began training in early 2007, with our deaf educators acting as mentors.

Conclusion

This initiative and our work with individuals with other disabilities on guiding tours represent a shift in our relationship with our audiences. Like many art museums, the Metropolitan Museum is moving beyond accessibility, towards inclusion, working with people with disabilities in a way that will include them more actively in the work of the Museum and empower them to use the Museum more actively. We look forward to extending this new and growing type of collaboration with our audiences with disabilities, as facilitators to help them use the Museum and its collections in a more empowered way.

The examples discussed here are just a few of the many initiatives employed by museums in the United States in an effort to reach and include the widest possible audience. Like educators in other U.S. museums, we continue to learn and develop more inclusive practices, aiming for universally accessible experiences for our diverse visitorship. By incorporating touch and other senses into our programming in well-considered ways, we are establishing a new paradigm for museum education. But there is still much work to be done.

I encourage all art museum educators and other museum professionals to:

- Be creative in welcoming new audiences

- Be flexible, offer choices, multiple "ways in"

- Constantly challenge your own and others' assumptions and expectations

- Enable people with disabilities to take part in the work of your museum

- Encourage collecting and interpretation that reflects the experiences of people with disabilities

- Think multimodal! Use all your senses! (Go ahead: lick some sculpture, smell a painting!)

Still, universally accessible museum exhibitions and programming do not happen overnight, nor will an audience of people with disabilities develop immediately. Setting the scene for success depends first on establishing an institutional commitment and a culture within each museum and in the museum community that supports inclusiveness. This requires a sustained investment on the part of museums in terms of staff time, funding, imagination, and other resources. It takes time to build relationships with the audience, to develop awareness of the needs of people with disabilities, to implement accessible exhibitions and installations, and to create a range of programming to meet the diverse needs of visitors. Begin this process gradually, with focused pilot programs that can be evaluated and developed in response to feedback. But always keep in mind a broader picture, one in which visitors have a range of options to choose from, a variety of ways to receive information and to engage with collections, regardless of ability or disability.

REFERENCES

American Heritage Dictionary. (2000). Disability. Retrieved March 30, 2007, from http://education.yahoo.com/reference/dictionary/entry/disability;_ylt=AoN.FKXfD_XttCpu42rgeaGsgMMF

Americans with Disabilities Act, Title 42, Chapter 126, Section 12102. (1990). Retrieved May 31, 2007, from http://www.ada.gov/pubs/ada.htm

Art Education for the Blind. (2006). *What is Art Beyond Sight Awareness Month?* Retrieved March 20, 2006, from http://www.artbeyondsight.org/change/aw-index.shtml

Arthritis Foundation. (n.d.) *Arthritis prevalence: A nation of pain.* Retrieved March 30, 2007, from http://www.arthritis.org/conditions/fact_sheets/arthritis_prev_fact_sheet.asp

Axel, E. S., & Levent, N. S. (Eds.). (2002). *Art beyond sight: A resource to art, creativity, and visual impairment.* New York: Art Education for the Blind/American Foundation for the Blind.

Bird, K., & Mathis, A. (Eds.). (2003). *Design for accessibility: A cultural administrator's handbook.* Washington, DC: National Endowment for the Arts.

Center for Universal Design. (2007). *About universal design (UD).* Retrieved March 30, 2007, from http://www.design.ncsu.edu/cud/about_ud/about_ud.htm

Donoghue, C. (2003). Challenging the authority of the medical definition of disability: An analysis of the resistance to the social constructionist paradigm. *Disability and Society, 18*(2), 199-208.

Gardner, H. (1983). *Frames of mind: The theory of multiple intelligences.* New York: Basic Books.

League for the Hard of Hearing. (2007). *Facts about hearing loss.* Retrieved March 30, 2007, from http://www.lhh.org/about_hearing_loss/index.html

Lesser, A. E. (2001). *Beyond access to opportunity: A guide to planning a universal environment for the arts.* New York: New York State Council for the Arts.

Lighthouse International. (2006). *When it comes to vision impairment, Americans are in the dark: Some eye-opening facts from Lighthouse International.* Retrieved March 30, 2007, from http://www.lighthouse.org/about/accessibility/bigtype_americans.htm

Maryland Commission on Human Relations. (2004). *People with disabilities: Dispelling the myths.* Retrieved June 4, 2007, from http://www.mchr.state.md.us/newpeoplewithdisabilities.html

National Organization on Disability. (n.d. a) *Economic participation: Finding good jobs.* Retrieved March 30, 2007, from http://www.nod.org/index.cfm?fuseaction=Page.viewPage&pageId=13

National Organization on Disability. (n.d. b) *Economic participation: Marketing to people with disabilities.* Retrieved March 30, 2007, from http://www.nod.org/index.cfm?fuseaction=Page.viewPage&pageId=15

Ostroff, E. (2001). Universal design: The new paradigm. In W. Preiser & E. Ostroff (Eds.), *Universal design handbook* (pp. 1.3-1.9). New York: McGraw-Hill.

Richner, N., Prezant, F., & Rosen, P. (2006). All access pass: Making a small museum disabled-friendly. *Museum News, 85*(4), 39-41.

Salmen, J. P. S. (1998). *Everyone's welcome: The Americans with Disabilities Act and museums.* Washington, DC: American Association of Museums.

Sanchez, I., & McGinnis, R. (2003). *Art and the alphabet: A tactile experience.* New York: The Metropolitan Museum of Art.

Touch Graphics. (n.d. a) *Interactive 3D touch rocket model.* Retrieved March 30, 2007, from http://www.touchgraphics.com/rocket.htm

Touch Graphics. (n.d. b) *Talking Tactile Tablet 2.* Retrieved March 30, 2007, from http://www.touchgraphics.com/ttt.htm

United Nations (1948). *Universal Declaration of Human Rights, Article 27 (1).* Retrieved March 30, 2007, from http://www.unhchr.ch/udhr/index.htm

U.S. Census Bureau. (1997). *Americans with disabilities.* Retrieved May 31, 2007, from http://www.census.gov/hhes/www/disability/sipp/disab97/asc97.html

U.S. Census Bureau. (2000). *Americans with disabilities.* Retrieved May 31, 2007, from http://www.census.gov/hhes/www/disability/cen00.html

FOOTNOTES

1 In the decade between 1990 and 2000, the number of Americans with disabilities increased by 25%, according to the US Census Bureau (2000).

2 Significantly, in 2001, the World Health Organization (WHO) altered its definition, positioning disability as a contextual variable, in recognition of the impact of the social as well as the physical environment on individuals and level of disability. See the article on Universal Design on the Adaptive Environments website for a discussion of the WHO International Classification of Functioning, Disability and Health (ICF 2001), at www.adaptiveenvironments.org/index.php?option=Content&Itemid=3&PHPSESSID=d2a05e5627f25115f0cc2ef6510e9357#

3 See, for example, Salmen (1998).

4 See, for more information, the Convention on the Rights of Persons with Disabilities, at www.un.org/disabilities/convention/

5 See www.ada.gov/ for detailed information and guidance on the Americans with Disabilities Act.

6 See the Smithsonian Guidelines for Accessible Exhibition Design, available online at www.si.edu/opa/accessibility/exdesign/start.htm; *Everyone's Welcome: The Americans with Disabilities Act and Museums and The Standards Manual for Sign and Labels*, available from AAM; Bird and Mathis (2003); and Lesser (2001).

7 The Principles of Universal Design as established by the Center for Universal Design at North Carolina State University, focus on products and environments. However, there have been efforts to expand their application to include learning environments, such as Universal Design for Learning, developed by the Center for Applied Special Technology (CAST) in Boston. Theories proposing a diversity of learning styles, such as Gardner's (1983) Theory of Multiple Intelligences, have been in circulation for some time, but recent neuroscience research, suggesting that everyone's brain processes information differently, gives biological credence to these suppositions. Based on this new biological evidence supporting theories of learning differences, researchers at CAST have developed principles of Universal Design for Learning, to help classroom educators to devise universally designed curricula that offer: multiple means of representation (various ways of acquiring information and knowledge); multiple means of expression (alternatives for demonstrating knowledge); and multiple means of engagement (that tap interests, offer appropriate challenges, and motivate learning). (Center for Applied Special Technology. www.cast.org)

8 For more information, see http://www.astc.org/exhibitions/wildmusic/dwildmusic.htm

PART 4

The Museum Experience and Gallery Practices

Gallery Teaching as Guided Interpretation: Museum Education Practice and Hermeneutic Theory

Rika Burnham
The Metropolitan Museum of Art

Elliott Kai-Kee
J. Paul Getty Museum

Save for the fashions in dress of the day, a photograph of museum visitors gathered around a work of art half a century ago would not look very different from a similar photograph taken today. The visitors, accompanied by a museum instructor, form a small group gathered around a work of art, looking intently. But if we could transport ourselves back in time to listen in on our mid-20th-century group and their guide, we would hear immediately that gallery teaching then was very different from what transpires in most of our museums now. Largely a lecture practice then, since the late 1970s museum teaching has been commonly based on discussion. The change in format from lecture to discussion came about as museums sought broader audiences in the name of inclusiveness. They turned away from a method of museum teaching that was ultimately rooted in a venerable tradition dating back to the 19th century of public lecturing on art and aesthetics, to embrace participatory activities that ranged from discussion to artmaking. Museum instructors

with a mandate to make their teaching more "relevant" experimented and discovered that their presentations were more lively and engaging for visitors when they adopted participatory approaches. Most museum educators today think that good gallery teaching works to discover rather than to assign meaning to works of art and that they must avoid assuming an authoritative voice in order to allow visitors to construct their own meanings.

Despite this shift in the direction of museum teaching, museum educators still struggle to define the nature and objectives of our teaching practice. Bringing people to appreciate and make sense of works of art is a complex task. Ultimately, we hope to inspire profound experiences— meditative, insightful, poetic, even transformative. We hope to respect equally both audience and object. Audience research gives museum educators a sense of who our visitors are and a sense of how they learn. Scholarship provides information about the objects. Bringing together audience research and object research raises, however, important

issues for museum pedagogy. Museum educators debate whether information provided by the educator discourages or even displaces understandings that visitors are able to make for themselves. If so, does the swing away from lecturing and the sense of institutional authority it conveys entail a need for educators to shift their focus "from what objects say to what viewers think," as some have asserted (Rice & Yenawine, 2002)?

As long-time practitioners of gallery teaching, we have looked for a model of museum education in which our interest in the viewer is served by our interest in the artworks, incorporating both what viewers and we, ourselves, know and think about the works of art. According to such a model, we could not simply transmit what we see and know about artworks, but neither could we narrowly focus on what our viewers see and think about them. We have found that in our teaching we join our viewers to probe and examine works of art that draw our interest. We ask that eyes and minds engage to unfold works of art in time, through open-ended conversations that require and benefit from everyone's contributions. We have come to view museum teaching as a guided, shared act of interpretation in which the objects of study invite

multiple views, such that our understandings of the artworks are enriched by discussion and debate with and among the visitors (Burnham & Kai-Kee, 2005).

Reframing gallery teaching as interpretation has allowed us to view our work as part of a broader interpretative practice that unites many disciplines, a practice with its own extensive literature and history. Within this larger literature and history we have sought a theoretical viewpoint from which to reflect upon, criticize, and better understand what it is we do and why we do it, to define our teaching practice anew, and thus to allow us to be more consistent in our work. Formulating in a general way where our discipline's history and our inventions have brought us deepens our understanding of our work and helps us explain it to others. Knowledge of relevant interpretive theory may also help us to discover new models for museum teaching.

Thinking about museum teaching as interpretation has led us to hermeneutics, the theory and practice of interpretation (Hooper-Greenhill, 2000). The word "hermeneutics" is derived from the name of the Greek god Hermes, one of whose tasks it was to interpret the sayings of the gods to mortals. Hermeneutics developed as a discipline during the Renaissance and Reformation to provide rigorous methods for interpreting Greek and Roman literature, Roman law, and, above all, religious texts. Biblical hermeneutics, in fact, could be said to underlie most subsequent methods of literary interpretation in the Western tradition. In the 18th and 19th centuries, philosophers (primarily in Germany) proposed that the

Toby Tannebaum
Los Angeles County Museum of Art

Over the past several years, the Education Department at the Los Angeles County Museum of Art (LACMA) articulated and continues to refine an approach to gallery teaching. Our present statement, revised from an earlier, longer one, reads, "The education department aims to create gallery experiences that provide a welcoming and comfortable environment in which visitors can engage with works of art. Museum tours at LACMA encourage careful looking, offer opportunities for active learning, and assist viewers in making connections to their own knowledge and experiences." This philosophy—and the training of gallery teachers—incorporate our ongoing experiences and reflection, the findings of tour program evaluations, and current research in the field.

practice of interpretation rested on general rules valid for all fields of knowledge (Mueller-Vollmer, 1988). In the 20th century, hermeneutic theory was dominated by Hans-Georg Gadamer, who wrote extensively on aesthetics, and whose writings have provided us with philosophical context and inspiration.

What art museum teaching shares with the hermeneutics of Gadamer is the core premise that dialogue and conversation are the foundation of understanding and interpretation. "An encounter with a great work of art has always been like a fruitful conversation," wrote Gadamer (1985, p. 250). The unique charge of museum teaching is to bring people and works of art together face to face so that conversation can take place. We invite people into dialogue—with us, each other, and above all, with the artwork. We initiate and guide a conversation, an open-ended discussion, an inquiry with the objective of finding words and terms for what we feel, see, and

want to know about the work of art. Within the play of dialogue, the object reveals itself. When we state in words what we see and understand, we create a common language for the exploration of the artwork. Our spoken words allow us to build upon each other's thoughts and observations. As Gadamer (1982) remarked, understanding is expressed in language, in questions and answers, in the unending process of finding words to communicate what we see.

When we first begin to look at an artwork, our groups start with an expectation that it will yield its meaning to them. The ensuing dialogue is driven by what Gadamer called "the anticipation of perfection," the expectation that our observations and thoughts about the work will come together into a coherent whole. Anticipation drives our conversation. And as the group unfolds the work in conversation, dwelling on this part and that, our emerging sense of the whole is revised, enlarged, and clarified. This constant revision of our sense of the whole in light of our discoveries is what Gadamer called the "hermeneutic circle." In museum practice, the hermeneutic

circle is punctuated by moments of repose for silent reflection and by moments of consensus. Museum instructors have a sense of direction, a sense of the possible outcome of any group's encounter with a given artwork, yet they must equally cultivate a willingness to listen and yield to what unfolds in conversation. In the hermeneutic circle, meanings are provisional, and we find that as our exploration deepens and widens in scope, we continually test the understandings that emerge against further observations.

Our understandings of a work of art are never complete. "An artwork is never exhausted. It never becomes empty. No work of art addresses us always in the same way. The result is we must answer it differently each time we encounter it" (Gadamer, 1997, p. 44). This is important for the museum educator because it teaches us that we are not working toward an ultimate truth, but that every conversation requires us to be open to the possibility of new meanings, new interpretations. Through dialogue, knowledge is constructed, and ideas and speculations are encouraged with the objective of opening possibilities, not limiting them. The results for all participants are, we hope, complex and rich experiences.

Gadamer (1982) also reminded us of the historicity of knowledge. Our knowledge is almost always framed within prior traditions of understanding that are incorporated into our own ways of thinking. These traditions narrow the ways in which we look at artworks, determining which questions are important, and what kinds of answers are valid. Artworks are passed down to us along with traditions of prior interpretation that, together with the details of

their provenance and analyses of their materials, constitute the "information" accumulated about them. In the museum, these traditions include art historical, art critical, and curatorial voices. Some interpretations are powerful because they have withstood the tests of criticism and competing interpretation; others perhaps simply because they have become part of institutional culture. We treat them critically, aware of their power to dominate the interpretive process. We use them to guide our interpretation and to keep our interpretations focused, but we always hope, as well, that our conversations will illuminate the artworks in unpredictable and surprising ways.

Yet even as we have come to understand our practice as fundamentally interpretive, unfolding in small communities of people who gather to discuss works of art in the galleries of our museums, our work suggests that more happens than can be accounted for by a strictly hermeneutic model. Take, for instance, a class of young adults sitting in the Japanese galleries of The Metropolitan Museum of Art one Friday evening:

Under our guidance, they look intently at four Momoyama sliding door panels (fusuma), early 17th-century Japanese paintings rendering an 8th-century Chinese subject that originally were part of the famous temple at Ryoanji. We ask the class to begin in silence. Several minutes pass as they see, ponder, receive the work of art. Eyes flicker across the panoramic whole, surrender in unpredictable sequences to dynamic details and the suggestions of a narrative. We ask them to take

the work into the mind's eye, without concern for information the label might convey. We will examine that later. We ask for thoughts and observations, and a lively discussion ensues. Several people note the opulent gold surface that serves as both background and foreground, a seamless atmosphere punctuated by magically buoyant clouds. Another brings our attention to a weightless central figure, disembodied and floating mysteriously in space. We wonder where, or in what world, this and the other figures have gathered. Some viewers comment on certain especially expressive faces, as if the figures had become friends we were concerned about. We note again the sumptuous gold background and speculate that it might represent fog or light. A gust of wind swirls up and blows through trees and clouds, catching and lifting the long sleeves of the robes worn by the figures. We wonder what has brought these personages to this strange place, which looks both familiar and unfamiliar at once; we wonder what they are seeing and doing in this mysterious assemblage. Someone suggests that unseen forces have summoned them; someone else that the figures have gathered to witness a momentous occurrence. Eventually the instructors identify the figures as Chinese sages in a remote paradise, a utopian realm where they have come for cultivation of self and spirit. They are seekers of immortality who have left the everyday world, and we see them here in astonishing stages of enlightenment in this large and panoramic work of art known as The Daoist Immortal Resshi, attributed to Kano Kotonobu. (Onishi, 1993, pp. 14-47)

It is easy to report the verbal aspect of this gallery discussion, to relate how the participants described what they were seeing and slowly built an interpretation together. What transpires in language is easy to relate in language. What are not so easy to describe are the moments without words, moments of attentive silence and reverie filled with astonishment and affection for the work of art. Visitors to our museums experience works of art beneath, in between, and after deliberate and focused acts of interpretation. We note the importance of the initial experience, before any words are said, the moment when we are silently absorbed into the work of art. Rapt attentiveness marks the beginning moments of silence, as the eyes of the participants absorb and question, consider various aspects, move back and forth from details to whole. These moments ground and motivate whatever meaning the viewers go on to construct, and it is essential to encourage and cultivate them.

After such a session, our visitors often speak urgently to us about the artwork we have viewed together—or about the discussion itself—and remark that the intensity of the dialogue took them by surprise. Clearly, there are states of appreciation beyond what unfold in words, and there is more in our museum practice than can be explained by Gadamer's theory of interpretation. This does not surprise us when we think of the solitary museum visitor (Armstrong, 2000; Walsh, 2004), for whom we believe this is a frequent and, indeed, sought-after way of appreciating the artworks in our museums. But it does surprise us to think of this as a part of our teaching practice and presents us

with the challenge to understand the people in our groups who find themselves inexplicably moved, sometimes to laughter, sometimes to tears, or others who lapse into listening, or are swept into moments of silent reverie. As one of the participants in the gallery conversation above said, "I'm sorry I was so quiet, but my experiences with works of art that are deep are without words."

We recognize now that our experiences with works of art unfold equally in words and in wordless moments. Although we might not go as far as to say that "in place of a hermeneutics we need an erotics of art," as Susan Sontag (1966, p. 23) wrote, we can embrace her idea that we must always make room for a profound sensory attentiveness to works of art. "What is important now," she wrote, "is to recover our senses. We must learn to see more, to hear more, to feel more" (p. 23).

In fact, no "erotics of art" could ever displace hermeneutics. As our gallery teaching reveals to us every day, interpretation is, finally, an irresistible impulse. We can, however, encourage visitors to delay the hermeneutic moment, if only a little, at least until after they have surrendered fully to the object's presence. We must allow the artwork to come in upon us—or to take us away—allow ourselves to be buffeted as it pushes our thoughts one way and another (Elkins, 2001). The artworks themselves direct and redirect us, providing us with new insights and new feelings. We are sometimes in control, but we relinquish control, too. Our growing attachment and affection

for the work of art intensifies the discussion, and the discussion intensifies our affection. We look again and listen to the object. It talks to us, comes alive. We are hearing more, feeling more. As one of our students said, "At first I thought we were looking at the work of art. Then I realized the work of art was looking at us."

A model for museum teaching, then, needs to account both for what transpires in words and what transpires beneath and beyond words. For a theoretical concept that would embrace talking and listening, interpretation and emotion, we turned to John Dewey's idea of experience. Dewey (1934/1980) described experience as occurring continuously when we interact with our environment. While emphasizing the active role that individuals must take in their relation to the world, he also highlighted the "undergoings" contained in experience. Too much zeal for action, Dewey wrote, results in dispersed and miscellaneous experience, as we museum educators sometimes observe in interpretations that are not focused by the object. And too much passivity results in loss of contact with the world. Here Dewey reminded us again of the importance of active dialogue and genuine engagement with a work of art. Dewey wrote that life is a series of "doing and undergoing." "Nothing," he wrote, "takes root in mind when there is no balance between doing and receiving" (p. 43).

Dewey's (1934/1980) discussion of experience explains the sometimes intensely affective nature of the experiences we have with groups in our galleries. He suggested that experiences with artwork are distinct and separate from everyday experience, examples of what he called "*an* experience" (p. 35), marked by a sense of wholeness and unity. When we ask our visitors to set aside daily concerns and enter into relation with a work of art, we ask that their focus create a separate space and time to experience it. We also ask them to engage with it, to make it their interest and concern for a brief period of time. They may like or dislike it. We realize that it is the wordless emotions that arise in our discussions, the emotions that we have not asked for, cannot direct or stop, that hold our attention on the artwork and give our discussions momentum. For Dewey, emotion was the moving and cementing force of experience, "providing unity in and through the varied parts of experience" (p. 42).

The concept of "*an* experience" describes the magical moments of our teaching with works of art. "*An* experience" of an artwork in some way never ends, but in the hour or so that we have with a group of visitors, we hope to create whole experiences that reach culmination, when the thoughts and observations and feelings of the group come together. Each encounter with a work of art will

end differently, unpredictably. The experience may end gradually, with a slowly developing appreciation of all the resources an artist has used to a particular effect. It may end suddenly, in a moment of discovery, as if the curtain has been pulled aside to reveal a work's final layer of meaning. It may end in words. Or it may end in silence and wonder. Dewey (1934/1980) suggested that "*an* experience" is shaped in a certain way, with a beginning, development, and culmination, running a course to fulfillment "so rounded out that its close is a consummation not a cessation" (p. 35). Dewey described aesthetic experience as one in which long enduring processes "arrive in an outstanding moment which so sweeps everything else into it that all else is forgotten" (p. 56).

We return to the galleries of our museum and the teaching we do in these buildings dedicated to beauty, filled with objects that inspire study, thought, discussion, wonder:

The group that was gathered around the fusuma has dispersed. The hour or so we had with them to study the work of art, to make sense of it, to be moved by it, has ended. A few of the participants linger, staying a few moments longer in the afterglow of their experience. Others who have left will later find the work of art inhabiting their thoughts, inspiring new questions, changing their perspectives on the world, perhaps even impelling them to return to the museum gallery with friends, to share what they had discovered. (Burnham & Kai-Kee, 2005, p. 67)

For Dewey (1934/1980), the experience of art ideally continues long after the initial transaction. Greene (2004) elaborated, describing aesthetic experience as "a reality made meaningful by acts of our imagination, intuition, emotion, belief, sensation, and cognition, no longer an abstraction rationally or logically defined" (p. 1). We know, then, experience as well as understanding is what we strive for in teaching when we ask our visitors to engage with works of art. Is it possible to find a model for museum teaching that proposes an ideal for both understanding and experience, yet is based in the realities of our everyday responsibilities?

When we allow ourselves to imagine a photograph of museum visitors of the future, we see gallery teaching that is inspired by a model simultaneously hermeneutic and experiential. According to this model, we understand that words build interpretation and construct understandings of the works we encounter. But we also recognize that silences, associations, recognitions, and feelings are the unpredictable preconditions and binding forces that hold our experience together. But when the interpretation is shaped into "*an* experience," we make it possible that our viewers will leave the museum changed, perhaps transformed, "so they can walk away at a different angle to the world" (Cuno, 2004, p. 73). We have suggested that bringing Gadamer and Dewey together as our theoretical guides will give us a way to understand our work more deeply and make it more effective. We understand our work as interpretive, measured, mediated, and structured through words, but always surrounded with the possibility of numinous experience.

REFERENCES

Armstrong, J. (2000). *Move closer: An intimate philosophy of art.* New York: Farrar, Straus, & Giroux.

Burnham, R., & Kai-Kee, E. (2005). The art of teaching in the museum. *Journal of Aesthetic Education, 39*(1), 65-76.

Cuno, J. (2004). The object of art museums. In J. Cuno (Ed.), *Whose muse? Art museums and the public trust* (pp. 77-102). Princeton, NJ: Princeton University and Harvard University Art Museums.

Dewey, J. (1934/1980). *Art as experience.* New York: Perigee.

Elkins, J. (2001). *Pictures and tears.* New York: Routledge.

Gadamer, H. G. (1982). *Truth and method.* New York: Crossroad.

Gadamer, H. G. (1985). Philosophy and literature. *Man and World: An International Philosophical Review, 18,* 241-59.

Gadamer, H. G. (1997). Reflections on my philosophical journey. In L.Hahn (Ed.), *The Philosophy of Hans-Georg Gadamer* (pp. 3-63). Chicago and LaSalle, IL: Open Court.

Greene, M. (2004) *On painting.* Unpublished essay.

Hooper-Greenhill, E. (Ed.). (2000). *Museums and the interpretation of visual culture.* London: Routledge.

Mueller-Vollmer, K. (Ed.). (1988). *The hermeneutics reader: Texts of the German tradition from the Enlightenment to the present.* New York: Continuum.

Onishi, H. (1993, Summer). Chinese lore for Japanese spaces. *The Metropolitan Museum of Art Bulletin.* 51/1, 3-47.

Rice, D. & Yenawine, P. (2002). A conversation on object-centered learning in art museums. *Curator, 45*(4), 289-301.

Sontag, S. (1966). *Against interpretation, and other essays.* New York: Farrar, Straus, & Giroux.

Walsh, J. (2004). Pictures, tears, lights, and seats. In J. Cuno (Ed.), *Whose muse? Art museums and the public trust* (pp. 77-102). Princeton, NJ: Princeton University and Harvard University Art Museums.

Understanding the Museum Experience

Carole Henry
University of Georgia

Art museums are an important aspect of contemporary culture. With their tasks of collecting, preserving, exhibiting, and interpreting works of art, they provide access to the history, beliefs, and values of cultures throughout time. They are, in effect, much like libraries holding vast quantities of information, information that is accessible visually in ways that can be quite powerful. Falk and Dierking (2000) referred to museums as "public institutions for personal learning" (p. xii). As such, museums offer rich opportunities for teaching from actual objects. Museums have long planned educational programming for schoolchildren, but now many are reaching out to adult audiences. Of course, there are many people who have discovered the potential for learning that museums provide, but there are also those who believe that museums are for someone else, not for them (*Insights*, 1992; Hood, 1983). This chapter considers the museum experience from the perspective of the museum visitor, with the explicit goal of helping make the museum visit a more rewarding experience for both children and adults.

What is it about art museums that make some people uncomfortable? The answer to this question has much to do with the philosophy that influenced the development of museums. Originally, many museums in this country focused on an aesthetic mission. One of the most well-known advocates of this position was Benjamin Ives Gilman of the Boston Museum of Fine Arts. He wrote an influential text, *Museum Ideals of Purpose and Method*, in 1918, in which he distinguished between science museums and art museums in a way that today reeks of elitism. He explained, "A museum of science is in essence a school, a museum of art in essence a temple" (Zeller, 1989, p. 30). Museum directors influenced by Gilman sought to create environments where those who entered could commune quietly with works of art. Little was needed in terms of education other than displaying the work. Even today, we can still find vestiges of this philosophy reflected in museum practice.

Others worked to infuse an educational mission into museum practice. One of Gilman's contemporaries was John Cotton Dana, founder and director of the Newark Museum, who advocated in practice, and in print, that museums had an educational responsibility to the broader community. To that end, Dana sought a more egalitarian approach, one that would reach out to the community through loans of works of art to schools and factories and the establishment of storefront museums in business areas. According to Dana, "A museum is good only in so far as its use" (Zeller, 1989, p. 35).

This educational mission became a reality with the passage of the Tax Reform Act of 1969 (Caston, 1989). This legislation provided tax exemptions to institutions in which education was a principal function. Where the debate in the museum field had been merely philosophical in the past, now there was a clear rationale for museums to assume stronger educational roles. For the most part, these educational efforts consisted primarily of programming for school groups through gallery tours, teacher resources, and outreach programs. Elementary schools became the primary target of programming because class changes in middle and high schools made scheduling museum visits difficult.

Over the last 30 years, much has changed in the ways art museums embody their educational mission. While there are still holdovers of the philosophy that a museum should be a quiet sanctuary for a few, today more and more museums are reaching out to an increasingly diverse public. Exhibitions are booked that have the potential to interest broad sections of the population, and blockbuster exhibitions designed to attract large crowds are commonplace. Increases in visitor attendance indicate that a growing number of people are changing their "perceptions of the role museums can play in their lives" (Falk & Dierking, 2000, p. 2). Museum educators in these museums work with curators to develop labels and wall text that are accessible to visitors with various levels of artistic experience. For example, at the High Museum in Atlanta, the principle goal is to help the visitor have a meaningful encounter with the work of art, and interpretation becomes something that the visitor discovers rather than something the curators predetermine (Remaking the High Museum, 2005).

The Personal Nature of the Experience

For most adults, deciding to visit an art museum is a conscious decision. It is a decision based on personal knowledge and past experience. People make this decision for a variety of reasons including the desire to have an experience that is meaningful. Many museum visitors are repeat visitors; they know that there is a payoff to their visit in terms of personal pleasure, knowledge acquired, and insightful reflection. Others feel uncomfortable and ill prepared to understand works of art and never, or only rarely, visit museums.

The idea that the museum should be a quiet sanctuary for the enjoyment of those who already know a great deal about works of art is being replaced by the museum that actively seeks out a wider audience. The *Treasures of Tutankhamen* exhibition in the mid-1970s demonstrated that museums that could go beyond simply displaying works of art to creating environments designed to maximize the viewer's potential for comprehension could attract large segments of the population (High Aims, 2002).

Textual connections among the social, cultural, and political context in which works of art were created are essential aspects of exhibitions in many museums. Audio tours often include music and poetry designed to help create a sense of time, place, and emotion. No longer are these tours necessarily static and sequential: the viewer can choose which works to see in whatever order desired and can choose to play or not play the accompanying audio. In other words, viewers can structure their own experiences.

Although most museums did not openly acknowledge this fact, to some degree, this has always been true. Visitors enter museums, choose the galleries to which they go, choose the works in the gallery they want to look at and the labels they want to read. They also choose when they want to leave the gallery and the museum itself. A museum visit is a very personal experience.

The Personal, Social, and Physical Contexts

There is growing interest in the nature of the museum experience among researchers in art and museum education.[1] The museum experience was broadly defined by Falk and Dierking (1992) as all that transpires between the "person's first thought of visiting a museum, through the actual visit, and then beyond, when the museum experience remains only in memory" (p. xv). Additionally, they proposed that this experience varies from individual to individual and, in fact, is dependent upon the interaction among the personal context (the visitor's life experiences, interests, and expectations), the social context (whether the individual visits the museum alone, with friends or family, or as part of a large group), and the physical context (the architecture, atmosphere, and objects on display within the museum). Most recently, they have added the dimension of time as an aspect of learning in museums and expanded the social context to include the sociocultural to explain how learning in museums is mediated socially and culturally (Falk & Dierking, 2000). Dierking (2002) conceptualizes such learning as "a series of overlapping and reinforcing experiences over time and place" (p. 16). In their earlier work, Falk and Dierking (1992) explained that every experience is different because each visitor comes to the museum with a different set of personal experiences operating within differing sociocultural contexts. Each is affected differently by the physical context of the museum and the choices individually made within that context.

It is not difficult to see how important the personal context is. We are all the sum products of our own personal experiences. We have backgrounds rooted in various cultures and differing levels of educational experience and economic levels. For some, visiting art museums is a habit formed in childhood; for others, it is a new experience. Expectations of a museum visit can be very different for repeat visitors than for those who are visiting for the first time. Repeat visitors base their expectations upon actual experience while first-time visitors' expectations may be based upon what they have read, seen in a movie, or heard from a friend. Understanding these differences can help facilitate experiences that are more positive for everyone.

People come to museums alone, with friends or family, and as part of organized groups. Each of these different social contexts can directly affect the quality of the experience as can interactions with museum staff and other visitors. Some people prefer to visit alone; they can take as much or as little time as they like with particular works of art without worrying about anyone else. Others prefer to come with someone to share their experiences, sometimes separating and reuniting to discuss what each experienced. Some visitors bring their families and view the museum as an environment in which they can learn new things together. People who choose to come as part of an organized group often enjoy learning about art in a group setting but have less control over which works they view during their visit.

The physical context of the art museum also affects the museum experience. The architecture can be imposing and even intimidating to a first-time visitor. Much like Gothic cathedrals, older museums were designed to inspire a sense of awe. Today's more contemporary buildings, although far less formal, can also be imposing. Vast, open spaces can be disconcerting to some viewers (Maxwell & Evans, 2002). Within these spaces, the layout of the galleries, the type of lighting, and the arrangement of the works of art all are intended to work together to create a space where it is possible to view the exhibition in the most positive way. Today's museums give considerable thought to these details, even changing the color of paint on the walls to better showcase the art. In theory, the museum staff creates the setting in which it is most likely the visitor can have a meaningful experience with the work of art, an environment free of distractions in which the work of art is the central focus.

Since the political and cultural changes of the 1960s, museums have increasingly sought to increase their relevance to contemporary life through broadening their range of exhibitions and increasing the diversity and number of their visitors. The more recent immigration of the last several decades to the United States has made this even more relevant. Today's budgetary realities also necessitate that museums take steps to assure that new visitors revisit the museum. Museum educators agree that a primary way to encourage repeat visits is to help visitors of all ages have positive experiences, those that Walsh-Piper (1994) described as "both meaningful and memorable" (p. 105). As a result, a number of studies (see Falk & Dierking, 1992) have sought to better understand the museum visitor. In general, these studies have shown that people visit museums for a variety of reasons that fall under the categories of: "(1) social-recreational reasons; (2) educational reasons; and (3) reverential reasons" (p. 14) and that museum visitors value opportunities to learn, the challenge of new experiences, and doing something worthwhile (Hood, 1983) that the museum visit provides. Museum educators and others are now beginning to question the nature of that learning (Dierking, 2002).

Some museums are learning about the museum visitor's experience through market research designed to help improve their public image and to better inform decisions regarding hours of operation, content of wall labels, admission charges, and, as an article in the New York Times suggested, "perhaps one day, even what kind of art to show" (Vogel, 1992, p. 1). Other museums have studied non-museum visitors to discover ways to make the galleries more meaningful to a broader range of people. In particular, The J. Paul Getty Museum used focus-group interaction to compare the expectations of adults who generally did not visit museums to their reactions to an actual museum experience at museums across the United States (Insights, 1992).

The Getty study found that people don't visit museums for a number of reasons. In general, they often feel intimidated by museums—they believe that everyone who visits museums is more knowledgeable about art than they are and that they lack the knowledge necessary to be able to understand the works

of art on display. They choose to do other things in their free time and often expect that they would be bored visiting an art museum. After their visits, first-time visitors found the experience "emotional" and "invigorating" and wanted to return. They were surprised that the art was "more interesting" and "less intimidating than expected" and reported that they "spent more time in the museum than [they had] planned" (*Insights*, 1992, pp. 10-15).

Another study conducted by Eisner and Dobbs (1988) looked at what museums do to help the visitor better experience the museum. They looked at "the way the works are displayed, the themes that relate one work to others, the content of the signage (wall panels and labels) that is provided, comprehensibility of the text, and the overall effectiveness of the installation" (p. 7) in 31 museums throughout the country. Their conclusions indicated that museums could greatly increase viewer involvement by having orientation galleries that provide some guidelines for viewing, displaying works in ways that invite comparison, providing contextual references for the works on display, and using language that is clear and invites emotional and cognitive connection. Museums throughout the country are making these kinds of changes.

In the late 1980s, the Denver Art Museum conducted a series of studies to gain information "from visitors that described not just who they were, but their reactions to art and the efforts of an art museum to communicate with them"

(Loomis, 1990, p. 133). The results of these studies were examined by museum staff, and many ideas were generated and put into practice. A visit to the Denver Art Museum today reveals a museum that is truly visitor friendly. Galleries include area rugs and comfortable sofas in front of works of art because visitors indicated they needed to places to relax as they viewed the art. Gallery guides are written in everyday language and tucked into convenient locations. Each exhibition floor has a library area that invites further research through books and computer terminals. These libraries are decorated in a style that reflects the content of the galleries on that floor with comfortable seating, casual lighting, and works of art. Areas are set aside for children complete with "dress-up" costumes and mirrors. The galleries are full of visitors of all ages and various ethnicities. Teenagers, families with young children, young adults, and senior citizens all seem to find the museum an inviting and welcoming place. In short, the museum has succeeded in attracting and maintaining a new audience because it paid attention to what museum-goers said they needed in order to have a more engaging experience.

The Denver Art Museum Interpretive Project (Grinstead & Ritchie, 1990) provided a strong theoretical and practical base for important changes in how museums now approach their visitors. It also had relevance for what McDermott-Lewis (1990) described as the

"novice" viewer, the viewer with "moderate to high interest in art and low to moderate knowledge" (p. 7). She used the term "advanced amateur" to describe those viewers who are "knowledgeable" about art and "pursue art as an avocation" (p. 7). Advanced amateurs are visitors who have continued to try to learn about art and regularly seek out and take advantage of opportunities to view works of art. What distinguishes the novice from the advanced amateur? How do they differ in terms of expectations of museum experiences and the ways in which they perceive art? Understanding visitor expectations can help museum staff create exhibitions in which visitors have more meaningful museum experiences.

Understanding Visitor Expectations

Novice viewers, those viewers who described themselves as having interest in art but as lacking knowledge of art, want their museum visits to be pleasant learning experiences. They prefer to come to the museum with others and to walk through the galleries until something grabs their attention. They also are quick to make judgments and tend to prefer art that is realistic or highly skilled and, above all, understandable. An emotional connection is important as well and is often the main motivation for viewing art. Although they know there is much more that they could learn about works of art that might enhance their viewing experiences, they are skeptical of over-intellectualization and experts who try to tell them what is good or bad in terms of art (McDermott-Lewis, 1990).

More advanced viewers plan the museum experience, either beforehand or upon entering the museum. They also want an enjoyable experience and have learned through experience that it is better to focus on certain works rather than trying to see everything in the museum. They expect the art to be displayed in such a way that they are not distracted by glare or other art or even other people. They expect to learn new knowledge but do not want that knowledge to be forced upon them. Although they are more likely than novices to visit museums alone, they also see benefits in visiting with someone and sharing reactions. A human connection is important; they are interested in historical information, the sources of the artist's ideas, and how certain effects are created. Comparison to adjacent artworks or art they have seen before is a meaningful part of their experience. Time is important as more advanced viewers are aware of how to look in depth at a work of art and need sufficient time to become engaged with the work and make discoveries on their own. The idea that the intellectual is valued does not negate the importance of an emotional response. It seems the more advanced viewer wants a balance between the two (McDermott-Lewis, 1990).

Making the Experience Meaningful

What does it mean to have a meaningful experience with a work of art? Those of us who are familiar with museums use this type of terminology frequently, sometimes without fully understanding what we ourselves mean by it. For many museum-goers, it is an experience of insight or emotion that is at the heart of our experiences, what is frequently referred to as an aesthetic experience. For others, this phrase—"the aesthetic experience"—can be troublesome and perplexing in itself. Because it is central to many viewers' idea of a positive museum visit, and, in fact, a goal of many visitors, it is important to recognize that frequent museum visitors value the insight and emotion that such an experience provides.

The aesthetic emotion is a particular type of emotional response. Traditionally, philosophers have connected the aesthetic to a sense of beauty (Eaton, 1988). In the early-20th century, the aesthetic emotion was linked to the way the formal elements of a work of art were arranged to create what aesthetician Clive Bell called "significant form" (Dickie, Scalfani, & Roblin, 1989). According to this viewpoint, content was considered less important than the formal components of a work of art. During the 20th century, artists challenged ideas about the nature of art resulting in a wide range

of artistic expression. In today's cultural climate, where works of art challenge our understandings and explore important social issues, the idea that one should react primarily only to the formal elements in a work of art in order to experience it "aesthetically" is counter to current thinking.

Walsh-Piper (1994) defined the aesthetic experience as "one of heightened attention to perception, which is what makes it both meaningful and memorable" and that has those "qualities that foster subsequent worthwhile reflection" (p. 105). She discussed how museums are designed as architectural spaces to set works of art apart from other distractions and to invite contemplation. She explained that visitors should have enough information to "stimulate curiosity and imagination, while allowing for the sheer pleasure and delight in looking" (p. 109). It is in this sense that the aesthetic experience is addressed in this chapter.

Csikszentmihalyi, a researcher known for his work investigating the flow experience in athletics and chess, and Robinson, an interdisciplinary social scientist, were commissioned by the J. Paul Getty Museum to study the aesthetic experience. Working under the assumption that the aesthetic experience is the ultimate museum experience, they conducted extensive interviews with museum professionals. They hypothesized that museum professionals possessed highly developed skills that allowed them to enjoy thinking deeply about works of art on a daily basis, that this ability to find pleasure in

viewing art is an acquired skill, and that a logical way to understand the viewing experience was "to study the practices of those who may be assumed to possess" that skill (Czikszentmihalyi & Robinson, 1990, p. vii). They explained that historical information, information about the social and cultural context, connections to basic human emotions, and the engagement of the imagination all are factors that can stimulate such a response. Csikszentmihalyi and Robinson stated that viewers need to understand that "viewing art is its own reward" and becomes an opportunity to "challenge their senses, their emotions and their knowledge" (p. 174). Out of such moments can come increased understanding, greater insight, and a sense of time well spent, all important aspects of a lifelong approach to learning.

Research in educational theory (Damasio, 1994) has shown that learning is connected to emotion and cannot be separated into exclusively rational domains. The arts have the power to engage us emotionally and intellectually. The potential for new knowledge and insight is one of the primary reasons people visit museums on a repeat basis (Dierking, 2002). Additionally, such experiences bring a sense of pleasure and give meaning to our lives. Csikszentmihalyi and Robinson (1990) explained, "The value of a person's life—whether it was filled with interesting and meaningful events or whether it was a sequence of featureless and pointless ones— is determined more by the sum of experiences over time than by the sum of objective possessions or achievements. By this measure, aesthetic experiences are important indeed" (p. 152).

Artists in the last two decades have expanded the traditional forms of art, crossing boundaries between media and creating works that demand new modes of understanding. Much of contemporary art falls under the category of postmodernism. Postmodern art seeks to dissolve boundaries between art forms, merge aspects of various styles and cultures, and deconstruct what has come to be the artistic standard of the artworld. Most obvious in architecture in many cities, postmodern art may also take the form of an installation in a gallery or a performance piece with accompanying digital imagery and sound. Gude (2004) has identified specific postmodern principles that she contends can also inform understanding. Examples include appropriation, or taking preexisting images and using them in new ways; juxtaposition, intentionally using disparate images and objects in ways that confront the viewer; recontextualization, taking traditional symbols and refiguring them to give them new meaning; layering, using images on top of one another to create complexity; and hybridity, merging newer art forms with traditional ones. Museum educators can help their visitors recognize these characteristics and how they are used to better enable those visitors to find meaning in contemporary art and enjoy the unique, interpretive challenge it presents.

Conclusion

This chapter has provided a basic overview of the educational role of art museums, the varying contexts in which they are experienced by the museum visitor, and the nature and continuing relevance of the aesthetic experience in the 21st century. In the '70s, '80s, and '90s, art museums were criticized by academics as being irrelevant to social issues and other concerns (Oberhardt, 2001). Today, they are in the process of evolving from institutions whose previously accepted role was to serve as "arbiters of taste and the ultimate authority" (Adams, Falk, & Dierking, 2003, p. 15) to collaborators with museum visitors in the construction of meaning, providing unique opportunities for reflection and moments of insight. In doing so, they empower individual viewers to have the kinds of personal museum experiences that make them want to return.

REFERENCES

Adams, M., Falk, J., & Dierking, L. (2003). Things change: Museums, learning, and research. In Xanthoudaki, M., Tickle, L., & Sekules, V. (Eds.), *Researching visual arts education in museums and galleries: An international reader* (pp. 15-32). The Netherlands: Klower Publishers.

Caston, E. (1989). A model for teaching in a museum setting. In N. Berry & S. Mayer (Eds.), *Museum education: History, theory, and practice* (pp. 90-108). Reston, VA: National Art Education Association.

Csikszentmihalyi, M., & Robinson, R. (1990). *The art of seeing: An interpretation of the aesthetic encounter.* Los Angeles: J. Paul Getty Museum and the Getty Center for Education in the Arts.

Damasio, A. (1994). *Descartes' error: Emotion, reason, and the human brain.* New York: G. P. Putnam's Sons.

Dickie, G., Scalfani, R., & Roblin, R. (1989). *Aesthetics: A critical anthology.* New York: St. Martin's.

Dierking, L. (2002). The role of context in children's learning from objects and experiences. In S. Paris (Ed.), *Perspectives on object-centered learning in museums* (pp. 3-18). Mahwah, NJ: Lawrence Erlbaum.

Eaton, M. (1988). *Basic issues in aesthetics.* Belmont, CA: Wadsworth.

Eisner, E., & Dobbs, S. (1988). Silent pedagogy: How museums help visitors experience exhibitions. *Art Education, 41*(1), 6-15.

Falk, J., & Dierking, L. (1992). *The museum experience.* Washington, DC: Whalesback Books.

Falk, J., & Dierking, L. (2000). *Learning from museums: Visitor experiences and the making of meaning.* Walnut Creek, CA: AltaMira Press.

Grinstead, S., & Ritchie, M. (Eds.) (1990). *The Denver Art Museum Interpretive Project.* Denver: Denver Art Museum.

Gude, O. (2004). Postmodern principles: In search of a 21st-century art education. *Art Education, 57*(1), 6-14.

Henry, C. (2000). How visitors relate to museum experiences: An analysis of positive and negative reactions. *The Journal of Aesthetic Education, 34*(2), 99-106

High aims to create a Paris on Peachtree. (2002, November 17). *Atlanta Journal-Constitution*, p. M1.

Hood, M. (1983). Staying away: Why people choose not to visit museums. *Museum News, 61*(4), 50-57.

Insights: Museum visitors, attitudes, expectations. (1992). Los Angeles: The J. Paul Getty Trust.

Loomis, R. (1990). Impressions of the Denver Art Museum Interpretive Project. In S. Grinstead & M. Ritchie (Eds.), *The Denver Art Museum Interpretive Project* (pp. 133-136). Denver: Denver Art Museum.

Maxwell, L., & Evans, G. (2002). Museums as learning settings: The importance of the physical environment. *Journal of Museum Education, 27*(1), 3-7.

McDermott-Lewis, M. (1990). Through their eyes: Novices and advanced amateurs. In S. Grinstead & M. Ritchie (Eds.), *The Denver Art Museum Interpretive Project* (pp. 7-39). Denver: Denver Art Museum.

Oberhardt, S. (2001). *Frames within frames.* New York: Peter Lang.

Remaking the High Museum: The art of connection. (2005, July 10). *Atlanta Journal-Constitution*, p. L1.

Vogel, C. (1992, December 20). Dear museumgoer: What do you think? *The New York Times*, p. 1.

Walsh-Piper, K. (1994). Museum education and the aesthetic experience. *Journal of Aesthetic Education, 28*(3), 104-115.

Zeller, T. (1989). The historical and philosophical foundations of art museum education in America. In N. Berry & S. Mayer (Eds.), *Museum education: History, theory and practice* (pp. 10-89). Reston, VA: National Art Education Association.

FOOTNOTES

[1] Portions of the following discussion of research investigating visitor response were first published in Henry (2000).

Shaping Experiences With Technology:
A Constructivist Approach to Learning in Art Museums

Giulia Gelmini Hornsby
University of Bergamo, Italy

The traditional role of both science and humanities museums has changed. Over the last few decades, museums have increasingly positioned themselves within the landscape of cultural institutions as places for rich learning experiences. Together with the emergence and consolidation of novel perspectives on learning, such as constructivism and socio-cultural theories, the repositioning of museums as leading institutions for informal learning has brought about the need for a redefinition of the tools and material resources involved in the structuring and delivery of museums' educational programs.

This chapter provides an account of the main tenets of constructivist learning theory as well as Falk and Dierking's (1992, 2000) model of museum learning and uses these as a framework to guide the design and evaluation of technologies to support the museum visit. Three examples of museum applications illustrate how this framework can be successfully applied to technology design and evaluation.

As museums are now taking on a variety of social and educational functions that extend their mission beyond that of preserving, studying, and presenting their collections, these institutions are faced with a new challenge: how to shape engaging, meaningful learning experiences for their audiences.

Facing this challenge has become even more crucial for art museums and galleries, where the meaning of the objects displayed is becoming more and more fluid and multi-faceted. Art museum education and interpretation strategies are moving away from a common 19th-century conceptualization of displays as representations that leave no room for ambiguity regarding the meaning of a given object (Hooper-Greenhill, 1994, 1995). Representations are no longer seen as static reflections of the curators' views: multiple readings, personal insights, cultural learning contexts, and social practices surrounding art works are now beginning to be acknowledged and valued (Caulton, 1998; Hein, 1996; Hooper-Greenhill, 1994).

Because works of art have no self-evident meanings, interpretation is called upon to embrace a willingness to experiment with new ideas and to recognize the validity of diverse audience responses (Wilson, 2004). These redefinitions of the role of museums in structuring knowledge interpretation have led many cultural institutions to take on a more visitor-oriented approach and to reflect on how to facilitate interpretation from a variety of perspectives, including physical resources organization, content delivery, and social inclusion. These three aspects involved in the structuring of a visitor's museum experience— the management of the physical resources at hand, the delivery of *ad hoc* content and the shaping for the social context —are well articulated in Falk and Dierking's (1992, 2000) model where the three key elements that contribute to the perception of the visit are, indeed, the physical context, the personal context, and the social context.

A Theoretical Framework

The physical context covers the material resources that define the space of an exhibition and the layout. These include traditional aspects such as the architecture of the building, the division into rooms according to the different themes or artists exhibited, the presence of a foyer, the lighting system, and so on, but also other elements, such as the use of new technologies to support the visit, their positioning within the museum space, and their function for information delivery. These are all contributing factors to the creation of an open and accessible environment, where information flows easily within the museum, but also to and from the museum, thus facilitating the above-mentioned openness to multiple perspectives and interpretations. The way a museum is organized around its material resources carries implicit assumptions about the way in which a museum conceives itself and its educational mission. Including tools that make it possible for visitors to access information that is not immediately available within the physical structure hosting the objects on display is not a simple matter of logistics and space arrangement, but an ideological and epistemological one: the choice of providing their visitors with resources that enable them to go beyond the physical exhibition space reflects how a museum conceives itself as an institution embracing a wide spectrum of voices and sources of information, as opposed to seeing itself as a self-contained entity (Bal & Janssen, 1996).

The personal context, on the other hand, includes the visitors' knowledge prior to the visit; their motivations for visiting the museum; their states of mind; their learning styles, expectations, and anticipated outcomes; and the agendas they bring to the museum. A hands-on approach may best suit some visitors, while a more abstract and reflection-oriented approach may be appropriate for others. Some visitors may want to get a brief overview of the objects displayed, while others may head straight for a selection of the most famous pieces in the collection. Others still may want to find out as much as they can about as many exhibits as possible, and so on. All these factors contribute to shaping each visitor's experience, and museums are now facing the challenge of catering to diverse audiences and customizing their programs in order to make each visit an individual and unique journey through knowledge (McLean, 1997).

Finally, the social context covers the social interaction during the museum visit between the visitor and any immediate companions (Falk & Dierking, 1992, 2000). Whether visitors come to the museum on their own, with their families and friends, or with a teacher will have a great impact on the museum experience. As sociocultural theory and research show, discussing ideas, sharing knowledge, and negotiating opinions are powerful means of meaning-making within a community (Bradbourne, 2001; Kelly, 2002; Lave & Wenger, 1991; Vygotsky, 1978), and museums are now beginning to realize that one of the foundations of an effective interpretive strategy is that of facilitating productive relationships among their visitors. The social context also pertains to co-visitors or all the other people who visit an exhibition at the same time. Space can be re-invented to create a social museum experience where co-located and remote visitors are able to exchange ideas and share knowledge. Finally, space is not the only boundary that communities of visitors cross and re-shape: Time is another variable that can be incorporated in this notion of the social museum. Co-visitors are not only the people synchronously visiting the museum, but also those who visit it before and after we do. But how exactly can communication occur among visitors across time and space?

With the emergence of new technologies such as the Internet, mobile phones, networked Personal Digital Assistants (PDA), and video conferencing, new possibilities for communicative encounters across time and space arise. Possible scenarios include real visitors leaving traces of their visit and their interaction with the objects in the museum in the form of comments on the museum's home page for virtual visitors to read or using their networked PDAs to bookmark the objects in the exhibition they enjoyed most. This would enable visitors to create alternative, personalized paths through the exhibition for future visitors to explore.[1]

These are only a few examples of museum practice (Galani & Chalmers, 2004; Marti, 2001; Not, Petrelli, Sarini, Stock, Strapparava & Zancanaro, 1998; Oppermann & Specht, 1999; Wilson, 2004; Woodruff, Aoki, Grinter, Hurst, Szymanski, & Thornton, 2002) where new media are creatively employed to shape entertaining and rich educational museum experiences in its threefold contexts: the physical, the personal, and the social.

Constructivism

Pervasive and crucial to Falk and Dierking's (1992, 2000) model, as well as to the design choices behind the systems described below, constructivism (Dominik, 2000; Hein, 1996; Jeffery-Clay, 1997; Vygotsky, 1978) views learners as active participants in the experience of learning, where the material, the personal, and the social contexts in which learning takes place play a crucial role in the construction of knowledge. Constructivism was first transposed to the museum context by Hein (1996), who proposed a set of learning principles that fit neatly with Falk and Dierking's threefold model of the museum experience.

Thought and experience, Hein (1996) claimed, are grounded in multi-sensory participation. Involving visitors with visual displays is not enough, or at least it is not the only effective way of engaging them. Touch, hearing, and to some extent smell and taste are all viable and untapped ways of shaping rich experiences for the visitors. In other words, the physical museum plays an important role in the orchestration of multi-sensory experiences that multimedia technologies can enhance. Audio guides providing background information to visitors observing a work on display or interactive exhibits complementing the objects in the exhibition are only a few examples of possible applications intended to augment the museum visit with multi-sensory features.

Constructivism views learning as contextual and situated (Lave & Wenger, 1991). Previous knowledge is a pre-requisite to learning, as what we learn is related to what we already know, our beliefs, and our interests. The personal context in which an experience takes place is an essential aspect of learning. Consequently, museums must deliver tailored, *ad hoc* information that fits into people's lives to enable meaning making through personal exploration (McManus, 1991, 1993). New technologies provide an untapped potential in facilitating this (Bowen, 2000; Keene, 1998; Thomas & Mintz, 1998). A PDA can be programmed to adapt the information it delivers according to its user's interests, learning styles, even what exhibits the visitor has already seen in the museum, for how long, and the information he or she was interested in.

Finally, constructivism claims learning to be a social activity that happens with others. With technology, a visitor can be connected to other co-located and remote visitors or even exchange information with past and future visitors.

Examples

The multiplicity of contexts surrounding a museum experience, together with the active role of the visitors, requires museums to turn to novel, flexible ways of designing the interaction between their collections and their visitors.

Sottovoce[2]

Sottovoce is an electronic guidebook (otherwise defined as a PDA) that enables visitors to share audio information by eavesdropping on each other's guidebook activities. The technology was developed by the Xerox Palo Alto Research Center and implemented at Filoli, a Georgian Revival historic house where numerous art works are displayed.

Sottovoce is designed to be used by pairs of visitors sharing audio content. When visitor A selects an object on her device, she always hears her own audio clip. If A is not currently playing an audio clip, but her companion B is, then B's audio clip can be heard on A's device. Audio clips are never mixed, and A's device always plays a personal clip (selected by A) in preference to an eavesdropped clip (selected by B). Audio playback on the paired devices is synchronized; if A and B are both listening to their own clips and A's clip ends first, A will then hear the remainder of B's clip as if it had started in the middle. To control a device's

eavesdropping volume (i.e., the volume at which A hears B's clips), the interface includes three option buttons: "off," "quiet" and "loud" (see Figure 1). "Loud" is the same as the volume for personal clips (Woodruff et al., 2002).

The headsets were designed to have a single ear plug to enable the visitors to hear each other speak and interact conversationally (Figure 1, right). Formal evaluation of *Sottovoce* shows that:

1. Visitors were more likely to discuss information and personal responses to the objects displayed when using the system,

2. The "eavesdropping function" enabled social interaction originating from the sharing of the information delivered by the system. (Woodruff et al., 2002)

Because *Sottovoce* supports personal responses to the information delivered and social interaction, the system fits within Falk and Dierking's (1992, 2000) model of a personal and social museum. With its one-ear headset and eavesdropping function, it represents an innovative example of an electronic guidebook that is far from traditional audio guides that constrain users to a solitary museum experience. The visitor using *Sottovoce* is no longer isolated, focused on the information being delivered by the system and therefore unable to interact, discuss opinions, and exchange experiences with others.

Figure 1. Electronic Guidebook and Headset.

The Multimedia Tour at the Tate Gallery, London

The Multimedia Tour Programme is an electronic guidebook that provides personalized and contextualized information within the museum visit. The system was developed as part of the Tate Gallery's interpretation and education program and was aimed at "extending the gallery's interpretation agenda as well as the visitors' experience and taking a pluralistic, activity-based approach towards learning to a new digital dimension" (Wilson, 2004).

The system consists of the following integrated modes:

1. "Interactive Map" function, supporting physical navigation through the gallery space.

2. "Gallery Info" function, providing information about memberships, gallery events, and generally giving an overview of the Gallery's mission.

3. "Select Work" function, supporting content navigation among the artworks. In this mode, the selected work is reproduced on screen, with various elements highlighted. When visitors touch a highlighted area, that detail appears larger on screen, and an audio section about it begins. For some works, the visitor can decide to play related music through their headphones or watch short clips of interviews with the maker of the artwork.

4. "Tate Text" function, providing a messaging space among visitors using the system. This allows visitors to send their views on artworks to other people taking the tour. Visitors are also encouraged to take part in opinion polls in front of selected works—such as voting on their first impressions of the Rothko room—and are able to track the percentages of other visitors' responses.

Bringing together audio, video, image, and text, as well as interactive features such as games and texting between visitors, the Tate's Multimedia Tour affords a personalized and social experience.

The two systems described so far are examples of innovative and creative technology implementations aimed at supporting the museum visit in a personal and social context. However, both systems seem to overlook the physical context. The following system is an example of technology implementation aimed at facilitating content exploration both inside and outside of the museum's walls, in a co-located and remote mode.

City

The City system (Galani & Chalmers, 2004) was developed to support co-visiting by people across two modes: the located, for visitors who are physically visiting the museum; and the remote, for visitors who wish to explore the museum via an online or a virtual reality representation of its content and physical layout. The prototype was implemented to support visits to two museums in Glasgow, UK: the Mack Room in the Mackintosh Interpretation Centre and the Lighthouse.

Onsite visitors carry a PDA that is location–aware and displays the ongoing positions of both co-located and remote visitors. Offsite visitors can choose whether to use a web browser to display the gallery content and the other visitors' locations (Figure 2) or to use 3-D representation displaying avatars of the other visitors (Figure 3). All visitors wear headphones and microphones that allow them to share an audio channel.

Figure 2. Floor plan on a Pocket PC, for onsite visitors.

Figure 3. Offsite Visitors Visualizing the Gallery via a 3-D Representation. © Equator, IRC – City project.

The system also supports multimedia information for the offsite visitors in the form of web pages that are dynamically presented upon movement in the map or VE. This is a particularly significant feature, as it affords visitors using technology to retrieve information outside the museum's walls, thus shaping their experiences not only within a personalized and social context, but also in a physical context, as defined in the theoretical framework.

Conclusions

This chapter discussed the potentials of new technologies in mediating engaging experiences in art museums and galleries. The theoretical stance used views museum visitors as active interpreters rather than as passive message decoders: their backgrounds, previous experiences, expectations and motivation towards the subject at the time of the visit, together with the people they share the visit with and the physical information resources available, are factors that heavily influence the visit experience (Caulton, 1998; Hein, 1996; Hooper-Greenhill, 1994, 1995). In particular, in this chapter the museum visit was seen as the result of three intersecting spheres of action: the physical, the personal, and the social. This theoretical framework was applied to three examples of innovative technology implementation in museums, where interpretation is delivered in a holistic way, thus allowing visitors to personalize and share information and to retrieve information from a wide range of sources beyond the museum walls.

Although the ever-accelerating progress of technology makes it difficult to give a continuously fresh account of the state of the art, this chapter illustrates how Falk and Dierking's (1992, 2000) theoretical framework can be productively used as a guideline for designing technology aimed at supporting the visitors' experience. The examples reported show the potential of new technologies to shape museum experiences that unleash visitors' curiosity, interests, and sense of inquiry (Rogers, 1969).

REFERENCES

Bal, M., & Janssen, E. (1996). *Double exposures: The subject of cultural analysis.* London: Routledge.

Bowen, J. (2000). The virtual museum. *Museum International, 2*(1), 4-7.

Bradbourne, J. M. (2001). A new strategic approach to the museum and its relationship to society. *Museum Management and Curatorship, 19,* 75-85.

Caulton, T. (1998). *Hands-on exhibitions: Managing interactive museums and science centres.* New York: Routledge.

Dominik, T. (Ed.). (2000). *Medium museum: Kommunikation und Vermittlung in Museen für Kunst und Geschichte* [Museum as medium: Communication and mediation in museums of art and history]. Bern: Haupt.

Falk, J., & Dierking, L. (1992). *The museum experience.* Washington, DC: Whalesback Books.

Falk, J. H., & Dierking, L. D. (2000). *Learning from museums: Visitor experiences and the making of meaning.* Walnut Creek, CA: AltaMira Press.

Galani, A., & Chalmers, M. (2004). Empowering the remote visitor: Supporting shared museum experiences among local and remote visitors. *Proceedings of 2nd International Museology Conference: Technology for the Cultural Heritage: Management–Education–Communication.* Lesvos, Greece.

Hein, G. (1996). Constructivist learning theory. In G. Durbin (Ed.), *Developing museum exhibitions for lifelong learning* (pp. 30-34). London: The Stationery Office.

Hooper-Greenhill, E. (Ed.). (1994). *The educational role of the museum.* London: Routledge.

Hooper-Greenhill, E. (Ed.). (1995). *Museum, media, message.* London: Routledge.

Jeffery-Clay, K. (1997). Constructivism in museums: How museums create meaningful learning environments. *Journal of Museum Education, 23*(1), 3-7.

Keene, S. (1998). *Digital collections: Museums and the information age.* Oxford, UK: Butterworth Heinemann.

Kelly, L. (2002). Extending the lens: A sociocultural approach to understanding museum learning. In *UNCOVER: Graduate Research in the Museum Sector Conference,* Sydney, Australia.

Lave, J., & Wenger, E. (1991). *Situated learning: Legitimate peripheral participation.* Cambridge, UK: Cambridge University.

Marti, P. (2001). Design for art and leisure. *Proceedings of International Cultural Heritage Informatics Meeting* (ICHIM), Milan, Italy (pp. 387-397).

McLean, F. (1997). *Marketing the museum.* London: Routledge.

McManus, P. M. (1991). Making sense of exhibits. In G. Kavanagh (Ed.), *Museum languages: Objects and texts* (pp. 33-46). Leicester, UK: Leicester University.

McManus, P. M. (1993). Memories as indicators of the impact of museum visits. *Museum Management and Curatorship, 12*(4), 367-380.

Not, E., Petrelli, D., Sarini, M., Stock, O., Strapparava, C., & Zancanaro, M. (1998). Hypernavigation in the physical space: Adapting presentations to the user and to the situational context. *The New Review of Hypermedia and Multimedia, 4,* 33-45.

Oppermann, R., & Specht, M. (1999). A nomadic information system for adaptive exhibition guidance. *Proceedings of International Cultural Heritage Informatics Meeting (ICHIM),* Washington, DC (pp.103-109).

Rogers, C. (1969). *Freedom to learn.* Columbus, OH: Charles E. Merrill.

Thomas, S., & Mintz, A. (Eds.). (1998). *The virtual and the real: Media in the museum.* Washington, DC: American Association of Museums.

Vygotsky, L. (1978). *Mind in society.* Cambridge, MA: Harvard University.

Wilson, G., (2004). Multimedia tour programme at Tate Modern, In *Proceedings of Museums and the Web,* Arlington, VA / Washington, DC.

Woodruff, A., Aoki, P. M., Grinter, R. E., Hurst, A., Szymanski, M. H., & Thornton, J.D. (2002). Eavesdropping on electronic guidebooks: Observing learning resources in shared listening environments. *Proceedings of Museums and the Web,* Boston (pp. 21-30).

FOOTNOTES

[1] To use a simple metaphor, what a visitor does when bookmarking features in the exhibition for future visitors is very much like what a person reading a book does when highlighting a few paragraphs to facilitate other readers' understanding of what s/he considers to be the most relevant parts of the text.

[2] *Sottovoce* can be translated as "whisper." Woodruff et al. (2002) described how they arrived at the name: "The intimate, often directed, nature of the resulting shared audio context has led us to call the system *Sottovoce*" (p. 21).

Art Viewing and Aesthetic Development: Designing for the Viewer

Abigail Housen

Visual Understanding in Education

My work began with this: how could viewing art make some uncomfortable, others bored or edgy, and still others animated and excited? Fascinated by these distinctive reactions, I wanted to know more about what I would later call aesthetic development. How do people experience art? What goes on in their minds as they stand in front of a painting? What goes on over their lifetimes as they stand again and again in front of many paintings?

From a pedagogical point of view, I wanted to know what aesthetic skills are developed in looking at a work of art. What causes such development? I decided that only by understanding viewing from the viewer's perspective could I understand how to support and nurture and, finally, foster aesthetic growth. Initially, I developed a research method to measure the art-viewing experience. Then, after years of teaching and research, I collaborated with Philip Yenawine to create educational practices that help learners move to new levels of aesthetic experience.

Stages of Aesthetic Development

In the 1970s, I demonstrated that, regardless of cultural or socioeconomic background, viewers understand works of art in predictable patterns that I call "stages." My research showed that we process artwork in a sequence of these stages (Housen, 1983). In the ensuing decades, I, with my colleague Karin DeSantis, demonstrated this fact in research studies where we showed that, if exposed to a carefully sequenced series of artworks, viewers' ways of interpreting images would evolve in a predictable manner. We also found that given certain key elements in the design of aesthetic encounters, growth in critical and creative thinking accompanied growth in aesthetic thought. In other words, in the process of looking at and talking about art, the viewer is developing skills not ordinarily associated with art. These findings were consistent over a wide range of cultural and socioeconomic contexts (Housen, 1992a, 2000, 2002; Housen, DeSantis, & Duke, 1997).

When viewers talk—in a stream-of-consciousness monologue—about an image, and every idea, association, pause, and observation is transcribed and analyzed, the different stages become apparent. Each aesthetic stage is characterized by a knowable set of interrelated attributes. Each stage has its own particular, even idiosyncratic, way of making sense of the image. I review them here.[1]

Stage I

At *Stage I, Accountive*, viewers are listmakers and storytellers. They make simple, concrete, observations:

Lines, ovals, squares… (Picasso, Girl Before a Mirror*)*

At times, the Stage I viewer makes observations and associations that appear idiosyncratic and imaginative:

[A] giraffe's back … a dog's face. (Picasso, Girl Before a Mirror*)*

Likewise, the Stage I viewer may incorporate people and objects into an idiosyncratic narrative:

I see two ladies, holding each other. (Picasso, Girl Before a Mirror*)*

It seems to me he's going home now, and he can't find his clothes. (Cezanne, Bather*)*

Judgments are based on what the viewer knows and likes:

The wallpaper is beautiful. (Picasso, Girl Before a Mirror*)*

Emotions color the comments, as the Stage I viewer animates the image with words and becomes part of an unfolding drama:

… Like he's hurt [his arms] when he was swimming or like he was mad or something the way he was holding his arms. (Cezanne, Bather*)*

The Stage I viewer (the "storyteller") and the image (the "story") are one. The viewer engages in an imaginatively resourceful, autonomous, and aesthetic response.

Stage II
At *Stage II, Constructive*, viewers set about building a framework for looking at art, using the most accessible tools at hand: their perceptions, their knowledge of the natural world, and the values of their social and moral world. Observations have a concrete, known reference point:

And they have five fingers, just like us. (Picasso, Girl Before a Mirror*)*

If the work does not look the way it is "supposed to"—if skill, hard work, utility, and realism are not evident (the tree is orange instead of brown), or if the subject seems inappropriate (if themes of motherhood are transposed into themes about sexuality)—the Stage II viewer judges the work to be "weird" and lacking in value:

The hair on the first person is blond, and it is true, but there is no such thing as a purple face. (Picasso, Girl Before a Mirror*)*

As this viewer strives to map what she sees onto what she knows from her own conventions, values, and beliefs, her observations and associations become more linked and detailed. The viewer looks carefully and puzzles. An interest in the artist's intentions develops:

The person has chosen, instead of using circles for the background, he used lots of diamonds. (Picasso, Girl Before a Mirror*)*

Emotions begin to go underground, and the Stage II viewer begins to distance herself from the work of art.

Stage III
At *Stage III, Classifying*, the viewer adopts the analytical stance of the art historian. Studying the conventions and canons of art history, she wants to identify the work as to school, style, time, and provenance. The Stage III viewer wants to know all that can be known about the artist's life and work, from when and where an artist lived to how the work is viewed in the panoply of artists:

I guess how much this resembles primitive art in a sense because the figures are flat and representational, and yet they're nudes which were sort of an 18th-century, 19th-century preoccupation, and yet [it] foreshadows modern art. (Picasso, Les Demoiselles d'Avignon*)*

The Stage III viewer searches the surface of the canvas for clues, using his library of facts, which he is eager to expand. His chain of information becomes increasingly complex and multilayered:

It seems to me that this is one of a number of Picassos that really is very indicative of … two of his styles that are blending, this sort of monumental style of female drawing and the later Cubist style which you see entering into it … (Picasso, Les Demoiselles d'Avignon*)*

This viewer believes that properly categorized, the work of art's meaning and message can be explained and rationalized.

Stage IV
In *Stage IV, Interpretive*, viewers seek an interactive and spontaneous encounter with a work of art:

I don't think that [drawing the ideal human form] was what he really had in mind as being that important, so maybe he de-emphasized some of the features, abstracted more because he was looking for us to look at other things—she does seem to be having some trouble with her reach, closing that circle, so that adds a little stress to the picture, that's nice, it gives you so much to think about. (Matisse, Dance*)*

Exploring the canvas, letting the meaning of the work slowly unfold, the Stage IV viewer appreciates formal subtleties. She unwraps methods and processes in a new way, discovers new themes in a familiar composition, and distinguishes subtle comparisons and contradictions:

It also reminds me of, I mean, I can imagine like the suffragettes of the time just thinking this painting was so terrific. … I don't know this, this is just an assumption of mine, but I think they would really, like, take it in, and like want it to be theirs as well, like the strength, the unity of women, sort of helping and nurturing each other in a way, sort of leading each other on a path. (Matisse, Dance*)*

Mary Erickson
Arizona State University

An Art Educator's Questions

As an art teacher educator and art education researcher, I have found Abigail Housen's approach to viewing art informative, and I am confident that art teachers as well as art museum educators will find it helpful. Housen's approach is strongly rooted in her own studies, often co-authored with her collaborator, Philip Yenawine. Researchers and theoreticians might want to know how her findings compare with others. How do her stages compare with those of Michael Parsons ([1987]. *How we understand art: A cognitive account of the development of aesthetic understanding.* New York: Cambridge.)? Are her stages compatible with other developmental studies and reports on diverse art worlds (Erickson, M., & Clover, F. [2003]. Viewpoints for art understanding. *Translations*, vol. 12, no.1, n.p.)?

Several questions arise as one considers the artworks best suited for Housen's approach and the possible implementation of that approach by teachers. Housen's examples are limited to three European Modernist painters from the first half of the 20th century (Picasso, Cezanne, and Matisse). One might wonder whether she also advocates this approach for contemporary work—for example, that of Barbara Kruger or Carmen Lomas Garza; for earlier eras in Western art history, for example, baroque or medieval art; or for artworks from other cultures, for example, Inuit or Song Dynasty Chinese. Is Housen's approach appropriate for viewers interested in work from diverse art worlds beyond Western Modernism? Housen's use of three paintings as examples and her identification of the central question for Stage I as "What is going on in this picture?" might lead one to wonder about other art forms. For example, does her approach apply to three-dimensional artworks?

Museums are limited by the diversity of artworks currently on display. On the other hand, teachers in schools with Internet connections can introduce artworks from virtually any culture or era. Teachers in schools almost always have sustained contact with students, whereas much less time is available for museum visits. Because public schools serve increasingly diverse students, teachers must consider diversity both in their selection of artworks and in their expectations of culturally informed student responses. When, if at all, should teachers share cultural background information about an artwork made in a culture with which students are unfamiliar?

Because Housen submitted her essay to a museum education publication, one can assume that she recommends her approach for viewers visiting art museums where they experience original artworks face to face. Is her approach effective for teachers using art reproductions in classrooms? When art teachers make decisions about how to introduce artworks to their students, many consider the skills and knowledge identified in National Visual Arts Standards, state standards, and district art curricula. If Housen recommends her approach for use in schools, how do the different opportunities and responsibilities of teachers (versus art museum educators) affect how they should introduce artworks to their students? If Housen limits advocacy of her approach to museum visits, how can art museum educators and art teachers most effectively collaborate in planning museum visit activities?

These and other questions stimulated by Housen's essay are evidence of its richness and potential to spur thoughtful reflection by art teachers and art education researchers, as well as art museum educators.

Critical skills are put in service of feelings and intuitions, as the Stage IV viewer lets the meaning of the work—its symbols—emerge. Each new encounter presents a chance for new insights and experiences, and with each new "aha" comes a new engagement:

And it's not perfect, there's like a humanity in this piece that speaks very clearly because of that irregularity in the line and the size, the proportion of each, which I'm sure means other things as well but really speak to me. (Matisse, Dance)

Knowing that the work of art's identity and value are subject to reinterpretation, this viewer trusts his own processes, which are knowingly subject to chance and change.

Stage V
At *Stage V, Re-Creative,* viewers, having established a long history of viewing and reflecting about art, now willingly suspend belief (as described by Coleridge, 1817). The work of art is not just paper and paint. The viewer sees the object as semblant, real, and animated with a life of its own:

The more I look at the painting, the more I have this sense of the sexuality as being a kind of pressure that pushes away from the canvas but in some ways is tightly held by the canvas itself. (Picasso, Les Demoiselles d'Avignon)

The Stage V viewer begins an imaginative contemplation of the work (Baldwin, 1975). Transcending prior knowledge and experience, this viewer gives himself permission to encounter the artwork with a childlike openness. A trained eye, critical

stance, and responsive attitude are his lenses as the multifaceted experience of the artwork guides his viewing. A familiar painting is like an old friend, known intimately yet full of surprise, deserving attention on a daily level, but also existing on a more elevated plane:

I think just the freshness of it just keeps coming through continuously, even though it's quite an old painting at this point, it still seems very new to me. (Picasso, Les Demoiselles d'Avignon)

Drawing on their own history with the work in particular, and with viewing in general, these viewers combine personal, playful contemplation with one more broadly encompassing and reflecting universal concerns. As with important friendships, time is a key ingredient, allowing the Stage V viewer to closely know the biography of the work: its history, questions, intricacies, and ecology. Here, memory infuses the landscape of the painting, intricately combining the personal and the universal.

There are preliminary drawings for this painting which incorporated a sailor and a doctor, I believe, standing to the side and pulling back a curtain and seeing the interior … and the idea that Picasso eliminated those male figures and just presented the painting directly to the viewer, almost asking the viewer to be in that position seemed to be a very interesting change in the thinking about art. (Picasso, Les Demoiselles d'Avignon)

Educational Implications of Aesthetic Stages
Listening to the wonderful complexity of viewers' remarks at each stage, it becomes understandable that their particular ways of processing—their stages—must be taken into account if we are to design effective educational experiences. Having a detailed map of aesthetic stages is a useful tool in this endeavor, for it enables us to select images based on our understanding of viewers' interests and needs at each stage. To begin with, our goal becomes clear: to design programs that foster aesthetic development in a measurable way (Housen & Yenawine, 2000a, 2000b, 2001b, 2002).

To be more specific about programs, the following discussion describes learning environments for Stages I through IV. For the first two stages (I and II), I cite questions used in Visual Thinking Strategies (VTS) (Housen & Yenawine, P. 2000a, 2000b, 2001b, 2002), a curriculum designed for beginner viewers. For Stages III and IV, I discuss the issues and questions central to learning environments for these stages. I do this even though we have found that VTS (the curriculum for Stages I and II) can be successfully and effectively used with all ages and levels, provided that the images are chosen appropriately (Yenawine, 2003).

"What is going on in this picture?" (Housen & Yenawine, 2001a)—the central question for Stage I viewers—is the first question we use in VTS. Although this question works for all stages, it emerges from the beginner viewer, who is asking, "What is happening in this image?" By using the active phrase, "is going on," we encourage beginners to do what they do naturally: enter into the picture and then create a list or tell a story. This question actively supports the viewer by keeping attention on the picture—"Eyes on the canvas!"—a pivotal step in art viewing. When a group of beginner viewers responds to this question, everyone starts looking longer and more intently, discovering new details, and listening to multiple points of view.

To keep a group of beginner viewers (Stages I and II) focused on the image, the next question, "What do you see that makes you say that?" (Housen & Yenawine, 2001a), asks that viewers to support their interpretative comments. This question concentrates the group discussion on the image, prompting everyone to look longer and harder, see more complexly, interact with one another, and revise and expand their initial interpretations. Viewers learn to reason by citing evidence found in the image. A third question—"What more can we/you find?"—recharges the process of looking and ensures that the group continues to look intensely, finding that the more they look, the more they see and that there can be more than one right answer.

Stage II viewers' central questions concern the way the image looks and how it was made; questions about technique and skill mix with

ones about artistic choice and values. VTS images are selected that meet viewers where they are, as well as challenge them to explore new subjects and pursue incipient questions. As Stage II viewers begin to be aware of a body of information unknown to them, the images they view allow them to feel comfortable, while at the same time stretching them to look at new things and to voice their thoughts. If the viewers value good draftsmanship and Cezanne's painting of his son does not look well rendered to their eyes, the VTS question "What do you see that makes you say that?" (Housen & Yenawine, 2001a) will lead the viewers to hear and consider different points of view. They begin to see that there can be paradoxes. The discussion provides a safe arena to think about why someone else—in this case, the artist—may have chosen to paint in a particular way. In time, the Stage II viewer arrives at the concept of intentionality as he or she considers that marks left on the canvas, which might at first look like carelessness or mistakes, were intentionally left there by the artist. With more viewing experience, more omplex, less narrative images are introduced, drawing the Stage II viewer further from his or her native preconceptions and deeper into the work of art (Yenawine, 2003).

Stage III viewers are interested in gathering and categorizing information about works of art and artists, styles and schools, methods and techniques. With

careful looking, discussion, and independent reading, Stage III viewers accumulate that sought-after information. As Stage III viewers deepen their study and encounter unexpected juxtapositions of images, they uncover and then must grapple with the shifting classifications of their recently acquired theories. Discussions drawing on themes like the misidentification and reclassification of masterpieces, fakes, overlapping styles of artists—issues that soften the distinctions among art historical categories—challenge Stage III viewers to build on, and go beyond, what they know and how they know it. Such challenges demand that the Stage III learner re-engage in a deeper and more complex observation of the object. Discussions encouraging learners to consider different pieces of information about one art object challenge the Stage III viewer to confront a multiplicity of viewpoints, deepen personal insights, and to uncover and take ownership of one's own point of view.

Stage IV viewers bring complex and nuanced personal sensibilities, experiences, and insights to art viewing. Programs intended for them will be open-ended, perhaps starting with a problem, a theme, or an inquiry. As prominent participants in any discussion, they easily share their evolving insights and discoveries. Stage IV viewers thrive on the ongoing, changing, and ever-expanding experience of

interacting with art. These viewers enjoy the moment-to-moment process of viewing, whether it is unexpected contrasts and comparisons, a surprising mix of media or disciplines, or unlimited access to one image. They are open to new conclusions reached in the moment. Openness to multiple voices and points of view allows Stage IV viewers to see the image through many perspectives simultaneously and to weave together many levels of viewing.

The Implication of Stages in Effective Pedagogical Design

Aesthetic stage research offers salient insights into when and how learning takes place. First, a viewer's thinking is characterized by a spectrum of thoughts, with those of one stage intermingled with adjacent stages. In other words, a range within a developmental architecture, not a single point, best represents each learner. Identifying the precise developmental level of each learner is less important than successfully estimating the general level of the group. In Visual Understanding in Education's (VUE) curriculum, this means the teacher does not have to know the exact stage of each viewer. As long as the most prevalent stage can be estimated, engagement in learning predictably takes place (Housen, 2000, 2001).

Second, stages are characterized by core questions in the viewer's mind. Therefore, as long as we understand what these questions are and develop experiences that allow the learner to grapple with those questions directly, development will occur. In other words, honoring the underlying developmental currents of the target population leads to pedagogical success. Within VUE's curriculum, the aesthetic development measurement system (Housen, 1983, 1992b, 2000) helps map in detail the questions learners face at different stages. This enables curriculum design that tracks with the questions of each population, increasing the incidence of growth.

Third, to design powerful developmental experiences, we need to track how thinking patterns shift from one stage to the next. In other words, we must understand the shape of the next developmental milestone of our population and target curricular experiences towards that turning point. When creating VUE programs, we use stage data to characterize shifts and then use this understanding to design proximal experiences (Housen & DeSantis, 2000, 2001, 2002; DeSantis, 2000). These new challenges require more hard-looking and reflection on the part of the learner, and yet each learner is supported by pedagogical scaffolds that bridge current needs with newly emerging questions and interests (Vygotsky, 1978). In this process of discovery, each new learner creates a dynamic tension as he or she chooses issues, constructs arguments, owns what he or she knows, discards the rest, and becomes ready for a new set of challenges. Education is about providing a taste of the next, proximal way of thinking. Exercises that are rooted in the logic of each side—old and new—promote growth most effectively.

Summary

My journey into the aesthetic experience led me deep into the world of the viewer, effectively undertaking—although I didn't realize it at the outset—an empirical exploration of developmental theory. The "road map" that grew out of my examination of aesthetic thought and growth, combined with an applied understanding of constructivist learning theory (Brown, 1992, Bruner, 1966; Kuhn, 1986; Vygotsky, 1978), guided our iterative decisions and enabled us to construct curricula that capitalize on the essential tenets of developmental theory.

In practical terms, we found that the most effective experiences for stimulating aesthetic development are question-based, give the learner repeated opportunity to construct meaning from different points of view, take place in an environment that supports looking in new and meaningful ways, and are inspired by rich, varied, and carefully chosen works of art.

Implementing such a curriculum opens a number of opportunities for the teacher, the learner, and the subject. The teacher's role is not so much to impart facts, or manage drill and practice, but to facilitate the learner's process of discovery. The teacher enables development by creating and managing a supportive learning environment that encourages learners to discover new ways to find answers

to their own questions, to construct meaning, to experience, and to reason about what they see. The act of constructing meaning cannot be something taught; the learner must discover his meaning on his own.

Within VUE's curriculum (Housen & Yenawine, 2000a, 2000b, 2001b, 2002), teachers encourage student participation and the sharing of each student's current understanding by asking carefully designed and sequenced questions that have been paired with carefully selected images. Both questions and images are targeted to the viewers' questions, interests, and skills based on their aesthetic stage. Students are asked to do what they can do. And they are challenged to do what they are ready to do next. Teachers paraphrase, in a nonjudgmental way, each student's contribution, ensuring that each voice is heard and understood. They link ideas, ensuring that the conversations deepen, encouraging learners to continue to look for and construct meanings. In the course of talking about the image, learners effectively teach each other, bringing new observations to light, offering opposing views, and ever widening the discussion. The carefully designed, suitable, and sequenced questions of this learning environment, paired with carefully selected images and paraphrased responses, are critical in the process of fostering aesthetic growth and critical thinking (Housen, 1992a, 1992b, 2002).

Art affords an ideal environment for such teaching and learning. It provides an object of collective attention—something concrete for a classroom to observe and experience, provoking thoughts and feelings while at the same time generating simultaneous and distinctive meanings. The more one looks and discusses images, together with well-chosen questions and adept facilitation by a teacher, the more there is to see, and the deeper and richer is the learning experience. There are many pathways to move through a stage, and each viewer discovers her own way. Well-chosen works of art support these multiple pathways, and well-crafted educational designs can support a multiplicity of learners as their thinking develops. Together, they provide the foundation for lifelong viewing and learning.

REFERENCES

Baldwin, J. M. (1975). *Thought and things: A study of the development and meaning of thought or generic logic,* (Volumes III and IV). New York: Arno Press.

Brown, A. L. (1992). Design experiments: Theoretical and methodological challenges in creating complex interventions in classroom settings. *The Journal of the Learning Sciences, 2*(2), 141-178.

Bruner, J. (1966). *Toward a theory of instruction.* Cambridge, MA: Belknap.

Coleridge, S. T. (1817). *Biographia literaria.* Retrieved November 2, 2006, from http://www.english.upenn.edu/~mgamer/Etexts/biographia.html

DeSantis, K. (2000, March). *The development of aesthetic thinking in the beginner viewer.* Paper presented at the conference of the National Art Education Association, Los Angeles, CA.

Housen, A. (1983). *The eye of the beholder: Measuring aesthetic development.* Ed.D Thesis, Harvard University Graduate School of Education. UMI number 8320170.

Housen, A. (1992a, May). *Museum education and aesthetic development.* Paper presented at the Museum Education Symposium: What Works and Why?, Edith Blum Art Institute, Bard College, Annandale-on-Hudson, NY.

Housen, A. (1992b). Validating a measure of aesthetic development for museums and schools. *ILVS Review, 2*(2), 1-19.

Housen, A. (2000, September). *Eye of the beholder: Research, theory and practice.* Paper presented at the Calouste Gulbenkian Foundation, Lisbon, Portugal.

Housen, A. (2001). Voices of viewers: Iterative research, theory and practice. *Arts and Learning Research Journal, 17*(1), 2-12.

Housen, A. (2002, December). *New research in aesthetic thought, critical thinking and transfer.* Paper presented at the Minneapolis Institute for Arts and the Minneapolis Public Schools Colloquy, Minneapolis, MN.

Housen, A., & DeSantis, K. (2000). *Annual report on year I of the aesthetic development and creative and critical thinking skills study, San Antonio.* Prepared for Holt Companies, San Antonio, TX. Unpublished report.

Housen, A., & DeSantis, K. (2001). *Annual report on year II of the aesthetic development and creative and critical thinking skills study, San Antonio.* Prepared for Holt Companies, San Antonio, TX. Unpublished report.

Housen, A., & DeSantis, K. (2002). *Annual report on year III of the aesthetic development and creative and critical thinking skills study, San Antonio.* Prepared for Holt Companies, San Antonio, TX. Unpublished report.

Housen, A., DeSantis, K., & Duke, L. (1997). *Interim report to the open society institute New York St. Petersburg longitudinal study years I and II.* Prepared for Open Society Institute, New York. Retrieved November 2, 2006, from www.vue.org/download.html

Housen, A., & Yenawine, P. (2000a). *Visual Thinking Strategies basic manual grades K-2.* New York: Visual Understanding in Education.

Housen, A., & Yenawine, P. (2000b). *Visual Thinking Strategies basic manual grades 3-5.* New York: Visual Understanding in Education.

Housen A., & Yenawine, P. (2001a). *Visual Thinking Strategies: Understanding the basics.* Retrieved November 2, 2006, from www.vue.org/download.html

Housen, A., & Yenawine, P. (2001b). *Visual Thinking Strategies year 2 manual grades 3-5.* New York: Visual Understanding in Education.

Housen, A., & Yenawine, P. (2002). *Visual Thinking Strategies, grade 5.* New York: Visual Understanding in Education.

Kuhn, D. (1986). Education for thinking. *Teachers College Record, 87*(4), 495-512.

Vygotsky, L. (1978). *Mind in society: The development of higher psychological processes.* Cambridge, MA: Harvard University.

Yenawine, P. (2003). Jump starting visual literacy: Thoughts on image selection. *Art Education, 56*(1), 6-12.

FOOTNOTES

[1] All quotes appearing here are taken from aesthetic development interviews we conducted over 18 years. Aesthetic Development Interviews are nondirective, stream-of-consciousness-type interviews (Housen, 1983).

Reconsidering Learning: The Art Museum Experience

Susan Longhenry
Museum of Fine Arts, Boston

"It seems clear that what the audience expects from an art museum is, above all, a magical transformation of experience." (Csikszentmihalyi, as cited in Insights, *1991, p 126.)*

Since their inception, most U.S. art museums have characterized themselves as democratized, educational institutions. Early thinkers such as John Cotton Dana (1917) and Theodore Low (1942) passionately argued that U.S. art museums had a responsibility to educate a wide and diverse public through school programs, lectures, and the like. The American Association of Museums (AAM), founded in 1906, has contributed to this dialogue through publications such as *Museums for a New Century* (American Association of Museums, 1984) and the formation in 1973 of AAM's Education Committee, which has stimulated further dialogue through publications including *Excellence and Equity: Education and the Public Dimension of Museums* (Hirzy, 1992), *Museums: Places of Learning* (Hein & Alexander, 1998), and *Excellence in Practice* (American Association of Museums, 2002/2005). Indeed, during the past two decades art museums have renewed a longstanding, shared belief that educating visitors is a primary institutional responsibility.

Despite this shared stance, many art museums struggle with exactly what it means to be an educational institution. Collection curators may interpret it to mean an emphasis on scholarship—and an imperative to provide information to visitors—while educators might argue for alignment with school curricula and interpretive content that is accessible to visitors of all skills and knowledge levels. Too often, however, this dialogue skirts the most compelling question of all: what kind of meaningful educational opportunities are unique to art museums? After all, one could learn about—or teach—art history without ever stepping foot in an art museum. And one could easily visit an art museum without having a meaningful or educational experience. The art museum experience involves human beings engaging with a physically present work of art in a space designated for that purpose. But what is the nature of that encounter and, more to the point, what exactly does it have to do with education? Using one art museum's visitor research as a case study, this chapter will explore the complexities of the art museum learning experience and argue that the art museum educator's reach should extend beyond classrooms and auditoriums and into the arena in which the most powerful learning experiences are happening—museum orientation areas and, especially, museum galleries.

One Museum's Visitors Speak
In December 2004, intent on learning more about visitors and potential visitors, the Museum of Fine Arts, Boston (MFA) conducted a demographically representative study of 301 adults living in the Boston area (Solarus, 2005). Participants were asked which leisure activities (including visiting an art museum) they would consider in the future, the number of times they visited art museums, and which art museums they visited. The study identified four audience segments for further study:

Segment Three: People who consider visiting art museums, but don't

Segment Four: People who visit art museums less than once per year

Segment Five: People who visit art museums every 6 months or so

Segment Six: People who visit art museums more than once every 6 months

In March 2005, a sample of 1,516 adults meeting these criteria and representative of the Boston population participated in an Internet study addressing leisure choices, art museums as compared to other leisure choices, motivations for past art experiences, psychographics (characteristics relating to values, personality, attitudes, lifestyles, or interests), MFA activities, MFA perceptions, demographics, and lifestyle. Across all four segments, participants indicated that learning is both a primary motivating factor for visiting an art museum and a critical component of the art museum experience. Participants in segments four, five, and six ranked "have an opportunity to learn" second in importance to "feel comfortable in surroundings" when defining key desired attributes of leisure activities, with segment three ranking learning as the third most important attribute. All segments ranked the statement "I like to learn about things even if they may be of no use" among the top 5 of 46 potential descriptive statements, and segments four, five, and six all placed the statement "I like to learn about art, culture, and history" among the top 5 descriptive statements. When asked specifically about the MFA, all four segments ranked the statement "The MFA gives me an opportunity to learn" second among 23 potential descriptive statements and ranked the statement "The MFA is an intellectually stimulating experience" as one of participants' top 5 perceptions of the museum.

Intrigued by these findings and desiring to better understand what visitors and potential visitors mean by "learning," the MFA conducted a series of four focus groups in July 2005 (Museum of Fine Arts,

Boston, 2005). Two of the focus groups consisted of individuals who had visited the MFA during the past 6 months, and the other two consisted of individuals who had not visited the MFA during the past year but had participated in other cultural activities. Each group was shown five statements and asked to share individual responses to them.[1] One statement focusing on learning read:

Every trip to the MFA is a learning experience. And I love to learn. Every time I go to the MFA I learn something new about culture, about perspective, about myself. On my next visit maybe I'll learn something from seeing a new collection, attending a lecture, or taking a class. I've learned so much at the MFA. And what I've learned about the MFA is that it defies a single definition. It's countless possibilities and experiences. And I enjoy exploring and learning more about each of them.

Given the emphasis on learning in the initial study, responses to this statement were somewhat surprising. Although the groups had some positive reactions to this statement—expressing an interest in learning new things, broadening their world view, and viewing programs as an impetus to visit the museum—the direct focus on "learning" was received negatively by several participants in all four groups. It was too closely associated with school for them, inspiring a sense of pressure to learn and making the museum experience seem like "work" rather than an enjoyable experience. Participants also did not want to feel that failing to learn something during the museum experience meant that they were not smart or that the experience had been wasted.

Each focus group was also shown a statement that read:

Every trip to the MFA is a personally rewarding experience. The MFA is a place for people who appreciate not just fine art, but appreciate their own potential for learning and experiencing different expressions of art, culture, and different points of view. To me, the MFA is not a place where I go to see things, rather a place where I go to experience things. Every time I go to the MFA, I feel like I've done something for my mind, my perspective, and me. I walk out the door feeling invigorated, revitalized, and a bit better about my priorities and myself.

Responses to this statement were also mixed. The idea that a visit can be a relaxing, fun, and enjoyable experience because one can learn in a nonstructured environment on one's own terms, in one's own time, resonated with participants in all groups. Participants also liked the idea that visiting is a personal experience and responded positively to the concept of determining their own goals for a museum experience. However, several focus group members stated that they do not like to be told what will happen to them if they visit the museum. Infrequent visitors, in particular, felt that this statement implied that they would be inadequate if they did not have the personal experiences described and that they would be considered a "lesser person" if they did not visit the museum. Participants felt that the statement conveyed too much emphasis on "bettering yourself" by becoming more cultured, and infrequent visitors felt that the statement made the museum seem intimidating and, again, too much like work.

The focus group report made the following conclusions:

Learning is an important and motivating benefit of going to the MFA, but how it is articulated is critical. When learning is positioned as a self-directed or voluntary experience it is very attractive; when it sounds more formal or like work, it is unappealing. "Learning" as a word has several negative connotations in terms of the type of experience (a lot of work, not self-directed, pressure-filled, not fun, etc.) "Explore" and "experience" both implied learning, but in a very positive and compelling way. They communicated that the experience would be fun and self-directed; visitors would learn on their own terms, according to their own needs, and on a voluntary basis. The visit experience should be interpreted as "self-directed," customizable experiences, where the MFA is experienced on each visitor's terms. (Museum of Fine Arts, Boston, 2005, p. 5)

Extrinsic and Intrinsic Motivation

Although just one research effort at one art museum, the study and its conclusions encapsulate much of what we know about the art museum experience and, more important, where art museum educators' efforts should be focused. Chief among these issues is the role that intrinsic, rather than extrinsic, motivation plays in effective art museum education. Extrinsically motivated people perform a task in anticipation of external rewards (students will study for a test to get good grades, an employee will go to work to earn a salary, a child will do something in the hope of gaining a parent's approval). It is precisely this kind of motivation against which the MFA's focus group members

rallied. Across the board, they resisted a museum experience characterized by the kind of extrinsically motivated learning that they encountered in schools. They rejected any suggestion that the museum defines the character or criteria of the experience for them, and they certainly didn't buy the idea that a desire to "better yourself" is a good reason to go to a museum (Museum of Fine Arts, Boston, 2005).

Around the time of the MFA's study, the Wallace Foundation commissioned a report arguing that museums and other cultural institutions have focused on articulating extrinsically motivated—or, to use the report's terminology, "instrumental"—benefits at the expense of the intrinsic benefits that the arts are uniquely able to provide (Brooks, McCarthy, Ondaatje, & Zakaras, 2005). The study defined instrumental benefits as those that result in measurable gain in areas that are of value to all members of a society, not just to those involved in the arts and especially not just to the individual engaged in the experience. Such benefits are all too familiar to art museum educators; for example, they include cognitive benefits such as improved academic performance as measured in student test scores, improved basic academic performance in valued areas such as math and reading, attitudinal and behavioral benefits typically focused on the young and including things like better school attendance and the development of life and social skills in at-risk youth, economic benefits that demonstrate the financial contributions that museums make

to communities, and social benefits including the promotion of social interaction among community members and the creation of a sense of community identity. From this perspective, the art museum experience is only an instrument for achieving an outcome that, while valuable to a community, may have little or nothing to do with experiencing an original work of art. And, as the MFA's study participants made clear, instrumental—or extrinsically motivated—benefits are certainly not the reason that people go to museums. Instead, as the Wallace study authors and many museum and education theorists including Dewey (1938/1970), Csikszentmihalyi (1990, 1995), and Falk and Dierking (2000) have argued, effective museum education experiences, like all educational experiences, are intrinsically motivated. The distinction between extrinsically and intrinsically motivated learning experiences is a simple one: where extrinsic motivation begins and ends outside of the individual, intrinsic motivation is just the opposite—it begins and ends with the learner. Owing to the manner in which they actively engage and directly benefit the individual learner, intrinsically motivated experiences are worth doing for their own sake rather than for the promise of external gain when the experience concludes. As Csikszentmihalyi (1995) has noted, research describes students who are intrinsically motivated as having "learning goals," whereas students who are externally motivated have

"performance goals"—suggesting that the transformation of performance into true learning is the facilitation of intrinsically motivated experience.

Museum Learning and the Self

So what does an intrinsically motivated museum learning experience look like, and how can art museum educators generate them? This is one question that the Museum of Fine Arts, Boston, hoped to answer through a series of visitor observations conducted in 2003 (Wellspring, 2003). Thirty-one visitors were recruited to participate in the study—15 museum members and 16 "infrequent visitors," defined as people who hadn't been to the museum in more than 2 years. Five MFA staff members drawn from the curatorial, museum learning, marketing, and visitor services areas were trained by three consultants—who also participated as observers—in how to track and observe visitors in the museum's galleries. Working in pairs, observers met their subjects at the museum entrance and, following a brief introductory discussion, asked subjects to visit the museum as they normally would. Observers followed their subjects for about an hour, taking careful notes the entire time, and then debriefed with subjects for approximately 30 minutes after the observation.

The observations made clear that museum visitors are unique individuals with specific, idiosyncratic characteristics that shape their goals for and experiences in the museum. For example, a single, 33-year-old man articulated his goals as "to wander and 'be' with art" and to find "spiritual solace." He purposefully chose to wander the museum without a map and walked slowly through the galleries, selecting certain objects on which to dwell. He sought out the MFA's Egyptian galleries and read a few labels, but not all of them. Observers noted that, unlike many visitors who focus their attention on paintings, this subject spent much more time looking at three-dimensional art. When asked about this during the post-interview, he stated "Well, my father was a painter, and I didn't get along with my father, so I don't like paintings." Observers also followed a 45-year-old female physician who, during her introductory interview, stated that she was a recent widow who had just moved to Boston and didn't know anyone in the area. Her primary museum experience goals were to be around other people with the hope of forging new friendships, to experience what was "new" at the museum, and to add to her intellectual knowledge. This woman began her visit by visiting exhibitions that she hadn't seen before and proceeded to look at every object, and to read every object label in those exhibitions. A third subject was a young Korean woman who had just graduated from a Boston university and was motivated to visit the MFA because she hadn't been there before, and she wanted to see the museum before returning home to Korea. She immediately sought out the collection of Korean art and spent a considerable amount of time engaging with the collection and discussing it with her male companion. After this experience the couple wandered through other parts of the museum's collection, taking turns waiting for the other to view a particular gallery but never being as engaged as they were with the collection of Korean art.

These three scenarios are excellent examples of the "personal context" that Falk and Dierking (2000) have identified as one of three contexts of the contextual model of learning. This model posits, among other things, that learning begins with the individual and is personally motivated. The personal context takes into consideration motivation, expectations, prior knowledge, and beliefs. The MFA couldn't have anticipated that one visitor wouldn't like paintings because they remind him of his estranged father or that another would have the richest experience with its collection of Korean art because it resonated with her memories of growing up in Korea. The intrinsically motivated experience of both visitors, however, was completely and inevitably filtered through the lens of their personal context—recalling Dewey's (1938/1970) assertion that the starting point for experience-based education is always the complex body of knowledge, insights, and personal experience that each learner brings to the educational arena.

The MFA's visitor observations demonstrate the role that the "self" plays in intrinsically motivated art museum learning experiences. On the most basic level, the self is the personal context—it is what we all bring to educational experiences. As Falk and Dierking (2000) and Csikszentmihalyi (1990, 1995) have noted, intrinsically motivated art museum learning experiences expand, transform, and ultimately affirm the self. Paradoxically, however, this process often involves temporarily losing, or

transcending, the self. For example, one participant in a 1990 study commissioned by the Getty Center for Education in the Arts noted that:

Art is primarily visual, but it heightens your sense of the other, the outside, the thing experienced, and in the process, heightens your awareness of yourself, and even though you're being fully absorbed and transported by an object perceived by the sense, you're losing yourself at the same time you become yourself. (Csikszentmihalyi & Robinson, 1990, p. 68)

A curator in the same study expressed his belief that "very great objects give one a sort of transcendent experience. It takes you out of the realm of everyday life. You lose the sense of where you are and become absorbed in the object" (Csikszentmihalyi & Robinson, 1990, p. 69). This transcendent loss of a sense of self is a key characteristic of Csikszentmihalyi's flow experience, which he described as a theory of optimal experience in which "people are so involved in an activity that nothing else seems to matter; the experience itself is so enjoyable that people will do it even at great cost, for the sheer sake of doing it" (Csikszentmihalyi, 1990, p. 4). Individuals engaged in the optimal state of flow, according to Csikszentmihalyi, lose the sense of being separated from the world around them and instead feel a sense of union with whatever is engaging them. On the same note, the *Gifts of the Muse* study identified "captivation" as one of the intrinsic benefits of the arts, stating that:

The initial response of rapt absorption, or captivation, to a work of art can briefly but powerfully move the individual away from habitual, everyday reality and into a state of focused attention. This reaction to a work of art can connect people more deeply to the world and open them to new ways of seeing and experiencing the world. (Brooks et al., 2005, pp. x-xvi)

Self-Directed Learning

Given what is known about the role of the personal context and the self in intrinsically motivated art museum learning experiences, how can museums create meaningful learning experiences? The answer appears to be a simple one: put learners in charge of their own experiences. Members of the MFA's 2005 focus groups sent this message loud and clear—they wanted to determine their own goals for the museum experience and to conduct the experience on their own terms and in their own time. Not surprisingly, the MFA's 2003 visitor observations yielded the same finding: subjects demonstrated a strong desire to plan and direct their own museum experiences. They didn't want to ask questions of guards or information center attendants, they didn't want to rely on a map, and very few wanted a guided tour. These visitors wanted the freedom to chart their course through the museum, rather than follow a prescribed route, and many subjects placed a high premium on being surprised and delighted by discoveries along the way that could spontaneously change the course of their visits.

This desire for choice and control reiterates conclusions reached by Dewey (1938/1970), Falk and Dierking (2000), Csikszentmihalyi (1990), and others. Dewey spoke of the need to reject external control of the learning experience in favor of finding the factors of control inherent within the learner and his or her experience. Csikszentmihalyi identified the control over and mastery of consciousness as a key feature of the flow experience, and Falk and Dierking, in particular, identified choice and control as a component of the personal context and asserted that learning is enhanced when learners can exercise choice over what and how they learn and, in general, feel in control of their learning. This notion is central to the theory of constructivism that posits that people learn best when they construct their own meaning through open-ended interaction with rich environments.[2]

Providing choices for intrinsically motivated learners means abandoning the linear narrative that so many art museums embrace in favor of a constructivist environment with many entry points and many opportunities for making personal meaning out of the museum experience.[3] It implies a general rethinking of the museum environment, and suggests that art museum educators work with curators and designers to entirely rethink in-gallery interpretive strategies with an eye toward facilitating multilayered, self-directed learning.

The Learning Environment

Dewey (1938/1970) described the learning experience as an interplay of objective and internal conditions and noted that their interaction forms what he called a "situation." "The conceptions of situation and of interaction," according to Dewey, "are inseparable from each other.

An experience is always what it is because of a transaction taking place between an individual and what, at the time, constitutes his environment …" (p. 43). Although Dewey was referring to experiential learning in general, his words have obvious resonance for educators responsible for generating learning experiences in art museums. By its nature, art museum learning takes place in a specific, unique environment that has been set aside as a space in which individuals and works of art come together. And, indeed, more than 60 years after Dewey wrote those words, Falk and Dierking (2000) identified the physical context as one of the three primary components of the Contextual Model of Learning, specifically identifying the importance of, among other things, advanced organizers and orientation. Csikszentmihalyi (1995) echoed this notion by stating that the presence of clear goals is a requirement for optimal experience and noting that many museum visitors are unable to form goals themselves because, on the most basic level, they don't know what to do when they enter a museum.

Helping visitors set manageable goals for the museum experience by providing advanced organizers, which can break the monolithic museum experience into a series of choices, and effective orientation could set the stage for valuable, intrinsically motivated learning experiences. Unfortunately, many art museums fail to do this. A visitor study of 11 major U.S. art museums found that a lack of effective orientation and wayfinding significantly compromised visitors' experiences at all 11 museums (*Insights*, 1991). The MFA's 2003 visitor studies yielded the same

insight: Visitors had a strong desire to chart their own course through the museum but were challenged by the scale and complexity of the museum and the absence of tools with which they might construct their customized experience. Frequent visitors participating in the MFA study demonstrated coping strategies that often took the form of first visiting familiar, well-loved "anchor" objects and then launching a customized museum experience. For example, one 30-year-old man who visits the museum almost monthly began his visit by viewing a Jackson Pollock painting with which he was very familiar. Surprised to find the painting juxtaposed with new works because of a gallery reinstallation, he spent a great deal of time comparing the texture of the Pollock painting with its new "neighbors" and decided to focus his visit on examining texture in paintings throughout the museum's collection. Infrequent visitors, on the other hand, often don't have the skills or knowledge to transform the museum's physical environment into an effective, intrinsically motivated learning experience. Almost every infrequent visitor tracked by MFA observers got lost in the museum, keeping the visitor from fully experiencing the museum and—even worse—causing the visitor to feel frustrated, inadequate, and angry. One such visitor commented, "You feel disadvantaged. Most people take pride in knowing their way around. Asking directions takes away from your visit. Being instructed by signs would make you feel more confident" (Wellspring, 2003, p. 17). Visitors clearly cannot have an intrinsically motivated learning

experience in which they exercise choice and control if the learning environment leaves them feeling frustrated, inadequate, and angry. As Dewey (1938/1970) noted, "The immediate and direct concern of an educator is … with the situations in which interaction takes place. The individual, who enters as a factor into it, is what he is at a given time. It is the other factor, that of objective conditions, which lies to some extent within the possibility of regulation by the educator" (p. 45).

At most art museums, however, the physical environment can be regulated by visitor services staff members, curators, and exhibition designers. To generate truly effective art museum learning experiences, educators need to add themselves to this group.

Social Interaction and the Human Connection
Dewey (1938/1970) noted that, when educational experiences are developed through interaction, education becomes a social process. A class of students becomes a social group that determines the structure of its own experience, leaving the educator to function not as an external authority but rather as a group leader. Cooley (1902), Mead (1934/1970), Vygotsky (1962) and Housen (2007) have informed art museum education theory and practice by demonstrating the role that social interaction plays in learning. Falk and Dierking (2000) have asserted that museum learning is a fundamentally social experience and have identified the sociocultural context as the

third component of the Contextual Model of Learning. According to Falk and Dierking, the sociocultural context has two components: sociocultural mediation within groups of people visiting the museum together and facilitated mediation by others, usually a museum professional or volunteer guide. On a similar note, *Gifts of the Muse* (Brooks et al., 2005) identified the creation of social bonds as an intrinsic benefit that results when people share the experience of works of art. And, as the physician's comments in the MFA's 2003 study demonstrate—along with the many people who visit art museums as a way to entertain out-of-town guests—visitors sometimes visit museums with a primarily social agenda.

Beyond this, however, art museum visitors often express a yearning to connect with a human presence in works of art. Many art museum educators became familiar with this phenomenon through a 1990 Denver Art Museum study arguing that novice art museum visitors tend to have a strong interest in being transported back in time to get inside an artist's mind and that all visitors consider experiencing a work of art to be an effective and rewarding way to connect with another human life (McDermott-Lewis, 1990). Other visitor studies have revealed the same tendency; for example, *Gifts of the Muse* (Brooks et al., 2005) characterized extended capacity for empathy as one of the intrinsic benefits of the arts, stating that "the arts expand individuals' capacities for empathy by drawing them into

the experience of people vastly different from them and cultures vastly different from their own" (p. xvi). And many visitors in the Getty study (*Insights*, 1991) and in Csikszentmihalyi and Robinson's (1990) earlier work characterized the optimal museum experience as one that facilitates connection with a human presence in works of art. One visitor in the latter study described this phenomenon as "an experience of finding something that I can respond to at my most profound level, as a human being" (p. 65). Another characterized the human connection experience as "finding a soul I could communicate with in a world where many people are so very different" (p. 65). This visitor was not alone in identifying a spiritual component to her experience; to the contrary, visitor research is replete with statements such as, "I was so calmed and recharged by the experience. Truly a soul event" and "I always find it tranquil. I always find myself at peace, almost like going to the synagogue" (*Insights*, 1991, p. 15).

Reconsidering Learning
In November 2006, the Museum of Fine Arts, Boston, conducted six follow-up focus groups—one consisting of museum members, one of frequent visitors, and one of infrequent visitors—exploring the role that learning plays in motivating museum visits (Solarus, 2006). When asked to describe a peak museum experience, one infrequent visitor spoke eloquently, and at length, about an experience that he'd had at a Paris museum. The experience that he described was, without a doubt, intrinsically motivated and self-directed. It embodied a

high degree of control, in that he was responding to Impressionist paintings that particularly "spoke" to him. He spoke about losing track of time, losing his sense of self, but ultimately feeling a transformation of his self. His comments echoed everything that we know about the museum learning experience. At the conclusion of his statement, however, he said, "But I didn't *learn* anything."

Although this anecdote is humorous, it can also be read as a challenge to art museum educators. Clearly, the art museum learning experience is different from the formal learning experience found in schools and universities. Because it integrates an aesthetic response, the art museum experience is also distinct from the learning experience that one might have in a science or history museum. We know better than to agree with the focus group participant's implication that art museum learning is solely about acquiring knowledge. But art museum educators can't just know better, they must do better. Effective art museum learning experiences are intrinsically motivated, self-directed, embody a high degree of control, and result in the expansion and transformation of the self. They transcend the constraints of both self and time. They include interaction with an environment set aside for that purpose, bring people together for a shared experience, are characterized by a desire to connect with a collective human presence, and are often described in spiritual terms. Although these experiences may happen in museum auditoriums and classrooms, the truly magical, transformative art museum learning experiences are integrated with the museum experience itself.

REFERENCES

American Association of Museums. (1984). *Museums for a new century: A report of the Commission of Museums for a New Century*. Washington, DC: Author.

American Association of Museums. (2002/2005). *Excellence in practice: Museum education standards and principles*. Washington, DC: Author.

Brooks, A., McCarthy, K., Ondaatje, E., & Zakaras, L. (2005). *Gifts of the muse: Reframing the debate about the benefits of the arts*. Santa Monica, CA: RAND Corporation.

Cooley, C. H. (1902). *Human nature and the social order*. New York: Charles Scribner's Sons.

Csikszentmihalyi, M., & Robinson, R. E. (1990). *The art of seeing: An interpretation of the aesthetic encounter*. Malibu, CA: J. Paul Getty Trust.

Csikszentmihalyi, M. (1990). *Flow: The psychology of optimal experience*. New York: HarperCollins.

Csikszentmihalyi, M. (1995). Intrinsic motivation in museums: What makes visitors want to learn. *Museum News, 74*(3), 34-37, 59-62.

Dana, J. C. (1917). *The new museum*. Woodstock, VT: Elm Tree.

Dewey, J. (1938/1970). *Experience and education* (12th ed.). New York: Macmillan.

Falk, J. H., & Dierking, L. D. (2000). *Learning from museums: Visitor experience and the making of meaning*. Walnut Creek, CA: AltaMira Press.

Hein, G. E., & Alexander, M. (1998). *Museums: Places of learning*. Washington, DC: American Association of Museums.

Hirzy, E. C. (Ed.). (1992). *Excellence and equity: Education and the public dimension of museums*. Washington, DC: American Association of Museums.

Housen, A. (2007). *What is VTS?* Retrieved January 10, 2007, from http://www.vue.org

Insights: Museum, visitors, attitudes, expectations. (1991). Los Angeles: The J. Paul Getty Trust.

Low, T. (1942). *The museum as a social instrument*. New York: Metropolitan Museum of Art.

McDermott-Lewis, M. (1990). *The Denver Art Museum interpretive project*. Denver, CO: Denver Art Museum.

Mead, G. H. (1934/1970). *Mind, self and society*. Chicago: University of Chicago Press.

Museum of Fine Arts, Boston. (2005). *Museum of Fine Arts positioning research: Topline observations and strategy*. Boston: Author.

Roberts, L. (1997). *From knowledge to narrative: Educators and the changing museum*. Washington, DC: Smithsonian.

Solarus Consulting. (2005). *MFA segmentation study*. Brookline, MA: Author.

Solarus Consulting (2006). *Museum of Fine Arts, Boston: Learning focus groups final report*. Brookline, MA: Author.

Vygotsky, L. (1962). *Thought and language*. Cambridge, MA: MIT Press.

Wellspring Consulting. (2003). *Museum of Fine Arts visitor research*. Boston: Author.

FOOTNOTES

[1] Other positioning statements used in the study were "I go to the MFA because it's a way to indulge myself with a quality experience," "I enjoy the MFA because it's a world-class collection and experience," and "Every time I go to the MFA it's a new experience."

[2] For a thorough discussion of constructivism, see: Hein, G. E. (1998). *Learning in the Museum.* New York: Routledge; Hein, G. E., & Alexander, M. (1998). *Museums: Places of learning.* Washington, DC: American Association of Museums.

[3] For a discussion of multiple narratives in the museum and their effect on learners, see Roberts, L. (1997). *From knowledge to narrative: Educators and the changing museum.* Washington, DC: Smithsonian.

Scintillating Conversations in Art Museums

Melinda M. Mayer
The University of Texas at Austin

An atmosphere of warmth and joy. The company of good friends. Delicious ideas. Food for thought. Great art museum education should be like a scintillating dinner party conversation. Lively exchanges replete with keen interest, fresh insight, and thoughtful reflection should be taking place all the time in our galleries. Engaging in conversation is one of the delights of being human. As we talk with each other about topics that matter, we find out what we care about, how we think, and who we are (ourselves and others). Conversation is inherently reciprocal; it requires speaking, listening, and responding (Noddings, 2002). Through the interchange of talk, we connect meaningfully. Although the outcomes are important, it's the processes of sharing as we talk that make conversation vital. Works of art offer a feast of topics to fuel intriguing conversations in galleries. The arts give us access to

the human conversation, the search for meaning in life (Goodlad, 1992). Yet far too few scintillating conversations are going on in our galleries. Why? Because this kind of dialogue is not just a matter of talk. It requires far greater skill and practice than the casual conversations in which we engage as we go about our daily lives.

In this chapter, I will explore the nature of the conversations that I contend should take place in art museum galleries. Teasing out the relationship among discussion, dialogue, and conversation will establish a foundation from which to position conversation in art museum education. Scintillating conversations involve a dynamic between the participants that needs to be carefully constructed and defined. Most important, I consider what it requires of the museum teacher to invite and sustain stimulating and intriguing conversations.

What Is Educational Conversation in the Art Museum?

Looking and talking have been the staples of art museum education as long as the field has existed. In the 1970s, the nature of that talk shifted from lecturing to such interactive techniques as questioning and storytelling (Grinder & McCoy, 1985; Sternberg, 1989). Instead of a one-sided oration of art historical information, teaching became a two-way communication centered

on objects. Through a professional discourse that continues today, art museum educators have explored what the nature of our talk with visitors has been and should be. Are we facilitating discussions (Burnham & Kai-Kee, 2005; Yenawine, 2003), entering into dialogue (Zander, 2004)), holding a conversation (Leinhardt, Crowley, & Knutson, 2002; Paris, 2002), or practicing some mixture of all of these? Although the latter may be the case, there are some subtle differences in each mode of talk that are instructive to framing the meaning and usefulness of being conversational in museum education.

The ability to lead a good discussion is important in both schools and museums. With the discussion method, the teacher has a pedagogical objective in mind and tries to achieve it through posing a series of deftly crafted questions to which students respond. Such discussions tend to be one-sided, even though both teacher and student participate (Zander, 2004). The educator may use open-ended questions, yet the goal is to close in on specific knowledge or information. No matter how freewheeling an educational discussion can appear, the model is most often formal and content-centered in character.

Dialogue and conversation are closely related. At the heart of these two modes of discourse is the relationship between the speaking partners (Noddings, 2002). An object or topic may elicit the exchange, but in true dialogue Noddings points out that the priority of the participants should be to pay attention to each other nonselectively. When applied in the museum, dialogic teaching[1] would be audience-centered. The educator would act as a participant and facilitator to the dialogue, rather than as its leader (Zander, 2004). In process, a dialogue is conversational. The two models, therefore, share a similar purpose and identity. Where they differ is in tone. Dialogue partakes of the formality, discipline, and logical reasoning of intellectual endeavor, while conversation is more exploratory and informal (Noddings, 2002).

Since the 1980s, Noddings (1984, 1992, 2002) has been theorizing and developing an educational philosophy and pedagogy based in an ethic of care. Although, as a math educator, she is committed to student learning in the discipline, Noddings (1984) contended that what we deem as being good for students must come out of a caring relationship—care for the students, care of students for each other, care for ideas, care for all living things. Conversation is the primary teaching method Noddings (2002) advocates. She has identified three types of conversation that should be prevalent in schools: formal, immortal, and ordinary.

Formal conversation is that which occurs in debate or scholarly discourse. *Immortal conversation* refers to a certain content of conversation. These include the important issues of life such as birth, growth, death, love, war, belief, loyalty. Although Noddings (2002) described immortal conversation as including themes found in fairy tales, legends, and religions, these themes also are found in visual art. The human quest for explanation of life's purpose and a higher order of experience than the merely mortal historically informs many of the secular and nonsecular stories we tell (and conversely inform us). These themes are also the stuff that frequently makes up the content of artworks. *Ordinary conversation* is the day-to-day talk that we engage in with others, by which we listen to, respond to, and respect each other. Like museum learning, ordinary conversation is informal. In conversation, we explore, wonder, puzzle, tell stories, make comments, and find purpose and meaning. Such conversation invites us to remember each other's history, cares, and interests. According to Noddings, when schooling is deeply infused with conversation, it moves beyond accumulating facts and information to engaging the issues of life that matter on the deepest levels. Is it not through a museum education based in Noddings' notion of ordinary conversation that we could achieve Stapp's (1984/1992) vision of empowering visitors and "sparking intellectual participation" (p. 114)?

The Role of Conversation in the Art Museum

Noddings' (1984, 1992, 2002) pedagogy of care holds promise for art museums on several levels. Central to the museum mission is care, albeit the word has traditionally been associated with our responsibility to the objects that make up collections. Care, however, affirms that in the museum where visitors are deemed no less precious than objects (Carr, 1989), the most worthwhile museum learning takes place. Since the 1980s, the literature of the museum field (Hirzy, 1992; Roberts, 1997; Weil, 2002) reflects an increasing balance between careful attention to objects and audiences. Conversation in Noddings' pedagogy of care, however, places the relationship between those participating above the object or topic of talk. Although some may balk at this displacement of the primacy of the object, it may be valuable to consider how cultivating relationships between visitors and museum facilitators or teachers might lead to stronger, more memorable relationships with works of art than when the object is the objective.

I remember many occasions when talking with children or adults while giving tours in museums where I would draw the analogy of getting to know and making friends with a painting as one would with a person. We would talk about how first impressions are adjusted or deepened as we find out more about the painting just like we would when we become more meaningfully acquainted with people. Literary theorist Richard Rorty (1992) spoke of texts, such as works of art, as honorary persons. A surrogacy can occur with artworks whereby they stand in for the artist and those who have viewed and responded to the work over

time. We enter into conversation with these honorary persons who people our galleries. In the video *Philadelphia Stories: A Collection of Pivotal Museum Memories* (Spock, 2000), museum professionals tell their tales of encounters with objects that often formed the basis of their future careers. Many of these museum professionals metaphorically turn objects into persons as they talk. In relaying his childhood experience in Boston's art museums, Lauriston Marshall said:

The paintings in them were friends to have conversations with and to always go back to. I still remember the paintings I saw when I was that age and how much they came to life, and of course there was a very rich fantasy life around them. And, I think there was something about the kind of dialogue or one-on-one conversation I could construct with them and around them that really meant a great deal to me. (p. 21)

Not all children, or visitors of any age, make friends and have conversations with artworks as effortlessly as Marshall did. It is, however, the kind of personal connections that Marshall achieved with the objects that he made friends within the museums of his childhood that we want all visitors to enjoy. His everyday conversations with works of art stimulated a lifelong relationship.

As museum educators, we are constantly making friends with the works in our collections, sometimes even with objects that initially don't appeal to us. Burnham and Kai-Kee (2005) pointed out that the art of teaching requires knowing collections well. It's hard not to make friends with objects as we get to know them more deeply. What we develop in this process is caring relationships with the objects and their potential meanings. When we go into the galleries to talk with visitors, however, our conversations must focus on nurturing a caring relationship with the people. Through our care for and conversations with visitors, we establish personal relationships. As visitors feel valued through our conversations, like friends at a dinner party, we forge a relationship with them. The caring values we focus on the visitors, they then transfer to the artworks. To turn Rorty's (1992) metaphor around, our relationships with visitors become honorary works of art. In other words, the relationships growing between ourselves and the visitors stand in for the connections we want to facilitate for visitors with the art objects. The personal connections we make with visitors become the basis and model for their relationships with the artworks.

When visitors feel cared for through our conversations with them in the galleries, they reciprocate by extending that care to the art objects. Although it may give us as lovers of artworks some comfort, this instrumental achievement is only the least of what we can achieve by taking up Noddings' (2002) challenge to place the person above the topic of conversation. Even more important, we may end up cultivating a vital, vibrant educational practice that is more about ourselves as cultural beings than it is about cultural artifacts. It is imperative, therefore, that conversations we engage in with visitors bear the characteristics and values that will facilitate the visitors' own relationships with the artworks, with each other, and with life itself. Such conversations are not didactic in tone or character. They are personal, compassionate, engaging, and sincere—just like good relationships. And, like a relationship, these conversations entail a great amount of effort, time, commitment, and skill. Ordinary conversation becomes scintillating through extraordinary work.

What Do Scintillating Conversations Require?

As stated earlier, true conversation is inherently reciprocal, involving speaking, listening, and responding. The same pattern applies to how museum educators should address their craft. Good museum conversationalists engage in careful preparation, practice, reflection, and make needed change to practice. Cultivating and facilitating these conversations makes demands of the environment, the museum teacher, and the relationship between the teacher and the visitor. Some of the following characteristics will be familiar, but it is in combination that they contribute most effectively to enabling the talk in galleries to be neither trite nor stilted, but intimate and meaningful.

The Environment

Although art museums vary in design, they are formal environments that are as much about keeping people away from the art as letting them get close enough to look at it. Museum teachers are in that environment almost every day and are so comfortable in the

galleries that they can become inured to the effect of the physical and psychological space on audiences. Galleries can feel cold and distancing, rather than warm and inviting. They are safe environments for objects, but not necessarily conducive for conversations. Yet a palpable sense of safety is needed for conversations of care to take place (Passe, 1984; Sandra & Spayde, 2001; Vella, 2002; Zander, 2004).

Not only do visitors need to feel safe both emotionally and physically in order to be receptive to conversation, they must feel comfortable. The museum teacher who is warm, responsive, empathetic, and open can counter the physical chill of formal spaces and cool temperatures as well as the icy elitism of these institutions of high culture. Moreover, seeking opportunities to enable our conversationalists to sit for awhile, or at least not stand in the same spot until backs ache and feet numb, demonstrates care for the body as well as the mind. Safe, comfortable environments are essential to nurturing caring, communicative relationships.

The Museum Teacher

The prowess to engage visitors in conversations that are intriguing and personal, but not overtly didactic, makes many demands on character and spirit. Ego must be under control. Humility is vital, especially in conversation with adult visitors (Vella, 2002). Conversation must be selfless, focused on the visitor, not on displaying how much the museum teacher knows. One of the most effective means of communicating these values is

Zhenya Gershman
The J. Paul Getty Museum

On the Tension Between the Role of the Museum Educator as Teacher and as Facilitator of Experience

Every teacher asks himself or herself a question: "What do I want my audience to walk away with?" You've spent weeks reading on a subject, and now you want to share that bulk of knowledge. But when it comes to dealing with a work of art, you want something else to take place, something we call an "experience." This demands something impossible—a teacher not teaching. A successful gallery talk, then, will have a synchronic relationship or a fluctuation between the teacher becoming the audience and the audience becoming the active leader. While being eager to impart knowledge, one must always keep in mind the amount of information that is appropriate for that particular audience before launching into an ocean of historic facts with the listeners left behind. At the same time, forcing interaction on the museum viewer could also be painful. Here are a few things to keep in mind. As teachers we often find ourselves in a situation where we want to elicit a response from our audience based on their observations. It is not always the case, however, that the audience is ready or willing to provide that response. In an attempt to bridge that gap, we say, "What do you see?" That seemingly risk-free question is loaded with baggage. For one, it tells your audience, "I know what's there, but you need to get it yourself." On the other hand, it is too simplified and makes one feel condescended to—a person might think, "Why should I say what's there when everyone can see it?" It is in the way we introduce the concept or choose our words that can make our audiences feel at ease or encourage them to participate. Consider rephrasing the original question after creating a shared viewing space: "Let's take a moment to look at this object together. There are many ways to talk about it. Depending upon where we start might lead us to different paths of understanding. Therefore, I'd like you to think about what attracted you to this object or where you were compelled to look first. Let's start there."

Another gallery teacher dilemma is eliciting a follow-up response from the audience that backs up their original observation. A common tool is to ask, "What makes you say that?" This friendly question can become annoying as the teacher relies on it over and over again. While desiring to be an invisible guide to an experience, this question reveals an insisting urge of the teacher to get a response from the viewer. It can also make viewers uncomfortable to share ideas, as they know that they will have to account for what they say. In my experience, I find it more productive to alleviate this pressure from the individual and to throw the question to the group as a whole. While a person might share an initial gut reaction, others might have the extra time to think about the meaning and be ready to follow up with an observation. Simply rephrasing the question—"Does anyone feel the same way?" or "Would anyone like to respond to this comment?"—can spark exactly what the teacher might be looking for, a teacher-facilitated experience. It is the delicate balancing act between the presence of the teacher who is ready to share knowledge of the work of art and the discrete absence of a teacher who steps back to let the viewer take charge of their experience that we call the art of gallery teaching.

through paying careful attention to visitors and listening actively and intently to their responses (Noddings, 2002; Sandra & Spayde, 2001; Zander, 2004).

Humor and lightheartedness enliven conversation (Sandra & Spayde, 2001). Scintillating conversations possess spirit, pace, and counterpoint. They should be both enjoyable and fun. To achieve this, the museum teacher must embrace an improvisational practice. Thorough preparation is needed that provides the educator with many ideas and topics to pursue, an abundance of well-constructed open-ended questions, and much contextualizing information. Yet, in the galleries, all that preparation should emerge in response to visitors and their mounting curiosity. Through improvisation based in active listening, educators flavor their conversations with questions, morsels of information, and possibilities of direction. The conversation should flow out of the reciprocal relationship developing between the educator and visitor. Educators, however, also need to be true to themselves and their individual style of communication. Active, caring conversations can be facilitated by educators who are dynamic and outgoing or subtle and reflective. As London (in Zander, 2004) pointed out, educators should speak from the heart.

The Relationship

The character and quality of the relationship that arises between the museum educator and visitor are vital. The terms "educator" and "visitor" can imply a hierarchy—one of authority, knowledge, and superiority on the part of the educator. An egalitarian foundation should exist between participants in order for an effective conversation to occur. Rather than teacher to student, the model should be that of learner and learner (Vella, 2002). Partners join together as they talk with each other. For a relationship of mutual trust and respect to occur almost immediately, which it must due to the limited time educators and visitors have with each other, the educator must project sincere interest in the visitor. Such qualities as empathy, patience, and appreciation are needed. When mutual respect is achieved, whether with adult visitors or young ones, control is not a problem.

As the educator focuses on establishing the relationship of care that fosters meaningful conversation, it is important to remember that what will grow is the visitor's care for the works of art, the museum, and the society beyond the museum doors. New relationships between visitors and educators, as well as visitors and works of art, will proliferate and circulate. The museum tour will become a progressive dinner as visitors move from work to work, feasting on new and wonderful delicacies.

Conclusion

Imagine galleries full of visitors intently engaged in conversations stimulated by works of art. This kind of gallery talk does not occur quickly, but it is possible. The more museum education practice moves toward a philosophy and pedagogy of care that builds relationships based in speaking, listening, and responding, the sooner this ideal will become the real. As our pedagogy shifts to the truly conversational, visitors and works of art will be well served, and so will culture. Scintillating conversations will no longer be reserved for dinner party talk; they will take place all day long. And, at the end of the day, our guests will be eager to come back for more.

REFERENCES

Burnham, R., & Kai-Kee, E. (2005). The art of teaching in the museum. *Journal of Aesthetic Education, 39*(1), 65-76.

Carr, D. (1989). Live up to learners. *Museum News, 68*(3), 54-56.

Goodlad, J. I. (1992). Toward a place in the curriculum for the arts. In B. Reimer & R. A. Smith (Eds.), *The arts, education, and aesthetic knowing* (pp. 192-212). Chicago: University of Chicago.

Grinder, A. L., & McCoy, E. S. (1985). *The good guide: A sourcebook for interpreters, docents and tour guides.* Scottsdale, AZ: Ironwood.

Hirzy, E. C. (Ed.). (1992). *Excellence and equity: Education and the public dimension of museums.* Washington, DC: American Association of Museums.

Leinhardt, G., Crowley, K., & Knutson, K. (Eds.). (2002). *Learning conversations in museums.* London: Lawrence Erlbaum Associates.

McKay, S. W., & Monteverde, S. R. (2003). Dialogic looking: Beyond the mediated experience. *Art Education, 56*(1), 40-45.

Noddings, N. (1984). *Caring: A feminine approach to ethics & moral education.* Berkeley: University of California.

Noddings, N. (1992). *The challenge to care in schools: An alternative approach to education.* New York: Teachers College.

Noddings, N. (2002). *Educating moral people: A caring alternative to character education.* New York: Teachers College.

Paris, S. (Ed.). (2002). *Perspectives on object-centered learning in museums.* London: Lawrence Erlbaum Associates.

Passe, J. (1984). Phil Donahue: An excellent model for leading a discussion. *Journal of Teacher Education, XXXV*(1), 43-48.

Roberts, L. (1997). *From knowledge to narrative: Educators and the changing museum.* Washington DC: Smithsonian Institution.

Rorty, R. (1992) The pragmatist's progress. In S. Collini (Ed.), *Interpretation and overinterpretation* (pp. 89-108). Cambridge: Cambridge University.

Sandra, J. N., & Spayde, J. (2001). *Salon: The joy of conversation.* Gabriola Island, BC: New Society.

Spock, M. (Ed.). (2000). *A study guide to Philadelphia stories: A collection of pivotal museum memories.* Washington, DC: American Association of Museums.

Stapp, C. B. (1984/1992). Defining museum education. In *Patterns in practice* (pp. 112-117). Washington, DC: Museum Education Roundtable. (Reprinted from *Roundtable Reports, 9*, 1, 3-4.)

Sternberg. S. (1989). The art of participation. In N. Berry & S. Mayer, S. (Eds.), *Museum education: History, theory, and practice* (pp. 154-171). Reston, VA: National Art Education Association.

Vella, J. (2002). *Learning to listen: Learning to teach.* San Francisco: Jossey-Bass.

Weil, S. E. (2002). *Making museums matter.* Washington, DC: Smithsonian Institution.

Yenawine, P. (2003). Jump starting visual literacy, *Art Education, 56*(1), 6-12.

Zander, M. J. (2004). Becoming dialogical: Creating a place for dialogue in art education. *Art Education, 57*(3), 48-53.

FOOTNOTES

[1] I distinguish here between dialogic *teaching* and dialogic *looking*. McKay and Monteverde (2003) proposed an approach to art museum education called "dialogic looking." Although this model may draw a museum visitor into dialogue with someone else, dialogic looking focuses on the internal exchange between objects and the viewer plus the multiple contexts of display. The dialogue is more metaphorical than actual.

Rethinking the Gallery Learning Experience Through Inquiry

Pat Villeneuve and Ann Rowson Love
Florida State University

As focus in art museum galleries has shifted from objects to audiences (Weil, 2002), art museum education practice has changed. Much rethinking of gallery learning is based on constructivism, an educational paradigm that holds that individuals actively form or construct their own knowledge and understandings (Bruning, Schraw, & Ronning, 1999).

Early proponents of constructivism in the museum setting advocated active learning and making connections with prior knowledge (Hein, 1994, 1998; Hooper-Greenhill, 1994). However, researchers have raised concerns

that few concrete examples of how the process works in museum galleries can be found in the literature (Hein, 1994; Lankford, 2002). Despite new approaches to installation and interpretation techniques, Lankford questioned the lack of dialogue, an inherently social interaction, found in museum galleries today. So we ask, "What could constructivism look like in the museum?" We contend that constructivist ideas can be more fully implemented by enabling inquiry in the galleries. In this chapter, we introduce an inquiry format, model its use with students, and provide recommendations for collaboration between art museum educators and teachers. We also suggest ways to encourage inquiry outside the context of school visits.

Constructivism and Inquiry

Constructivism finds its roots in the work of cognitive psychologists Piaget (Piaget & Inhelder, 1969), Vygotsky (1978), and Bruner (1966, 1985). Authors suggest that Piaget's stages of cognitive development coupled with Vygotsky's social cultural theory, whereby knowledge is constructed based on social interactions within a cultural framework,[1] establish the underlying assumptions of constructivism. Bruner used both

Piaget and Vygotsky in his theory to suggest that student learning can be stimulated through engagement within environment and social structure (Schunk, 2004). He advocated multiple instructional methods to meet the needs of different types of learners. Inquiry, or generating and answering pertinent questions in a dialogic manner, can foster learning through social interaction using methods of mentoring, peer collaboration, and teacher facilitation.

Why pursue inquiry and the changes in practice that would inevitably follow? Inquiry encourages participation in the museum interpretive process and provides a venue for multiple voices. It also represents an investment in the future because it enables students and others to become independent, enthusiastic, life-long learners in our complex and rapidly changing world: "The ability to ask questions is the foundation of inquiry. When students can articulate their own questions, they can begin to take charge of their own understanding. … In the end, the information students discover and the directions they take often depend on the questions they ask. … Art can lead students to new discoveries about themselves, others, and the world in which they live" (Keller, Erickson, & Villeneuve, 2004, p. 155).

Questioning Format for Art-Based Inquiry

Erickson's (2005, 2006) questioning format includes four types of questions about works of art: (1) questions about an artwork, (2) contextual questions, (3) questions about viewpoints for interpretation, and (4) questions about connections among artworks (Keller, Erickson, & Villeneuve, 2004). Villeneuve (2007) has suggested two additional types of questions: (5) interdisciplinary questions and (6) metacognitive questions. (See Figure 1.)

Questions about the artwork address visual elements within the work, primarily through viewer observation of the artwork itself. Further inquiry and research are required to answer questions related to context, meaning, and connections among artworks. Metacognitive questions, as well as interdisciplinary ones, offer students the opportunity to reflect on their learning, both personally and as a means to identify and stimulate transfer of knowledge from other subject areas. Although museum educators often advocate starting an inquiry with an art object's visual properties, inquiry about an artwork may begin with any category, at any entry point. Educators may formulate questions, but student-generated inquiries can lead to richer learning. Elaborations of each inquiry category and two examples of gallery inquiry follow.

Questions About the Artwork: Learners Ask "What Can I See?"[2]

Questions about the artwork address the features listed here. Although the questions seem oriented toward fact-gathering using evidence from the artwork, students who have more experience engaging with

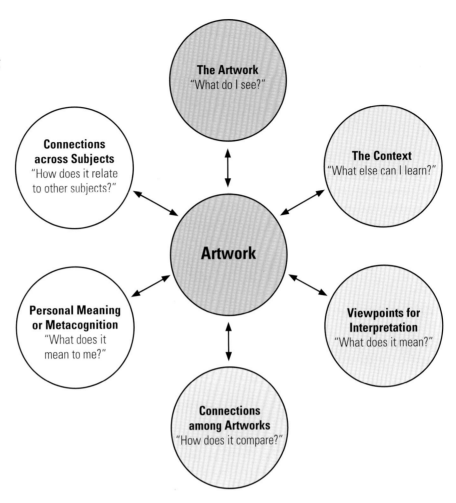

Figure 1. Questioning Format for Art-Based Inquiry: A Model.

artworks can promote learning for less-experienced students. The following topics guide question construction and are followed by sample questions:

- *Subject Matter*
 What people, places, or things does the artwork show?

- *Technical Features*
 What tools, materials, and processes did the artist use?

- *Visual Features*
 What elements of art are evident in the artwork?

- *Compositional Features*
 What principles of design did the artist use to organize the artwork?

- *Reproduction*
 How does the original artwork differ from a reproduction of it?

- *Care*
 How has the museum exhibited the artwork to protect it from harm?

(Keller, Erickson, & Villeneuve, 2004)

Contextual Questions: Learners Ask "What Else Can I Learn?"

Contextual questions delve into the life, times, utility, environment, and culture of the artist and artwork using the contexts below. Students build on personal observations of an artwork by placing it within a sociohistorical perspective. Although students gather

evidence from historical sources, interpretation and validation of sources use higher-level thinking skills. The following contexts and example questions provide a framework for contextual questions:

- *Artist's Life*
 What is the background and life experience of the artist?

- *Natural and Built Environments*
 What are the natural and built environments like where the artwork was made?

- *Function*
 What does the artwork do?

- *Artworld Context*
 What training, traditions, ideas, and expectations about art influence the artist?

- *Cultural Context*
 What do people think, believe, or do in the culture in which the artwork was made?

(Keller, Erickson, & Villeneuve, 2004)

Questions About Viewpoints for Interpretation: Learners Ask "What Does It Mean?"

Questions pertaining to interpretation seek information within and outside of the artwork. Students encounter different artworld and social perspectives, such as how art professionals interpret meaning versus a particular society or culture. Perspectives and sample questions include the following:

- *Artist's Intention*
 Why did the artist want the artwork to look the way it does?

- *Art Specialists' Understandings*
 How do artworld specialists understand the work of art?

- *Cultural Understanding*
 How is the artwork understood within the culture where it was made?

- *Personal Viewpoints*
 How do individuals' personal experiences affect how they understand the artwork?

(Keller, Erickson, & Villeneuve, 2004)

Questions About Connections Among Artworks: Learners Ask "How Does It Compare?"

Often classroom and museum educators seek to draw comparisons among works of art guided by a theme or one artist's body of work for in-depth exploration. Observations of artworks and other contextual sources allow students to use higher-order thinking skills such as analysis, synthesis, and evaluation in order to make comparisons. Example topics and questions include the following:

- *Style*
 How does this artwork look like other artworks, either by the same or different artists?

- *Art influences*
 What other artists and artworks influenced the artist?

- *Themes*
 What other artworks address the same general topic?

(Keller, Erickson, & Villeneuve, 2004)

Interdisciplinary Question: Learners Ask "How Does It Relate to Other Subject Area[s]?"

Using a constructivist framework, educators desire to build on students' prior knowledge and experiences. An interdisciplinary approach fosters the building of knowledge gained from other subject areas and applies it to new situations. Learning and more questions arise from a meaningful connection between familiar content and a work of art (Villeneuve, 2007). Questions for interdisciplinary inquiry are individually framed based on the following model:

- *What connections are there between the artwork and [content from another discipline]?*

Metacognitive Questions: Learners Ask "What Does It Mean to Me?"

Metacognitive questions help students to think about their own thinking processes. These are worthwhile questions to ask as inquiry ends. They encourage students to reflect on their experiences and articulate what they have learned. Capturing responses to metacognitive questions can take place during dialogue or as reflection. Such questions set the stage for future inquiry by conveying to students that they are responsible for their learning.[3] Villeneuve's (2007) students offered extensive responses and commented that doing inquiry was more meaningful and memorable than listening to a lecture on the artwork. Metacognitive questions may address the following:

- *Thinking about thinking*
 How has my thinking changed about this artwork?

- *Personal meaning*
 What does it mean to me?

- *Further inquiry*
 What more do I still want to know?

Terry Barrett
The Ohio State University

Two Questions, With Variations

1) "What do you see?"

In discussions of works of art, I ask this question of a group and do not provide answers myself. I encourage the individual speakers to mention only one thing that they see, so as not to exhaust the exercise. I encourage everyone to respond or sometimes "make" them by calling on individuals or taking turns in a circle.

It is difficult to get people to say what they see because we tend to assume that what we see everyone already sees, and we are reluctant to be obvious. However, we see different things and see them differently, and our language influences how others will see.

If we identify something in a work of art inaccurately, the discussion that follows will be faulty. It is important for the group to gently correct misperceptions or inaccurate articulations. Sometimes we have to conclude we are not sure of something that we see in an artwork.

Sometimes we tell what we *infer* rather than what we *see*. We should know the difference. I don't *see* panic in *Guernica*; I see figures and shapes in the way Picasso painted them, and they lead me to interpret panic in the painting. It is important to distinguish between fact and interpretation, although the two overlap. Interpretations require evidence in their support.

Similarly, we do not *see* beauty in Monet's paintings of water lilies. We see colors and textures, and we may *judge* them to be beautiful. It is important to know differences between describing and judging; otherwise we think our judgments are factual when they are actually arguable.

2) "What's it about?"

This is the essential question for art and life. There are many ways to phrase the question to keep the conversation going. "What does the work express?" "What is my emotional response to the work?" "What in the work brings forth your thoughts and feelings?" "What do you think about what she said?" "What else?" "Say more."

There are different *kinds* of questions for works of art:

- "What do you think the work might mean to the artist who made it?" (Artist's Intention)

- "What might it express to the patron who commissioned it?" (Patron's Desire)

- "How might those who saw it when it was first made have understood it?" (Original Audience)

- "How does it fit with other works in this gallery?" (Curator's Intent)

- "What might it mean to us today?" (Current Audience)

- "Most importantly, might it have any *personal meaning to your life*?" (Significance to the Viewer)

I can start with any of these questions, ask them one at a time, and rarely do we apply all of them to one work of art. I do not provide answers, but invite speculation from the group based on their observations. Nor do I present historical information about the work, other than what may be available on a wall label.

My desire is for people to construct meanings based on what they see, what they hear from others in the group, and based on all that they already know about life. Some insights and interpretations will be better than others. The group will know this by comparing what they hear to what they see in the work. I do not need to be the authority.

Some of what they say will be very incomplete, overly speculative, or even "wrong," but their curiosity might be aroused enough that they will seek further answers in the bookstore, online, or at the library. The goal is not that they find the "right" answers but that they come back to the museum with friends and family and have enjoyable conversations of about art and life, independent of a tour guide.

Examples of Inquiry

Florida State University Graduate Students at the John and Mable Ringling Museum of Art

Graduate students in arts administration and art museum education at Florida State University modeled the inquiry process at *Gallery Praxis*, a National Art Education Association co-sponsored academy at the John and Mable Ringling Museum of Art (Villeneuve, 2007).[4] Students selected questions and prepared sample responses to *Still Life With Parrots* (Figure 2), as displayed in Table 1.

Figure 2. Jan Davids de Heem, Dutch, 1606–about 1684.
Still Life With Parrots, late 1640s;
Oil on canvas, 59¼ by 46¼ inches, SN289.

Bequest of John Ringling, Collection of The John and Mable Ringling Museum of Art, the State Art Museum of Florida.

Table 1. FSU Graduate Students Respond to Questions Using the Questioning Format for Art-Based Inquiry.

Questions about the artwork: students ask "What can I see?"		
Artwork Feature	**Related Question**	**Student Response**
Subject matter	What does the artwork show?	**Juliana:** This still life presents oysters, a red lobster, piles of silver plates, a golden wine chalice, and silver wine pitchers on a red tablecloth made of a material that could well be velvet. A smaller table or bench holds shells in the foreground. All are symbols of abundance and luxury, reflecting the 17th-century prosperity of the Dutch. In the background, a black, silky textile opens to reveal a thunderstorm. There are two parrots, an African gray and another bright red one that is most likely from South America. The parrots and the exotic food items underscore the extent of the travels of the Dutch at the time. … Overall, this painting presents a lush depiction of abundance.
Technical features	What tools, materials, and processes did the artist use?	**Angie:** De Heem painted *Still Life With Parrots* on canvas fabric stretched across a wood frame. He used oil paints, made from linseed oil mixed with ink, to produce a heavy paint that blends easily and takes a long time to dry, providing extended production time. All painting was done during the daytime or by candlelight, which can cast strong light and shadows. De Heem probably set the scene for *Still Life With Parrots* in his studio, carefully draping the cloth over the table and placing the objects around the scene to create balance and movement throughout the painting. De Heem may have used a device called the camera obscura to "trace" the composition of his still lifes. The camera obscura was used by many artists of the time to project images onto a surface. This device helped artists accurately record objects' shapes in the proper perspective. One easily recognized sign that a camera obscura was used here is an out-of-focus point of light in the foreground of the painting.

Contextual Questions: Students ask "What else can I learn?"

Context	Related Question	Student Response
Natural and built environment	What are the natural and built environments like where the artwork was made?	**Kara:** De Heem painted *Still Life With Parrots* in Antwerp. … It is located in [present-day] northern Belgium near the Dutch border. Antwerp is inland, but it is located on the Scheldt River and is the second largest harbor in Europe. The land around Antwerp is agricultural, open and rolling, and the weather is damp, with mild winters and cool summers. The style of architecture in Antwerp during the time that *Still Life With Parrots* was painted was late Gothic. The buildings had lots of ornamentation and used their windows to maximize the natural light allowed inside.
Cultural context	What do people think, believe, or do in the culture in which the artwork was made?	**Nicole:** During the Eighty Years' War (1568-1648), the Dutch fought against Spain for independence, and their area became an important trading center that flourished in what is often called the Golden Age. During the 17th century, the Netherlands became a republic and was governed by an aristocracy of city-merchants called regents. Every city and province had its own government and laws and a large degree of independence. Many immigrants moved to Dutch cities, especially from Protestant Germany. The northern provinces were mostly Protestant, while the southern Netherlands [including the area that is now Belgium] were Catholic. Tolerance was important because of the continuous influx of immigrants that was essential for the economy.

Questions about viewpoints for interpretation: Students ask "What does it mean?"

Artwork Feature	Related Question	Student Response
Cultural understanding	How is the artwork understood within the culture where it was made?	**Debra:** De Heem's lush, colorful still lifes would have been a welcome addition to the creation of social status among the wealthy merchant class. Viewers would have appreciated the references to Dutch dominance of world trade through the use of opulent velvets and silks, exotic birds, fruits, plants, seafood, and shells. The choice of theme would not have offended either Catholic or Calvinist patrons. Calvinists might have viewed the painting as symbols of material wealth and artistic refinement to exalt the glory of God.

Questions about connections among artworks: Students ask "How does it compare?"

Artwork Feature	Related Question	Student Response
Style	How does this artwork look like artworks from the same period?	**Kimberly:** This is an example of a Baroque painting. The Baroque period lasted from about 1600 to 1700 in Europe. One characteristic of the Baroque style are forms that are open and are not symmetrical. A second characteristic of the Baroque style is the dramatic contrast between light and dark; the art historical term for this is "chiaroscuro." The foreground of this painting is bathed with light, while the background is plunged into darkness. A third characteristic of the Baroque style is extreme naturalism. During this time, there was a value placed on producing visual verisimilitude without any of the idealization that was so prevalent in Renaissance art. An item depicted in this painting that exemplifies this is the shells. The artist must have spent a long time painting these shells to appear as they do in real life.

Interdisciplinary Questions: Students ask "How does it relate to other subject areas?"

Subject Area	Related Question	Student Response
Social studies: European economic history	What does the artwork reveal about the economic conditions of the culture in which it was made?[5]	**Debra:** Jan de Heem's still life is a reflection of the economic wealth of the Dutch republic. The Dutch, traditionally able seafarers and keen mapmakers, dominated world trade and commerce during the 17th century, making them one of the foremost powers in the world. Dutch merchants and shippers imported and exported gold, silver, copper, spices, tobacco, and other exotic fare from Asia, West Africa, and the Caribbean. Along with agriculture, the Dutch fishing industry formed part of the economic base of the Netherlands. As the urban population saw dramatic growth, many farmers turned to market gardening to supply the cities with vegetables. Like the Baltic grain trade, it also contributed to the rise of the shipping industry for the Dutch economy. The textile industry rebounded in the early-17th century because it found export markets for its expensive cloths in the Mediterranean, much to the detriment of Italian cloth producers. The artist's use of exotic birds, plants, fruit, seafood, textiles, and precious metals mirrors the economic explosion of the Dutch Golden Age.

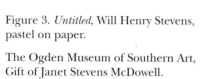
Figure 3. *Untitled*, Will Henry Stevens, pastel on paper.

The Ogden Museum of Southern Art, Gift of Janet Stevens McDowell.

Table 2. Lusher Charter School Fourth-Grade Students Respond to Art-Based Inquiry in the Classroom and at The Ogden Museum of Southern Art—University of New Orleans.

Questions about the artwork: Students ask "What can I see?"		
Artwork Feature	**Related Question**	**Student Response**
Compositional features	[Where] can you see any Japanese compositional elements in that artwork?	**Robert:** It's asymmetrical and there's lots of diagonal lines. … Because if you look at it like this, they've got a walkway over here; [but] there's no walkway over here (points to the other side).

Contextual Questions: Students ask "What else can I learn?"		
Context	**Related Question**	**Student Response**
Artworld context	Knowing that the artist was from New Orleans, why do you think we would also see elements of Japanese art in his work?"	**Marcus:** Because Western artists … were inspired by the Japanese … to use their elements of art and techniques to make other paintings.

Questions about viewpoints for interpretation: Students ask "What does it mean?"		
Artwork Feature	**Related Question**	**Student Response**
Artist's intention	Museum educator reads the following quote from the artist and then asks the question: *A painter would go far to find a richer field, but to paint it one must love it. For my part, I must feel rooted to a place … or I cannot take the expression of it seriously.* What do you think that means?	**Camille:** Well, I think that if he doesn't really know the place that well, then it would be hard for him to paint it.

Questions about connections among artworks: Students ask "How does it compare?"		
Artwork Feature	**Related Question**	**Student Response**
Themes	[How] did [the artist's] color change between New Orleans and North Carolina?	**John:** Up here in some of these pictures (points to North Carolina scenes) he uses a lot of lighter colors to capture some of the trees and mountains.

Interdisciplinary Questions: Students ask "How does it relate to other subject areas?"		
Subject Area	**Related Question**	**Student Response**
Social studies	What are some things that make New Orleans the place that it is?	**Andrew:** It has wetlands **Robert:** It has a lot of old houses.

Table 3. Recommendations for Building an Inquiry Partnership.

Process Phases	Museum Educators	Teachers
Preparation	• Be well informed about constructivism. • Be familiar with local school district or state standards for the participating grade levels. • Investigate what information and other resources about museum objects you can make available to teachers.	• Keep in mind school district or state standards you would like to target across subject areas. • Organize access to library and Internet sources. • Investigate what information and other resources are available at your school to assist with student art inquiries.
Planning	**Plan together** • Ideally, planning should include a meeting at the museum with a walkthrough and discussion in the galleries with follow-up by e-mail or telephone. • Select contexts and develop questions, as appropriate. A sample worksheet is available (Appendix A). • A few good questions are enough to get started. (There's no need to answer them all.) • As students become more familiar with the process, allow them to determine which questions they will pursue. • Decide on the sequence of classroom- and museum-based instruction. • As you construct the unit, consider how you will encourage inquiry, offer feedback, and assess student process.	
Implementation	• Offer assistance with classroom instruction (you, staff member, docent…). • Co-facilitate gallery dialogue. • Arrange additional resources (artist interviews, studio activity, curatorial research…).	• As necessary, become comfortable with the perception of having less control over a lesson. • Be flexible and allow adequate time. Inquiry generates excitement— and more inquiry. • Use transparent facilitation if teaching with a museum educator. Let students see the process of your partnership.
Evaluation/ Reflection	• Use formative and summative measures to assess strengths and weaknesses of the process and learning. Assessment is key to building future gallery learning.	

Lusher Charter School Fourth Graders at The Ogden Museum of Southern Art

Fourth graders in New Orleans studied the work of Louisiana artist Will Henry Stevens (Lavine, 2003). The classroom teacher and the museum educator collaboratively facilitated the inquiry process to build on student knowledge and make interdisciplinary connections. Following a unit on Japanese woodblock printing, the collaborators agreed to focus on the Louisiana artist's use of similar techniques. Educator-directed questions prompted student inquiry to expose how the artist integrated Japanese compositional influences as well as references to his own geography in his work. Students looked at examples of artwork to investigate similarities and differences. One artwork from the unit (Figure 3) and student responses (Table 2) can be seen to the left.

Facilitating Inquiry in the Gallery

The type of inquiry described above may change the nature of the relationship and responsibilities of art museum educators and teachers, whether generalists or specialists, as well as the content and form of the school gallery visit. Done at its best, inquiry encourages a true partnership incorporating the expertise of both collaborators: the teacher expanding on state-mandated concepts and the museum educator facilitating the museum learning experience. Since this approach requires an in-depth working relationship, museum educators should decide how and to what extent they wish to implement inquiry in the galleries. Options range from one-time teacher requests to a complete change in the museum-school

program requiring new policies, training, and procedures for gallery staff and volunteers. This approach necessitates commitment from both partners—museum educators and teachers.[6]

Recommendations for Building an Inquiry Partnership

The process above (Table 3) indicates possible roles museum educators and teachers play when building inquiry for gallery learning. An established theme may provide a good starting point for selecting works of art, asking questions, and making interdisciplinary connections. For instance, *Still Life With Parrots* might inspire a unit of study on bounty or consumption.[7]

Figure 4. *Untitled*, Will Henry Stevens, circa 1940, pastel on paper.

The Ogden Museum of Southern Art, University of New Orleans, Gift of Janet Stevens McDowell.

WILL HENRY STEVENS (1881-1949)
Untitled, circa 1940
Pastel on paper
Gift of Janet Stevens McDowell

How do you compare to a 1940s art viewer?
Many will be grateful to Stevens for giving them abstractions they can like and understand. And die-hard, pure abstract painters may soon be forced to admit that intellect never won all the way in a pitched battle with nature.

- New York critic in response to Stevens' Kleeman Galleries' Show, 1941, New York*

In 1941, just months before the U.S. entered World War II, Will Henry Stevens was hailed as a popular modernist, an unusual feat. The concern in the New York artworld over how to incorporate European precedents into a unique American viewpoint bore little interest to the general public, who generally disliked abstract art – not unlike many viewers today. Yet, this artist's blending of European modernism with the longtime American painting tradition, which focused on the natural world, can be seen in this abstract work. Although almost non-objective, the influence of the Blue Ridge Mountains can be seen in the rich color palette, mountain triangular form, and elongated tree trunks that divide the space into distinct segments.

What further references to the natural world do you see?

* Label from the archives of The Ogden Museum of Southern Art – University of New Orleans

Facilitating Inquiry for Other Audiences

The inquiry model above depends on the collaboration of school teachers and art museum educators. Museum educators may also wish to consider ways to facilitate inquiry for other audiences. For instance, they might set the stage for inquiry by providing information in handouts or on the museum's website. Educators could also use the website to pose the question "What more do you want to know?" and welcome bloggers to post their responses. In the galleries, art museum educators could provide suggested reading lists and resource areas. Or they might encourage questions on object labels, as illustrated above.

The first question engages the viewer by asking her or him to make a comparison and starts the intrigue for further reading. As a follow-up to the text, the reader is then asked a question that requires returning to the artwork for further viewing. Like this example, a label can stimulate personal learning, provoke discussion, and require a viewer to take a closer look at the artwork. This engages viewers in the personal, sociocultural, and physical contexts of the museum experience, as described by Falk and Dierking (2000).

Conclusion

Gallery inquiry befits the constructivist museum. A compelling question, whether posed by the viewer, an educator, or an object label, activates learning. It encourages learners to think about and build on prior experiences and construct new meanings. When done with others, inquiry stimulates social interaction and collaborative learning. At best, inquiry calls on viewers to look closely, seek out other sources, and enjoy a continuous journey of learning about art.

Appendix A: Educator Planning Worksheet Using the Questioning Format for Art-Based Inquiry

Questions about the artwork: Students ask "What can I see?"	
Artwork Feature	**Related Question(s) (Teacher or student generated):**
☐ subject matter	
☐ technical features	
☐ visual features	
☐ compositional features	
☐ reproduction	
☐ care	

Contextual Questions: Students ask "What else can I learn?"	
Context	**Related Question(s):**
☐ artist's life	
☐ natural/built environment	
☐ function	
☐ artworld context	
☐ cultural context	

Questions about viewpoints for interpretation: Students ask "What does it mean?"	
Artwork Features	**Related Question(s):**
☐ artist's intention	
☐ art specialist's understanding	
☐ cultural understanding	
☐ personal viewpoints	

Questions about connections among artworks: Students ask "How does it compare?"	
Artwork Feature	**Related Question(s):**
☐ style	
☐ art influences	
☐ themes	

Interdisciplinary Questions: Students ask "How does it relate to other subject areas?"	
Subject Area	**Related Question(s):**
☐ language arts	
☐ math	
☐ science	
☐ social studies	
☐ other	

Metacognitive Questions: Students ask "What does it mean to me?" and "What more do I want to know?"	
Artwork Feature	**Related Question(s):**
☐ thinking process	
☐ personal meaning	
☐ seeking further learning	

REFERENCES

Bruner, J. (1966). *Towards a theory of instruction.* New York: Norton.

Bruner, J. (1985). Models of the learner. *Educational Researcher, 14*(6), 5-8.

Bruning, J. H., Schraw, G. J., & Ronning, R. R. (1999). *Cognitive psychology and instruction* (3rd ed.). Upper Saddle River, NJ: Merrill/Prentice Hall.

Erickson, M. (2005). *Art making and meaning: Understanding art through questions.* Tuscon, AZ: Crizmac.

Erickson, M. (2006). *Exploring art with questions.* Retrieved December 21, 2006, from http://www.maryericksonventures.com

Falk J. H., & Dierking, L. D. (2000). *Learning from museums: Visitor experiences and the making of meaning.* Walnut Creek, CA: AltaMira Press.

Hein, G. E. (1994). The constructivist museum. In E. Hooper-Greenhill (Ed.), *The educational role of the art museum* (pp. 73-79). New York: Routledge.

Hein, G. E. (1998). *Learning in the museum.* New York: Routledge.

Hooper-Greenhill, E. (1994). Museum learners as active postmodernists: Contextualizing constructivism. In E. Hooper-Greenhill (Ed.), *The educational role of the museum* (pp. 67-72). New York: Routledge.

Keller, G. D., Erickson, M., & Villeneuve, P. (2004). *Chicano art for our millennium.* Tempe, AZ: Bilingual Press.

Lankford, E. L. (2002). Aesthetic experience in constructivist museums. *Journal of Aesthetic Education, 36*(2), 140-153.

Lavine Production Group, Inc. (2003). *Collaborating with a cultural resource.* In *The arts in every classroom: A video library, K-5.* Washington, DC: Annenberg/Corporation for Public Broadcasting. Also available at www.learner.org

Love, A. R., & Lilly, N. (2003). *Will Henry Stevens and a place for me: A 4th Grade Unit of Study.* New Orleans, LA: The Ogden Museum of Southern Art.

North Central Regional Education Laboratory (NCREL). (n.d.) *KWL.* Retrieved May 26, 2007, from http://www.ncrel.org/sdrs/areas/issues/students/learning/lr2kwl.htm

Piaget, J., & Inhelder, B. (1969). *The psychology of the child.* New York: Basic Books.

Schunk, D. H. (2004). *Learning theories: An educational perspective* (4th ed.). Upper Saddle River, NJ: Pearson Education.

Villeneuve, P. (2007, January). *Inquiry and the Constructivist Gallery Learning Experience.* Paper presented at the Gallery Praxis conference, Sarasota, FL.

Villeneuve, P., & Stamey, E. (2006). Beyond bountiful. *Art Education, 59*(6), 25-32.

Vygotsky, L. (1978). *Mind in society: The development of higher psychological processes.* Cambridge, MA: Harvard University.

Weil, S. E. (2002). From being *about* something to being *for* somebody: The ongoing transformation of the American museum. In S. E. Weil (Ed.), *Making museums matter* (pp. 28-52). Washington, DC: Smithsonian.

FOOTNOTES

[1] Vygotsky is known for his articulation of the *zone of proximal development* that represents the amount of learning possible by a student given the assistance of an educator or another person with greater knowledge.

[2] Erickson (2006) first framed the questions from the perspective of the learner.

[3] Many students are familiar with K-W-L charts (NCREL, n.d.), which are a useful tool for inquiry. The learning topic goes across the top, and students write what they already know about it in the left column ("Know"). They then list what they want to know in the middle column ("Want"). Afterward, they add what they learned in the right column ("Learned"). Variations include an "H" column that indicates how students will find the information or an "S" column on the right indicating what they still want to know as they culminate inquiry. K-W-L charts can be done individually, in groups, or as a class.

[4] Florida State graduate students included Juliana Forero, Kaci Kelly, Kara Leffler, Angie Lewis, Kimberly Qualters, Nicole Suarez, and Debra Wiedel.

[5] Kaci Kelly, a secondary social studies teacher, formulated this question as part of a sample curriculum unit presented at the *Gallery Praxis* conference (Villeneuve, 2007).

[6] To view the video (Lavine Production Group, 2003) of a museum educator and classroom teacher collaboration for fourth grade in New Orleans, see *Collaborating With a Cultural Resource* available at www.learner.org/channel/libraries/artsineveryclassroom. For the full unit of study, see Love and Lilly (2003) available at www.ogdenmuseum.org/education.index.html

[7] For a model, see Villeneuve and Stamey (2006).

PART 5

Assessment

Museum Education Assessment: Designing a Framework

Amy K. Gorman
Muscarelle Museum of Art
Williamsburg, Virginia

Museum education has been in a state of flux for many years. Reports such as *Museums for a New Century* (American Association of Museums, 1984) and *Excellence and Equity: Education and the Public Dimension of the Museum* (Hirzy, 1992), commissioned by the American Association of Museums (AAM), have called for reform in museums to focus on education. Outside funding sources and government agencies have increased demands for accountability. As a result, assessment is gaining momentum and entering the museum vernacular. There are many studies on museum education and learning, but there is no consensus in the field of museum education on how to assess a program, or even what to assess (Dierking, Ellenbogen, & Falk, 2004; FLAG, n.d.; Gruber & Hobbs, 2002; Hicks, Hicks, Powel & Simonton, 1996; Soren, 2001).

Falk (2000) commented, "That museums are inherently educational is easy to say, harder to prove (p. 7)." There is no question about the complex nature of museum education and the variety of components that encompass museum learning. As researchers and practitioners, we must establish what to assess and why. We must also learn what questions to ask, as well as how to ask the questions. This chapter reviews some common philosophical frameworks and principles of assessment and proposes a framework for program evaluation in museum education by asking basic questions pertaining to how, why, and what.

How Are We Assessing? Principles of Assessment

Although our programs and institutions are complex and diverse, we share philosophies of assessment that inform how our organizations approach assessment. The following principles derive from assessment philosophies in several fields of education and programming:

- Assessment begins with values, attitudes, and beliefs. In other words, the underlying philosophies of the organization will guide assessment practices. For example, understanding core values of education and learning directs a department on how to create and implement programming. This same understanding of education and learning guides assessment practices (Astin, 2002).

- Assessment is a tool kit of instruments, techniques, and strategies for evaluating something in a context. It is the visitor studies, observations, and processes that collect and find information pertaining to questions asked (Linn, 2001; Schulman, 2007; Scriven, 1999).

- Assessment measures institutional goals and objectives and compares mission with outcome. Assessment works best when a program has clearly stated goals. Determining a program's guiding theme can help identify goals and objectives to correlate with the museum mission. There is an understanding in museums that activities and programs should support the institution's mission (Cunningham, 2004; Ehrmann, 1998).

- Assessment is most effective when it is ongoing versus intermittent. Assessment should be an integrated part of the learning process, rather than a follow-up. Ongoing assessment evaluates throughout a program, not just in the final stages (Burrough, 2003).

- Assessment measures outcomes, but also considers the process leading to assessment (Burrough, 2003).

- Assessment uses multiple methods. There is no standard or individual test in assessment. Choosing the methods and processes of assessment requires consideration of context and purpose. Each study seeks diverse results, as each study has a different context and purpose (Schulman, 2007; Scriven, 1999).

- Assessment leads to improvement of programs and services. One purpose of assessment is to ensure a program is working and repair what is not, thereby promoting positive change in the larger framework of an institution (Astin, 2002).

- Assessment affects each department and employee. While only a handful of people may actually perform assessment, a ripple effect reaches each person and department in the organization. Getting all staff involved in the assessment practice also helps create effective assessment and encourages communication (Cunningham, 2004).

- Assessment demonstrates results and meets accountability demands. The data collected from assessment projects substantiate how a program is functioning and give evidence to interested parties (Astin, 2002; Linn, 2001; Schulman, 2007).

Why Assess? Justification for Assessment

Assessment is not a four-letter word and is not about unconstructive judgment. Rather, it is about making museums more effective as well as more accountable. Assessment is a tool to pinpoint opportunities for future growth. For museum educators, it is also a key component to building integrity and increasing status for educational programs and departments (Linn, 2001; Miles, 1993).

In any field, there are four main justifications that an organization would use to evaluate programming: validation, improvement, continuation, and staff relations. In the museum, there is a fifth: the relationship of the program to the museum mission. First, evaluation validates the existence of a program and measures the value. In the case of the museum, outside funding and government agencies are increasingly requiring evaluation methods to be included in any publicly funded programming. Assessment can demonstrate the benefits of having and supporting a program. In the museum, these evaluations can also show the worth of a program or department. For example, an education department can use the results to build standing with administration. As an education department proves it is more valuable, it can attract more resources to support new and expanded programming (Dunbar, 2003; Linn, 2001). Second, results

lead to program improvement. Evaluation results can detect the strengths and weaknesses of a program. Successful results are tools to draw others to join and contribute to programs. Unsuccessful components found in programming can identify costly weaknesses to avoid and correct (Bresciani, 2003). Third, evaluation determines the continuation of a program. Assessment yields results that can be used to continue or discontinue a program. The reasoning behind continuing or discontinuing a program should not completely depend on the results of an evaluation, but the results can strengthen an argument for or against maintaining or, in some cases, revamping programs (Dunbar, 2003). Fourth, assessment can build camaraderie among staff. As assessment can affect each person working in a museum, assessment can be used to improve staff relationships. It can bring together a variety of staff and bridge gaps between departments and staff that do not usually work together (Bresciani, 2003; Cohen, 1998; Ehrmann, 2001; Hooper-Greenhill, 2004; Sheppard 2000; Weil, 1997). Fifth, in the museum field, a program's relationship to the museum mission is relevant. A program may yield successful assessment results, but what if the program does not reflect the museum mission? According to the governing bodies for museums, the museum has a moral and social obligation to maintain the mission through all initiatives, including programming (Munley, 1986; Sheppard, 2000).

What to Assess? Framework of Assessment

Justifying why we assess something is often not difficult, but determining what we are assessing raises vital questions. Assessment must have the goal of answering a question. To answer a question effectively, a framework is needed for structure and context. A framework organizes vocabulary, process, and methods for assessment. Structuring a framework is not intended to box museum education assessment into a one-size-fits-all approach; rather, it is a base on which to build.

Education, learning, and experience need to be clarified before looking at a framework for assessment. Educators such as Eisner (2001) and Hein (2005) have long separated education and learning, and now researchers like Falk and Dierking (1992) have separated learning from experience. All three—education, learning, and experience—are entwined and influence one another, but determining their relationships leads to identifying the types of assessment used. *Museum education* refers to the formal efforts of a museum staff to create programs for teaching and instruction (Hooper-Greenhill, 2003). *Museum learning* refers to the actual knowledge gained by the individual, whether through formal or informal programs or guided or self-guided tours (Hooper-Greenhill, 2003; Rennie & Johnston, 2004). *Museum experience* is the impact of the individual's reactions and feelings during and after the visit (Falk & Dierking, 1992). Distinguishing among these three aspects of museum education is a step toward creating an assessment framework.

With these distinctions in mind, we can create levels of assessment. A model from program researcher Kirkpatrick (2003) provides a framework for museum education assessment that addresses the distinctions among education, learning, and experience. The four levels of assessment are reaction, learning, behavioral, and results.

1. *Reaction Level* – This level pertains to the satisfaction of the participants. Did they enjoy themselves? Was the program pleasing? This gauges the museum experience, and these types of questions are asked in visitor studies. Whereas satisfaction does not measure learning, researchers accept that learning potential is linked to levels of satisfaction (Kirkpatrick, 2003; Parkin, 2005).

2. *Learning Level* – This level addresses the actual knowledge that participants gained. What facts can be recalled, what information was received? This most directly addresses museum learning. These types of research questions are most closely associated with formal test taking and skills analysis. A school setting commonly uses this level of assessment, but it is applicable to the museum with appropriate assessment tools (Kirkpatrick, 2003; Rennie & Johnston, 2004).

3. *Behavioral Level* – This level examines the behavior changes in the individual prompted by participating in a program or by having an experience in a museum. It questions how the visitor's beliefs, attitudes, and actions changed as a result. These results reflect a combination of an individual's experience and learning during a museum visit. Research is often associated with long-term impact on attitude and behaviors (Kirkpatrick 2003; Mayberry, 2005).

4. *Results Level* – Kirkpatrick's model is based on training program evaluation, and this level refers to the "bottom line" or how work output has increased to improve the company or product. The museum framework must modify this level to examine not just the museum but also the community, as a museum has broader social interests compared to traditional corporate endeavors. This measures how the program has affected the organization, culture, and community. Has the program affected the museum organization; has the program affected the population served by the museum? The results level examines changes in the museum as well as the social impact. This is an emerging field of research in museums as they shift into becoming social institutions (Kirkpatrick, 2003; Sheppard, 2000).

Kirkpatrick created a hierarchical model for these levels (Figure 1). His research is based in training program assessment, so a system that gauges the progression of a learner in an organization is appropriate because the goals of a training program are to improve a workplace. In the museum, the progression of a learner is not so

direct. Each viewer is an individual case. When applied to the museum, a radial diagram as seen in Figure 2 offers an enhanced analysis for the field. There are two main reasons for this graphic shift. First, a museum visitor is not affected in the same progression as a training participant. The museum viewer is not expected to climb the hierarchy but rather to create his or her own path. Viewers may skip levels or reorder them to fit individual needs. Second, in research this allows for an examination of the relationship among the stages and a cross-pollination of practices. The diagram creates areas for comparison among any combinations of levels that have been renamed sectors. Each sector represents a different category of analysis, with assessment as the core goal, but a focus on preferred data. It also allows for a cross-examination of multiple sectors. In museum research, there are often several factors being examined simultaneously. An analysis of several sectors offers opportunity to explore several factors influencing the museum experience.

Kirkpatrick's levels introduce what to assess, but in the museum's complex and informal setting, a secondary factor needs to be integrated: the context. Through their research in museums, Falk and Dierking (1992, 2000) presented three contexts in the contextual model of museum experience: the physical, sociocultural, and personal. The physical context is the museum setting, the atmosphere that influences the visitor's experience.

Figure 1. Kirkpatrick's Four Levels of Assessment.

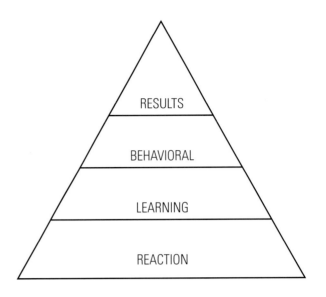

Figure 2. The Modified Four Levels or Sectors.

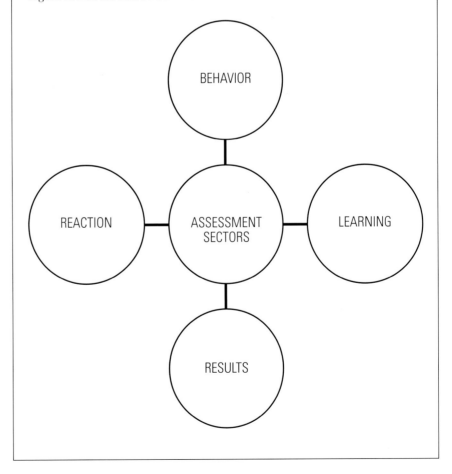

The sociocultural context is the visitor's social group. Whether the visitor travels alone or with another person or a group can influence the visitor experience. The personal context is the knowledge and experiences the individual visitor brings to the museum. Coupling Kirkpatrick's levels and Falk and Dierking's contextual model creates the base of an assessment framework.

In educational assessment, the researcher looks at the objectives[1] of a program to formulate questions for assessment. Two aspects of programming can be evaluated: the visitor or the materials (Bresciani, 2003). If there are no objectives or formal information for starting an assessment, the program first needs to be examined to determine the objectives and the aspects to be assessed. By categorizing the questions of assessment within the levels, giving consideration to context and program objectives, an assessment plan can be formulated.

An assessment plan is guided by the philosophy of an institution and the purpose of evaluation. If assessors do not know why something is being asked, how it should be asked, or what is being asked, the assessment results can fall short of the intended purpose (Bernick, 2005; Lea-Greenwood, 2003). The combination of the theories discussed here can create a framework for determining how, why, and what is assessed.

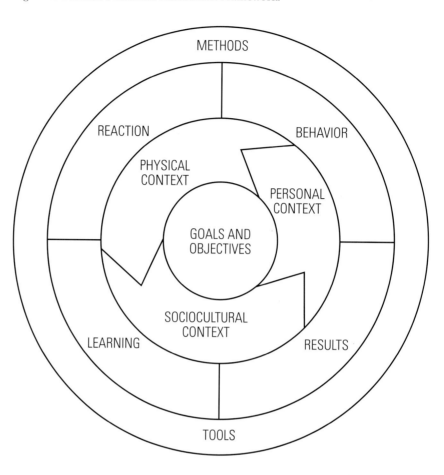

Figure 3. Gorman's Museum Assessment Framework.

Table 1. Summary of Context Components in Falk and Dierking's Interactive Experience Model (1992).

Personal Context	Social Context	Physical Context
• Knowledge base • Understandings • Motivations • Agendas • Perceptions • Preconceptions/ Expectations	• Individual • Group (family, school, other) • Interactions with museum staff • Interactions with other visitors • Crowdedness, social atmosphere	• Exterior (parking, transportation) • Physical space (lighting, display, architecture) • Amenities (gift shop, restrooms, seating, café) • Atmosphere, feeling, mood • Labels, wall text

Table 2. Summary of Assessment Stages.

Reaction Stage	Learning Stage	Behavioral Stage	Results Stage
• Satisfaction • Visitor studies • Immediate reactions • Feelings • Thoughts • Emotions	• Knowledge • Understanding • Comprehension • Abilities • Skills	• Awareness • Ability to use knowledge • Changes in behavior	**Visitor** • Appreciation • Long-term personal effects **Museum** • Social impact • Community impact

Combining these theories creates a framework for assessment in the museum. A single evaluation will rarely produce results that address all of the implications in these levels and contexts. Rather, these levels are introduced as a guide to organize what is being assessed, how it is assessed, and why it is assessed. The question of what you are assessing remains prominent in museum research. Figure 3 examines the relationship in a series of concentric circles.

Goals and objectives are at the center of the framework because they are most often what evaluation seeks to substantiate. Generally, goals and objectives are set during the creation of a program, but sometimes program goals are not available or are unclear. In these cases, by examining the major themes in a program, we can discover objectives. The goals and objectives often indicate why something needs to be assessed. The second ring contains context. The context of the experience influences not only the visitor but also the assessment approaches. The influential factors of context create the next level of the framework. The context is the first stage to answer what will be assessed. Table 1 shows what would be examined in each area.

A study that encompasses every area within each context is not efficient for researchers and not justifiable for visitors; therefore, we break down the context into specific areas of study.

The next ring is divided into quadrants that are the assessment stages. This determines what answers are sought and what questions will be asked. Each stage offers different insight into a particular area of the museum visitor's experience. Table 2 summarizes the areas of study associated with each stage.

The combination of the contexts and the stages determines what is studied. The outer ring holds the methods and tools used to best answer the assessment questions or how to assess. Most methods can be used in any context or stage, but certain tools are more useful for certain tasks. By using each ring of the framework, the researcher can answer why, what, and how something is assessed in a clear, organized method. Creating a framework specifically for museum education gives museum professionals the basis to build and compare research findings. As we move into the future of museum education, assessment will become an integral part of our daily activities. This framework adds the stability and organization needed to support future research as studies in the museum continue to develop.

Conclusion

Assessment can build camaraderie among staff, justify the existence of a program, and share valuable research about museum visitors and learning. Assessment can come at all phases of a program: deciding which phase and the depth of the assessment depends on the desired results. There are also many questions for each museum to consider as they begin, expand, or continue assessment in their institutions. Assessment is now and will remain a necessary activity. The question is not *will* you assess; the question is *how* you will embrace assessment.

REFERENCES

Angelo, T. A. (1999). Doing assessment as if learning matters most. *American Association for Higher Education Bulletin 51*(9) 3-6.

Astin, A. W. (2002). *Assessment for excellence: The philosophy and practice of assessment and evaluation in higher education.* Phoenix, AZ: Oryx.

Bernick, R. (2005). *Assessment: Adopting, adapting, or developing an aligned assessment for your lesson.* Retrieved June 15, 2006, from http://www.rmcdenver.com/useguide/assessme/aindex.htm?

Bresciani, M. J. (2003). Assessing student development and learning in the co-curricular: Moving our institutions closer to providing evidence of educating the whole student. *American Association for Higher Education Bulletin 55*(8).

Burrough, L. A. (2003). *A rolling evaluation gathers no moss.* Retrieved March 8, 2005, from http://www.archimuse.com

Cohen, J. (1998). Reforming the museum. *Art New England, 20*(1), 23-25.

Commission on Museums for a New Century. (1984). *Museums for a new century.* Washington, DC: American Association of Museums.

Cunningham, M. K. (2004). *The Interpreter's training manual for museums.* Washington, DC: American Association of Museums.

Dierking, L. D., Ellenbogen, K. M., & Falk, J. H. (2004). In principle, in practice: Perspectives on a decade of museum learning research. *Science Education, 88*(supplement 1), S1-S96.

Dunbar, T. (2003). *Assessing the Un-assessable.* Learning and Teaching in ACTION. Retrieved August 25, 2006, from http://www.ltu.mmu.ac.uk/ltia/issue4/dunbar.shtml

Ehrmann, S. C. (1998). *What outcomes assessment misses.* American Association for Higher Education. AAHE Assessment Conference. Retrieved September 10, 2006, from http://www.tltgroup.org/programs/outcomes.html

Ehrmann, S. C. (2001) *Transformative assessment: Research ideas.* Retrieved September 10, 2006, from http://www.tltgroup.org/resources/Research_Ideas/Transformative_Assess.htm

Eisner, E. W. (2001). The educational imagination: On the design and evaluation of school programs. New York: Prentice Hall.

Falk, J. H. (2000). Assessing the impact of museums. *Curator, 43*(1), 5-7.

Falk, J., & Dierking, L. (1992). *The museum experience.* Washington, DC: Whalesback Books.

Falk, J. H., & Dierking, L. D. (2000). *Learning from museums: Visitor experiences and the making of meaning.* Walnut Creek, CA: AltaMira Press.

Field-tested Learning Assessment Guide (FLAG) (n.d.) *Assessment Primer.* Retrieved August 25, 2006, from http://www.flaguide.org/start/start.php

Gruber, D. D., & Hobbs, J. A. (2002). Historical analysis of assessment in art education. *Art Education, 55*(6), 12-17.

Hein, G. (2005). *Learning in the museum.* New York: Routledge.

Hicks, J. M., Hicks, M. A., Powel, J., & Simonton, L. (1996). Evaluation: Need for a new landscape. *Art Education, 49*(3), 51-57

Hirzy, E. C. (Ed.). (1992). *Excellence and equity: Education and the public dimension of museums.* Washington, DC: American Association of Museums.

Hooper-Greenhill, E. (2003). Education, communication and interpretation: Towards a critical pedagogy in museums. In E. Hooper-Greenhill (Ed.), *The educational role of museums* (pp. 3-27). New York: Routledge.

Hooper-Greenhill, E. (2004). Learning from culture: The importance of the museums and galleries education program (phase I) in England. *Curator, 47*(4), 428-49.

Kirkpatrick, D. L. (2003). *Evaluating training programs* (2nd ed.). San Francisco: Berrett-Koehler.

Lea-Greenwood, G. (2003). Developing a new assessment strategy. *Learning and Teaching in ACTION, 2*(1).

Linn, R. L. (2001). Assessments and accountability. Practical Assessment, *Research & Evaluation, 7*(11).

Mayberry, E. (2005). *Kirkpatrick's level 3: Improving the evaluation of e-learning.* Retrieved January 4, 2007, from http://www.learningcircuits.org/2005/may2005/mayberry.htm

Miles, R. (1993). Grasping the greased pig: Evaluation of educational exhibits. In S. Bicknell & G. Farmelo (Eds.), *Museum Visitor Studies in the 90s* (24-31). London: Science Museum.

Munley, M. E. (1986). Asking the right questions: Evaluation and the museum mission. *Museum News, 64*(3) 18-22.

Parkin, G. (2005). *Revisiting Kirkpatrick's level one.* Retrieved January 4, 2007, from http://parkinslot.blogspot.com/2005/08/revisiting-kirkpatricks-level-one.html

Rennie, L. J., & Johnston, D. J. (2004). The nature of learning and its implications for research on learning from museums. *Science Education, 88*(1), S4-S16.

Schulman, L. S. (2007). Counting and recounting: Assessment and the quest for accountability. *Change, 38*(1), 20-25.

Scriven, M. (1999). The nature of evaluation: Part 2 training. *Practical Assessment, Research & Evaluation, 6*(12), Retrieved May 4, 2006, from http://PAREonline.net/getvn.asp?v=6&n=12

Sheppard, B. (2000). Do museums make a difference? Evaluating programs for social change. *Curator, 43*(1), 63-74.

Soren, B. J. (2001). *Evaluation and Assessment.* Retrieved March 8, 2005, from http://www.edcom.org/resources/eval.shtml

Weil, S. (1997). The museum and the public. *Curator, 16*(3), 257-271.

FOOTNOTES

[1] Objectives are measurable goals that the museum educator creates as part of any educational program.

New Directions in Evaluation

Randi Korn
Randi Korn & Associates, Inc.

Evaluation is a way of thinking as much as a tool for determining a program's successes and shortcomings. Ideally, assessment can be integrated into organizational behavior to help museums make decisions, learn, and change. This chapter discusses how museum evaluation has changed over the last several decades and identifies the forces responsible for its rise in stature within the museum community. It also explains how evaluation can help an organization build its institutional capacity to become a learning organization.

The Changing Meaning of Evaluation

At one time, if a museum conducted an evaluation, it meant that the museum had used a reliable system for tracking attendance figures because high visitation was and still is considered a criterion for success (Cameron, 1970). Today, however, evaluation is about documenting and studying visitors' experiences during their museum visit. Once viewed as a luxury or add-on that usually occurred at the end of a project, evaluation now has four distinct phases that occur throughout program design and implementation (see Figure 1). The first phase, front-end evaluation, tells program planners how visitors think about and understand the concept of a new program or exhibition. This information can help planners determine how best to communicate their concept and fulfill their most important responsibility: creating exhibitions and programs that demonstrate the value of the museum's greatest assets—its collection, knowledgeable staff, and viewers— and pique the interest of others (Korn, 1998, 2003).

Figure 1. Program Development and Evaluation.

Audience Input	Program Development Phases	Institutional Input
	1. Conceptual Development	
Front-End Evaluation	Revisions	Content and Interpretation Analysis
	Goals & Objectives	
	2. Design Development	
Formative Evaluation	Revisions	Design and Technical Development
	Final Design	
	3. Installation	
Remedial Evaluation		Troubleshooting
Summative Evaluation	Revisions	Institutional Review
	Excellent Program	

Phase two, formative evaluation, takes place farther along in the development process and is likened to piloting a program or testing prototype exhibit components. Formative evaluation is used to identify problems before finalizing a program or exhibition component. For an exhibition, formative evaluation can focus on pragmatic issues such as communication, intellectual and physical accessibility, legibility, and usability (Taylor, 1991). For a program, formative evaluation can examine organizational issues such as program management, in addition to program attendees' experiences. Some institutions also conduct a remedial evaluation after an exhibition is installed to address problems not identified during the formative evaluation (Bitgood & Shettel, 1994). In formative testing, components are isolated from the context of the full exhibition environment. But in remedial evaluation, all components vie for visitors' attention, causing different problems to surface. Before conducting the summative evaluation, evaluators expect staff to change aspects of the exhibition based on findings from the remedial evaluation. Summative evaluation, the fourth evaluation phase and the one that institutions are most familiar with, is conducted after opening an exhibition or presenting a public program to determine whether the visitor experience is similar to or different from program planners' intentions.

As shown in Figure 1, the museum (far right column) and audience (far left column) collaborate, in a sense, to develop programs (middle column), with each contributing

equally. Note, however, that the public is not consulted *before* developing a concept, but rather *after* the idea is identified. In both front-end and formative evaluation, infusing the public into the process helps practitioners clarify their thinking, improve their product, and learn how they can best communicate their ideas. Evaluation is a tool that fine-tunes exhibitions and programs, indicates whether an exhibition or program is achieving its intended effect, and assists in decision-making.

The Larger World of Visitor Studies

Evaluation has not only grown to embrace the planning process, but it is also now one of three distinct areas of study in the field of museum visitor studies, along with scholarly research and market research (see Figure 2). While the three focus areas require thoughtful analysis and use similar data collection strategies, and,

in some ways, study similar ideas, they differ in how practitioners use the information they collect. Researchers test hypotheses and generate theories, and the information they collect is generalizable and may create new knowledge (Patton, 1986). The Museum Learning Collaborative (2005), funded by the National Science Foundation (NSF), the Institute of Museum and Library Services (IMLS), the National Endowment for the Arts (NEA), and the National Endowment for the Humanities (NEH), was an example of a museum research project. This 5-year endeavor, which ended in 2003, produced an annotated bibliography,[1] numerous research papers,[2] and several edited volumes. The project was established for academic and museum researchers to collaborate so they could proceed with a

Figure 2. Museum Visitor Studies.

Basic Researchers	Evaluators	Market Researchers
Study	**Study**	**Study**
Learning styles Social interactions Gender differences Effect on community Cultural differences Emotive responses Learning	Visitor experiences Visitor understanding of content Visitor learning Visitor pathways Experience with interpretive methods Design of components Effect on community	Demographics Psychographics Target audience Community perceptions Visitor satisfaction Nonvisitor perceptions
Result	**Result**	**Result**
Test hypotheses and generate theories	Determine a program's successes and shortcomings	Identify market segments

common research focus that built from two substantial bodies of knowledge—on learning and on museums—to clarify how learning occurs in museums.

Evaluation, on the other hand, generates systematically collected information about the characteristics, activities, and outcomes of a program that are examined against stated goals and objectives to determine how the program has succeeded and how it has failed (Weiss, 1972). An individual program evaluation, while highly valuable to the museum that designed the program and the funder, is less valuable to people outside those spheres. Although there is a distinct difference between how one uses research findings and how one uses evaluation findings, an evaluator can also conduct research. For example, Serrell (1998) conducts what she calls descriptive research. Her questions are: How do visitors behave in exhibitions? What are the parameters of visitor behavior? What is normal "use" of an exhibition? Do visitors behave differently in different types of museum exhibitions? People conducting descriptive research look for baselines and patterns within existing situations without asking theoretical or experimental research questions about cause and effect or influences of particular variables. Whereas a timing and tracking study is one component of an exhibition evaluation, more than 100 timing and tracking studies are included in Serrell's descriptive research study. Other evaluators use her analysis to gauge success in exhibitions because she reports the average time that visitors spend in exhibitions by museum type and the average percentage of use

of exhibit components. Thus, her accumulated tracking and timing studies are serving a larger purpose than one tracking and timing study would in one evaluation.

Market researchers seek to understand how museums can reach different audiences and how they can best "sell" their museums to the public (Kotler & Armstrong, 2001). Because evaluation is centered on visitors' experiences and historically has been associated with attendance, museum staff often confuse marketing and evaluation. Market research is conducted to understand how and to whom to sell the museum and its programs, and evaluation is undertaken to examine the visitor experience and determine the success of the museum and its programs against stated goals and objectives. Certainly a program evaluation can include questions to accommodate the marketing department, but typically the questions an evaluator asks are different from the questions a marketing specialist asks.

Sometimes research, evaluation, and marketing are so intertwined that it is difficult to label a study as marketing, evaluation, or research. For example, a visitor survey has always been conceived as an initial step in getting to know a museum's visitors, but visitor surveys have evolved from asking a few demographic questions (for marketing purposes) to asking several pages of thoughtful, probing questions that try to discover visitors' personality characteristics, their attitudes toward art and museums, their

emotional response to art, the appeal of various interpretive media, the depth and quality of experiences with art in the museum, and their preferences for viewing and experiencing art, to name a few (for evaluation and research purposes). The reasons an institution chooses to conduct a visitor survey and how staff intend to use the information it generates should determine how the visitor survey is characterized.

While it is an asset for an institution to know its visitors, it is also valuable for an institution to know its organizational self (e.g., what kind of institution it is, what its educational philosophy is, what its management philosophy is), whom it wants to serve, and how it wants to serve its public. Institutions should resolve internal struggles before attempting to understand their audiences (Korn, 2004). A visitor survey will be most useful to an institution if it is conducted for the right reasons at the right time and within a context that will help staff understand their visitors from an institutional vantage point. For example, if an institution has a core idea or philosophy it would like to put into practice, a study could explore visitors' attitudes from that context and provide the museum with concrete information about executing its ideas. Similarly, an institution's staff should not conduct a visitor study as a panacea for the institution's problems. Staff—not visitors—solve institutional problems.

The Evolution of Evaluation

During the last five decades, the visitor studies field has matured and is now a valued endeavor in museums. Its rise in stature is tied to several factors operating simultaneously but independently. The most critical factor is a museum's funding source. Outside funders control the flow of money to many museums; if those funders value evaluation and require it of their grantees, evaluation will rise in popularity (Sheppard, 2000). The competitive marketplace also has played a significant role in the growth of visitor studies in the marketing realm, but perhaps more important is the museum field's recognition that the communities surrounding museums are valuable assets and that museums should respond to the diverse constituents (visitors and potential visitors) in their communities (Holman & Roosa, 2003). Finally, visitor studies literature has flourished, providing ideas and information. Museums' desires to embrace their communities' and funders' emphasis on accountability have fueled the need for museums to determine how they affect visitors inside the museum and how they could improve their image in their community. Evaluation has become the tool for understanding the visitor experience, measuring program effectiveness, and determining the impact of a museum on its community.

Evaluation's rise in stature correlates with the establishment of several federal agencies that fund museums. The NSF was established in 1950, and the NEH and NEA were established in 1965. In 1996, IMLS was established from two

Ann Rowson Love
Department of Art Education,
Florida State University

As Korn discusses, many of us think of evaluation as coming at the end of a grant-funded project to be used as a reporting measure, or we think of evaluation as a major, multiyear, endeavor, often expensive, involving organizational overhaul. Yet, even those of us who practice in small to mid-sized museums can use assessment and program evaluation strategies on a daily basis.

I think of assessment and program evaluation as being similar to the process of curriculum development. First, develop objectives related to what the museum team wishes to accomplish for a program or project. Before developing a product or sequence of instruction ask, "What does it look like when visitors or participants achieve the objectives?" Here's a brief example:

Objective: Object labels will include questions to stimulate reading, looking, and dialogue in the exhibition.

Outcome: Visitors will read the labels, as evidenced by their spending more time reading and looking at artwork.

Objective: Visitors will use social interaction to further their understandings.

Outcome: Visitors in groups will engage in discussion with other members of their party.

With objectives and outcomes as a tentative starting point (they may change during the process), coming up with a sequential method for obtaining the outcomes is like developing lesson plans and creating resources. I find it helpful to include community members with specific knowledge as active team members. This will ensure community involvement in making decisions about content and format throughout the development process. Building on the example here, a possible sequence might include team members doing the following:

1. Select works of art in the exhibition.

2. Research the artist(s) and artworks to generate label content and questions.

3. Write and format label copy using an agreed-upon structure.

4. Ask for feedback from colleagues, family, friends, and gallery visitors to start the editing process.

5. Complete the editing process with more feedback as needed.

6. Install new label copy.

7. Select different times and days for gallery observations. Observe or ask visitors what they think about the new labels.

8. Make changes as needed.

The process inherently embeds evaluation strategies—front-end, formative, and summative. By including community members from the starting point, we are addressing audience needs, which, in turn, establish ownership of the project and the museum itself.

separate government departments, one for museums and one for libraries. While these government funding agencies *support* evaluation by questioning prospective grantees about their processes for evaluating their programs, NSF and IMLS go a step further to *require* evaluation. IMLS adopted outcome-based evaluation (OBE), which tremendously affected the museum community because the Institute was extraordinarily successful in communicating the value of OBE and evaluation in general. Private foundations also started to require their recipients to evaluate their programs to prove they were using the foundation's funds as they had purported—thereby allowing foundations to improve what they do (York, 2005a). In so many endeavors, evaluation is tied to money. If government agencies and private foundations—those holding a museum's purse strings—require evaluation, evaluation will happen. As the last several decades have demonstrated, museum staff are learning that evaluation can satisfy funders *and* help them understand the visitor experience and know which aspects of a program are successful. Institutions ready to integrate visitor studies information into how they think about their public selves are realizing that evaluation can be a powerful planning and decision-making tool.

While funding agencies advocated evaluation, the number of publications about visitors' experiences quickly grew. This body of literature supported evaluation and introduced the museum visitor experience to a novice audience. In *The Museum Experience*, Falk and Dierking (1992) introduced the contextual model of learning. This model proposed that three contexts—the personal context, the sociocultural context, and the physical context—overlap and influence visitors' interactions and museum experiences. Falk and Dierking championed evaluators' and researchers' work, which became part of museum practitioners' conversations. Emerging from the museum field at large was the notion that museums should be more visitor-centered, and evaluation was and continues to be a process that is strongly associated with museums' desires to be visitor-centered.

Weil (2002) wrote eloquently about the shifting focus of museums in his book *Making Museums Matter*. He argued that museums must shift from being *about* something to being *for* somebody. If a museum does not have the ultimate goal of "improving the quality of people's lives," he asks, "On what other basis might we possibly ask for public support?" (p. 39). As early as 1920, John Cotton Dana expressed a similar idea (Peniston, 1999), but Weil's writings came at the right time—as museums pondered their value to society *and* when IMLS declared their grantees would need to plan their programs following OBE's logic model. Weil became the scholar spokesperson for IMLS.

The Next Step

Evaluation can serve a broader function in museums beyond programs and their audiences. As audiences are studied and programs are evaluated, the information can be used to provide feedback about organizational functioning and effectiveness. Sanders (1993) wrote:

Evaluation gives direction to everything that we do in an organization. It is the process used to identify needs. It is the process used to set priorities among needs and translate needs into program objectives or modifications of existing objectives. It is the process used to identify and select among organizational strategies, staff assignments, materials and equipment, schedules, facilities and other alternatives faced by staff of any organization. It is the process used to monitor and adjust programs as they are implemented. It is the process used to determine and document program results and why they are as they are. It is the process used by outsiders to determine whether an organization should be supported. (p. 13-14)

Traditionally, strategic planning includes asking important institutional questions about mission and core philosophies regarding audiences, learning, interpretation, and visitor experiences, and developing a plan to realize the mission through programs. However, few museum leaders can state, in concrete terms, what they hope or expect their institution to accomplish (Weil 2002). Museum leaders could and should consider the following questions when developing a strategic plan: What purpose does the museum serve? How does it expect to affect its community?

How *does* it affect its community? How does it define "community"? What kinds of visitor experiences does the museum value? How will the museum create a platform so visitors can have those kinds of experiences? What is the museum's educational philosophy? How does the museum plan to actualize that philosophy? What are the anticipated outcomes? What evidence does the museum need to know it has achieved its objectives?

Precise thinking is an important component of strategic planning. To think precisely, museum leaders should answer these questions: Who are the target populations? How will the museum accommodate each one? Which audiences are best served through which programs? How does the museum define museum learning in exhibitions? How does the museum define museum learning in school programs? What mechanisms will the museum employ to achieve the ideals implicit in staff members' responses to the above questions? As a museum begins to answer these questions, visitor studies can assist in two distinct ways. First, staff discussions about the above issues can be exploratory, and results from carefully crafted visitor studies can clarify staff members' thinking by providing insight and information about visitors in different contexts. Feedback helps planners realize what constitutes realistic goals for a museum program and often helps them identify effective strategies for achieving those goals. With feedback, staff from all museum departments will be able to make informed decisions about programs, based on real information about visitors and their experiences. Second, precise thinking leads to identifying outcomes (e.g., What does success look like?) and describing how one will achieve them (e.g., What is the plan of action for achieving success?). Visitor experience outcomes can be studied—not to accommodate a funder, but to inform the museum of its progress in facilitating the kind of visitor experience it envisions.

Findings from timely and periodic evaluation studies—or visitor surveys that delve into the quality of the visitor experience—can also identify gaps between outcomes and organizational capacity. For example, careful analysis of data from an evaluation conducted as part of organizational planning can ascertain the strength of the relationship between the education department and visitor experience outcomes. The museum can learn which parts of the education department need attention and resources and which parts are functioning optimally (The Conservation Company, 2002).

When relevant information is infused into the planning process, an organization can confidently plan for its future because it has knowledge about its inner workings and its constituents. Combining planning and evaluation provides balance because evaluation reflects the visitor experience and tempers the institutional vision with reality. An organization that combines evaluation with planning is a true learning organization (Senge, 1990) because it is constantly exploring and learning about its institutional self (i.e., how staff in the museum view themselves) and its public self (i.e., how the public views the museum).

Most museums place education and learning at the center of what they do, and staff say they wish to provide learning opportunities for visitors. But staff can be learners, too, and there is great value for them to become learners in the context of the organization in which they work. In an interview, Michael Quinn Patton, a prolific writer and evaluator, promoted evaluative thinking as a "willingness to do reality testing, to ask the question: How do we know what we *think* we know?" (Waldick, 2002, ¶10). Evaluative thinking is thinking analytically about your organization, ideas, programs, and actions. Evaluative thinking includes taking action—conducting a study to answer planning questions or to determine whether a program is achieving its objectives so staff can decide whether to continue it. Patton (2005) said that evaluative thinking connects action and reflection. To reflect on action, he noted, one must know how to integrate and use feedback, weigh evidence, consider inconsistencies, articulate values, interpret findings, and examine assumptions. Evaluative thinking and conducting evaluations can facilitate ongoing institutional learning if they are infused into organizational planning and program execution and if staff members see themselves as stakeholders in the process. Learning from evaluative thinking and evaluation data and applying that knowledge to one's day-to-day work activities is the highest level of organizational learning that one can achieve (York, 2005b). It is apt for staff members to strive to become life-long learners in the context of their museum. Evaluation is an inquiry strategy that can infuse new information into an organization while allowing staff to continually learn about themselves and their visitors along the way.

REFERENCES

Bitgood, S., & Shettel, H. (1994). The classification of exhibit evaluation: A rationale for remedial evaluation. *Visitor Behavior, 9*(1), 4-8.

Cameron, D. (1970). The numbers game. *The Gazette, 4*(1), 11-15.

Falk, J., & Dierking, L. (1992). *The museum experience.* Washington, DC: Whalesback Books.

Holman, K., & Roosa, A. M. (2003). Cultivating community connections. *Museum News, 82*(3), 40-47.

Korn, R. (1998). Making sure the time is right for front-end evaluation. *Visitor Studies Today, I*(1), 12-13.

Korn, R. (2003). Making the most of front-end evaluation. *Visitor Studies Today, VI*(III), 1, 22-24.

Korn, R. (2004). Self portrait: First know thyself, then serve your public. *Museum News, 83*(1), 32-35, 50-52.

Kotler, P., & Armstrong, G. (2001). *Principles of marketing.* NJ: Prentice Hall.

Museum Learning Collaborative. (2005). Retrieved September 21, 2005, from http://museumlearning.com/default.html

Patton, M. (1986). *Utilization-focused evaluation.* Beverly Hills, CA: Sage.

Patton, M. (2005). *The challenges of making evaluation useful.* Retrieved October 6, 2005, from http://www.scielo.br/scielo.php?script=sci_arttext&pid=S0104-40362005000100005&lng=en&nrm=iso&tlng=en

Peniston, W. (1999). *The new museum: Selected writings by John Cotton Dana.* New Jersey and Washington, DC: The Newark Museum and American Association of Museums.

Sanders, J. R. (1993). Uses of evaluation as a means toward organizational effectiveness. In S. T. Gray (Ed.), *A vision of evaluation: A report of learning from independent sector's work on evaluation* (pp. 13-18). Washington, DC: Independent Sector.

Senge, P. (1990). *The fifth discipline: the art and practice of the learning organization* (1st ed.). New York: Doubleday.

Serrell, B. (1998). *Paying attention: Visitors and museum exhibitions.* Washington, DC: American Association of Museums.

Sheppard, B. (2000). *Perspectives on outcome-based evaluation for libraries and museums.* Washington, DC: Institute of Museum and Library Services.

Taylor, S. (1991). *Try it! Improving exhibits through formative evaluation.* Washington, DC: Association of Science-Technology Centers

The Conservation Company. (2002, Fall). *Perspectives: A newsletter for the clients and friends of the conservation company.*

Waldick, L. (2002). *In conversation: Michael Quinn Patton.* Retrieved September 20, 2005, from http://www.idrc.ca/en/ev-30442-201-1-DO_TOPIC.html

Weil, S. E. (2002). *Making museums matter.* Washington DC: Smithsonian.

Weiss, C. (1972). *Evaluation research: Methods for assessing program effectiveness.* New Jersey: Prentice-Hall.

York, P. (2005a). *A funder's guide to evaluation.* St. Paul, MN: Fieldstone Alliance.

York, P. (2005b). *Learning As We Go: Making Evaluation Work for Everyone.* Retrieved September 21, 2005, from http://www.tccgrp.com/pdfs/per_brief_lawg.pdf

FOOTNOTES

[1] See http://informalscience.org, retrieved on September 21, 2005.

[2] See http://museumlearning.com/paperresearch.html, retrieved on September 21, 2005.

PART 6

Moving Forward

A Vocabulary for Practice

David Carr
Carrboro, North Carolina

"Let us search … for an epistemology of practice implicit in the artistic, intuitive processes which some practitioners do bring to situations of uncertainty, instability, uniqueness, and value conflict." Schön (1983, p. 49)

Progressive art museum education depends on the way its practitioners talk about their work and continuously redefine their practice through a fluid and inspiring vocabulary. When disciplined and articulate museum educators speak to each other about what they do, the vocabulary they use matters deeply: it evokes assumptions, clarifies objectives, and implies experiential dimensions. When these things remain unexplored, the value of the learner and the complex qualities of museum experience may be diminished. In this chapter, I offer the beginnings of a progressive language of art museum education, a language that might construct more awareness of art museum experiences and provoke a modest step away from tradition. As in any art or science, professionals who frame their practice with clarity and determination can engage more generatively in inquiry and discourse and move more confidently toward understanding its parts. When we have a way of framing practice and speaking critically, we also have a way of thinking usefully about what we do.

There are likely practical values in a renewed vocabulary for practice. When we speak about professional behaviors and their consequences in the lives of museum users, we need good ways to move between the specific and the generic. We want to encourage a practice of ideas as well as the transmission of information, never easy to speak of. And, when art museum educators regard themselves and their work, a strengthened vocabulary can hold abstract or tentative concepts at the center of professional awareness. A practice of ideas will comprise usable theories of learning and experience, informed assumptions about the lives of users, and, simply, renewal in the educator's daily mission. Language can empower such revisions in our work and how we talk about it. The hard, narrow, self-reinforcing systems we tend to keep in place constrict our ability to reflect; without a full vocabulary, when our rigid systems fail, we are limited in how we can respond.

Unless we have been tested by disappointment and failure, we are in danger of assuming too much about the social world. Schön (1983) wrote,

When practitioners are unaware of their frames [i.e., their assumptions] for roles or problems, they do not experience the need to choose among them. They do not attend to the ways in which they construct *the reality in which they function; for them, it is simply the given reality. … When a practitioner becomes aware of his frames, he also becomes aware of the possibility of alternative ways of framing the reality of his practice. He takes note of the values and norms to which he has given priority, and those he has given less importance, or left out of account altogether. (p. 310)*

A renewed vocabulary for practice can provide motives and values and restore perspectives, in much the same way that an organization's mission uses words to guide its work. When educators are able to say, "This is what I do," it resonates against all other choices. There is neither an educative practice nor an educator without need for conversations devoted to constructive practices. How might we think and act in order to anticipate and influence the experiences we want to observe among museum users? What is the next step in the evolution of educative practice in the art museum?

Discovering useful, generative language is a form of inquiry; it is at the core of all guiding questions, hypothetical thinking, and tentative understanding. It may be risky to suggest a vocabulary, and so the words "tentative" or "possible" must be used. But when words fit our lives, they are no longer tentative. We may not agree at first on the words that matter most to educative museum work or perceive how our words will change as we use them, but they will lead to critical thinking. In any fluid vocabulary, words change as we use them; no dictionary will fully denote the meanings given to our work by the energy of our discourse. That energetic discourse should be informed by what actually happens in art museum experiences. To determine a set of critical terms is also to ask a cluster of questions surrounding each word. What do we mean by this? How will we say this? What examples can we find? But ambiguity is a permanent atmosphere in our world, and I find that there is promise in it: as the possible experiences of feeling and knowing in the presence of art become less obscure and more communicable, the value of what art museum educators can bring to viewers' lives will become more refined and subtle.

The task is daunting, because often we are so starkly opened and exposed by what we see in great artworks; yet, in my view, this exposure is what museum educators hope to cause. Practice addresses the lived experiences of museum use—our acts and thoughts, our discoveries, and their outcomes. These are moments of intense privacy and complexity, yet they are the primary moments of museum experience. They happen in a public space. There are many ways for the cautious expression of cognitive experiences in museums: our attention becomes focused, we notice themes, we alter our stance among different works, we use questions to stimulate new thoughts and encourage their telling, we extend our awareness beyond the gallery, we fabricate links and relationships between disparate works, and we carry them, despite distractions, across the museum expanse.

Art museum educators have conscientiously developed their own variable styles of cognitive engagement. "Variable" is the key word: there is no room for rigidity or permanence in our attention. All practice is an interpretation of a challenge in the moment, and each moment differs. The best practices in art museums are unlikely to be founded thoughtlessly on a textbook process, or on a formal theory, or on routine, unquestioning assumptions about users' needs or knowledge. In its ideal form, professional practice is a fresh interpretation of the given situation and what it requires us to do. To appropriate a phrase from law, museum thinking is nearly always in "discovery," the period before inquiry and judgment.

Every educative profession needs to open its interpretations to scrutiny; every educative profession especially needs to understand ways to ensure that original thinking, inspired by authentic questions, is never far from its discourse. Integrity requires that professional assumptions should be unfolded, questioned, and aired: every museum educator holds constructions and ideas about art history, the nature and awareness of museum users, and the place of the museum in contemporary experience. All of these need to be shaken up by questions. Art museum educators might remind themselves and their institutions that human experiences and understandings have no template, that we are all engaged in mutual and personal paths when we stand in the presence of original artworks, and that it honors those works when we speak of them as though we had just discovered them and have not finished our thinking about what they are.

To achieve such immediacy in response to art also respects the presence and integrity of users, who, I believe, are almost always challenged by the moment of encounter. They, too, must divest themselves of assumptions about art and its place in favor of a more robust idea of the museum and its human effects. Two of the educator's great tasks are to find the user's unspoken experiences of art and to assist their articulation. The museum user needs to be invited to step safely to the edge of discovery and to accept an invitation in the presence of the unfamiliar and the unknown.

The Museum as a World Apart and as a World Connected

The removal of insularity and the articulation of connections between artworks and contemporary human experiences are important goals for museum educators. Insular art museums tend to be worlds apart, contained, constructed, and wholly different, even from other museum worlds. Such places are often silent and unconvivial. In my experience, I have thought them to be charged with invisible dimensions and elitist barriers, a sensuous world intentionally kept out of human touch. This austerity often means that artworks cannot be interpreted in contemporary dimensions or everyday language, because they have been made remote and privileged by where they are and what the museum is. Consequently, the challenge for the user is to ransom the artwork itself and restore it to the living fabric of life.

Though intended to broaden and deepen the presence of art in lives, the museum apart is laden with history and scholarship. The information given nearby is often a brief and clumsy composition of answers to questions no one has asked. Imagine a world infused with intensity, reason, belief, anguish, nihilism, death, and conflict, yet also full of serenity, awe, insight, passion, eroticism, bliss, and consolation. What would we ask for in this provocative world? Names and dates? Geography? I find myself, like Blake's etching of the man with a ladder to the moon, saying, "I want! I want!" but often to no avail. Though its users may carry and feel all of the intense elements of experience, the museum is by nature a mechanism of only transitory alignment with the living, fluid world where unforgiving time, ravenous commerce, and intrusive information have dominion over our lives. By giving information sparely, when generosity is our want, the museum reduces itself and denies its users.

Having imagined the museum as a world apart, we can now regard its logical opposite, the museum as a world connected and engaged, a place of continuous relationships between lived experiences and living works of art. Such a place might be imagined based on the idea that because artworks are made by human beings and are tangible achievements, they stand before us as complete entities derived from human knowledge and experience. Each work has come into existence—and to the museum—out of a succession of inspirations and states and values. Each is comprehensible as a human attempt to communicate and represent; each work has traces and fingerprints, so to speak. And each work is a tentative way to enlarge, or affirm, the experienced worlds of others.

Each work is awake (and awakens us) in a different way. The engaged museum will assume that artists and museum users have much in common; each leads a feeling life and constructs and revises provisional ideas grounded in familiar contexts. And each person, whether artist or museum user, has the power of presence as one among others. Collection, artist, artwork, museum user: these are the four sources of energy given to the art museum educator. Given these sources, how might a new fusion of museum experience and personal experience occur?

The Practice We Need

The way to renew the practice of art museum education is to redefine it as a responsive institutional process, reconfigured every day, improvised in the same way that our conversations are reconfigured when we encounter others. The spontaneity of our conversations does not diminish our character or our intentions, but it does give a human voice to interactions with users. "Today, as I look at this painting, I think about…" Practice in art museum education should regard the experience of learning as fluid and complex, neither curricular nor explicitly didactic, and certainly not condescending or arrogant. (Learners will not become competent or independent if the educator's knowledge makes them feel small.) Educators should regard the museum user as a participant in a culture of this moment—a culture of fragility, volatility, and caution. We should assume that a person has come to the museum to review with us the evidences of art, as we look together for images and ideas that will animate and strengthen an awareness of the possible.

For the museum user, there is the possibility to understand the aesthetic impulse, the need to record an image, decorate the utilitarian tool, or express faith. Looking in the gallery, apart from the history of art, we might understand the interior lives of artists and others. Deepened insights are possible. Understanding faiths and faith practices is possible. Explorations of memory and evocations of stories are possible. It is possible to explore human differences across time and space. It is possible to find solace and self-renewal, rapture and self-recovery. It is useful to articulate a vocabulary of the possible as it is held for us in the art museum.

Practice provides an educator with daily opportunities to trace the thoughts and observations of museum users in the situation of the art museum. It is a situation of many components: motive and desire, cumulative visual experience, a repertoire of cultural knowledge. The situation is immediate and direct: the work is here, and so is the user. The situation is almost inevitably reflective and complex. Any single art object is an embodiment of skill and technique; it represents style and tradition; it is the outcome of a process, comprising countless decisions; it reflects the constraints of materials; it is the unique example bearing traces of the artist's processes and choices. And any work can be seen as an artist's response to a situation, in a context of time and space that must in some way connect to our own. Every experience of art by any museum user is in some way without precedent, yet it can have great power in a familiar world.

When educative practice is responsive to the immediate observations of users, the barriers of didacticism can be replaced by a living language, improvising questions that have neither easy nor apparent answers. This does not compromise the authority of the museum, but extends it toward a view of the user at the center of museum life. Sustaining this kind of practice means redefining the work of art education, guiding it to become the primary voice of the museum in the life of the user—and the primary listener to the user, as well. The art museum educator is at the center of the living, contemporary museum.

These might well be the uncompromising values of art museum education: to evoke the voice of the user, to listen to it and take lessons from it, and to conduct educative practice as a responsive process where change is constant. In this way, it is possible to understand and adjust the mutually formative relationship between the museum educator and the museum user.

Museum Use as Lived Experience

If art museum education is to move forward and if its practitioners are to understand what they do and for whom it is done, we must encourage each other to understand and explore the changing landscape of the lives of museum users. Lives and aspirations evolve continuously and with them needs for independent learning. Our experiences provide us with tacit understandings of how the world works. Consequently, in a world that flows inexorably forward, we often require new models for thinking and different models for the changing tasks of mature life.

We seek our integrity against the odds: every life functions within a series of complexities and constraints, often requiring unanticipated roles. Lives are blends of stability and change; no learner appears identically in the museum twice, and no life is simple to grasp. We might also say that no life in the museum is ever finished and every life is therefore ever capable of renewal. What does this imply for the experiences of art made possible by museum collections?

Art experience is special experience, different in structure and texture from other experiences. The art museum is beyond everyday life, marked as a space without the intrusions of evaluation or coercion. At the risk of undermining that part of the museum I find most essential, I want to make clear my belief that learning in the art museum space is a completely natural response to the environment. Place fine and engaging objects, more of them than we can fully apprehend, among other similar objects of different kinds, forms, and cultures, and a great opportunity to think and feel has been created. In such places, it is extraordinary *not* to be engaged nor to feel a human pulse nor to see the traces of life deeply etched in object after object.

To educate in such places is to assist—in Vygotsky's (1978) sense of being a more advanced peer—rather than to instruct. To educate is to respond to ideas, to assist in connecting them elsewhere in the museum, to verify the observer as an autonomous perceiver, and to aid in constructing a passage toward more thoughts and ideas of the user's own. To educate in such places is also simply to be together as observers, and to speak together as peers. As I wrote these words, I thought of a passage from a poem, "Chocorua to Its Neighbor" (Stevens, 1964):

To say more than human things
with human voice,
That cannot be; to say human
things with more
Than human voice, that, also,
cannot be;
To speak humanly from the height or
from the depth
Of human things, that is acutest
speech. (p. 300)

Humans are learners, and human things are what we learn in art museums. Therefore it is important to be clear: museum educators must first embrace themselves as learners, as people unusually well-prepared to construct possible ways to move and think acutely among works of art in the museum. Their work occurs during the most intimate and private moments in lives, when a person's experiences, dreams, and realities may suddenly and inexplicably awaken. For this reason, the art museum is a place of empathy and challenge.

When Elkins (2001) asked to hear from people who wept in the presence of paintings, one artist wrote, "When I cried in front of those paintings, I also did so in response to the painter's courage, because I felt the painter ... had been out on the edge, held it all together, and made it work" (p. 228). "Out on what edge?" we might be tempted to ask, and as we start to answer our own question we might realize that the "edges" of great works are countless and that to speak among them, much less to achieve "acutest speech," is a task that often defies mastery. Elkins wrote, "If they are given the chance, pictures can ruin our stable sense of ourselves, cutting under the complacent surface of what we know and starting to chafe against what we feel" (p. 208). What, then, is "educating" here? How does an educator bring others to see, grasp, and feel the edges of things?

Evasively, I offer a metaphor in response. The art museum educator might be seen as the leader of an exploration, guiding numerous volunteer explorers as they emerge out of their individual paths and choices, to undertake a passage in the art museum. Each volunteer brings lived experiences and a history of choices; each has energy and intellect and the hope of an illuminating discovery. The leader is at once a shepherd, servant, protector, and gatherer. As the group moves into an unfamiliar interior, the metaphor reminds us that guiding, serving, protecting, and gathering also are the most critical elements of teaching. They construct the conditions that make new observations possible. The growth of the person through guided exploration is the intention the art museum educator is challenged most to fulfill.

A Vocabulary for Practice

When we talk about art museum education, what do we talk about? Following are four loosely assembled domains of the museum environment, each affected by the educative conversations we hold and the ideas presented in museum education. With caution, I believe each should be approached as a continuing problem of practice—in much the same way that balance is a continuing problem of practice for the acrobat and dexterity is a continuing problem of practice for the surgeon. The main terms and others embedded within them represent issues addressed every day in thoughtful practice. They hold challenging concepts to be addressed, and they are not likely to disappear, no matter how much talk is given to them.

None of these amorphous concepts should be regarded without a cluster of other terms and ideas to give them shape. When we talk of one idea, we will be led to talk of another. Underlying all of them are guiding questions that similarly will not go away, nor necessarily become clearer as we address them. Given their persistence, they may be useful as formative questions in the context of the vocabulary for practice that follows.

What experiences do we want to cause in the lives of art museum users? What do audiences need from us if they are to become the users we hope them to be? In what ways can we speak to the user about works of art, other than through the assumptions and practices of art history?

We may not know how to respond to these questions. There are, however, concepts to reflect on. The concepts and commentaries I offer below are mere beginnings to the informed conversations we might have if we are to move forward in our thinking about what happens when we strive to educate in the art museum. It is likely that other concepts will appear and take precedence, but these are the parts of practice that require attention and discipline, review and questioning. As possible responses to the question "What should museum educators talk about when they talk about what they do?" I suggest four themes: *experience, the user, possibility,* and *situation.*

Experience: Invisible Traces

Art museum experiences are transient; in a lifetime context, we can see their smallness and their privacy. Though they are likely to seem small and not dramatic, art museum experiences may become increasingly consequential over time. The momentary negotiation we have with an extraordinary object—looking directly at it, backing off, then returning to it before we leave the museum—has a cumulative effect. It leaves invisible traces on us. "What makes artworks interesting," Elkins (1999) wrote, "is the precise unnamable sensation particular to a single image. The moods and meanings I have been sketching creep into our experience without our noticing, sparking directly from the eye to the mood without touching language at all. How do substances speak eloquently to me without using a single word?" (pp. 100-101).

Walsh (2004) said that art museum experiences "can generate sensations that bypass the rational brain and go right to the scalp,

the tear ducts, the lungs, the heart" (pp. 78-79). A page later, he asserted, "You need to be there, in front of it" (p. 80). You do, indeed, need to be there in front of it in order to feel those direct sensations: excitement, disturbance, personal identification, profound silence.

Dewey (1934) wrote of aesthetic experience:

The experiences that art intensifies and amplifies neither exist solely inside us, nor do they consist of relations apart from matter. The moments when the creature is both most alive and most composed and concentrated are those of fullest intercourse with the environment, in which sensuous material and relations are completely merged. Art would not amplify experience if it withdrew the self into the self. ... (p. 103)

For Dewey (1934) the experience of an artwork was whole, emotional, concentrated, indivisible, personal ("A beholder must *create* his own experience" [p. 54]), fulfilling, and complete. And yet it is also generative, lesson-bearing, and ongoing, in the sense that we can return to it with a vivid sense of its original power. What is amplified is not the artist's experience, but the museum user's. The lessons are our lessons, unfolding for us alone. The lessons of art do not exist until we have brought them into the world.

Jackson (1998) described discovering issues that caused him to believe "the power of art to be genuinely transformative, to modify irrevocably our habitual ways of thinking, feeling, and perceiving. Changes of that magnitude may occur infrequently, true enough, but when they do,

they leave no doubt in the mind of the experiencer that something significant, perhaps even spiritual, has taken place" (p. xiv). Works of art, as they are experienced, are generative because they require nonroutine thinking and temporary occupancy of frameworks not founded on everyday logics. The idea of the different—and the making of difference—defines the museum space. A completed artwork is always in a state of unfinished definition, yet its duration is continuous, open, steadily becoming. Having seen and experienced the work of art, we continue its life in our own.

What does the art museum educator want to happen? What experiences can the art museum educator cause to happen? What aspects of a museum experience can be understood, considered, and brought into speech?

The User: An Active, Intentional Presence

The appropriate term of regard for the person we address in the museum is the museum *user;* the term implies an active, intentional presence and the application of attention and thought to experience. We may assume in the museum user a readiness for observation and reflection and an ability to sense patterns and structures; this awareness prepares the user for new and unexpected experiences as well. The museum user has a capacity for growth unlimited by age. The user brings experiences, motives, and a lifetime of continuous, inconspicuous, independent learning to the museum. These are likely to remain unspoken in the museum.

Among the museum user's capacities is a developing awareness of his or her evolution, including past experiences, emerging interests, and learning strategies. Among these strategies are the asking and sustaining of guiding questions and other uses of language, including metaphor. The museum user has a long record of experiencing, remembering, and forgetting (Smith, 1998). The index to this record, variable and imprecise, is memory. School and its effects are an influential and potentially dominant and distorting part of this record.

How do we regard, elicit, and serve the experiences and intentions of the museum user? How do we overcome the effects of schooling on inquiry? How do we encourage the effective use of language and questions in the experiences of the museum? How does the museum user become aware of patterns, connections, themes, and other elements of the museum's structure?

Possibility: The Transformation of Capacity

The art museum experience has indeterminate outcomes for its users. Among them are transformations that permit the user to discard previously confining masks and forbidding unknowns. Possible transformations include a new tendency to observe in greater detail and to look beyond one's previous awareness, a readiness to reflect on experiences and enfold them within previous experiences, and a willingness to tolerate an open question over time, without rushing toward closure.

"It is imagination," Greene (2001) wrote, "that discloses possibilities" (p. 65). It is essential to acknowledge the need to "break through" the routine confinements of conventional, unimaginative thought. This means we should develop situations devoted to imaginative energies, places where the tendency to reach beyond the present, in order to reinvent the world that matters to a life, is not only encouraged but also made newly possible.

There is a terrible passivity and carelessness to be overcome: feelings of malaise, hopelessness, powerlessness. The arts will not resolve the fearful social problems facing us today; they will not lessen the evils and the brutalities afflicting the modern world. But they will provide a sense of alternatives to those of us who can see and hear; they will enhance the consciousness of possibility if we learn how to attend. And this itself may make a difference if more and more people are awakened, if they are freed to move through openings and develop a sense that things can indeed be otherwise than they are, somehow better than they are. (p. 47)

Auyang (2000), addressing the same concept in cognitive science, said, "Awareness of alternatives … opens a realm of intelligibility like a clearing in a dark forest. With the clearing, mind is born" (p. 377).

A commonly heard phrase can innocently carry a potentially revolutionary implication; it becomes an essential element here. In the art museum, what lies "within the realm of possibility" is what we might become aware of,

what might appear in our lives, as a consequence of contemplation and conversation amid artworks. The possible remains latent, silent and unexplored, but immanent and potentially reachable within us. It appears, again using Greene's (2001) words, as "the unexpected surging up in experience" (p. 94). The art museum educator's work is to make divergent thinking less remote, to bring the imagination closer to the user's lived experiences, and to make such "surging up" more likely in the future.

Think of the possibilities opened to the museum user if alternate ways of organizing and comparing museum experiences supplant traditional roaming. Alternative patterns of museum use could be suggested. Open storage walls could focus attention on smaller objects from various cultures, including our own. Selected objects could be surrounded by interpretations and commentaries, an immersion to demonstrate multiple ways of thinking about a single artwork.

Consider that art may be the key to art. Think of the possibilities opened by selectively juxtaposed works, chosen from different centuries, media, and continents. Think of the possibilities opened by consistent references to literature and music in the art museum. Think of the possibilities opened by helping the user to understand the inextricable weave of contexts and complexities surrounding artworks: religion, politics, history, mythology, metaphor, biography, allegory. If this weave can parallel the complex intelligence required in everyday functioning, a breakthrough is possible.

Consider the possibility that the museum user will come to find the museum as a center for understanding actions beyond the museum, in the world it mirrors. Is it possible to live a life configured by the lessons of artists and their works?

Consider the values of disorder and the unexpected. Think of the possibilities opened by conversations about the hypothetical, encounters with the unanticipated, the values of surprise, and the authentic, empirical observations of unmediated experiences between the user and the work. It is a hopeful moment when the observer says, "I don't know what to make of this."

If we were given the opportunity to create a new situation for guiding and assisting museum users in their experiences of art, what would we want to make possible? How would we define the breaking through that "possibility" implies: the understanding of a different frame of thinking and becoming?

Situation: What Is Given to the User

The museum situation comprises the design and dimensions of a collection, the depth of information easily and publicly given to the user, and the stance of the museum in support of learning and learners. The situation is not passive. It can be characterized by its level of generosity and invitation: its purpose is to bring museum users closer to artworks and to facilitate engagement and thought, inviting boldness and courage in learning.

The art museum by its nature and content implies inherently ambiguous experiences; the visible object contains invisible processes and contexts. To go beyond the given object requires

imaginative, constructive, even playful ideas. Only small parts of these experiences can be transferred from an educator to a museum user. In the situation of the museum, the user thinks alone; the primary negotiation made possible by the situation is always between the user and the artifact, a conversation likely to occur outside art historical discourse. When we speak to our companions, it is to report what we know as our own experiences.

The situation is not found in a single place or tied to an individual, but is a moving force, a climate intended to lead the user toward art and then toward reflection and language. What might this moving force contain? Opportunities for conversations and feedback; privacy and trust in these exchanges; opportunities to revise and question previous ideas; and access to an information resource, a useful library collection, and, as needed, the presence of educators. The value of a situation is clear, Smith (1998) reminds us, when we are made comfortable among others who will "help you to say what you are trying to say," and who "help you to understand what you are trying to understand" (p. 18).

How does an art museum express its advocacy for learning? How does the museum express its values and describe the situation for learning it has created? How does this situation adapt to museum users of differing capacities and experiences? How must practice change if users are to trust themselves, explore alternative logics, make original discoveries? How does the museum evoke trust in itself? How does an art museum express an ethos of generosity and service?

What Endangered Thing?

In museums of natural history, in zoos and aquaria, it is common to find a pervasive institutional mission to preserve and protect the biosphere and to advocate its rescue from ignorant policy and exploitative commerce. The eloquence of such advocacy is strategic, and it speaks across generations, declaring the imminence of dire threats and invoking humans' responsibility to acknowledge and repair environmental damages. The collection and study of endangered species, husbandry programs in zoos designed to sustain and expand fragile populations, and public educational campaigns in support of biodiversity and wildlife are clearly extensions of those institutions' active public missions.

Museums of history and living history settings advocate preservation, documentation, and personal recollection as ways to understand the implications of the disappearing past. The artifacts of our childhoods appear in museum cases as poignant reminders of the histories we have lived and our own fading time. More deeply, the artifacts of crisis and fear, the remnants of disasters, and the awful documents of war can be seen as ways to recover endangered memory and to remind a public that history is neither remote nor over, but continuous and formative, and requires action or it will be lost. Historical collections can inspire an active process to preserve and treasure what we can and to gather its implications for our lives.

What is lost without art museums, or when art museums fail to engage us as we look? What endangered thing does the art museum protect? What advocacy for human sustenance does the art museum embrace? In keeping what it keeps, in expressing pertinent knowledge, in creating extensive and brilliant collections, what does it rescue for us? What does it encourage us to save against loss in our own lives? I have no answers here; these questions are better answered by enlightened educative practices in museums.

In my view, the art museum does not hold remote or austere collections; rather it holds objects made by human beings whose need to change the world took specific forms and left specific traces. Artists make special things that survive them and carry unchanging evidence of their visions and skills; these surviving works continue to change those who see and experience them. When we talk about a work of art, we also talk about the human impulse to make something the world has not yet seen. It is a courageous but neglected impulse; perhaps it is taken for granted. But when we assume that an artist is led by undeniable urgency to express, or by a need to make the world different in a lasting way, our questions should change: *By making this, how did you expect to change lives or change the world?* When, in rare, brilliant moments, we encounter the work of art that we know is somehow *made for us to see*, we need to pause to find its importance—and its specific grace. We need to place it within ourselves before we can move on.

When we are free to become less interested in art history as a form of museum classification and explanation, we are free to become more interested in the effects of artworks and artmakers in a culture's history. Our questions in museum collections can draw us to consider the roles of artworks and artists in our own time and how they can help us to understand what remains incomplete for us. Or we can be free to experience the ways that art challenges our assumptions, leads us to imagine, and opens our memories. As never before, the devastating politics of the world challenge us to become more worldly and more likely to think and act beyond the patterns of our previous assumptions and conventions.

An Unfinished World

The educator in the art museum works in an unfinished world, among objects and logics that have the power to reconstruct the awareness of the museum user. Worts (2003) wrote of the art museum having the potential to contain situations where we can see ourselves more clearly as participants in a diverse system of feelings and implications. Each artist, in his view, allows us a connection to archetypal patterns, toward an understanding of life in a mythological dimension, where creativity and metaphor illuminate us. Perhaps we are too attentive to the invariable dimensions of living; we need more acquaintance with the variables, the possibilities, and the infinite. These ideas recognize that the great challenge of living now is to know *why* we live and what we might make of the possibilities our lives give us. We enter the art museum and leave behind the immediate barbarities of war, the cynical manipulations of politics, and the reductive bottom lines of industry and economics. There is another economy in place in the museum of art.

Emerson (1844/1983) began his essay on experience with the question, "Where do we find ourselves?" (p. 471). In the art museum, we give ourselves the task of making, rescuing, and saving that perpetually endangered part of our mind likely to remain invisible otherwise. We discover the presence of the mythic in the everyday. We come to understand the nature and image of heroism. We recover our capacity for reverence and silence. We rededicate ourselves to personal, self-transforming inquiry. We recognize moment after moment when it becomes imperative to know more. We rediscover balance and humility in one life and learn disdain for arrogance. Moving forward, it is the task of the educator in the art museum to define practice that makes a difference in the user's experience. Every day, engaging in the tentative conversations that transform the vocabulary for practice, such practice becomes more possible. These are moments of experience that rarely appear elsewhere; to miss them, to allow them to drift out of reach, is a personal loss.

REFERENCES

Auyang, S. (2000). *Mind in everyday life and cognitive science.* Cambridge, MA: MIT.

Dewey, J. (1934). *Art as experience.* New York: Capricorn Books.

Elkins, J. (1999). *What painting is.* New York: Routledge.

Elkins, J. (2001). *Pictures & tears: A history of people who have cried in front of paintings.* New York: Routledge.

Emerson, R. W. (1844/1983). *Experience. Essays and lectures.* New York: The Library of America.

Greene, M. (2001). *Variations on a blue guitar: The Lincoln Center Institute lectures on aesthetic education.* New York: Teachers College Press.

Jackson, P. W. (1998). *John Dewey and the lessons of art.* New Haven, CT: Yale University Press.

Schön, D. A. (1983). *The reflective practitioner: How professionals think in action.* New York: Basic Books.

Smith, F. (1998). *The book of learning and forgetting.* New York: Teachers College Press.

Stevens, W. (1964). *Collected poems of Wallace Stevens.* New York: Knopf.

Vygotsky, L. (1978). *Mind in society: The development of higher psychological processes.* Cambridge, MA: Harvard University.

Walsh, J. (2004). Pictures, tears, lights, and seats. In J. Cuno (Ed.), *Whose muse? Art museums and the public trust* (pp. 77-101). Princeton, NJ: Princeton University.

Worts, D. (2003). On the brink of irrelevance? Art museums in contemporary society. In M. Xanthoudaki, L. Tickle, & V. Sekules (Eds.), *Researching visual arts education in museums and galleries: An international reader* (pp. 215-232). Dordrecht, The Netherlands: Kluwer Academic Press.

Performing Openness: Learning With Our Audiences and Changing Ourselves

Jessica Gogan

The Andy Warhol Museum

In *Civilizing Rituals: Inside Public Art Museums,* Duncan (1995) asserted that the meaning of the museum is enacted in its rituals. As ritual implies the repetition and performance of specific actions, this would suggest that for a museum to put forth an expanded notion of itself and its place in the community, it could do so only through repeated practice—constantly (re)performing itself to its publics and, necessarily, in ways those publics recognize. Borrowing Umberto Eco's concepts of "openness" from *The Open Work* (1989), Carr (1995) advanced the notion of the museum as a performative space in his formulation of the museum as an open work created only in the play of its users. He offered this idea as a theoretical concept for how museums can become places for learning. As such, the "open work" underlines the importance of the audience's place within the "work," emphasizing a creative and active learning process as the "work" has to be performed to derive meaning. The museum, here, is a key player, as provider of a ritual space of physical and sociocultural contexts for interaction and as a creative user, shaping and learning from "the work."

So how does a museum perform or signal this openness? How do we understand the nature of the art experience in this "open" environment? What does this mean for education and curatorial practices? What examples are there of this "openness"? Why would we want to be "open," and what are the benefits in doing so? In this chapter, I consider these questions focusing on two key areas for this openness to take place: (1) diverse display and interpretation practices in the museum galleries, and (2) new models of curatorial synthesis, internally and externally. Through exploring examples of "open" interpretive practices, I argue that it is not enough for a museum to posit itself as "open" with its publics; it must perform it and in ways that those publics recognize. I further make the case for not one, but many, modes of art presentation. The process of opening up the museum's mediating role also means understanding and fundamentally valuing that we are learning not only *from but also with* our audiences; in other words, we see ourselves as learners, too, and expect to change in the process. This does not mean that we give up our voices or our expertise or our role as interpreters. Indeed, the process of opening up demands great skill in combining an articulation of our knowledge with listening to many voices and in explaining ourselves with clarity *and* complexity. This suggests a new model of curatorial synthesis that is open to creating and curating with audiences and communities and among museum staff. Here, the museum plays a critical role in galvanizing energies and promoting the sharing of knowledge that in turn builds trust and relationships within communities and within the institution. An "open" museum ultimately offers richer and more meaningful possibilities for learning and experience and an expanded sense of a museum's civic role and place in community.

Why Be "Open"?

Andy Warhol (1985) once quipped, "Department stores are kind of like museums" (p. 22). The department-store-like atmosphere of museums extends not only to the display of art, from boutique lighting to white walls, but also to the way visitors experience museums, "shopping" galleries for what catches the eye. This form of cultural grazing can, of course, be highly entertaining and, given its currency throughout the 20th century to the present, can be seen as the *de facto* diorama of art for our time. Yet, often it falls short of our hopes for aesthetic experience, as witnessed by the wistfulness of art critic Peter Schjeldahl (2003) in an otherwise admiring review of a new art museum:

Its "white box" galleries conform to a convention that, for more than 50 years, has been the default mode of a civilization that lost a way of integrating art into the world architecturally, decoratively, or spiritually. No one, I think, is happy with this situation. Who wouldn't welcome a grand, potently symbolic reintegration—a new Baroque? (p. 88)

Schjeldahl's (2003) comments reflect that, despite a century of modern and contemporary art critiquing institutions, diverse forms of artistic practice, and much discussion of curatorial practice, the paradigms of presentation remain solidly formalist. Would the experience of art deepen if we changed these paradigms?

What would we lose and gain in the process? What values underlie the status quo and the desire for change? The criticism of art not being "integrated into the world" is similarly shared, albeit motivated by a different critique, by cultural activists, non-Western perspectives, socially engaged art practice, and those who argue for an increased ethical and social role for public institutions in the midst of declining public space. This all points to fertile ground for exploration and issues a challenge to 21st-century art museums.

What Is the Nature of the Art Experience in an "Open" Museum?

At the New York Armory exhibition in 1913, Marcel Duchamp put forth as an artwork a urinal signed "R Mutt," thus introducing the concept of the ready made and pointing to a radical change in our understanding of art practice, where the essence of art is seen as an invitation to contemplate and engage rather than a demonstration of craft. Duchamp's gesture and artistic shift of focus from object to practice proffered a challenge to art museums' forms of presentation and display, one with which they still struggle. In response, the post-Duchampian art world seems to have accepted a sort of non-action policy on the art museum environment for fear of overly inscribing the art object—and the non-art object, particularly when considering contemporary art—preferring to see the optimal viewing experience as one of unfettered looking, an unmediated dialogue between artwork and viewer. However, rather than leaving art "open" to multiple interpretations, this privileges the point of view that art speaks without any (Gogan 2005). The "open" museum, in contrast to formalist paradigms of display, recalling the more process-oriented work of performance art, acknowledges that it is both a context as well as a content provider. Here, the art experience, similar to recent formulations of learning by researchers Falk and Dierking (2000), is one of exploring the interrelationships between art and sociocultural, physical, and personal contexts. Drawing on Hein's (1998) notion of the constructivist museum, the "open" museum asks visitors to apply the conceptual approaches, processes, and questions of artmaking to their own lives to build knowledge and understanding of the self, the world, and art. Historical and cultural contexts of works of art and multiple points of view are highlighted amid diverse forms of display and interactivity, old and new, and the art museum experience becomes less about looking at art and more about making sense of the world.

How Do We "Open" Up? Strategies and Examples

The following outlines strategies of "openness." I draw significantly from my experience at The Andy Warhol Museum (AWM) in Pittsburgh and highlight examples from art museums nationally and internationally. By no means comprehensive, these cultural and regional samplings of practice in the field reflect "openness" in new models of display, interpretation, and ways of curating.

Where to Begin? Artistic Practice Inspiring Interpretive Practice

In his 1822 painting, *The Artist in His Museum* (http://en.wikipedia.org/wiki/Charles_Willson_Peale), Charles Willson Peale, full of Enlightenment faith in reason, science, and self-education, depicted himself as an artist-impresario. Surrounded by examples from his collections and his painter's palette, Peale directed our attention to the museum as a site of collection and education. In 1969, Andy Warhol revolutionized established display practices with the exhibition *Raid the Icebox* (http://edu.warhol.org/app_aw_raid.html). Mining the collections of the Rhode Island School of Art and Design, Warhol, functioning both as artist and curator, chose objects that had been ignored and seen as second-rate to create an unconventional set of installations (Warhol, 1969). Here, the artist's provocative displays engaged viewers to consider the museum as a site of art production. Warhol was one of the first in a late-20th-century trend of artists as curators and the use of the museum as a creative site and inspiration for artists that has proven to be a rich field of possibilities for artistic practice (McShine, 2002; Schnaffer, Winzen, Batchen, & Gassner, 1998; Weschler, 1996; Wilson & Corrin, 1994).

Both Peale and Warhol, although at opposite ends of the artistic spectrum, pointed to the immense creative and cultural potential of the museum. Their works, and those of other contemporary artists, offer examples of creative agency from which museums can draw inspiration to craft new practice. Being inspired by and affecting the role of artist does not suggest that what the museum produces is a work of art; rather, it proposes the museum should be fully engaged in "the *work* of art" (Dewey, 1934/1980, p. 162). In *Art as Experience*, Dewey noted the difference between *a* work of art and *the* work of art: "... the first is physical and potential; [the work of art] is active and experienced. It is what the product does, its working" (p. 162). Strong, creative, and effective interpretion programs are rooted in "the work" of art and embrace the interdisciplinary thinking, art practices, and narratives of "being an artist" in approaches to interpretation and display. A characteristic of different institutions experimenting with new ways of working is that they draw their inspiration from artists' practice.

New Models of Curatorial Synthesis

A museum engaged in a more open practice also opens up and shares the curatorial process so that an exhibition or project's development or synthesis happens with audiences. This is distinctly different from traditional curatorial practice where ideas are fully synthesized by an individual curator before public presentation. Opening up the curatorial process challenges internal and external perceptions of what art museums do and how they work: curating becomes a function and not necessarily an individual role; a museum's expertise manifests itself as a weaving together of different strands of knowledge, as opposed to being the holder of knowledge; and the traditional lines between education and curatorial are blurred as both are challenged to work in new ways (Gogan 2005).

In 2001-2002 AWM presented the *Without Sanctuary* project, a successful, multifaceted initiative to generate dialogue on race and related issues of bias and bigotry. Co-directed by education and curatorial departments and planned and presented with diverse community organizations and an advisory committee, the project featured daily public dialogues, interpretive displays, many audience feedback opportunities, artists' projects, and a wide range of programs, at the center of which was the exhibition *Without Sanctuary: Lynching Photography in America*. Featuring photographs and postcards that documented lynching in the United States, these images were laden with the emotional intensity of America's problematic past and present

regarding race. In line with the museum's mission as a forum for contemporary issues and Warhol's own practice of risk-taking and exploring popular media and visual culture in his work, the museum saw the exhibition as an opportunity to contribute to the dialogue on race relations in the city. The project responded to a number of contexts: a local climate fraught with racial problems, particularly following two racially motivated killing sprees, one against whites and the other against African Americans and minorities, and a corresponding communitywide openness to address these challenges; the museum's interest in testing its new mission; a desire among African-American leadership to encourage youth activism and their sense that "building white allies" was essential in the fight against racism (Gogan 2005). The project also opened 10 days after the September 11 terrorist attacks. The exhibition's difficult subject matter, seen in the museum with its equal emphasis on image, context, and response, seemed to provide a needed place of reflection at that time. The project marked an important moment in the museum's history. As Janet Sarbaugh, director of the Heinz Endowments' Arts & Culture Program, remarked, "*Without Sanctuary* shows they can take on controversial subjects with sensitivity and without pulling punches. This gives them permission to attempt even more as they continue to explore popular culture" (Davidson, 2002, p. 10). AWM has subsequently presented exhibition projects exploring themes related to the lynching images: Andy Warhol's *Electric Chairs: Reflecting on Capital Punishment in America* and more recently *Inconvenient Evidence: Iraqi Prison Photographs from Abu Ghraib*. While the museum had actively been working with communities in a variety of ways, the project's success encouraged the institution to consider working with community and civic issues in more comprehensive, museumwide manner. The AWM's ongoing practice of community engagement will be incorporated into plans to reinstall and reinterpret the museum's permanent collection and will be the focus of special projects.

In his essay *Conversation Pieces: Collaboration and Artistic Identity*, Kester (2000) reflected that an aesthetic of collaboration needs to "evoke instead a form of art practice defined by openness, listening, and inter-subjective vulnerability" (p. 2). This challenges art institutions to think differently about their expertise as they work with communities. As Janna Graham, manager of community programs at the Art Gallery of Ontario (AGO) in Toronto, Canada, noted, this kind of practice asks the question, "Is this going to be a project or a relationship, and how would you orient yourself differently in a project if you were committed to a relationship?" (personal communication, April 2005). In August, 2004, the AGO's *Tauqsaiijiit* (loosely translated as people who exchange), co-curated by education and curatorial departments, presented galleries transformed into sites of art production, new display formats, and meeting places: a makeshift TV studio atmosphere, lots of young people hanging out; performances, a storytelling circle reorienting the traditional display for sculpture to have them face inwards; contemporary artist-produced arctic soundscapes; and a traditional Inuit summer tent presenting inside a 13-piece video series recently acquired into the AGO's collection as early examples of contemporary Inuit video. The project was inspired by a number of intersecting contexts: the museum's experience with youth programs and interest in experimentation; a previous successful in-gallery artist residency with a First Nations performance art group working at the nexus of theater, performance art, and community-based practice; an interest in exploring new models of interpretation for the Inuit and First Nations art collections; the newly chartered Inuit territory of Canada, Nunavut, where 70% of the population is under the age of 20; and a desire among Inuit elders to create opportunities

for intergenerational and cross-regional understanding using public spaces. *Tauqsaiijiit* involved artists from the South and the North working with Inuit and First Nations youth in Ottawa, Iqualit, Mantoulin, and Toronto, all of whom worked as artists-in-residence at the AGO for 3 weeks during the summer. The strength of the relationships and the quality of the art experiences built through the project positioned the AGO to continue to build an appreciation internally and externally for this kind of participatory art practice as well as push its possibilities for learning and civic engagement further. Additionally, this process enabled an active consultation on the museum's current and potential Inuit and First Nations art collections. Director of Education Kelly McKinley commented that the project "enabled the institution to truly value non-Western perspectives that do not see objects separated from contexts and to realize that particularly with those collections, in order to make them living resources we have to work curatorially in a different way" (personal communication, April 2005).

The characteristic of this way of working, as Helen O'Donoghue (2003), senior curator for education and community, Irish Museum of Modern Art (IMMA), noted, involves a practice that engages not only in "the ideas inherent in a place but with those living in that place" (p. 80) and, as such, brings a new sense of responsibility to artmaking and curatorial work. In 1992, the museum presented the exhibition *Unspoken Truths*, an artist-initiated project that engaged 32 older women in an exploration of the meaning that Dublin, as a city that was rapidly changing, had in their lives. The project used the principles of art education and applied them in a community-development context, and the result manifested in a series of major events: a touring exhibition of 14 artworks, a major national conference, a video documentary, and a publication. The museum worked with two inner-city, community-development projects and engaged a number of artists, poets, and writers, coordinated by the artist Ailbhe Murphy, to create opportunities for the women to reflect on and analyze the patterns in their own lives. It was empowering for the women to see the validity in using their own lives as sources for artmaking, further emphasized when they mediated the exhibition of their work. Like other institutional examples, the project responded to varying contexts: the museum's interest in establishing new practice, artists' desire to explore new ways of working, community organizations looking for new models of engagement, and a supportive cultural and political climate. The exhibition was opened at an important juncture in Irish life by the recently elected and first-ever woman President of Ireland, Mary Robinson. It was a defining moment for the newly opened museum and critical to the foundation of its policy of access and engagement, resulting in an ongoing practice of curating exhibitions with artists and community groups. It also led to the museum incorporating within its acquisitions policy the stipulation that work created through the education and community programs will be considered for acquisition, and one such purchase has been made. Many community groups have since approached IMMA to request access, and the museum has played a leadership role in bringing an arts-based perspective to community-development work in Ireland. In addition, working with older audiences became a core practice. O'Donoghue observed "older people's contact and involvement with contemporary art and artists is keenly felt to be essential to the exploration of new forms of expression and personal creativity. It contributes to the ongoing process of dealing with change in society" (p. 77).

Societal change can also be richly explored through working with youth, and often they become catalysts for new ways of working, as suggested by the Art Gallery of Ontario's experience. Walker Art Center in Minneapolis initiated its leadership work with teens in the mid-1990s by seeing a natural synergy between the exploration and challenging of culture by

contemporary artists and the rebellion and identity-searching of teenagers. Teens got involved by participating on a teen committee coordinated by museum staff. Projects have ranged from an artist residency project with Glenn Ligon, where teens made art in response to works in the institution's permanent collection that were then displayed in the galleries, to the teens being invited to curate aspects of the recent exhibition *Hip Hop Generation* (personal communication, April 2005). Since 2002, AWM has presented the annual program *Youth Invasion*, planned by a teen committee with museum staff. The author and education staff with the teen committee developed a program where youth take over the museum with their "take" on Warhol, comprising youth artwork hung in the galleries; youth-curated exhibitions, performances and fashion show; and youth point-of-view labels on Warhol's work. Sarah Schultz, director of education and community programs at the Walker Art Center, and I have found that not only have our programs been enormously successful, they have also increased teen audiences in our museums, and, drawing on the spirit of teenage experimentation and sense of the provisional, have opened up our institutions to fresh approaches to art and new ways of working (personal communication, April 2005).

Many other institutions are finding that embracing an ongoing practice of working with teens can bring new perspectives to art interpretation. One such example is *Visual Dialogues*, a recent initiative of the Tate Britain in collaboration with five regional art galleries engaging artist-led teams to work with young people to develop new ways of interpreting contemporary works in the Tate's collection (*Visual Dialogues*, n.d.). Another example of teens bringing a different creative vision to a museum's collection is *Visões e (sub)versões: Cada olhar uma história (Each Look a Story)*, an exhibition presented by the Museu de Arte Contermporânea (MAC) in Niterói, Brazil. Whereas MAC staff now work extensively on creative projects with teens in local *favelas* (shantytowns), this project had the simple origins of an in-gallery activity handout. The museum, which opened in 1996, is situated across from Rio de Janeiro in a beautiful location overlooking Guanabara Bay and was designed by renowned Brazilian architect Oscar Niemeyer. The signature building and location drives tremendous visitation. Responding to the frustrations of limited resources and staff as well as an enormous number of visitors to the newly opened museum, Director Luiz Guilherme Vergara, then director of education, created an activity handout for young audiences inviting them to choose four works and to create a story that linked them. Another activity handout directed for adults invited audiences to reflect on the role of curator by "curating" four works in the collection. Large audiences gravitated to the more playful option of creating a story with the artworks, with teens often returning with friends to do the activity. The education staff and staff from other divisions read the stories, which led to the idea of exhibiting the works together with their stories. A total of four stories, each featuring four artworks, were exhibited in gallery displays that included the artworks, stories, and the photos and names of the writers. A catalogue was also published. The exhibition was well received by general and specialized audiences alike. Artists appreciated seeing their work in this context— some preferred it to traditional models. Curators remarked on the intuitive affinities and interesting connections the stories made between the artworks. Significantly, the exhibition showcased and truly valued a creative and personal response to art and established openness within the institution to a more participatory interpretive practice (Vergara, 2006).

All of these examples point to the benefits of risk-taking and experimenting with fresh approaches to interpretive practice and developing new audiences. Another important facet of these projects is that embracing new models of curating sets the stage for future projects and relationships where even richer and deeper explorations may be possible.

Modeling an Attitude: From Provocation to Service

Because the physical and social environment of the museum is a key factor in affecting visitors' experiences, an attitude of openness should be reflected and ritualized not only in exhibitions and programs, but also throughout the institution. For example, at AWM visitors often comment on the welcoming atmosphere, citing the gallery attendants, who do not wear uniforms and are mostly students, as being different from the usual security guards "spying on you" (Knutson, 2005, p. 11). IMMA similarly works with staff called mediators who respond to public questions. Education and curatorial staff meet with the mediators for discussion, for sharing information on exhibitions and programs as well as to hear feedback about public response. O'Donoghue emphasized her work with the mediators as an important example of "embedding practices of access within the institution" (personal communication, 2005). As new models test established institutional rituals, staff throughout the museum are urged to think differently.

Creating a welcoming environment does not mean refraining from challenging visitor perspectives; rather, it enables receptivity to new ideas. At the recently opened new building of Walker Art Center, one of the interpretive features of their Arcade (the interactive public spaces located between galleries) presented *Dolphin Oracle II*, a life-size, virtual dolphin with an artificial-intelligence capability designed by artists Piotr Szyhalski and Richard Shelton. Commissioned by the Walker's education and community program, the dolphin is a way for visitors to gain knowledge about art, but like an oracle, it does not give itself up too readily, playing with visitors' questions and never quite revealing answers, with the goal of modeling diverse responses to artworks. This approach is also featured as part of interpretive cards in the galleries. To engage viewers in an understanding of their role in the meaning-making process, the cards ask questions related to the many contexts that may influence artmaking and art viewing, such as "Does biography matter?" Although presented in a traditional interpretive format, the cards introduce a new tone to the standards of institutional labeling. Sarah Schultz, Walker's director of education and community programs, said, "It's one of the most radical things we've done" (personal communication, 2005). This kind of open-endedness and "thoughtful play" often are core elements in successful interpretive programs.

Another important aspect of the "open" museum is service. Arts and culture workers can mobilize connections and collaboration through creative action. As Schultz noted, commenting on the numerous examples of Walker staff involved in organizing citywide events, this knowledge and skill set are valued in the community and enable us to participate in "building social capital and may be one of the great untold stories of our work" (personal communication, April 2005).

Presenting Multiple Points of View

Another key practice for museums in creating a more open or dialogic relationship with audiences is presenting multiple points of view with diverse formats (Gogan, 2005). For example, during AWM's *Without Sanctuary* project, visitors could participate in one of the daily-facilitated discussion groups, write in a comment book, record their video comments, or complete a "postcard for tolerance." Visitors were invited to complete a self-addressed, personal resolution on a postcard they could pin to the wall as part of a collective display. At the end of the project, the museum sent all of the postcards to their authors. The goal was to encourage reflection and action on a personal level and to reinforce the learning experience by reminding visitors of their resolutions weeks or months after their museum visit. It also was a small way to offer a positive message to counteract the fact that some of the *Without Sanctuary* images had been sent as postcards through the U.S. mail. Even those visitors who may not have been drawn to comment could still engage with others by reading or listening to different points of view, thereby testing their perspectives. This kind of internal dialogue and responsive understanding (Romney, 2003) is made possible when the museum encourages an articulation of the viewing experience and shows the diverse nature of that experience.

Other examples of this practice at AWM are interpretive artwork labels featuring perspectives from diverse viewers (everyone from religious leaders to teens) and interactive artmaking displays presented in the museum's galleries, such as the project developed in conjunction with an exhibition of Warhol's *Time Capsules*. Inspired by Warhol's collecting of everyday objects, we invited visitors to engage in their own transformation of the everyday by photocopying the contents of their pockets or purses on 11 by 17-inch sheets of paper to add to an ongoing display. More than 1,000 of these personal collections were displayed, constituting a fascinating ethnographic sampling of the museum's visitors and contemporary culture (http://edu.warhol.org/pocketproject.html). In evaluation studies, many visitors— not only those who participated in the project—commented on how great it was to see the "collections" of other visitors (Knutson, 2005). The project was recently re-created at various venues with a traveling exhibition of Warhol's work in Russia. Similar in-gallery artmaking and display projects at MAC in Brazil featuring visitor collages and assemblages, inspired by an exhibition of the work of Kurt Schwitters, have been highly successful (Vergara, 2006).

These examples emphasize the importance of active engagement in interpretation and the museum's potential to be a place for exchange, for many points of view to be presented and expressed. These new forms of display and activity rupture traditional modes of presentation and enable the museum to serve as a performative space of personal memory and subjectivity by engaging viewers as they connect their experiences with the museum—its physical and sociocultural contexts and its systems of knowledge, artworks, and artifacts (Garoian, 2001).

On Being "Open" and Building Critical Dialogue

Being open means being willing to experiment and become more provisional in our approach to interpretation and display. It means mixing strategies—from a contextual and interactive interpretation to the traditional white-cube presentation—as well as presenting many points of view to signal openness to our audiences in ways they can recognize. In the process, we model the possibilities of different readings and ways of seeing. If we truly want to open ourselves to interpretation, we must put as much thought into creating an environment that is conducive to free exchange as we do into how exhibitions look. A comment book left on a pedestal at the end of an exhibition will be treated as such, an afterthought.

Fundamental to this evolving practice is the need for critical discourse, for museum staff to reflect and write about their work individually and in collaboration with colleagues, community partners, and peers in other institutions to share learning, build knowledge, and explore the potential of new and more open ways of working. Telling the stories of our work with "open" and critical narratives is essential to generating engaged dialogue in the field and vital to the articulation of new vision and practice for art museums in the 21st century.

REFERENCES

Carr, D. (1995, November). *What do you want to have happen?* Paper presented at the meeting of the American Association of Museums, Chicago, IL.

Davidson, J. (2002). Without sanctuary. *H: The Magazine of The Heinz Endowments 2*(1), 2-16.

Dewey, J. (1934/1980). *Art as experience.* New York: Perigee.

Duncan, C. (1995). *Civilizing rituals: Inside public art museums.* London and New York: Routledge.

Eco, U. (1989). *The open work* (A. Cancogni, Trans.). Cambridge, MA: Harvard University.

Falk, J. H., & Dierking, L. D. (2000). *Learning from museums: Visitors experiences and the making of meaning.* Lanham, MD: AltaMira Press.

Garoian, C. R. (2001). Performing the museum. *Studies in Art Education, 42*(3), 234-248.

Gogan, J. (2005). *The Warhol: Museum as artist: Creative, dialogic & civic practice.* Retrieved November 24, 2006, from http://www.artsusa.org/animatingdemocracy/pdf/labs/andy_warhol_museum_case_study.pdf

Hein, G. E. (1998). *Learning in the museum.* London and New York: Routledge.

Kester, Grant. (2000). Conversation pieces: Collaboration and artistic identity. *Unlimited partnerships: Collaborations in contemporary art.* CEPA Gallery, Buffalo, New York. Retrieved February 2, 2006, from http://digitalarts.ucsd.edu/~gkester/GK_Website/Research/Partnerships.htm

Knutson, K. (2005). *Visitor experience evaluation report of The Andy Warhol Museum & the exhibition Andy Warhol's Time Capsules.* Pittsburgh, PA: UPCLOSE.

McShine, K. (2002). *The museum as muse: Artists reflect.* New York: Museum of Modern Art.

O'Donoghue, H. (2003). Come to the edge: Artists and learning at the Irish Museum of Modern Art (IMMA): A philosophy of access and engagement. In M. Zanthoudaki, L. Tickle, & V. Sekules (Eds.), *Researching visual arts education in museums and galleries: An international reader* (pp. 77-90). Dordrecht, The Netherlands: Kluwer Academic.

Romney, P. (2003). *The art of dialogue.* Retrieved November 24, 2006, from http://www.artsusa.org/animatingdemocracy/reading_room/reading_010.asp

Schjeldahl, P. (2003, January 13). Art houses. *The New Yorker*, 87-89.

Schnaffer, I., Winzen, M., Batchen, G., & Gassner, H. (Eds.). (1998). *Deep storage: Collecting, storing, and archiving in art.* Berlin/New York: Prestel.

Vergara, L. G. (2006). *In search of mission and identity for Brazilian art museums in the 21st century: Case study Museu de Arte Contemporânea de Niterói.* (Doctoral Dissertation, New York University).

Visual Dialogues. London: Tate Britain. (n.d.) Retrieved December 25, 2006, at http://www.tate.org.uk/national/visualdialogues/london.htm

Warhol, A. (1969). *Raid the icebox 1 with Andy Warhol.* Houston, TX: Houston Institute for the Arts/Rice University.

Warhol, A. (1985). *America.* New York: Harper Trade.

Weschler, L. (1996). *Mr. Wilson's cabinet of wonder: Pronged ants, horned humans, mice on toast & other marvels of Jurassic technology.* New York: Vintage.

Wilson, F., & Corrin, L. G. (1994). *Mining the museum: An installation.* New York: New Press.

Art Museums and Visual Culture: Pedagogical Theories and Practices as Process

Elizabeth B. Reese
Texas A&M University–Corpus Christi

"In short, seeing is not believing, but interpreting." (Mirzoeff, 1999, p. 13)

By the 1990s, traditional art museum pedagogical practices stemming from the late-19th century no longer fulfilled contemporary needs and expectations for educationally significant art museum experiences. Practices deemed problematic included authoritative perspectives, limited interpretations, and the inclusion of minimal contextual information (Corrin, 1994; Garoian, 2001; Hooper-Greenhill, 2000; Reese, 2001; Roberts, 1997). New pedagogical theories challenged absolute truths as declared by authoritative perspectives, brought in many perspectives from diverse voices, and called for an active dialogue including reflective critical examination and reflexivity. Critical and reflexive inquiry into exhibition narratives would include, for example, discussions and debates that analyze what is being said, what is not being said, how it is presented or not presented, what biases are presented or not presented, what voices are included and excluded, and other similar questions. Perhaps the most discussed of the pedagogical possibilities of the last decade are the theories and practices associated with visual culture.

Art Museum Exhibition Pedagogical Practices and Visual Culture: Current Explorations

While dialogues about visual culture continue to shape the field of art education, art museum educators maintain a relatively low profile. Why is this so? What *is* "visual culture"? Is it relevant to the museum field? If so, how might the study and practice of visual culture inform the work of museum educators and the experiences of their users? Does a shift toward visual culture enable more meaningful relationships among museum professionals, visitors, and the art and objects that surround them? If so, how? What are the benefits and challenges? In this chapter, I explore, examine, and critique the possibilities of using visual culture to inform art museum pedagogical practices.

What Is Visual Culture?

There are numerous writings about and definitions of visual culture (Duncum, 2004; Freedman, 2003; Garoian & Gaudelius, 2004; Hooper-Greenhill, 2000; Mirzoeff, 1999; Sturken & Cartwright, 2001; Tavin, 2003, 2005; Wilson, 2003). This suggests that, like most theories, visual culture has many strands and applications. Rather than cover the spectrum of definitions, I will investigate how ideas associated with visual culture make sense in terms of creating meaningful, yet critically aware, experiences within art museum exhibitions and related programs.

How Is Visual Culture Relevant to the Museum Profession?

For several years it seemed that art museum educators were not engaging in conversations about visual culture. While some educators may have been disinterested in theory or doubted its difference from other theories such as postmodernism, others were uncertain whether fine arts "fit in." According to many theorists, including Sturken and Cartwright

(2001), the study of visual culture does indeed include *all* forms of visual images, from traditional fine art including paintings, sculptures and photography to advertising, gaming, television, cinema, and so on. Additionally, Tavin (2003) identified a key thread of visual culture literature as addressing "an inclusive register of images, artifacts, objects, instruments, and apparatuses" (p. 202). This concept of an "inclusive register of images" that comprises images typically experienced in art museums is especially important to museum professionals. In addition to claiming the site of the museum as necessary for the study of the content of visual culture, museums also provide unique opportunities to examine the form of visual culture.

In *Education and Power*, Apple (1995) suggested that the content and form of an educational system must be vigorously interrogated to better understand its underpinnings. He described content as the information and knowledge that is presented both overtly and covertly. Form includes the manner in which the content is synthesized and organized. Although Apple did not explicitly refer to art museum exhibitions in his discussions about content and form, his analyses regarding the presentation of information and knowledge may

be applied to exhibitions. His theories provide a framework that requires inquiry into what is presented on the surface, such as the exhibition elements themselves, and demands interrogation into how the presentation is organized "behind the scenes." In recent years, the content and form of art museum exhibitions and related programming have been critiqued for their authoritative presentations, the lack of contextual information and varied perspectives, and minimal critical examination, reflection, and self-reflexive dialogue (Garoian, 2001; Hooper-Greenhill, 1992, 2000; Kamien, 1992; Mayer, 1998; McLean, 1999; Newsom & Silver, 1978; Reese, 2001, 2003a; Roberts, 1997; Wallach, 1998).

In one of the first texts that directly addressed the convergence of visual culture and museums, Hooper-Greenhill (2000) defined *visual culture* as an area of inquiry that investigates seeing in relation to learning and knowing. She stated, "Visual culture works towards a social theory of visuality, focusing on questions of what is made visible, who sees what, how seeing, knowing, and power are interrelated" (p. 14). Hooper-Greenhill's definition of visual culture addresses the challenges that museum professionals have faced with the traditional content and form of art museum programs. Theories and practices associated with visual culture, however, may

enable museum professionals to reconfigure traditional practices in favor of processes that prioritize the experiences between the visitor and the object.

Underscoring this concept, Hooper-Greenhill (2000) wrote:

The idea of varying interpretations constructed by different gazes has not been seriously accepted until fairly recently. Visual culture theory, however, enables a focus on the relationship between the seen and seer, with a prioritisation of the seer. It problematises the acts of looking, and disturbs the conventional notion of the transparency of the visible. It insists that vision is socially constructed and thereby provides some theoretical tools and analytical methods that may be used for the analysis of vision and visuality in the museum. (p. 15)

Although for years museum educators have made a priority of visitors and their experiences (Falk & Dierking, 1992; Hein, 1998; Hooper-Greenhill, 1992; Reese, 2001, 2003a), many of the pedagogical practices have not overtly explored, examined, and critiqued the ways that exhibitions and programs are made visible, nor have they explicitly educated visitors about the social construction of seeing inside the institution. This is perhaps the most significant possibility for museum professionals embracing the study of visual culture: teaching viewers how to critically view the objects and images inside the museum setting in order to apply these

critical skills outside of the museum as well. Mirzoeff (1999) claimed that visual culture encourages individuals to see everyday experiences with awareness and criticality rather than focus on structured settings like the gallery space. But because of their focus on creating meaningful experiences for viewers, art museums are well suited to teach people how to critically examine everything they see in their cultures every day.

Like experiences in museums, individuals' everyday experiences constantly evolve. Underscoring this concept, Sturken & Cartwright (2001) stated that "culture is the production and exchange of meanings, the giving and taking of meaning, between members of a society or group" (p. 4). They also contended that just as interpretation is a dynamic process, so is culture: neither is fixed in time or space. Similarly, the ideal relationships among museum professionals, objects, artists, and visitors within the cultural institution of the art museum are not static, but rather are based on the process of continuously producing and exchanging meaning.

Informing the Work of Museum Professionals: Art Museum Pedagogical Practices as Process

In *Teaching Visual Culture: Curriculum, Aesthetics, and the Social Life of Art*, Freedman (2003) stated that "curriculum reflects people's hopes and dreams. It represents expectations, mediates cultural knowledge, and is intended to communicate our best thinking to our fellow human beings" (p. 106). The work of museum professionals—our pedagogical practices—embraces these notions related to curriculum, including the simple fact that one of the main roles of museum educators is to teach (Vallance, 2004). Freedman (2003) also invited educators to reconceive curriculum as a process: "conceptualized as a process, curriculum can refer to the ways in which students learn outside, as well as inside of classrooms or institutions, and the intended part of the curriculum process may change as the curriculum is enacted" (p. 108). If museum professionals and their objects and visitors are truly engaged in relationships that embody the continuous exchange of meanings, it follows that exhibitions and related programs could continuously change and evolve as they are enacted (Irwin, Beer, Springgay, Grauer, Xiong, & Bickel, 2006).

Freedman (2003) outlined five conditions of curriculum considered as a process. She stated that curriculum can be (1) a form of representation, (2) like a collage, (3) a creative production, (4) made of likely stories, and (5) made transparent. In the following paragraphs I will discuss an art museum project that was designed, implemented, and evaluated based on the possibilities of museum programs functioning as a process.

Texas Mystique: Art Stories, Our Stories

In summer 2002, I began the role of project manager for an exhibition cycle at the Art Museum of South Texas in Corpus Christi. I was hired to help transform into a cohesive narrative a slate of exhibitions primarily featuring artworks by Texas women. The exhibitions included an array of media, techniques, and stories. I saw this as a perfect opportunity to employ theories and practices associated with visual culture, including investigating and examining what is visible and by whom, power structures, contexts, and interpretations. Moreover, I was curious whether an exhibition and its related programs could function more like a dynamic process rather than a static presentation.

Art museum pedagogy is a form of representation.

Curriculum is a form of representation. It embodies, in ephemeral and concrete ways, the hopes and dreams of people as well as what they know. As such, it is not only a matter of knowledge per se, but of the shape of knowledge formed in relation to values, beliefs, and social structures. (Freedman, 2003, p. 109)

The first step on this adventure was to challenge typical exhibition-planning power structures by creating possibilities for collaborations and multiple perspectives from museum professionals and community members. Because the slate of exhibitions represented various images, values, beliefs, and social structures, we wanted the planning team to represent this composition as well. Thus, the team consisted of myself, the museum's curator, the educator, and a local journalist who was invited to write the catalogue for one of the exhibitions.

Additional members of the staff were eventually brought in as team members, including the preparator, security guards, communications specialist, technology specialist, outreach educator, and others. Moreover, the team created numerous opportunities for visitors' voices to be represented within the exhibition narratives. When the project was nearing its end, individuals involved were asked to evaluate the process and project.

While there were many benefits of working as a team and bringing together our varied personal, cultural, and social backgrounds, team evaluations revealed that members found the process time-consuming. Indeed, it seemed as if there was a meeting for almost every decision! Although this method of exhibition planning, implementation, and evaluation required more time than one individual making all of the decisions, most team members thought that the sum of everyone's efforts outweighed the challenges (Reese, 2003b).

Art museum pedagogy is like a collage.

[Curricula] are made of multiple contributions, from various sources, with competing interests. They involve a cut-and-paste construction of the ideas of individuals and groups. The ideas are selected and brought together, with care and a sense of unease, to form a whole. (Freedman, 2003, p. 110)

Because museum visitors have diverse needs and learning styles (Berry & Mayer 1989; Falk & Dierking, 1992; Hein, 1998; Newsom & Silver, 1978), the team made great effort to offer visitors numerous opportunities to engage with the artists, media, narratives, team members, and other visitors. We sought to offer a collage of ways for viewers to engage with the various exhibitions, both singularly and as a whole, as well as with one another. To that end, there were numerous areas within the museum for visitors to explore, examine, and critique the content and form of *Texas Mystique.*

In the Dorothy Hood exhibition of large abstract paintings and collages, we provided an interactive computer presentation showing the process of picking up the large paintings and collages and moving them from Houston to south Texas; a re-creation of the artist's studio;[1] a collage-making activity; and a book for the visitors to contribute comments, suggestions, or questions. In the Wambaugh exhibition of ballet dancers backstage, visitors could relax on a padded bench and view a video of *Sleeping Beauty,* one of the ballets featured in her photographs. Marilyn Lanfear's exhibition of installation and mixed media, including quilts, provided a unique opportunity to create a community quilt, with contributions made by exhibition visitors and by youth offsite in their schools. Additionally, visitors were offered an online exhibition with a computer station in the museum and comfortable reading areas with books, journals, and magazines.

Perhaps the greatest challenge of *Texas Mystique* was the sheer number of interactive possibilities: there was so much to maintain for a relatively small staff. Yet some of the greatest successes were the visitors' frequent engagement with the activities and their appreciation of our efforts to make the exhibition more dynamic.

Art museum pedagogy is a creative production.

Curriculum is a creative production. It is sketched, formed, and enacted and it continually changes as it is implemented, criticized, and revised. … it is influenced by the constraints of its institutional medium, the talents of its actors, and at any given moment, the vision of its subject. (Freedman, 2003, p. 110)

The component of *Texas Mystique* that best reflected the possibility that museum pedagogy is a creative production was the community quilt-making experience for Marilyn Lanfear's highly autobiographical exhibition. The team encouraged viewers to explore, connect, examine, and contribute their own histories so that through the process they could learn not only about art and an artist, but also about one another (Garoian, 2001; Reese, 2003a). In this manner, art exhibitions can be seen as a catalyst for creating connections among ideas, objects, and individuals.

The idea of a community quilt arose during installation of the Lanfear exhibition. As I watched the preparator and Lanfear unpack her works, I envisioned a quilt of narratives by community members. Through discussion with the team, and with enthusiasm

from the artist, we developed the concept of using paper squares, pencils, and pipe cleaners to enable visitors to share a personal story and then physically connect their quilt square to the collaborative work. Though we cringed a bit over the idea of pipe cleaners, we discussed the need for the visitors to actually perform the task of contributing to the exhibition, thus literally becoming a part of it (Garoian, 2001; Reese, 2003a). As the quilt outgrew its designated area within the exhibition, a section was removed and reinstalled in a hallway near a museum entrance. Then we invited a local newspaper reporter to join our team and write a "narrative about the narratives." The published article included images of the paper quilt, thus creating another visual context for the *Texas Mystique* project. Finally, during one of the team meetings, the outreach educator suggested that she could make paper quilts with students during her visits and then hang them in the museum's art studio. This also became a meaningful exhibition: not only could visitors to the art museum view the youth's collaborative quilts, the students who made the quilts could also visit the art museum to experience their own creative products as part of the greater project.

The benefits of this component were many. Including visual narratives of recognized artists, such as Lanfear, with museum audiences provided viewers the opportunity to become a crucial part of the exhibition, challenging typical museum practices. This suggests the possibilities of including visual culture within the museum context.

Art museum pedagogy is formed of likely stories.

Curriculum could be seen as a collage-like combination of information— like other aspects of life—which is necessarily ambiguous and suggestive of multiple meanings. It is a vital part of lived experience. (Freedman, 2003, p. 110-111)

In addition to the community quilt component and various team members contributing their personal and professional knowledge and stories to the planning, implementation, and evaluation of *Texas Mystique*, information and ideas were included in the exhibition from the art and artists, as well as other museum professionals and viewers of different ages. Most of these contributions were presented in the form of wall labels with the author's name listed on each. Including the name of the writer signifies that while the perspective of the museum professional is important, the contributions of others, both literal and conceptual, also are meaningful (Garoian, 2001; Hooper-Greenhill, 1992, 2000; Reese, 2001, 2003a; Roberts, 1997; Vallance, 2004). By encouraging the continuous contribution of interpretations, comments, and questions, *Texas Mystique* became a dynamic narrative or work-in-progress in and of itself.

These practices of making multiple interpretations visible have become more popular in recent years (Corrin, 1994; Davitt, 2005; McLaughlin, 2005; Reese, 2001, 2003a). This acceptance may occur not only because of the ease, availability, and low cost of creating labels featuring different voices, but also because museum professionals can learn what visitors think about in the exhibition. Additionally, the practice may create an informal dialogue among visitors as they read the interpretation of others. Indeed, for the visitors, written conversations may promote a better understanding not only of the exhibition, but also of one another. Perhaps the most interesting challenge of offering multiple interpretations is creating unique ways to present the information in addition to the typical wall labels.

Art museum pedagogy can be made transparent.

To make curriculum transparent is a matter of revealing … the ways in which curriculum is constituted through the actions of conducting research, reporting, 'reading,' and otherwise interpreting, planning and writing, and enacting, including the ways in which individual teachers come to understand curriculum structures and content and present these in class. (Freedman, 2003, p. 111)

There were several essential ways the team made public the planning, implementation, and evaluation of *Texas Mystique*. First, in the museum's newsletter, we published articles about the exhibitions

and planning process before the opening. In this way, we attempted to make visible the content and form of the project. Second, in at least one of these articles and in the introductory wall text we included information about the history of the representation of women in art history and art museum exhibitions. Here we sought to reveal the history of power structures that typically silence women's perspectives and why we found it necessary to create a series of exhibitions that featured female artists.

Third, several related public programs, called Dynamic Dialogues, brought together artists, team members, and other museum staff members to discuss works of art, the exhibition project, and exhibition processes in general. The purpose of these conversations was twofold. First, the team hoped to reveal and problematize the museum as a socially constructed site for sight. Next, we tried to communicate how the systems of power within museums also exist outside its walls and that we can benefit from being critically aware of how information and knowledge are presented to us.

Concluding Comments

The work accomplished through *Texas Mystique* demonstrates the potential for embracing and enacting theories of visual culture. Through this project, a group of professionals and community members worked to make the museum experience a dynamic process rather than a static encounter. By exploring and examining *Texas Mystique* through the conditions of curriculum outlined by Freedman (2003), we learned that museum exhibitions and related programs can be designed, implemented, and evaluated as a process. While there were many challenges along the way, the fact that the team agreed that nothing was absolute or final offered us freedom to explore new possibilities, to be satisfied or seek revision, and ultimately, to learn from the process, one another, the art, and the museum's visitors.

REFERENCES

Apple, M. W. (1995). *Education and power* (2nd ed.). New York: Routledge.

Berry, N., & Mayer, S. (Eds.). (1989). *Museum education: History, theory, practice.* Reston, VA: National Art Education Association.

Corrin, L. G. (1994). An installation by Fred Wilson. In L. G. Corrin (Ed.), *Mining the museum: Artists look at museums, museums look at themselves* (pp. 1-22). New York: The New Press.

Davitt, G. (2005, March). *Art museum education and visual culture: Histories, realities, and possibilities.* Panel discussion presented at the 44th annual convention of the National Art Education Association, Boston, MA.

Duncum, P. (2004). Visual culture isn't just visual: Multiliteracy, multimodality, and meaning. *Studies in Art Education, 45*(3), 252-264.

Falk, J., & Dierking, L. (1992). *The museum experience.* Washington, DC: Whalesback Books.

Freedman, K. (2003). *Teaching visual culture: Curriculum, aesthetics, and the social life of art.* New York: Teachers College.

Garoian, C. R. (2001). Performing the museum. *Studies in Art Education, 42*(3), 234-248.

Garoian, C., & Gaudelius, Y. (2004). The spectacle of visual culture. *Studies in Art Education, 45*(4), 298-312.

Hein, G. E. (1998). *Learning in the museum.* London: Routledge.

Hooper-Greenhill, E. (1992). *Museums and the shaping of knowledge.* Leichester, UK: University of Leicester.

Hooper-Greenhill, E. (2000). *Museums and the interpretation of visual culture.* London: Routledge.

Irwin, R., Beer, R., Springgay, S., Grauer, K., Xiong, G., & Bickel, B. (2006). The rhizomatic relations of A/r/tography. *Studies in Art Education, 48*(1), 70-88.

Kamien, J. (1992). From the guest editor. *Journal of Museum Education, 17*(3), 3.

Mayer, M. (1998). Can philosophical change take hold in the American art museum? *Art Education, 51*(2), 15-19.

McLaughlin, P. (2005, March). *Art museum education and visual culture: Histories, realities, and possibilities.* Paper presented at the 44th annual convention of the National Art Education Association, Boston, MA.

McLean, K. (1999). Museum exhibitions and the dynamics of dialogue. *Daedulus: America's Museums, 128*(3), 83-108.

Mirzoeff, N. (1999). *An Introduction to Visual Culture.* London: Routledge.

Newsom, B., & Silver, A. (Eds.) (1978). *The art museum as educator.* Los Angeles: University of California.

Reese, E.B. (2001). From static to dynamic interpretations: Transforming art museum exhibitions through intertextual narrative pedagogical practices. Unpublished doctoral dissertation, The Pennsylvania State University.

Reese, E.B. (2003a). Art takes me there: Engaging the narratives of community members through interpretive exhibition processes and programs. *Art Education, 56*(1), 33-39.

Reese, E.B. (2003b). *Texas (Ms.) mystique: Art stories, our stories: Final summary and evaluation.* Unpublished report, South Texas Institute for the Arts, Corpus Christi.

Roberts, L. (1997). *From knowledge to narrative: Educators and the changing museum.* Washington, DC: Smithsonian.

Sturken, M., & Cartwright, L. (2001). *Practices of looking: An introduction to visual culture.* Oxford, UK: Oxford University.

Tavin, K. (2003). Wrestling with angels, searching for ghosts: Toward a critical pedagogy of visual culture. *Studies in Art Education, 44*(3), 197-213.

Tavin, K. (2005). Hantological shifts: Fear and loathing of popular (visual) culture. *Studies in Art Education, 46*(2), 101-117.

Vallance, E. (2004). Museum education as curriculum: Four models, leading to a fifth. *Studies in Art Education, 45*(4), 343-358.

Wallach, A. (1998). *Exhibiting contradiction: Essays on the art museum in the United States.* Amherst, MA: University of Massachusetts.

Wilson, B. (2003). Of diagrams and rhizomes: Visual culture, contemporary art, and the impossibility of mapping the content of art education. *Studies in Art Education, 44*(3), 214-229.

FOOTNOTES

[1] After a presentation of this exhibition project at the Visual Culture Retreat at Pennsylvania State University in November 2004, several colleagues expressed concern regarding this component and whether we were creating one of those bizarre anthropological displays of the "other." Clearly that was not our intent. Rather, we sought to reveal to visitors the kind of space and organization Hood created for herself so that she could create her art—to demystify the location of where her works were created.

AFTERWORD

Pat Villeneuve
Florida State University

What does it take to incorporate the changes in gallery and education practices that the authors describe here? I contend that two important requirements are a knowledge base and adequate political power within the museum structure. I hope this book and its many references and resources offer opportunities to build knowledge. Two books that can give art museum educators a set of skills to advance their agendas to best advantage are:

Bolman, L. G., & Deal, T. E. (2003). *Reframing organizations: Artistry, choice, and leadership.* San Francisco: Jossey-Bass.

Meyerson, D. E. (2003). *Tempered radicals: How everyday leaders inspire change at work.* Boston: Harvard Business School.

ABOUT THE EDITOR

Pat Villeneuve has been a member of the National Art Education Association Museum Education Division since 1985. She is associate professor of arts administration and art museum education and coordinator of graduate studies in the Department of Art Education at Florida State University. Previously, she held a dual appointment at the University of Kansas where she was curator of education at the Spencer Museum of Art and associate professor of visual art education and art museum education. Pat has published, presented, and consulted extensively in art education and art museum education. In 2001 she completed her tenure as editor of the NAEA *Art Education* journal. Pat organized *Gallery Praxis*, an art museum education conference and NAEA Co-Sponsored Academy held at the John and Mable Ringling Museum of Art in 2007. With Mary Erickson, professor in the School of Art, Arizona State University, Pat was the recipient of a National Art Education Foundation research grant, and she was named Kansas Outstanding Art Museum Educator of the Year in 1993.

ABOUT THE CONTRIBUTORS

Dr. Marianna Adams, President, Audience Focus Inc, specializes in assessing the effectiveness of community partnerships, museum/school collaborations and learning in interactive/participatory exhibitions. Her research/evaluation work, combined with past experience as an art museum educator and public/private K-12 art and language arts teacher, has recently led her to draw on theory, practice, and research to develop content for interactive art museum exhibitions.

Catherine Arias develops and manages education programs for teens and families at The Museum of Contemporary Art, Los Angeles, where she has served as a staff member since 1999. Her responsibilities include supervising program staff, working with guest artists and community representatives, mentoring youth, and working with an interdepartmental customer-service committee. Arias holds a B.A. in American Studies from Pomona College and presents regularly at national and regional museum education and professional development events.

Melanie L. Buffington is Assistant Professor of Art Education at Virginia Commonwealth University. Her research interests include museum education, technology in art/museum education, Web 2.0, critical pedagogy, preservice teacher preparation, and contemporary art. She earned her B.S. from Penn State University and her M.A. and Ph.D. from The Ohio State University.

Margaret Burchenal has been the Curator of Education and Public Programs at the Isabella Stewart Gardner Museum since 2000. She has previously held leadership positions at the Museum of Fine Arts in Boston, the Portland Museum of Art, and the Philadelphia Museum of Art. She and her Gardner colleagues have recently completed a 3-year research project called *Thinking Through Art* that demonstrated how learning to look at art helps urban elementary students develop critical thinking skills.

Rika Burnham is Associate Museum Educator at The Metropolitan Museum of Art, Lecturer at Teachers College Columbia University, and Visiting Museum Educator for the Summer Teacher Institute of Contemporary Art (TICA) and the Teaching Institute for Museum Educators (TIME) at the School of the Art Institute of Chicago. She was a guest scholar at the Getty Museum and Research Institute in 2002 and with Elliott Kai-Kee is coauthor of "The Art of Teaching in the Museum" and "Museum Education and the Project of Interpretation in the Twenty-first Century."

David Carr teaches librarianship in Chapel Hill, North Carolina, specializing in reading and reference work. Recognized as a master teacher, he lectures and writes on learning and thinking in libraries and museums and the passion for reading in adult life. He has published two essay collections, *The Promise of Cultural Institutions* (2003) and *A Place Not a Place* (2006). He is now working on *When Communities Read*, a study of public reading projects, and further essays on cultural institutions.

Yi-Chien Chen Cooper, independent scholar and artist, received her Ph.D. in Art Education, with a Certificate in Museum Studies, from Florida State University. She was an Assistant Professor at Grand Valley State University (GVSU), where she got the art teacher preparation program certified. As a guest curator at Taiwan's Kaohsiung History Museum, she displayed museum objects in an audience-centered approach using interactive elements. She has presented nationally and internationally and has received numerous awards, including Pew Technology Enhancement Award at GVSU.

David Ebitz is Associate Professor of Art Education at The Pennsylvania State University. He was formerly Head of Education at the J. Paul Getty Museum and Director of the John and Mable Ringling Museum of Art and of the Museum of Art of the University of Maine. His current research is on the theory and practice of museum education and educational uses of technology. He has a Ph.D. in art history from Harvard University in medieval art.

Karen Gerety Folk is the Curator of Education at the Nerman Museum of Contemporary Art, Johnson County Community College. Prior to the opening of the museum in 2007, she established a tour program and developed the educational mission. She studied at the University of Kansas (M.A., Art Museum Education, 2005; M.A., Art History, 2005; BFA, Art History, 2001). Her previous positions include Educational Outreach Coordinator in charge of children's and family programs at the Spencer Museum of Art.

Jessica Gogan is Curator of Special Projects at The Andy Warhol Museum, where as Assistant Director for Education & Interpretation from 1997–2007 she directed the education department. Previously she was Education Officer of Contemporary Interpretation at the Art Gallery of Ontario, Toronto, Canada. Gogan has a bachelor's degree in French and Philosophy from Trinity College Dublin, Ireland, and a master's in Philosophy in Textual and Visual Studies, also from Trinity and Université de Paris 7, France.

Amy K. Gorman is currently Curator of Education at the Muscarelle Museum of Art at The College of William and Mary. Her graduate studies at Florida State University have included arts administration, museum education, program evaluation, and studio arts. Current projects include ArtCreates.org, an online forum to promote the use of art for education, advocacy, and awareness.

Denise A. Gray is Senior Education Program Manager at the Museum of Contemporary Art, Los Angeles, where she has served on staff since 1997. She holds an M.S.Ed from Bank Street College and a B.A. in Art History from Smith College and serves on the Executive Board for the Committee on Education for the American Association of Museums. Gray presents nationally and regionally on the topics of educator training, community partnerships, and teen museum programs and has written for *Museum News* and the *Journal of Museum Education.*

Carole Henry is Associate Professor and Chair of Art Education, Lamar Dodd School of Art, The University of Georgia. She chaired the NAEA *Standards for Art Teacher Preparation* (1999) and is currently chairing the revision of this document. She has long been interested in the field of museum education and has published research investigating various aspects of museum experience in *Studies in Art Education, Art Education, The Journal of Aesthetic Education,* and *Visual Arts Research.* In 2005, she was named a Meigs Distinguished Teaching Professor at UGA and selected as a Distinguished Fellow by NAEA. She is currently working on an introductory text on the museum experience designed for beginning art and museum education students.

Giulia Gelmini Hornsby is a Research Assistant and a Ph.D. candidate in the Learning Sciences Research Institute at the Nottingham University (UK). Her background is in communications and cultural studies. For her M.A. dissertation on the educational potential of new media in museums, she carried out a case study on the ZOOM children's museum in Vienna. In 2003, she obtained a Marie Curie scholarship to study in the UK, where she is now carrying out her work on the pedagogical potentials of technology in a number of settings including formal and informal learning environments.

For over 25 years **Dr. Abigail Housen** has been an independent researcher and consultant to museums and schools in aesthetic development and education. Together with Philip Yenawine, Housen is Co-Founder of Visual Understanding in Education and co-author of Visual Thinking Strategies (VTS), a multi-year art viewing curriculum and professional development program. From 1979 to 1994, Housen was on the faculty at Massachusetts College of Art as Professor of Art Education and Director of the Graduate Program in Art Education.

Elliott Kai-Kee is an Education Specialist at the J. Paul Getty Museum. He has a Ph.D. in European history and taught history before becoming a museum educator. He has held various positions in the Education Department at the Getty, in school and teacher programs, college and graduate intern programs, and currently supervises the gallery teacher staff in the department. He is working on a history of gallery teaching in U.S. art museums.

Dana Carlisle Kletchka is the Curator of Education at the Palmer Museum of Art and an Affiliate Instructor of art education at Penn State University. In addition to publishing articles and presenting at national and state conferences, she has served on the editorial board of *Art Education* and was the Museum Education Division Director for the Pennsylvania Art Education Association. She is currently conducting research for her dissertation.

Randi Korn is Founding Director of Randi Korn & Associates, Inc. (RK&A), a company dedicated to using visitor studies to guide museums to improve their practice and achieve their missions. RK&A's client list includes the Guggenheim Museum, Dallas Museum of Art, and San Francisco Museum of Modern Art, among others. Her most recent article, "The Case for Holistic Intentionality," underscores the need for museums to evaluate the ways in which they are achieving their missions and demonstrating the value of museums in people's lives.

Gillian Kydd is Co-Founder of the Open Minds/Campus Calgary Program in Calgary, Canada. This concept, which allows teachers to move their classrooms to the rich worlds of community sites such as museums, galleries, and zoos for a week, has spread to other cities in Canada, the United States, and Singapore. She has a doctorate from the University of Calgary in Curriculum Studies, and her focus in teaching has always been the importance of giving children interesting authentic experience and connecting that to language.

Richard Lachapelle is Associate Professor of Art Education at Concordia University (Montreal, Canada) where he has just completed a three-year mandate as Chair of the Department of Art Education. He is also the editor of the *Canadian Review of Art Education*. He was formerly a professional educator at the National Gallery of Canada and a studio instructor at the Ottawa School of Art. His research interests include museum and aesthetic education. He holds a Ph.D. in Art Education from Concordia University.

Sara Lasser has been the Manager of School and Docent Programs at the American Folk Art Museum since 2006 after implementing museum/school programs at the Isabella Stewart Gardner Museum and the Worcester Art Museum.

With a Ph.D. from the University of British Columbia, **Wan-Chen Liu** has over a decade of experience in museum education. Liu has received research fellowships and grants from different academic institutions, including the J. Paul Getty Trust, and has conducted research in the United States and the UK as a visiting scholar. She has an extensive publications and presentations record and has published two books in Chinese, *Thoughts and Practices in Art Museum Education* (2002) and *Museums as Theatre* (2007).

Susan Longhenry is the Alfond Director of Museum Learning and Public Programs at the Museum of Fine Arts, Boston. She holds an M.A. from the School of the Art Institute of Chicago and a B.A. from Indiana University. Her awards include NAEA's Western Region Museum Art Educator Award. Longhenry has served on the Executive Board of the American Association of Museums' Education Committee and on its National Program Committee. She has published articles in *School Arts Magazine* and *Museum Practice*.

Ann Rowson Love is a doctoral student in art education at Florida State University. Prior to her studies, she was Curator of Education and Adjunct Faculty at the Ogden Museum of Southern Art–University of New Orleans. She has been a museum educator for 15 years in both large and small museums in the Midwest and Southeast. In addition to presenting at national conferences, she was a member of the editorial board of *Art Education*. In 2006, she received the Marylou and Ernestine Kuhn Scholarship for Women Art Education Students.

Jessica Luke is a Senior Researcher at the Institute for Learning Innovation, a non-profit educational research and development organization based in Annapolis, Maryland. Her research and evaluation work focuses on youth development, family learning, and community engagement in and from museums.

As an art museum educator, Melinda M. Mayer has held positions in both art museums and universities. Her doctorate in art education is from The Pennsylvania State University, and she is currently on the art education faculty of The University of Texas at Austin. Articles she authored have appeared in *Studies in Art Education*, *Art Education*, and *The Journal of Aesthetic Education*. She speaks widely and currently serves on the editorial board of *Art Education* as the Instructional Resources Coordinator.

Rebecca McGinnis is Access Coordinator and Associate Museum Educator at The Metropolitan Museum of Art. She is Co-Chair of the Museum Access Consortium. She co-authored *Art and the Alphabet: A Tactile Experience*, a children's book combining braille, tactile pictures, and images of art. She was previously Director of Making Sense Access Consultancy and worked at the Victoria & Albert Museum and Royal National Institute for the Blind in London. She has master's degrees in art history and museum studies.

Elizabeth B. Reese, Independent Consultant, as well as Director of University Galleries and Visiting Assistant Professor at Texas A&M University-Corpus Christi, holds a B.S. and Ph.D. in art education and a MA in Interdisciplinary Studies. She is a former Marcus Fellow at the University of North Texas and has worked in children's and art museums and galleries for over 15 years. Her research focuses on the pedagogical potential of art exhibitions, and she has articles published in journals and books.

Julia Rose, Ph.D., is the Director of the West Baton Rouge Museum, Louisiana. Previously, she was a curator of education in American history museums for two decades before joining the faculty for the museum studies program at Southern University of New Orleans. Rose earned her doctorate degree from Louisiana State University and her Master of Arts degree from the George Washington University. Her research interests focus on historical interpretations and ethics of representations of American slavery.

Barbara Zollinger Sweney, Ph.D., is Educator for School & Docent Programs at the Columbus Museum of Art. She is also an adjunct faculty member in the Art Education Department of The Ohio State University where she teaches in the museum education strand of the Master's program. Ohio's Museum educator of the year in 2006, Sweney is a regular presenter at the Ohio Art Education and National Art Education Association conferences. Sweney holds a B.A. in Art History from Vassar and an M.A. and Ph.D. from the Ohio State University where she her research focused on learning in museums.

Betty Lou Williams, Ph.D. (Florida State University, 1994), is Associate Professor of Art Education in the Department of Curriculum Studies in the College of Education and an Adjunct Professor in the Museum Certificate Program in the Department of American Studies at the University of Hawaii at Manoa. Williams has been at UH Manoa since 1997. Her area of research is primarily focused on art education and policy issues connected to museums.

Glenn Willumson is Associate Professor of Art History and Director of the graduate program in museology at the University of Florida. Previously he held positions as Senior Curator at the Palmer Museum of Art and Curator at the Getty Research Institute. His research interests include museums, photography, and American visual culture. His publications include *W. Eugene Smith and the Photographic Essay*, and he is currently completing a book about the visual culture surrounding the first transcontinental railroad. Willumson is the recipient of fellowships from the Smithsonian American Art Museum, Yale University, the National Endowment for the Humanities, the Huntington Library, and the Kress Foundation.

NOTES

NOTES

NOTES

NOTES